Replication in the Long Nineteenth Century

Re-makings and Reproductions

Edited by Julie Codell and
Linda K. Hughes

EDINBURGH
University Press

Edinburgh University Press is one of the leading university presses in the UK. We publish academic books and journals in our selected subject areas across the humanities and social sciences, combining cutting-edge scholarship with high editorial and production values to produce academic works of lasting importance. For more information visit our website: edinburghuniversitypress.com

Edinburgh University Press Ltd
The Tun – Holyrood Road,
12(2f) Jackson's Entry,
Edinburgh EH8 8PJ

Typeset in 11/13 Adobe Sabon by
IDSUK (DataConnection) Ltd, and
printed and bound by CPI Group (UK) Ltd
Croydon, CR0 4YY

A CIP record for this book is available from the British Library

ISBN 978 1 4744 2484 4 (hardback)
ISBN 978 1 4744 2486 8 (webready PDF)
ISBN 978 1 4744 2487 5 (epub)

Contents

List of Illustrations

Acknowledgments

We wish to thank our respective institutions for their support of this project from the beginning to now, and the archive staff who assisted our research.

Julie would like to acknowledge funding support from the Institute for Humanities Research (IHR) and the Herberger Institute for Design and the Arts (HIDA), both at Arizona State University, which permitted her to visit collections, gather research material, and write. The IHR supported her research with a collaborative project seed grant for research and travel and helped arrange her lecture series on replicas, Fall 2016. The HIDA supported her research with three project and seed grants for various stages of this project's research. She would also like to thank the many curators and archivists for their assistance and permission to cite archival documents: Jo Briggs, curator, and Diane Bockrath, archivist and librarian, Walters Museum; Mary Lister, study center manager, Megan Schwenke, archivist / records manager, and Tara Cerretani, study center staff, Harvard Art Museums; Jim Moske, Metropolitan Museum; Angela Fuller, Taft Museum of Art; Peter Nahum; Suzan D. Friedlander, Arkell Museum; Emily Rice and Jane Joe, Philadelphia Museum of Art; and Alison Smith, Tate Britain curator of nineteenth-century art, with whom Julie co-organized a July 11, 2016, British Art Network Seminar on Victorian artists' autograph replicas, as well as the presenters and audience at that seminar. Thanks go to colleagues who shared suggestions and helpful comments on her presentations on replicas at conferences: Victorians Institute, Christie's Education Department in London, and Susan Bracken and Adriana Turpin, organizers of the 2016 conference on art agents. And thanks to my partner, Ted Solis, for his support.

Linda extends warmest thanks to Susan Swain, library specialist, Special Collections, Mary Couts Burnett Library, Texas Christian University (TCU), for creating images of Tennyson's versions of *The Princess* from materials in the library's permanent collection; and to Merry

Roberts, TCU English Department office manager, for expert assistance in merging files into a press-ready complete typescript. She is also deeply grateful to the English Department and three Ph.D. students at TCU, Claire Landes, Heidi Hakimi-Hood, and Samantha Moore, all of whom served as successive Addie Levy Research Fellows from 2014 to 2017, for their excellent research assistance as her chapter on *The Princess* unfolded in its own successive iterations. Mary Culley, the inaugural Addie Levy Research Fellow (2013–14), researched digitized nineteenth-century periodical databases for transdisciplinary uses of "replica"; and Samantha Moore additionally helped with arrangements for a Mini-Symposium funded by a TCU Research and Creative Activity Grant (RCAF) in 2014. The RCAF funded travel to TCU so that co-editors Julie Codell and Linda, along with contributors Sally Foster and Ryan Tweney, could meet face to face to pilot cross-disciplinary exchanges at an early stage of the project. A major TCU Invests in Research Grant of 2015 funded honoria and travel to TCU for Julie Codell and eight additional contributors to the current book, four of whom traveled from the UK, for a day-long symposium convened on the TCU campus April 10, 2015, which culminated in collective discussion that helped shape the introduction to this volume. Thanks as well for thoughtful questions posed by members of the TCU community present at the Mini-Symposium and those from off campus who traveled as far as 300 miles to attend the April 10 symposium.

We both thank our outstanding contributors for their groundbreaking essays, patience with our twofold requests for revisions, and timely responses to emails over the course of this project. We benefitted alike from your scholarship and collegiality.

Introduction: Replication in the Long Nineteenth Century – Re-makings and Reproductions

Julie Codell and Linda K. Hughes

In 2014 a Wallace Collection exhibition's online blog asked,

> why would you pay a vast sum for a copy piece of furniture? . . . In the second half of the 19th century and the first decade of the 20th century, many of the best pieces of 18th-century French furniture were copied by skilled cabinet-makers in Paris and London. Rather than being dismissed as mere "reproductions," these copies were of great quality and were highly prized by their owners. ("To copy or not to copy" n.p.)

The owners of these replicas included the Marquis of Hereford, whose former home is now the Wallace Collection. This furniture exhibition included comparisons between original works and their copies. The nineteenth-century cabinetmakers did not pursue exact reproductions, however, and often the wood and finish were better than the eighteenth-century originals, though the marquetry was simpler and less skillful (Figure 1.1).

In the same century Continental scientists Alcide d'Orbigny (1802–57) and August E. Reuss (1811–73), two of the earliest micropaleontologists, made a "plaster army" of microfossil models. D'Orbigny, who earned Charles Darwin's praise, saw a difficulty in disseminating his work on microfossils to a wider audience because of the specimens' small size. His carved scale models of foraminifera microfossils from limestone are now in the Muséum national d'histoire naturelle in Paris. He sold plaster replicas in sets to accompany his 1821 publication of the first classification of foraminifera. Later Václav Frič (1839–1916) made fresh models under the supervision of A. E. Reuss. One set can now be found in the Natural

Figure 1.1 Charles Couët Dreschler, *Roll-top desk, Copy of the bureau du roi of Louis XV*, c. 1855–60. Oak, sycamore, ebony, box, amaranth, Sèvres biscuit porcelain plaques gilt-bronze, leather, satiné, steel, brass, and enamel. 143 × 183 × 97.5 cm.

History Museum in London. Other sets are still being used to teach micropaleontology students (Miller 263–74).[1] Scientists were not the only fashioners of reproductions: glass artists Leopold Blaschka (1822–95) and his son Rudolf made models, including those of invertebrate animals (Loudon et al. 68ff.).

These examples, from French furniture to minuscule foraminiferal microfossils, point toward what Miles Orvell terms the "culture of replication" (Orvell 39), a phenomenon that crosses the boundaries among reproduction, imitation, and copies. Replication occurred in art, literature, the press, merchandising, the many historical revivals in the nineteenth century (for example, medieval or classical revivals), scientific concepts (for example, in biology, paleontology, and geology), and the repeated experiments associated with the scientific method. In this book we analyze the term's rich uses and associations,

and suggest in the Afterword that replica / replication also has special relevance for our contemporary intersections of digital culture and physical and biological systems.

Our title includes the word "re-making" because replications re-made prior versions, altering the meanings of prior and subsequent versions in the process. Replications were not mere copies or imitations; rather they materially provoked the rethinking and re-evaluations of ideas, cultural values, iconographies, and objects' functions and uses. In doing so, nineteenth-century replications challenged and changed cultural relations, such as, for example, the meanings of colonial objects or news that went viral (Cordell; Cordell and Smith; Smith et al.; Mussell).

In light of this pervasive re-making, we argue for the importance of exploring the historical roots of replications in scientific and cultural systems and their impact on ideas about creativity, originality, authenticity, and authority. In our multidisciplinary study, "replica," which had a special meaning among artists and artisans, is hardly the only term for acts of reproduction. We explore a range of re-makings, the various terms used for re-making processes, the variety of venues – markets, schools, museums – for which re-makings were undertaken, and the differing values placed on reproduced or replicated objects across art, literature, science, and media in the nineteenth century.

"Replica" derives from an Italian term signifying repetition or reply and by the nineteenth century designated a copy of a painting executed by the artist who made the first version (*Oxford English Dictionary*); the eighteenth-century Italian verb *replicare*, to reply or respond, is especially relevant. We consider replicas to be material responses to varied historical factors in the nineteenth century: public demand for access to high culture, Victorian historicism, global markets, new technologies, aesthetic ideals, and rising scientific professionalism. Notions of creativity, invention, and genius were intertwined in a complex way with ideas about the arts, evolution, and national identity, so that replicas became measures of changes in cultural values and discourses, such as the dichotomy between original and copy, and they had a central role in the democratization and accessibility of knowledge.

Re-makings were pervasive in a range of idioms and material culture: replicas by Vincent Van Gogh, J. A. D. Ingres, Dante Gabriel Rossetti, Eugène Delacroix, and others (Kahng; Rathbone); photographic copies (which radically affected notions of copies); authorial "reproductions" in successive editions; transnational

reprintings of English-language texts trailing new concepts of copyright, piracy, and authorial identities, and enabled by telegraphy and industrialized printing; new models of biological reproduction and adaptation in evolutionary theory; replicated experiments by scientists; and manufactured replicas of foreign and colonial goods. Improved methods also arose for making one medium look like another, such as casts of ancient and Renaissance sculptural monuments. Such widespread practices became institutionalized, extending the democratization and accessibility of goods and images, aided by expanded literacy and education, political reforms, a capitalist ideology of social benefit (writ large in the Great Exhibition of 1851), and steam-driven trade by rail or boat that carried a world of goods across geographies and time zones.

Replication in its myriad forms thus offered new pleasures of dominating nature or of "owning" versions of masterpieces or "exotic" goods, and played a part in the creation of infinite goods to satisfy infinite consumer desire. Venues for displaying replicas and reproductions also emerged across new or expanded socio-cultural strata, including provincial museums displaying art, archaeological, or geological specimens; department stores; international exhibitions; advertising; illustration; scientific societies; and universities.

Given all this, replication and its sister terms merit a history of their place in production, consumption, social functions, and aesthetic worth. While this is a tall order, the modern replica is not very old, becoming distinct from medieval and Renaissance copying practices in the eighteenth century, when replication took on new functions for industrial production and an emerging mass consumption through machine technologies and burgeoning mass print and photography.[2] To date no interdisciplinary study has been made of this shared impulse and vitality across nineteenth-century sciences, social sciences, arts, technology, and humanities. We seek to create that body of collective knowledge.

Methodology

In the realm of re-making, terms like replication, reproduction, copying, and imitation often overlap and serve as synonyms. These terms' meanings change, too. We propose here both a broad and a narrow view. We will generally not consider such areas as sculptural casts, forgeries, or mass reproductions across media – engravings or photographs of paintings, for example. Yet even these distinctions can be permeable at times, as in the case of archaeological casts

(Chapter 2) or *tableaux vivants* (Chapter 5). Instead, we are most interested in re-makings that exhibit, sometimes self-consciously, a relation (or reply) to a prior version or that travel away from a prior version in distinctive or innovative terms. Casts of medieval artifacts, for example, were important attempts to recuperate the past yet could acquire status as "originals" in the long arc of disciplinary history, just as shawls manufactured in Paisley, Scotland, were cheaper versions of Indian Kashmiri shawls yet could be revalued not as inferior imitations of the "real thing" but as artifacts tied to modernity and national pride.

Our methods are derived from material culture studies, with its focus on the object, and from individual disciplinary histories, but we seek underlying links among these histories and objects. Some philosophical issues that we address emerge from replication's materiality: the nature of the original, of a work of art's material boundaries if replicated, of genre as a form of replication, and of disrupted temporality in replication that generates a non-hierarchic sequence of variations in which nothing is truly an original or a copy. Replicas can help to gauge nineteenth-century cultural values, historical beliefs and myths, scientific knowledge, and public taste.

Our transdisciplinary, epistemological study of replicas fits what Mieke Bal calls a traveling concept. She argues that "interdisciplinarity in the humanities, necessary, exciting, serious, must seek its heuristic and methodological basis in concepts rather than methods . . . to look at the practice of cultural analysis" (Bal 5). Bal advocates a scrutiny of concepts not so much as firmly established univocal terms but as dynamic in themselves: "While struggling to define, provisionally and partly, what a particular concept may mean, we gain insight into what it can do . . . The struggle is a collective endeavor" (11; see also Tweney 731; Tweney et al. 137–58).

Bal avoids positing a master narrative; rather she acknowledges overlapping meanings among different fields and the intersubjectivity of knowledge. In this book we crisscross among disciplines to find an adequate, flexible definition of "replica" that nonetheless marks the term historically within the nineteenth century and in relation to subsequent notions of the term and its synonyms. The meanings of replication and re-makings are rich and we resist reducing them. As a traveling concept, "replica" can embrace multiple meanings and intersubjective knowledge (our broad view) while maintaining some specificity of historical meaning (our narrow view). Ambiguity and indeterminacy are thus to be expected, as are the plural meanings of a traveling concept, while we will at times define "replica" against parallel nineteenth-century terms such as imitation, copy, and forgery.

Replication Before the Nineteenth Century

Reproduction and replication had appeared earlier in eighteenth-century industrial production. Paul Saffo considers the printing press the

> first industrial replication machine, with its pieces of type amounting to standardized parts centuries before the idea occurred to the captains of the industrial revolution. As a replication machine, it was also a star-making machine, for the notion of authorship barely existed before the multiplication of texts invented the audience. The book and its replication led to a cult of the individual and of individual originality unprecedented in human history. (Saffo 95)

Ironically, perhaps, the replication of texts generated debates about concepts of individuality and originality. In her study of eighteenth-century invention, Maxine Berg notes that

> imitation was considered to be part of the inventive process. Invention, based in "imitative" principles, especially in taste, resulted in new commodities seen at the time as "modern luxuries" . . . a trade, not in "excess," "corruption," or "vice," but in "convenience," "utility," "ingenuity," "novelty," "taste and style," the defining characteristics of "modern luxury." Imitation . . . was at the heart of the eighteenth-century invention of consumer goods, and luxury provided the signposts towards a new British pathway to the production of quality consumer goods for rapidly expanding middling-class and international markets. (Berg 2)

As Berg is careful to note, the motives for this market-driven demand were "symbolism, taste and style, and especially . . . an eighteenth-century concept of 'imitation'" (2–3) that was

> not slavish copying in cheap materials . . . It was an evocation of objects in other forms, and indeed the new form might well surpass the original in inventiveness, value, and rarity. The commercialization of luxury in the making of new consumer goods was conceived as a part of invention – it was invention, and it was inextricably linked with all manner of process invention. (Berg 3)

Berg's definition of invention is remarkably close to the notion of replication among Victorian artists, in which the measures were taste and value; artists argued that the replica was an improvement over the first version, due to the artist's acquiring more skill and

practice since the production of the first version. Berg also focuses on consumption, as well as production, on consumer demand. In the nineteenth century, reception was a vital motivation for replication. Imitation, as Berg identifies it, also went beyond objects to imitate cultural symbolism and aesthetic sensibilities, which explained why imitations had special aesthetic qualities deemed desirable (Berg 11–12). This was also true of Victorian replications – they replicated systems of knowledge, not simply objects.

Aesthetics have an economic value, as noted first by Adam Smith in *The Theory of Moral Sentiments* (1759), in which he considered beauty and elegance as sources for demand and the wonder we experience when we see imitations (Berg 13). Economists thus credit Smith with making imitation a creative act (Berg 14, 22). We can apply these notions of imitation and value to nineteenth-century replication. What was replicated often had a high cultural value among consumers, whether Rossetti's paintings, Tennyson's poetry, serial texts, or Celtic or ancient sculpture, imparting to the first version and to the replica auras of originality, value, and even sanctity at times.

Replica / Replication in Nineteenth-Century Practice

Ralph Waldo Emerson asserted the inevitability of replicas in 1859, the year Darwin published *On the Origin of Species*:

> . . . there is no pure originality. All minds quote. Old and new make the warp and woof of every moment . . . By necessity, by proclivity and by delight, we all quote . . . not only books and proverbs, but arts, sciences, religion, customs and laws . . . many times found and lost, from Egypt, China and Pompeii down; and if we have arts which Rome wanted, so also Rome had arts which we have lost. (Emerson 8:178)

Despite the inevitability of replication in manufacturing and mass production, as Marx noted, workers suffered alienation from their own humanity when forced by industrial production to work by repetitive actions to make things they could not enjoy and under horrific working conditions beyond their control. Workers appeared to their employers as a kind of replicant, replications of one another, often reduced to body parts, "hands" who carried out factory work, and thus commodities themselves.

But from the perspective of consumption, replications offered an increasingly literate public, and especially the lower classes, an

entrée into Victorian cultural life through reproductions of images, texts, news, furnishings, and a host of geological, paleontological, and archaeological objects. Replications became, like Marx's commodity fetish, objects that naturalized capitalist economic relations to make them appear transhistorical or universal. In this way objects reflected and shaped social relations. As anthropologist Mary Douglas and others argue, consumption was primarily a social act for communication, not for survival (Douglas 150–1). Replications and reproductions of commodities, then, offered the lower classes more entry into public discourses and greater opportunities to treat goods as an information system and consumption as a social practice, "making visible and stable the categories of culture" (Douglas and Isherwood 59), buoyed by a series of Education Acts (1870, 1876, 1880) that helped spread literacy.[3]

In explaining how the terms "replica" or "reproduction" were used in their respective fields in the nineteenth century, our contributors present an intriguing array of terms and meanings. In media, cut-and-paste journalism, by which newspapers took and sometimes modified content from other newspapers or magazines (which were not covered by copyright), was a legitimate form of replication. Periodicals even had columns in which they reported on what other newspapers wrote. The periodical press popularly serialized fiction, poetry, non-fiction, and news stories in installments, a publishing format that replicated the title and author from installment to installment while also generating new content. And the press repeated many items, such as advertisements. Replication was, and still is, a major structural organizing principle of news in all media.

In the sciences, replication might be folded into the notion of mimicry, the resemblances among species intended for deception, and reproduction through cell division. Michael Faraday replicated others' experiments not only to test their results but also to study the processes of the experiments and learn more about physical properties of chemicals and electricity. John Tyndall, building on Faraday's ideas about glaciers and trying to understand further how glaciers move, created a mold to squeeze melting ice and imitate the resulting geological forces on glaciers, leading to his discovery that glaciers move through a process of continuous thawing and freezing (Tyndall 378–80). In biology, and especially in evolution, "reproduction" rather than "replication" is the most common term; but as variations on our parents and ancestors, we are biological replications of them. Robert Macfarlane terms Darwin's book one that "influentially advocated repetition with variation as a paradigm of change leading to newness" (Macfarlane 11).

In geology J. Poulett Scrope, describing the irregular motion generated by the pressure of overlying strata and the impact of specific gravity within overlying strata, asserted, "It may even be difficult to draw a line between the effects of these two replicating and fracturing forces" (Scrope 228). Successive earthquake shocks were likewise termed replicas, as in this passage on a Neapolitan disaster in *Leisure Hour*:

> "The Earthquake! the Earthquake!" the panic-struck inmates rushed from their dwellings into the streets. Two minutes had scarcely elapsed when the *replica* was experienced, or repetition of the shock, waited for with an agony of apprehension, as usually more violent than its precursor. ("Earthquakes" 165)

Charles Lyell's *Principles of Geology* (1830–3) propelled the new science of paleontology in which replicas played a vital role. The popularity of paleontological replicas in the Crystal Palace and emergent museums served a wide range of meanings and functions, from entertainment to knowledge to notions of time, history, and national identity. As early as 1842 at the Hunterian Museum in London, artist Thomas Hosmer Shepherd illustrated the paleontological replicas on display. Interestingly, paleontological "originals," the fossil bones extracted from the earth, were themselves a kind of replica. In the process of petrifaction the bones were denuded of their original organic materials and made into stone, as if organically cast, so paleontological replications such as those in museums or at the Sydenham Crystal Palace might be thought of as replicas of naturally made replicas. In addition, replicas of dinosaur skeletons had implications beyond science and art; Gowan Dawson argues for the relevance of paleontology to the aesthetics and criticism of serial fiction, for example (Dawson).

The Natural History Museum in London in 1883 was a repository of replicas. The museum created a groundbreaking display of 150 cases of the natural settings of nesting birds with replicated habitats of each species and had replicas of the 10,000-year-old giant ground sloth of South America, a plaster cast from bones from two partial skeletons. A replica of a dinosaur then in the Carnegie Museum in Pittsburgh, created at the request of Edward VII, Prince of Wales, who visited the Carnegie Foundation, was displayed in the London museum. This dinosaur replica of the *Diplodocus* was reproduced several times as gifts to other European museums, the gift of these replicas becoming a political component of American diplomacy in the run-up to the First World War (Nieuwland 61–8).[4]

Archaeological finds were often cast and electrotyped into replicas for study or for circulation among museums in Britain, Ireland, and beyond. So-called Celtic finds of sculpture from Ireland, Scotland, and the Isle of Man were especially popular and were disseminated to museums, while early medieval Irish and Scottish metalwork was faithfully reproduced and brooches re-made for contemporary fashion (Foster et al. 141–3). Victorian medievalists sought to replicate the Middle Ages in everything from neo-Gothic estates to jousts and the Young England movement, with its hoped-for revival of feudalism that appealed to a future prime minister, Benjamin Disraeli, and a future viceroy of India, Edward Robert Bulwer-Lytton, both members when young (see Ulrich). Largely influenced by John Ruskin's *Seven Lamps of Architecture* (1849) and *The Stones of Venice* (1851–3), Victorian architects like G. G. Scott (1811–78) recovered elements of Gothic design and replicated them as a modern architectural idiom, as in his St. Pancras station (1866–70) and Albert Memorial (1863–76). As well, William Morris revived and extended the older medieval use of vegetable dyes, in contrast to the chemical dyes of mass-produced fabrics and decorative objects that Morris loathed; here, too, Morris's replication was also a form of invention. Historical novelists, like Sir Walter Scott in *Waverley* (1814), sought to replicate a past event and milieu, as did non-fiction historical writings such as Thomas Carlyle's *The French Revolution* (1837), in which the author attempted to capture the feelings and thoughts of the various individual actors in that historical drama.

In art, autograph replicas (made by the original artist) were produced as a result of commissions by patrons or by artists exploring a favorite subject on their own. In some cases, a replica was a "reduction" made for a printmaker to prepare a print of a painting, and then later touched up by the artist and put on the market. Despite the persistence into the nineteenth century of art academies' pedagogy of copying Old Master paintings or classical sculpture, replicas became distinct from earlier practices to fit free market demands for widely circulating images for a mass public. As a version of a work by the original artist, a replica was both a production and a reception of the first version. As a form of reception, the replica commented on prior versions. It still bore the "aura" of the artist's hand, so it was an original as much as the first version was. Many major Victorian artists – Dante Gabriel Rossetti, Ford Madox Brown, William Holman Hunt, G. F. Watts, Frank Holl – made a living through autograph replicas commissioned by patrons who frequently requested changes from the first versions. Versions differed from one another in medium (an oil

might be replicated in watercolor or vice versa), details, or size, and artists often needed permission from a painting's owner to make a version from that painting, though artists insisted that replicas were not copies of prior versions and were done "from scratch."

Yet even the copying practices in the nineteenth century were more nuanced than the copying that had governed art production in the Renaissance, when copies were made by apprentices, not master artists (who usually then revised their apprentices' work). For Van Gogh, copying Old Masters in his own visual language was a way of expressing his personal style and his modernity through an "original copy" (Homburg 3), or what some art historians call a "creative copy" that reflected both the transmission and the creation of ideas. Thus, copying was not simply mechanical but could be expressive and reinventive, approaching our definition of the artist's autograph replica (Haverkamp-Begemann 13–21).

In literature replicas are as old as scribes, who often creatively intervened in what they reproduced, but nineteenth-century industrialized printing and dissemination of literature radically transformed literary re-makings. Nicholas Frankel traces the impact of the typewriter on Oscar Wilde's prison narrative, *De Profundis*. After reading the manuscript that Wilde wrote on the single sheet of paper daily allotted to him in prison, Lord Alfred Douglas destroyed it, and we would not have this work had Wilde not commissioned a replica typescript – very different in meaning and production from the original written in solitary confinement (Frankel 83–100). Authors frequently changed their texts in subsequent publications, sometimes radically, from the serialized chapters to the book or in subsequent reprintings. Fascination with imbricated technology's effect on creativity and replication was also thematized as the modified copy or "double" in Mary Shelley's *Frankenstein*, Joseph Conrad's "The Secret Sharer," and Robert Louis Stevenson's *The Strange Case of Dr. Jekyll and Mr. Hyde*, and as "double consciousness" in nineteenth-century psychology.

Within the intellectual framework of our project, then, each new production of a novel or set of poems was a replica, a positive entity in itself while economically an instance of both literary obsolescence and new manufacture. New editions involving authorial intervention (textual changes, added paratexts, and so on) aesthetically registered the writer's ongoing creativity. As the publication of a novel ended its magazine serialization (where illustrations were often placed at the front of each installment) and became a three-decker, illustrations moved next to relevant chapters or passages, which changed

the relationship of text and image in the reading experience. Jerome McGann's work on social processes and meanings that accrue to each edition of a work validates the importance of multiple versions over a single "definitive" edition. McGann's innovative sociology of texts has shifted attitudes, so that successive editions are now seen as having distinctive meanings that together create the genetic unfolding of a text's meaning and place in society (McGann 5–6).[5] Even the very concept of genre itself posits endless replication with each successive version of a genre in literature or in film.

Replica, Copy, Forgery, Imitation, Simulacrum

Only in painting (or analyses of earthquakes), however, was the term "replica" regularly used in the nineteenth century, and even then usage was not always consistent. Combinations of imitation and invention involved a cluster of terms referring to various versions, usually alluding to an original that was chronologically first. In addition to temporal order, the producer's identity – original artist, apprentice, forger – was crucial in assessing the quality and value of later versions. Engravings and photolithographs, for example, were identical copies by printmakers from the artists' instructions. Replicas could differ radically, like differences between a musical theme and its variations. Uncoupled from their first versions, an uncoupling that de-privileged first versions no longer considered "originals," the practice of making replicas had a profound effect on artists' and writers' ideas about the nature of authorship and of creativity, issues still relevant in cultural theory today.

The intriguing status of replication includes its combination of alienability (different, uncanny) and iterability (a variation on the first version or experiment). Contra Walter Benjamin's view that reproduction eliminated auras inherent in art works, it appears that "secondhand" images were highly treasured objects in the nineteenth century, and accrued their own auras through accessibility and familiarity (Benjamin 214–18; Codell 214–25). Reproductions' "aura" could be activated by a viewer's ownership of them (Bann). Recently, scholars have come to consider originality and reproduction as issues of historical contingencies and receptions, defined differently in different periods (Hansen 336–75). If replicas in art, literature, manufacturing, and science were both creative and commercial productions, replicas were not determined solely by commodification or commercial interests (as copies and imitations usually are) but remained tied to the creative process.

As noted earlier, replica culture also made inroads into consumers' social identities. As hubs of their own networks and of consumption, replicas resemble Baudrillard's simulacra (Baudrillard). For Gilles Deleuze, replicas undermine distinctions between copy and model, since a replica's production, agenda, and circuits differ from those of its "model" (Deleuze 1983: 47–8).[6] Nineteenth-century replicas took on their own life, what Brian Massumi calls their "own mad proliferation [that was] . . . an index" not of proximity but of distance (Massumi 91). This seems a counter-intuitive definition, but it is exactly how artists defended replicas as new variations done "from scratch," not imitations, insisting that replicas were value-added variations.

As a reply or response, a replica in painting or subsequent literary text might be a second version's reply to the first version and its reception. Like Deleuze's metaphoric rhizomes, replicas created their own copies, receptions, canons, networks, and contexts, as a replicated image or object changed meanings in and through every reception. In this essay collection we plan to map nineteenth-century debates about replication and its cultural underpinnings, and suggest ways that replicas and the processes of replication moved across disciplines and practices.

Replica / Replication: Themes and Theory

Replicas can map creative processes, public taste, and global markets through complex, collective negotiations. We believe that what became an industry of replicas reveals the fundamental cultural beliefs of nineteenth-century Europe. Within industrial capitalism and new exhibition and patronage venues, replicas acquired their own functions, meanings, and "auras." As sociologist and anthropologist Pierre Bourdieu argues, a work of art is co-produced by critical and public reception and dissemination through reproductions, critical reviews, and exhibition catalogs (Bourdieu 10–11). Replicas, as forms of reception, epitomized the late nineteenth-century marginalist economic theories of Alfred Marshall (1842–1924), in which value was increasingly determined by consumption and desire rather than by production, as in the labor theory of classical economics.

Replicas, as material objects, also had relationships with other things and with humans who see, desire, and use them. Many replicas were both creative acts and commercial potboilers, offering profound implications for understanding creative processes; even copies of art or artifacts sold in museums today, because they are sold there, bear an aura for many people (Reisinger and Steiner 68–71).

Every autograph replica bears its creator's reputation, its prominent patron's provenance, its cultural stature, and its publicity and reception by multiple audiences in its own time and later. In this sense each replica acquires its own cultural biography (Foster 339–55); cumulatively, multiple versions map the changing yet interactive effects and functions of objects.

Nineteenth-century replicas, then, disrupted and transformed economic, social, and aesthetic hierarchies while also affecting scientific thinking and mass education, helping to effect a cultural shift away from a shamanistic originality privileged by the Romantics to highly valued re-makings until modernism's fetish of originality and self-consciousness about tradition – as in Ezra Pound's "Make it new!" – denigrated replicas. For postmodernism in turn, however, originality became suspect and replication was welcomed in postmodern cultural analyses, being in line with postmodernism's skepticism and hostility to grand narratives and absolute truths.[7]

We have grouped the chapters that follow into themes to stress the interdisciplinarity of our topic and to connect replication with other overarching themes that dominated the period.

Replication and Networks

In this section the authors explore the place of the replication of material goods within larger social, professional, and national networks in Britain and America. Sally M. Foster analyzes the production of archaeological replicas that appeared in museums and international fairs, and sometimes figured in diplomacy from the Great Exhibition of 1851 to the First World War. Focusing on nineteenth-century Scotland, she constructs biographies of these objects as material goods and as comments on the "originals" they replicated; through the narrative of the social networks they created through their production, circulation, uses, and afterlives, they generated revised notions of authenticity and value. Julie Codell explores the ways in which European autograph art replicas served the aesthetic, social, and national interests of American collectors from the end of the nineteenth century to the early twentieth century. Focusing on the transatlantic network of replicas produced in Britain and France, and brought to Baltimore's Walters Museum and Harvard's Fogg Museum, Codell contrasts nineteenth-century British and French artists' motives for producing autograph replicas, American collectors' motives for collecting them, and their repository in museums where these objects acquired a new narrative, a revised aesthetic function, and a national purpose. Emilie

Taylor-Brown shows the intersection of authenticity, scientific replication, and the anxieties of science practitioners in the work of Nobel Prize-winning malariologist Ronald Ross (1857–1932), for whom replication was a major methodology in work that crossed several disciplines, although he felt threatened by his competitors' use of it. Taylor-Brown explores replication as scientific method and as ideological formation to expose the politics of disputes within the network of parasitologists competing for scientific priority of their findings. Dorothy Moss studies William Merritt Chase's use of portrait conventions in photos from social elites' *tableaux vivants* published in *Harper's Weekly* in 1905. These photos reveal conflicts within the elites' social networks and broader cultural conflicts between notions of performance and high art, and between painting and photomechanical reproduction.

Replication and Technology

Replication was a major facet of industrialization, and the authors in this section examine case histories of goods whose mass production generated debates about culture, empire, consumption, and class. Linda K. Hughes discusses literary replication by means of the rapid issuing and successful sales of five different versions of Alfred Tennyson's *The Princess* produced from 1847 to 1853, all bearing the same title. As Tennyson altered each version of *The Princess*, meanings accordingly shifted. Enabled by new print technologies and the poet's ongoing creative acts, the five *Princess* versions were all authentic but not identical, signifying a convergence of mass manufacture and key traits of art replicas. Suzanne Daly examines factory-made imitation Indian shawls in mid-nineteenth-century England and Scotland and the many economic, class, and policy factors that contributed to their mass production. Grounding her analysis in debates about the necessity, benefits, and best means of improving Great Britain's industrial arts, Daly argues that the shawls were ultimately linked to competing views of British imperialism, taste, and national identity. Elizabeth Miller explores replication across William Morris's many manufacturing endeavors in wallpaper, textiles, and books. She argues that his use of replication embodied his critique of capitalist modernity and his efforts to reconceptualize social arrangements and the relation of part to whole. For Morris, replication functioned on several levels as a trope, a method, and an aesthetic and political philosophy. Kathryn Ledbetter maps the migration of an image associated with the U.S.–Mexican war in 1846 across media and materials, from replicating newspaper stories to lithographs and finally to a utility quilt. Her analysis demonstrates the public role

of mass-produced images, which could create a furor that might be exploited to attain support for military ventures; but she gives more particular attention to the social affiliations formed by divergent media and temporalities of production, affiliations that profoundly affected the reception of a war incident and its image.

Replication and Authenticity

In this section the authors foreground replicas in relation to cultural debates over authenticity and fraud, including replicated identities and language, and replication as a means of controlling the representation of one's activities. Gowan Dawson analyzes paleontologist Richard Owen's claim to have discovered the dinornis, an extinct flightless bird, from a single fragment of a femur bone found in New Zealand. Owen claimed not only to have reconstructed (or replicated) a species long extinct but also to have been the sole discoverer. While keeping scientific replication in view, Dawson also considers literary replication, since this last enabled Owen to establish his account as fact and to suppress the role of others' contributions. Will Abberley examines mimicry and authenticity in a late-century writer notable for interweaving science writing and popular fiction, Grant Allen. Cognizant of parasitic mimicry in nature, Allen reconceptualized fraud in capitalist society as an extension of nature's dynamics of deception. Such use of science undermined traditional ideas of nature as a source not only of moral authority but also of authenticity. Abberley reads Allen's *An African Millionaire*, a depiction of fraud, within this framework to tease out the relation of mimicry to nature and society. Dan Bivona analyzes the trope of doubling and repetition in nineteenth-century literature, a long-standing literary feature but one that acquired peculiar relevance for science, cognition, language, and technology in works such as *Frankenstein* and *The Strange Case of Dr. Jekyll and Mr. Hyde*. He devotes extended attention to *Alice's Adventures in Wonderland*, which repeatedly represents not only failed replication but also the failure of any metalanguage to convey its occurrence – which takes Bivona, in his final peroration, to chatbots and the Turing Test.

Replication and Time

The authors in this section address how replications intersect with temporality to test scientific knowledge and re-evaluate replication itself as a process. James Mussell takes up a widely known example of industrialized print in the nineteenth century, the serial, which relies on

both identity (each part continues the story) and difference (each part adds something new). Mussell also considers literature's capacity to thematize replication in *Mugby Junction*, Dickens's 1866 extra Christmas number of *All the Year Round*. In these linked stories, repetition effects both progress and stasis in unexpected ways. Ryan D. Tweney focuses on a central scientific question and a central British scientist, Michael Faraday, who, like his contemporary scientists, sought to validate the objectivity and reliability of experiments. Faraday's solution was "repetition" (then the preferred term rather than replication). Faraday ensured that others could repeat his experiments and also used "repetition" to verify or invalidate others' work. Tweney concludes with historical scientific replication in the form of his own attempts to replicate Faraday's laboratory practices based on documentary records. Like Tweney, David Amigoni analyzes scientific replication in both the nineteenth and twentieth centuries through a specific lens: Bateson's Rule, named after the late Victorian geneticist William Bateson. Bateson, responding to the central role of replication in Darwin's theory of natural selection, posited morphological replication – the repeated production of a biological structure – to explain monstrous variations in insects such as double legs, using mechanical replicas to do so. In the twentieth century Gregory Bateson, anthropologist and cyberneticist, reread his father's work and coined the term "Bateson's Rule," renaming and repositioning William Bateson's scientific practices. Amigoni thus elaborates on scientific replication while also demonstrating the relevance of replication to cultural and linguistic manifestations such as a son's revision of his late father's scientific practices.

Afterword

In the Afterword the co-editors, after noting the larger questions this project poses about nineteenth-century replication, consider the legacy of nineteenth-century replication practices and remediation for the twentieth and twenty-first centuries, including our experiences of virtuality and digital culture.

Notes

1. See the London Natural History Museum sites at <http://www.nhm. ac.uk/research-curation/research/projects/dorbigny/dOrbhistory.html> and <http://www.nhm.ac.uk/natureplus/blogs/micropalaeo/2011/11/29/ plaster-army-of-microfossil-models-sent-to-help-inspire-students> (last accessed September 29, 2017). Loudon's groundbreaking collection of

models and replicas demonstrates the pervasiveness of visual, tactile replication in nineteenth-century science; as Lynne Cooke notes in *Object Lessons* (Loudon et al. 67), the exquisiteness of glass-blown and other models means that, while never foregoing scientific function, such replicas can easily pass into the "broad arena of art," a view that accords with this collection's interdisciplinarity and approach to replication as a traveling concept (see below).

2. One-off replicas were also being produced for and by museums during the nineteenth century, as seen in the large number of plaster casts that individual antiquaries donated to the National Museum of Antiquities in Scotland from the late 1840s, a trend that continued into the twentieth century. The "art and industry" museums produced casts with an eye to their multiple production and in different contexts. Thanks to Sally Foster for this comment.

3. On Marx's views on the commodity and for secondary literature on this topic, see Wendling 49–55.

4. We thank Gowan Dawson for sharing this information.

5. McGann's innovative approach to evolving editions dates back to *A Critique of Modern Textual Criticism* (1983), with each new volume altering elements of his thought, especially with the advent of digital humanities.

6. See also Deleuze, *Difference and Repetition*.

7. Interestingly, the term postmodern was first used in 1880 (Hassan 12ff.). Thus, like its reflection of marginalist economics, replication was embedded in many nineteenth-century concepts and practices.

Works Cited

Bal, Mieke. *Travelling Concepts in the Humanities*. Toronto: University of Toronto Press, 2002.

Bann, Stephen. *Parallel Lines: Printmakers, Painters, and Photographers in Nineteenth-century France*. New Haven, CT: Yale University Press, 2001.

Baudrillard, J. *Simulacra and Simulation*. Trans. S. Glaser. Ann Arbor: University of Michigan Press, 1994.

Benjamin, Walter. *Illuminations*. Ed. H. Arendt; trans. H. Zorn. London: Fontana, 1968.

Berg, Maxine. "From Imitation to Invention." *The Economic History Review* 55.1 (2002): 1–30.

Bourdieu, Pierre. *The Field of Cultural Production*. Ed. Randal Johnson. New York: Columbia University Press, 1993.

Codell, Julie, "'Second Hand Images.'" *Visual Resources* 26.3 (September 2010): 214–25.

Cordell, Ryan. "'Taken Possession of': The Reprinting and Reauthorship of Hawthorne's 'Celestial Railroad' in the Antebellum Religious Press." *Digital Humanities Quarterly* 7.1 (2013): n.p.

——, and David Smith. *Viral Texts: Mapping Networks of Reprinting in 19th-Century Newspapers and Magazines* (2017), <http://viraltexts.org> (last accessed September 29, 2017).

Dawson, Gowan. "Literary Megatheriums and Loose Baggy Monsters." *Victorian Studies* 53.2 (2011): 203–30.

Deleuze, Gilles. "Plato and the Simulacrum." Trans. R. Krauss. *October* 27 (1983): 45–56.

——. *Difference and Repetition*. Trans. Paul Patton. New York: Columbia University Press, 1994.

Douglas, Mary. *Risk and Blame: Essays in Cultural Theory*. London: Routledge, 1992.

——, and Baron Isherwood. *The World of Goods*. New York: Basic Books, 1979.

"Earthquakes." *Leisure Hour* March 18 (1858): 165–7.

Emerson, Ralph W. "Quotation and Originality." *The Complete Works*. Volume 8: *Letters and Social Aims*. Boston: Houghton Mifflin, 1904: 175–204.

Foster, Sally. "Embodied Energies, Embedded Stories: Releasing the Potential of Casts of Early Medieval Sculptures." *Making Histories: Proceedings of the Sixth International Conference on Insular Art, York 2011*. Ed. Jane Hawkes. Donington: Shaun Tyas, 2013: 339–55.

——, Alice Blackwell, and Martin Goldberg. "The Legacy of Nineteenth-Century Replicas for Object Cultural Biographies." *Journal of Victorian Culture* 19.2 (2014): 137–60.

Frankel, Nicholas. *Masking the Text*. High Wycombe: Rivendale Press, 2009.

Hansen, Miriam Bratu. "Benjamin's Aura." *Critical Inquiry* 34 (Winter 2008): 336–75.

Hassan, Ihab. *The Postmodern Turn: Essays in Postmodern Theory and Culture*. Columbus: Ohio State University Press, 1987.

Haverkamp-Begemann, Egbert, with Carolyn Logan. *Creative Copies: Interpretative Drawings from Michelangelo to Picasso*. New York: The Drawing Center and Sotheby's Publications, 1988.

Homburg, Cornelia. *The Copy Turns Original: Vincent Van Gogh and a New Approach to Traditional Art Practice*. Amsterdam: John Benjamins, 1996.

Kahng, Eik, ed. *The Repeating Image: Multiples in French Painting from David to Matisse*. New Haven, CT: Yale University Press, 2007.

Loudon, George, Lynne Cook, and Robert McCracken Peck. *Object Lessons: The Visualisation of Nineteenth-Century Life Sciences*. London: Ridinghouse, 2015.

Macfarlane, Robert. *Original Copy: Plagiarism and Originality in Nineteenth-Century Literature*. Oxford: Oxford University Press, 2007.

McGann, Jerome. *A New Republic of Letters: Memory and Scholarship in the Age of Digital Reproduction*. Cambridge, MA: Harvard University Press, 2014.

Massumi, Brian. "Realer Than Real." *Copyright* 1 (1987): 90–9, <http://www.brianmassumi.com/textes/REALER%20THAN%20REAL.pdf> (last accessed September 29, 2017).

Miller, C. G. "Micropalaeontological Models at the Natural History Museum, London." *The Geological Curator* 7.7 (June 2002): 263–74.

Mussell, James. "Moving Things: Repetition and Circulation in Victorian Print Culture (4/5)." Blog, July 22 (2014), <jimmussell.com> (last accessed September 29, 2017).

Nieuwland, Ilja. "The Colossal Stranger: Andrew Carnegie and *Diplodocus Carnegii*, 1902–1913." *Endeavour* 34 (2010): 61–8.

Orvell, Miles. *The Real Thing: Imitation and Authenticity in American Culture*. Chapel Hill: University of North Carolina Press, 1989.

Rathbone, Eliza E., William H. Robinson, Elizabeth Steele, and Marcia Steele. *Van Gogh Repetitions*. Exhibition catalog. New Haven, CT: Yale University Press, 2013.

Reisinger, Y., and C. Steiner. "Reconceptualizing Object Authenticity." *Annals of Tourism Research* 33.1 (2005): 65–86.

Saffo, Paul. "The Place of Originality in the Information Age." *Looking Closer 2: Critical Writings on Graphic Design*. Ed. Michael Bierut. New York: Allworth Press, 1997: 94–6.

Scrope, J. Poulett. "On the Formation of Craters, and the Nature of the Liquidity of Lavas." *American Journal of Science and Arts* 24 (September 1857): 217–30.

Smith, David A., Ryan Cordell, and Elizabeth Maddock Dillon. "Infectious Texts: Modeling Text Reuse in Nineteenth-Century Newspapers." *Proceedings of the Workshop on Big Humanities, 2013*. Washington, D.C.: IEEE Computer Society Press, 2013, <http://www.ccs.neu.edu/home/dasmith/infect-bighum-2013.pdf> (last accessed September 29, 2017).

"To copy or not to copy?: Reproducing Eighteenth-Century French Furniture." London: Wallace Collection Online Blog, March 10 (2014): n.p., <http://www.wallacecollection.org/blog/2014/03/to-copy-or-not-to-copy-reproducing-eighteenth-century-french-furniture/> (last accessed September 29, 2017).

Tweney, Ryan. "Replication and Ethnography of Science." *Journal of Cognition and Culture* 4 (2004): 731–58.

——, Ryan P. Mears, and Christiane Spitzmüller. "Replicating the Practice of Discovery: Michael Faraday." *Scientific and Technological Thinking*. Ed. Michael E. Gorman, Ryan D. Tweney, David C. Gooding, and Alexandra P. Kincannon. Mahwah, NJ: Erlbaum, 2005: 137–58.

Tyndall, John. *Hours of Exercise in the Alps*. New York: D. Appleton & Co., 1871.

Ulrich, John M. "Thomas Carlyle, Richard Owen, and the Paleontological Articulation of the Past." *Journal of Victorian Culture* 11 (2006): 30–58.

Wendling, Amy E. *Karl Marx on Technology and Alienation*. London: Palgrave Macmillan, 2009.

Replications and Networks

Replication of Things: The Case for Composite Biographical Approaches
Sally M. Foster

Introduction

The subject of this chapter is what are now anachronistically referred to as "replicas" of archaeological material from the long nineteenth century, generally referred to at the time of their creation as "reproductions," "facsimiles," or occasionally "models." Focusing on copies of early medieval (post-Roman / pre-Romanesque) material culture, and drawing on case studies from Scotland, I will consider the broader merits of a biographical approach to the study of replicas – as authentic things in their own right and as part of the composite biographies of the original and all its reproductions. The approach advocated here has relevance and application anywhere in the world that replicas were or continue to be created, and where present-day society needs to understand and be able to assess critically their contemporary value, significance, and authenticity. The objects that form the focus of this study were primarily made for and by antiquarians and museums whose aspiration was that these were exact copies of the shape, if not the precise color and texture, of their subjects. There was never any pretense that they were the originals but in due course they came to be regarded as inauthentic because of the prevalence of the idea, now challenged, that authenticity is a property bound up with the intrinsic fabric of the thing (Jones 2010: 182).

The production and exhibition of replicas of archaeological material was a very significant and serious enterprise for museums and international fairs, particularly between the Great Exhibition of 1851 in London and the First World War. Indeed, living in a world of reproductions and replicas has been seen as a defining attribute

of late nineteenth-century culture in general (Orvell xv, 39). In museums they were intended for observation, education, handling, documentation, presentation, and art training, not least as part of a concerted effort to improve the quality of industrial design and the taste of nations through the advocacy of universal principles of art. The reproductive media embraced the technologies and craft of plaster casts, electrotypes, fictile ivories, architectural models, watercolor copies of medieval stained glass, brass rubbings, paper mosaics, and, particularly from the 1850s onwards, photographs (Baker). The aim was usually to enable the acquisition of a representative canon of art. Collections could comprise many reproductive media (the "reproductive continuum," to use Baker's expression). Classic examples of the central role replicas played in the origins and identities of museums are the Cast Courts at what we now call the Victoria and Albert (V&A) Museum in London (Figure 2.1), the Musée d'Archéologie nationale at Saint-Germain-en-Laye near Paris, and the Römisch-Germanisches Zentralmuseum in Mainz.

Slightly earlier, antiquaries and others had begun to create and circulate reproductions, primarily for research and display purposes. From the seventeenth and eighteenth centuries onwards art schools and academies used them in teaching, receiving fresh impetus in Britain in the early nineteenth century with the widespread circulation of copies of the Elgin Marbles, and from 1837 with the philosophy and practices of the Government School of Design in London (Wade 173–230). From the end of the nineteenth century, and for a host of reasons but often related to changing attitudes to authenticity, such facsimiles – attempts at reproducing exact copies – largely fell out of favor (Baker; Foster forthcoming). It was not that plaster cast production totally stopped between the World Wars; towards the end of the twentieth century fiberglass and related materials went on to replace plaster for the production of direct copies cast from the original object, superseded in the twenty-first century by contact-less digital technologies.

The nascent scholarly and curatorial turn in the contemporary appreciation of the significance of such historic replicas is most visible in relation to plaster casts of classical, later medieval and Renaissance material (for example, Frederiksen and Marchand), largely because that is where the modern interests in obtaining copies first lay. There has been limited academic interest in replicas of other archaeological material, although that tide is also turning (Curtis; The Heirs to the Throne project, focusing on replicas of Aegean Bronze Age objects: Kulturstiftung des Bundes).

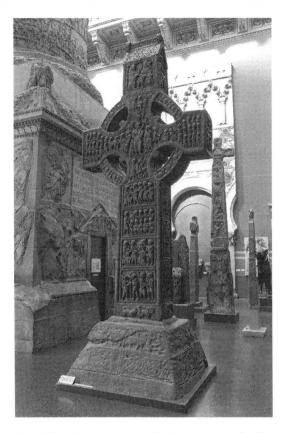

Figure 2.1 The Cast Court at the Victoria and Albert Museum opened in 1873, one of the most famous and influential examples of assembling plaster casts of sculpture for display to the public. Muiredach's Cross, Clonmacnoise, with the Ruthwell Cross in the background.

A facet of the new scholarly turn is that replicas can be considered not just as material culture directly connected to more ancient archaeological things – valued if the original thing is lost or damaged, for example – but also as artifacts in their own right, things that are becoming historic, with their own patinas of age and use (Foster and Curtis). They can therefore be of scientific value as examples of craft technologies and practices, just as cast museums and galleries are now also monuments in their own right (Camille 198). Beyond this, replicas embed many stories and embody considerable past human energy. Behind their creation, circulation, use, and afterlife lies a series of specific social networks and relationships that determined why, when, how, and in what circumstances they were valued, or not

(cf. Gosden and Larson). Individuals, museums, and skilled crafts-people strove to access, copy, multiply, share, and sell the copies from the molds that they made or commissioned. These networks and their physical traces speak of historically specific desires for the exotic, the intriguing, and things that were hard to acquire. The resulting entanglements extended between "centers" and "provinces," and across many countries of the world. Notably, the South Kensington Museum (which became the V&A in 1899) drew on the skills and connections of former military engineers with their experience of working in the colonies (McCormick 2010: 88–133). Replicas played a role in cultural diplomacy, as evidenced in the *Convention for Promoting Universal Reproductions of Works of Art for the Benefit of Museums of all Countries*, when fifteen royal attendees of the Paris Exposition of 1867 agreed to promote and facilitate the systematic acquisition and exchange of replicas of objects between countries and their institutions (Conway 84–5).

What follows makes the case for a composite biographical approach to the study and appreciation of early medieval historic replicas, and then briefly introduces three entirely original case studies focused on nineteenth-century and later replicas of early medieval carved stones in Scotland that illustrate different approaches. It ends with reflections in relation to understandings of value and authenticity.

Composite Biographies

Perhaps surprisingly, given the interest in how visual technologies play their part in making meaning and the recognized power and value of reproductions in many academic disciplines, replicas have so far featured little in archaeologists' cultural–biographical studies of things (for example, Benjamin; Hughes and Ranfft; Schwartz; Moser 2001; Nordbladh; Perry). Exceptions include Joy's 2002 study of his grandfather's replica medal, which illustrated how meaning transferred from the empty medal box of the lost original to the replica, and Foster and Jones's incorporation of the interpretative reconstruction of the Hilton of Cadboll cross-slab into their long biography of the monument.

Foster and Curtis have argued that the optimum interest and value of archaeological replicas lie in their appreciation as part of what we call "composite biographies" of the original and all its reproductions. Replicas of archaeological objects are things that lend themselves to a cultural–biographical approach in their own

right and to an analysis of their contribution to the biography of the thing that they are copying. Our work builds on that of Latour and Lowe, who argue for the positive value of both the "authentic original" and "reproduced originals." For them, the phenomenon that we really need to explain is how the relationship between these evolves. A cultural–biographical approach is open to many interpretative and methodological possibilities, but at the heart of the enquiry is exploring the changing relationships between people and things, and also places, through the life history of the object, which might be an artifact, monument, or landscape. With its focus on the materiality and agency of the thing as it entangles with people (Gosden and Marshall; Hoskins), the biographical approach enables us to identify how the meanings of things change in different contexts and through time. It allows for things to have multiple lives, both simultaneously and consecutively, extending beyond a short biography (birth, life, and death) into a long biography (to the present). The latter end of a long biography is where we encounter the discovery of archaeological objects, how they have come to be the things we interpret them to be (Holtorf), and also when the replication of archaeological objects may have played a role in that understanding. Of the three case studies that follow, the first two are published (and fully referenced), while the third relates to work in progress.

The first approach involves mapping out what Latour and Lowe (288) describe as object trajectories, a diachronic approach that can be considered to follow a vertical axis. They use the analogy of hydrographers examining the full extent and catchment of a river rather than focusing on the original spring. Bringing copies into the picture increases the physical manifestations of the changing meanings of things through time (as demonstrated at Hilton of Cadboll; see Foster and Jones). This route traces and considers the extended agency of the authentic original thing, including artifacts that might not have moved (far) from where they were first erected, while direct copies might make their way around the world.

The second approach entails exploring the massing of events in particular periods, the horizontal axes: that is, the examination and comparison of individual biographies to identify when trends in use, or non-use, of replicas become visible, which in turn provides a broader context for assessing and appreciating the significance of individual objects and their trajectories (cf. Swinney 152). Such events might relate to nodes within networks of people and things (Byrne et al. 2011b: 15), specifically "acquisition events" (Wingfield 27).

For the third approach, the focus is the biography of an individual *collection* or assemblage of replicas. There is an emerging interest in biographical approaches to museums, not least because they can produce "emotionally compelling and satisfying narratives. They mediate the academic and popular, spanning the physical and imaginary worlds" (Hill 1). At the same time, there is a growing interest, most notable among those working on ethnographic material, in "unpacking the collection." Characteristically, this involves a relational approach that plays with theories about agency and materiality, and draws insight from Actor Network Theory (Latour) to understand the networks of material and social agency that contribute to museum collections and that have ongoing legacies for the collections. Object biography provides the framework for this study, not least since objects are the things around which relationships stick together (Gosden and Larson 5). Behind the individual objects are messy backstories from which we can derive insights into the actual details of what people do and why (cf. Shanks 47; Hodder 222). Varied studies bring out the multiple and overlapping kinds of agency that are involved in such complex historical processes, from the "creator community" to, ultimately, the public (Byrne et al. 2011a). They frequently highlight the challenges of the historical sources available to the researcher but successfully illuminate the benefits of combining long (object) and short (individual person) biographies. They illustrate the different geographical scales of the agency, and the merits of a greater emphasis, on the one hand, on the communities producing the objects and, on the other hand, on what are the oft-neglected activities at the museums themselves.

To date, biographies of museums have often focused on a defined collection closely related in some way to a particular individual, usually a field collector or collector or curator (Elliot; Carreau; Byrne), or a whole museum (Gosden and Larson), as well as specific case studies that may illuminate particular aspects of processes in the past (Torrence and Clarke; Harrison) and present (Knowles). Methodological approaches are varied. Some may be underpinned by detailed statistical analysis, such as Wingfield's exploration of "acquisition events" at the Pitt Rivers Museum, Oxford, but commonly the narrative is shaped by a characterization of key trends in the object / collection biographies, defined by what may often be particular "nodes" in the networks under study.

How usefully, then, might a biographical approach be applied to a collection of replicas in an individual museum? Like ethnographic objects, there are many kinds of agency that would need to be factored

into understanding a collection of replicas, but with some differences in character, agency, and emphasis. Notably, the role of the museum as creator (in various guises) is an important dimension that stands out and distinguishes this sort of biography from others. A "collector," which may be the museum, will have prompted the creation of the object, and the "creators" may also include the museum, or its agents commissioned to make the replica. There is a growing academic appreciation of the value and role of the Victorian craftsperson, for trade, labor, and manufacture were at the core of debates about cultural institutions in nineteenth-century Victorian Britain and further afield (Kriegel; *Mapping the Practice and Profession of Sculpture*). Beyond the museums themselves, however, unlike in ethnographic field studies, there are no descendants of the "creator community" to engage with, although the communities associated with the authentic originals from which the replicas were made can still have an interest.

Replicas relate to individual objects that are usually not in the same museum (if a museum at all). Only the most recent elements of their *composite* biographies will intersect with the museum, yet the composite biography in its entirety – of both the authentic originals and the reproduced originals – will have a bearing on understanding the thing in the museum and its associated network of relations.

Replica collections are rarely created at a single moment in time, although there may be marked acquisition, and indeed disposal, events, which in turn could relate to wider events or trends (the second approach outlined above). Many of the stories and significances that attach to the replicas in the collection will fall between gaps unless the *process* of the creation of the collection as a whole is also looked at. Depending on the nature of the museum collection, there may also be the parallel biography of its collection of authentic originals of equivalent material.

Overall, the biography of a collection is, like the biography of an individual object, a framework for understanding broader networks of material and social agency, and attributing meaning to the various key stages in the life of the subject, even if that subject (a collection or assemblage of objects) is not strictly a "thing." This plays to the idea of a museum as a collecting agent and node of exchange in a network of relationships, where personal, institutional, collection, and object biographies are all part of that understanding (Wingfield 127; Carreau 208). In considering the biographies of many things in parallel, changes in value and meaning attributed to replicas in general, not just an individual object, are more likely to surface, and in an institutionally specific context where local nuances can be appreciated.

Replicating the Early Medieval

In general terms, the study of archaeological replicas since the nineteenth century can offer us important historical insights into the unfolding purpose of collections of plaster casts and related materials; the relations between museums and other organizations (international to national, national to provincial; and between different sorts of institutions); and relations of craft and industry. Of the archaeological material that was replicated, copies of early medieval material culture offer the most exciting prospects because of what was produced and the peculiarities of their biographical potential. Early medieval history and archaeology fired the nineteenth- and early twentieth-century imagination, contributing to the definition and construction of the identity of European nation states, and the contents of newly established national museums (Geary). Such thought has shaped the academic labels and structures we use in relation to early medieval people and culture, how early medieval portable art contributed to modern myths of modern European origins and modern aesthetic responses to medieval times (Williams; Effros and Williams). Replicas of early medieval material culture played their part in this at a provincial as well as national and international level, including at World Fairs (for example, the Jelling Stone placed at the entrance to the Denmark Building of the 1915 Panama Pacific International Exposition: Kolding 26).

Outside the scholarship on Celtic Revival metalwork (Edelstein), recently reinvigorated by Kelly's detailed 2013 study of mid-nineteenth-century commercial facsimiles of Irish archaeological jewelry, relatively little work has been undertaken to date. Exceptions are Effros's work on the creation and use of replicas of Merovingian material (Effros 2008; Effros 2012: 237–98), notably their impact at the Vienna World Fair, and the burgeoning interest in plaster casts of early medieval sculpture from Britain and Ireland (Redknap and Lewis 28–35; Ó Floinn; McCormick 2010; McCormick 2013; Foster 2013; Foster 2015; Foster 2016; Foster et al.). Such early medieval replicas circulated in Europe and further afield, and are a distinct aspect of the wider trade in plaster casts of sculpture, in terms of both the subject matter and the timescale for their production; starting in the 1830s, their production took off significantly in the 1850s, and peaked in the late 1890s and first decade of the twentieth century, with the last significant exchanges extending into the 1930s.

Carved stones are a key early medieval resource of much of northwestern Europe. A composite biographical approach that includes

their replicas offers added value and interest, since both the authentic original and the reproduced original(s) can move between static and portable states (Foster 2001; Foster 2010). This means that the relationships with the places and communities associated with them also change. At certain times, then, they acquire histories by virtue of their longevity, as reinterpretations build up around them. When portable – whether it is the parent material or the copy that has moved – histories build up through exchange and circulation (cf. Joy 2009; Foster and Jones; Jones 2010: 190–7).

Early Victorian Replicas of the St. Andrews Sarcophagus

This first case study considers the St. Andrews Sarcophagus and a series of plaster casts made of it, primarily between 1839 and 1853. Methodologically, the overall story has been enriched by observing the casts and Sarcophagus using a critical set of eyes and scientific techniques. This approach was instrumental in establishing the linked, modern biographies of the Sarcophagus (Figure 2.2) and the Norrie's Law silver hoard, two of the most important surviving Pictish relics from early medieval Scotland. What first unites their biographies is the fact that in 1839 an antiquarian, George Buist, arranged for them both to be replicated by a local plasterer, Mr. Ross, and a jeweler, Mr. Robert Robertson, for display in the museums of the Fifeshire Literary, Scientific and Philosophical Society and the St. Andrews Literary and Philosophical Society. This early documented program of replication of non-classical, local archaeological material culture took place in societies that were at the vanguard of the nineteenth-century establishment of county and local societies throughout Britain. A masterpiece of Pictish carving, the Sarcophagus with its Christian and kingly iconography was created in the mid- to late eighth century AD, probably as a royal shrine and certainly for use in a monastery endowed by royalty. After only a short time, it was dismantled and buried, to be discovered in 1833 during grave digging. From 1838 it became a museum exhibit for the newly founded St. Andrews Society, although not before a part of it had disappeared with another antiquarian to York. Spurred on by the lively polymath Buist, its existence motivated the Society to make the study and preservation of St. Andrews one of the foci of its activities, alongside its role in the world's earliest photographic activities. In 1839, before migrating to India to further his

Figure 2.2 Composite biography of the St. Andrews Sarcophagus and its plaster casts.

profession as a newspaper editor, Buist arranged for plaster casts to be made for the Cupar-based Fifeshire Society, seeing the benefits for research and communication. Casts of the Sarcophagus became sought-after antiquarian cultural capital for expanding regional and aspirant national museums in Newcastle-upon-Tyne (1848) and Edinburgh (1849). Wilson illustrated the Edinburgh cast (with all its tell-tale idiosyncrasies) in his influential *Prehistoric Annals of Scotland* of 1851 (opposite 503); this and the presence of the cast in Edinburgh helps explain why the Dublin Industrial Exhibition sought casts in 1853 to further its objective of illustrating the connection between the "aboriginal inhabitants of Great Britain and Ireland." The subsequent fortunes of each set of casts varied; some are now lost and others were created and circulated. In 1997 the Sarcophagus acquired a rejuvenated international status as part of the British Museum's Heirs of Rome exhibition, leaving St. Andrews and touring for the first time in its history.

This recent scholarly interest brought the significance of the plaster casts into the picture, and their historical impact and ongoing legacy are now being recognized. Biographical studies of the Sarcophagus and Norrie's Law hoard included the detailed examination of the fabric of both the Pictish and nineteenth-century objects for what they could say about the replication story and interdependent trajectories of both originals and replicas. The outcome was an appreciation of multiple strands: the physical legacies for the original; the interpretational legacies of the original; the confusion of reproductions with originals; the use of images of reproductions as if they were the originals; and the extended and fissile trajectories of objects, with their implications for the accuracy of the multiple reproductions (Goldberg and Blackwell; Foster et al.).

Creating Replica Collections of "Celtic" Sculpture, 1901–5

Bespoke collections of plaster casts of so-called "Celtic" sculpture were created for the 1901 Glasgow International Exhibition and for museums in Dundee in 1904 and Aberdeen in 1905. This highly visible pulse of activity occurred when museums across the world were furiously debating the value of plaster casts. The objects themselves and documentary sources (contemporary museum archives, museum journals, and newspapers) were researched to understand the networks behind what, why, and how items were selected for casting.

The outcome provides a Scottish example of a wider phenomenon and its context (Foster 2015).

When the Glasgow International Exhibition opened in 1901, its purpose-built centerpiece, now the Kelvingrove Museum, contained an area devoted to a "Selection of Reproductions of the Sculptured Stones of Scotland." In 1904 the Dundee Free Library acquired "a series of casts of the finest Celtic Crosses of Scotland," and in 1905 a major extension to Aberdeen Art Gallery and Industrial Museum opened as the Sculpture Gallery. This comprised a large collection of plaster casts of sculpture from prehistoric to eighteenth-century subjects, one part of which was a "Celtic Court" (Figure 2.3). The Dundee and Aberdeen collections were derivative of the Glasgow collection. The explanation is the role that the V&A played in supporting the "provincial" museums of Britain and Ireland. Its Circulation Department was responsible for arranging touring temporary exhibitions of material from the metropolitan center, but it also administered central government's grants to museums and art schools. At the time these grants were preferentially for "reproductions." The motivation was South Kensington's agenda for teaching

Figure 2.3 Aberdeen's Sculpture Gallery of plaster casts opened in 1905 to widespread critical claim. The Celtic Court was an important element of this, designed specifically to improve the quality of the local granite carving industry.

art, improving manufactures through technical art, and widening education and social benefits through an appreciation of "high art."

A Scottish antiquary headed up the selection of the material for Glasgow 1901, Robert C. Graham, informed by J. Romilly Allen, co-author of the magisterial *Early Christian Monuments of Scotland* (Allen and Anderson), then nearing publication. Robert F. Martin, an officer of the V&A's Circulation Department, largely piggy-backed on what Glasgow produced in his selections for Dundee and Aberdeen, where he had a free hand in the selection. The annual meetings of the relatively newly founded Museums Association pro-vided the place and opportunity for Martin and his provincial col-leagues to develop the friendships and networks that underpinned the creation of these collections. Martin's selection for Dundee and Aberdeen was what was expected of South Kensington-inspired dis-plays. By contrast, Glasgow aimed to promote Scottish history to an international audience through a general collection illustrative of, among other things, the country and people of Scotland, rather than improve the taste of a nation. The coincidence of the maturing study of early medieval sculpture and an awakening sense of national identities made "Celtic" sculpture perfect for creating and promot-ing cultural resources distinctive to the countries, and had become a source of inspiration for Celtic Revival artists and craftspeople, primarily from the 1880s. This "horizon" of newly created "Celtic" collections is a striking example of what Pittock calls "imperial local-ism," the idea that "local colour accentuated the glory of the Empire through stressing how many cultures it contained, and was welcome" (Pittock 106–7).

The Replica Collection of the National Museums of Scotland

This final example stems from ongoing research that aims, ulti-mately, to produce a biography of the replica collection of National Museums Scotland (NMS). This has its origins in two separate collections that merged in 1985: the Royal Scottish Museum (RSM; before 1904 the Edinburgh Museum of Science and Art, or EMSA) and National Museum of Antiquities of Scotland (NMAS). Only a short walking distance apart, each acquired and displayed plas-ter casts of early medieval material, but for very different reasons subject to very different institutional rationales and cultures. These differences are reflected in how the value and meaning attached to these casts changed with time (Foster forthcoming).

The EMSA was, along with the Dublin Science and Art Museum (now National Museum of Ireland), a branch of the South Kensington Museum (SKM). Although in one sense regarded as "provincial," it was not eligible to receive grants from South Kensington to develop collections, or indeed circulating collections, as Glasgow, Dundee, and Aberdeen could do. The SKM / V&A lent items to Dublin and Edinburgh, and they sold each other casts that they had caused to be created. The SKM / V&A used London *formatori* (plaster molders) as well as producing casts in house, but Dublin and Edinburgh always commissioned local *formatori*. EMSA acquired a small collection of early medieval material from Britain and Ireland, not least the Nigg cross-slab, and Ruthwell and Bewcastle Crosses that it commissioned. These were a small but locally significant part of a very large collection of plaster casts illustrating world art. From the mid-1930s onwards curators deemed these plaster casts to have no worth and began their destruction. During and immediately after the Second World War, material that had been in storage was destroyed rather than redisplayed, with a few examples passed to other institutions. Little now remains.

The NMAS developed from the museum of the Society of Antiquaries of Scotland in the 1860s. It acquired around 170 examples of casts of early medieval sculpture in the Isles of Britain and Ireland; most survive. Many were individual or small-group donations from individual antiquaries, a practice that spanned the 1850s to 1930s. Purchases were not common. Plaster casts were also acquired from the second half of the nineteenth century of prehistoric rock art and later medieval sculptures, as well as replicas in plaster and other media of portable objects, but the collection of replicas of early medieval sculpture stands out for its size (in all senses). Future work on the biography of this collection of replicas cannot divorce itself from an understanding of the 180 or so authentic original early medieval sculptures that are also in the NMS's collection. The chronological profile for their acquisition, again largely single or small assemblages donated by landowners / antiquarians, almost mirrors that of the casts. Together, these authentic originals and reproduced originals were a defined and significant category of material in the museum (Wilson), one that drew no distinction between the casts and the stone originals (Society of Antiquaries of Scotland; Figure 2.4).

This study is in its infancy, but a biographical approach to a collection of replicas *in context* can offer insight into differing historical

Figure 2.4 The curators Joseph Anderson and George Black amid the replicas (such as the Kildalton Cross, right), carved stones, and other antiquities on display in the National Museum of Antiquities of Scotland in George Street, Edinburgh, shortly before its transfer in 1892 to Queen Street.

attitudes to authenticity across diverse communities and geographies of interest, and the changing value and significance of this material. In the case of the NMS, we need to establish the "backstory" of donations and purchases, terse terms that are likely to underplay the complex range of practices that precede these events; explore the role of nineteenth-century curators and their successors in comparison to the agency of donors, manufacturers of the replicas, and other associated parties (this includes their influence on what was collected and displayed in the museum, why, when, and how); analyze the value of non-systematic and non-rationalized collecting practices (donation) in comparison to selection (purchase); reflect on whether we tend to over-reify the agency and actions of the curators because they are the most visible people; and consider the agency of the replicas in the construction of knowledge and meaning, and in the production of the identity and narrative of the museum(s) (cf. Alberti; Gosden and Larson; Moser 2010).

Concluding Reflections: Authenticity and Value

This paper has highlighted some of the interest of nineteenth-century and later replicas of early medieval sculpture and introduced different ways in which a composite biographical approach to the study of replicas can provide frameworks for understanding, in particular, the unfolding purpose of collections, relations between institutions, and roles of the craftsperson. The value given to replicas, individually and as assemblages, should lie in an appreciation of their biographies and the specific, socially constructed meanings attached to them, rather than merely considering how faithful a copy of the original they are. That said, the study of object trajectories requires a return to examining the material aspects of the objects too, and this may need to include scientific technologies and analysis to inform cultural biography (Foster 2016).

As the third case study shows, the study of existing replicas also provides a historical and contemporary laboratory in which to explore the concepts of value and authenticity, and their application. As original, authentic things in their own right, replicas, with their changing fortunes, stops, and starts in their individual and collective appreciation – richly documented in archival sources, scholarly and curatorial writings, and in the originals, reproductions, and surviving reproductive technology like molds – make an excellent medium for a historical perspective on the question of authenticity and value. Factors to consider include how / if the purpose of replication – and of those who made the replicas – affected the appreciation of authenticity then and now. This includes the extent to which replicas were destined to be commodities intended for exchange as opposed to cultural capital that could be circulated and (ultimately) donated (Appadurai). Linked to this are the nature of the technologies of replication, the material used, and the levels of craftsmanship involved. Of particular relevance is how the appreciation of replicas evolved within the emerging disciplines of art and particularly archaeology, and within individual institutions (cf. Alberti; Whitehead). By the end of the nineteenth century, curators from different disciplines on both sides of the Atlantic were involved in furious debates about the value of casts, particularly in the arrangement of museums of art, as recorded blow by blow in their first professional journals. The so-called Boston "battle of the casts," with its links through Edward Robinson, Director of the Boston Museum of Fine Arts, to what was happening in Aberdeen in 1905, is perhaps the best-known example of this (Whitehill 180–99; Foster 2015: 89).

The study of replicas has the potential to offer new insights that are relevant to both cultural heritage and collections management, a connection that is enriched by the dual identity of sculpture (and its replicas) as both monument and artifact. This presents enhanced opportunities to study and compare authentic originals and reproduced originals in a host of different contexts, in places where it will be possible to explore their contemporary social values as well as their evidential and historical ones. Replicas, old and new, still play an important role in museum collections and displays, but they are a particularly important consideration in external environments, where they increasingly replace or substitute for an "original" that is closed to the public, covered, or moved inside for its long-term preservation (Foster 2001). The experience of authenticity is fundamental to heritage management and conservation, but there are issues to resolve (Phillips; Jones 2009: 141–3). For example, social biography may be instrumental in revealing how people experience and negotiate authenticity, but there is insufficient research on how people make individual connections with the networks of relationships that the thing embodies, and how curators can therefore aid this process.

Reflecting on historical replicas can also tell us about the value of future technologies, while not diminishing the value of the historic originals. The historical and digital technologies used to create virtual replicas share the goal of faithful replication to promote a sense of authenticity; they therefore share an interest in how aura is generated and its relationship to the thing being copied (Latour and Lowe). Digital technology, a thing that can be perceived as having no substance, severs the "chain of proximity" to the original (Jeffrey 147; Cameron 70; Mussell on transparency or opaqueness of replicas compared with their first versions); this has implications, including if and how future researchers will find the intimate links and webs of personal, physical engagements that now make historic replicas such illuminating material. There are, however, processes such as democratization and co-production, and recognition of the value of creativity in visualization, which may contribute to the ongoing composite biography of the original (Jeffrey).

Acknowledgments

Professors Julie Codell and Linda Hughes very kindly arranged for me to participate in their 2014 workshop and mini-symposium on "19th-Century Replication and the Prehistory of Virtual Reality."

This was sponsored by TCU-RCAF funding, Dean Andrew School-master, AddRan College of Liberal Arts, and the office of the Provost and the Department of English at Texas Christian University. What I learnt from my fellow participants (Julie, Linda, and Ryan Tweney) fed into Foster and Curtis. In turn, this work has drawn from material within Foster and Curtis: ©, published by Cambridge University Press, reproduced with permission, and by permission of Neil Curtis and the European Archaeological Association. I thank David Clarke, Martin Goldberg, Alice Blackwell, Geoff Swinney, and Godfrey Evans for access to and discussions about the NMS's records and stores, and distilled wisdom on the history of these collections. The Strathmartine Trust, Henry Moore Foundation, and the University of Stirling funded the figures.

Works Cited

Alberti, Sam J. M. M. *Nature and Culture: Objects, Disciplines and the Manchester Museum.* Manchester: Manchester University Press, 2009.

Allen, John Romilly, and Joseph Anderson. *The Early Christian Monuments of Scotland.* Edinburgh: Society of Antiquaries of Scotland [1903]; rpt Balgavies: The Pinkfoot Press, 1993.

Appadurai, Arjun. "Introduction: Commodities and the Politics of Value." *The Social Life of Things: Commodities in Cultural Perspective.* Ed. Arjun Appadurai. Cambridge: Cambridge University Press, 1986: 3–63.

Baker, Malcolm. "The Reproductive Continuum: Plaster Casts, Paper Mosaics and Photographs as Complementary Modes of Reproduction in the Nineteenth-century Museum." *Plaster Casts: Making, Collecting, and Displaying from Classical Antiquity to the Present.* Ed. Rune Frederiksen and Eckart Marchand. Berlin and New York: De Gruyter, 2010: 485–500.

Benjamin, Walter. "The Work of Art in the Age of Mechanical Reproduction" [1936]. *Illuminations.* Ed. Hannah Arendt; trans. Harry Zorn. London: Pimlico, 1999: 211–44.

Byrne, Sarah. "Trials and Traces: A. C. Haddon's Agency as Museum Curator." *Unpacking the Collection.* Ed. Byrne et al. New York: Springer, 2011: 307–25.

Byrne, Sarah, Anne Clarke, Rodney Harrison, and Robin Torrence, eds. *Unpacking the Collection: Networks of Material and Social Agency in the Museum.* New York: Springer, 2011a.

Byrne, Sarah, Anne Clarke, Rodney Harrison, and Robin Torrence. "Networks, Agents and Objects: Frameworks for Unpacking Museum Collections." *Unpacking the Collection.* Ed. Byrne et al. New York: Springer, 2011b: 3–26.

Cameron, Fiona. "Beyond the Cult of the Replicant: Museums and Historical Digital Objects – Traditional Concerns, New Discourses." *Theorizing Digital Cultural Heritage*. Ed. Fiona Cameron and Sarah Kenerdine. Cambridge, MA: MIT Press, 2007: 49–75.

Camille, Michael. "Rethinking the Canon: Prophets, Canons and Promising Monsters." *The Art Bulletin* 78.2 (1996): 198–201.

Carreau, Lucie. "Individual, Collective and Institutional Biographies: The Beasley Collection of Pacific Artefacts." *Museums and Biographies*. Ed. Kate Hill. Woodbridge: Boydell & Brewer, 2011: 201–14.

Conway, Moncure C. *Travels in South Kensington with Notes on Decorative Art and Architecture in England*. London: Trübner & Co., 1882.

Curtis, Neil. "'The Original may yet be Discovered': Seven Bronze Age Swords Supposedly from Netherley, Kincardineshire." *Proceedings of the Society of Antiquaries of Scotland* 137 (2007): 487–500.

Edelstein, T. J., ed. *Imagining an Irish Past: The Celtic Revival 1840–1940*. Chicago: University of Chicago Press, 1992.

Effros, Bonnie. "Selling Archaeology and Anthropology: Early Medieval Artefacts at the Expositions Universelles and the Wiener Weltausstellung, 1867–1900." *Early Medieval Europe* 16.1 (2008): 23–48.

Effros, Bonnie. *Uncovering the Germanic Past: Merovingian Archaeology in France, 1830–1914*. Oxford: Oxford University Press, 2012.

Effros, Bonnie and Howard Williams, eds. "Themed Edition: Early Medieval Material Culture in the Nineteenth- and Twentieth-century Imagination." *Early Medieval Europe* 16.1 (1992): 1–2.

Elliot, Mark J. "Sculptural Biographies in an Anthropological Collection: Mrs Milward's Indian 'types'." *Museums and Biographies*. Ed. Kate Hill. Woodbridge: Boydell & Brewer, 2012: 215–28.

Foster, Sally M. *Place, Space and Odyssey: Exploring the Future of Early Medieval Sculpture*. Rosemarkie: Groam House Museum, 2001.

Foster, Sally M. "The Curatorial Consequences of Being Moved, Moveable or Portable: The Case of Carved Stones." *Scottish Archaeological Journal* 32.1 (2010): 15–28.

Foster, Sally M. "Embodied Energies, Embedded Stories: Releasing the Potential of Casts of Early Medieval Sculptures." *Making Histories*. Ed. Jane Hawkes. Donington: Shaun Tyas, 2013: 339–55.

Foster, Sally M. "Circulating Agency: The V&A, Scotland and the Multiplication of Plaster Casts of Celtic Crosses." *Journal of the History of Collections* 27.1 (2015): 73–96.

Foster, Sally M. "Expiscation! Disentangling the Later Biography of the St Andrews Sarcophagus." *Ancient Lives: Object, People and Place in Early Scotland. Essays for David V Clarke on his 70th Birthday*. Ed. Fraser Hunter and Alison Sheridan. Leiden: Sidestone Press, 2016: 165–86.

Foster, Sally M. "Smashing Casts: Replication of Early Medieval Sculpture as a Case Study in the Fragility of Cultural Value." *Destroy the Copy – The Fate of Plaster Cast Collections*. Ed. Annetta Alexandridis and Lorenz Winkler-Horacek. Berlin and New York: De Gruyter, forthcoming.

Foster, Sally M., Alice Blackwell, and Martin Goldberg. "The Legacy of Nineteenth-century Replicas for Object Cultural Biographies: Lessons in Duplication from 1830s Fife." *Journal of Victorian Culture* 19.2 (2014): 137–60.

Foster, Sally M., and Neil G. W. Curtis. "The Thing about Replicas – Why Historic Replicas Matter." *Journal of European Archaeology* 19.1 (2016): 122–48.

Foster, Sally M., and Siân Jones. "Recovering the Biography of the Hilton of Cadboll Cross-slab." *A Fragmented Masterpiece: Recovering the Biography of the Hilton of Cadboll Pictish Cross-slab.* Ed. Heather James, Isabel Henderson, Sally M. Foster, and Siân Jones. Edinburgh: Society of Antiquaries of Scotland, 2008: 205–84.

Frederiksen, Rune, and Eckart Marchand, eds. *Plaster Casts: Making, Collecting, and Displaying from Classical Antiquity to the Present.* Berlin and New York: De Gruyter, 2010.

Geary, Patrick J. *The Myth of Nations: The Medieval Origins of Europe.* Princeton: Princeton University Press, 2002.

Goldberg, Martin, and Alice Blackwell. "The Different Histories of the Norrie's Law Hoard." *Making Histories.* Ed. Jane Hawkes. Donington: Shaun Tyas, 2013: 326–38.

Gosden, Chris, and Frances Larson. *Knowing Things: Exploring the Collections at the Pitt Rivers Museum 1884–1945.* Oxford: Oxford University Press, 2007.

Gosden, Chris, and Yvonne Marshall. "The Cultural Biography of Objects." *World Archaeology* 31.2 (1999): 169–78.

Harrison, Rodney. "Consuming Colonialism: Curio Dealers' Catalogues, Souvenir Objects and Indigenous Agency in Oceania." *Unpacking the Collection.* Ed. Byrne et al. New York: Springer, 2011: 55–82.

Hill, Kate, ed. *Museums and Biographies: Stories, Objects, Identities.* Woodbridge: Boydell & Brewer, 2012.

Hodder, Ian. *Entangled: An Archaeology of the Relationships between Humans and Things.* Chichester: Wiley–Blackwell, 2012.

Holtorf, Cornelius. "Notes on the History of a Potsherd." *Journal of Material Culture* 7 (2002): 49–71.

Hoskins, Janet. "Agency, Biography and Objects." *Handbook of Material Culture.* Ed. Chris Tilley, Webb Keane, Susanne Küchler, Mike Rowlands, and Patricia Spyer. Los Angeles and London: Sage, 2006: 74–84.

Hughes, Anthony, and Erich Ranfft, eds. *Sculpture and its Reproductions.* London: Reaktion Books, 1997.

Jeffrey, Stuart. "Challenging Heritage Visualisation: Beauty, Aura and Democratization." *Open Archaeology* 1.1 (2015): 144–52.

Jones, Siân. "Experiencing Authenticity at Heritage Sites: Some Implications for Heritage Management and Conservation." *Conservation and Management of Archaeological Sites* 11.2 (2009): 133–47.

Jones, Siân. "Negotiating Authentic Objects and Authentic Selves: Beyond the Deconstruction of Authenticity." *Journal of Material Culture* 15.2 (2010): 181–203.

Joy, Jody. "Biography of a Medal: People and the Things they Value." *Maté-riel Culture: The Archaeology of Twentieth-Century Conflict.* Ed. John Schofield, William G. Johnson, and Colleen M. Beck. London and New York: Routledge, 2002: 132–42.

Joy, Jody. "Reinvigorating Object Biography: Reproducing the Drama of Object Lives." *World Archaeology* 41.4 (2009): 540–56.

Kelly, Tara. "Products of the Celtic Revival: Facsimiles of Irish Metalwork and Jewellery, 1840–1940." Unpublished Ph.D. dissertation, Trinity College Dublin, 2013.

Knowles, Chantal. "'Objects as Ambassadors': Representing Nation through Museum Exhibitions." *Unpacking the Collection.* Ed. Byrne et al. New York: Springer, 2011: 231–47.

Kolding, Frederik B. "California Calling – Denmark and the 1915 Panama Pacific International Exposition." *Erhvervhisorisk Årbog* 23.1 (2013): 12–32.

Kriegel, Lara. *Grand Designs: Labor, Empire, and the Museum in Victorian Culture.* Durham and London: Duke University Press, 2007.

Kulturstiftung des Bundes, The Heirs to the Throne, <www.kulturstiftung-des-bundes.de/cms/en/programme/fellowship_internationales_museum/die_thronfolger.html> (last accessed February 21, 2017).

Latour, Bruno. *Reassembling the Social: An Introduction to Actor-Network-Theory.* Oxford and New York: Oxford University Press, 2007.

Latour, Bruno, and Adam Lowe. "The Migration of the Aura, or How to Explore the Original through its Facsimiles." *Switching Codes: Thinking Through Digital Technology in the Humanities and the Arts.* Ed. Thomas Bartscherer and Roderick Coover. Chicago and London: University of Chicago Press, 2011: 275–97.

McCormick, Elizabeth L. "Crosses in Circulation: Processes and Patterns of Acquisition and Display of Early Medieval Sculpture in the National Museums of Britain and Ireland, circa 1850 to 1950." Unpublished Ph.D. dissertation, University of York, 2010.

McCormick, Elizabeth L. "'The Highly Interesting Series of Irish High Crosses': Reproductions of Early Medieval Irish Sculpture in Dublin and Sydenham." *Making Histories.* Ed. Jane Hawkes. Donington: Shaun Tyas, 2013: 358–71.

Mapping the Practice and Profession of Sculpture in Britain and Ireland 1851–1951, <sculpture.gla.ac.uk/> (last accessed February 20, 2017).

Moser, Stephanie. "Archaeological Representation: The Visual Conventions for Constructing Knowledge and the Past." *Archaeological Theory Today.* Ed. Ian Hodder. Cambridge: Polity, 2001: 262–83.

Moser, Stephanie. "The Devil is in the Detail: Museum Displays and the Creation of Knowledge." *Museum Anthropology* 33.1 (2010): 22–32.

Mussell, Jim. *The Nineteenth-Century Press in the Digital Age.* London: Palgrave, 2012.

Nordbladh, Jarl. "The Shape of History: To give Physical Form to Archaeo-logical Knowledge." *Histories of Archaeological Practices: Reflections*

on *Methods, Strategies and Social Organisation in Past Fieldwork*. Ed. Ole W. Jensen. Stockholm: National Historical Museum, 2012: 241–57.

Ó Floinn, Raghnall. "Reproducing the Past: Making Replicas of Irish Antiquities." *A Carnival of Learning: Essays to Honour George Cunningham and his 50 Conferences on Medieval Ireland in the Cistercian Abbey of Mount St. Joseph, Roscrea, 1987–2012*. Ed. Peter Harbison and Valerie A. Hall. Roscrea: Cistercian Press, 2012: 146–57.

Orvell, Miles. *The Real Thing: Imitation and Authenticity in American Culture 1880–1940*. Chapel Hill and London: University of North Carolina Press, 1989.

Perry, Sara. "Archaeological Visualization and the Manifestation of the Discipline: Model-making at the Institute of Archaeology, London." *Archaeology after Interpretation: Reframing Materials to Archaeological Theory*. Ed. Benjamin Alberti, Andy M. Jones, and Josh Pollard. Walnut Creek, CA: Left Coast Press, 2013: 281–303.

Phillips, David. *Exhibiting Authenticity*. Manchester and New York: Manchester University Press, 1997.

Pittock, Murray. *Celtic Identity and the British Image*. Manchester and New York: Manchester University Press, 1999.

Redknap, Mark, and John M. Lewis. *A Corpus of Early Inscribed Stones and Stone Sculpture in Wales*. Vol. 1. Cardiff: University of Wales Press, 2007.

Schwartz, Hillel. *The Culture of the Copy: Striking Likenesses, Unreasonable Facsimiles*. New York: Zone Books, 1998.

Shanks, Michael. *The Archaeological Imagination*. Walnut Creek, CA: Left Coast Press, 2012.

Society of Antiquaries of Scotland. *Catalogue of the National Museum of Antiquities of Scotland*. Edinburgh: Society of Antiquaries of Scotland, 1892.

Swinney, Geoff. "Towards an Historical Geography of a 'National' Museum: The Industrial Museum of Scotland, the Edinburgh Museum of Science and Art and the Royal Scottish Museum, 1854–1939." Unpublished Ph.D. dissertation, University of Edinburgh, 2013.

Torrence, Robin, and Anne Clarke. "'Suitable for Decoration of Halls and Billiard Rooms': Finding Indigenous Agency in Historic Auction and Sale Catalogues." *Unpacking the Collection*. Ed. Byrne et al. New York: Springer, 2011: 29–53.

Wade, Rebecca J. "Pedagogic Objects: The Formation, Circulation and Exhibition of Teaching Collections for Art and Design Education in Leeds, 1837–1857." Unpublished Ph.D. dissertation, University of Leeds, 2012.

Whitehead, Chris. *Museums and the Construction of Disciplines: Art and Archaeology in Nineteenth-Century Britain*. London: Duckworth, 2009.

Whitehill, Walter M. *Museum of Fine Arts Boston: A Centennial History*. Cambridge, MA: Belknap Press of Harvard University Press, 1970.

Williams, Howard. "Forgetting the Victorian in Anglo-Saxon Archaeology." *Britons in Anglo-Saxon England*. Ed. Nick J. Higham. Woodbridge: Boydell Press, 2007: 27–41.

Wilson, Daniel. *Archaeology and the Prehistoric Annals of Scotland*. Edinburgh: Sutherland & Knox, 1851.

Wingfield, Chris. "Donors, Loaners, Dealers and Swappers: The Relationship behind the English Collections at the Pitt Rivers Museum." *Unpacking the Collection*. Ed. Byrne et al. New York: Springer, 2011: 119–40.

Transatlantic Autograph Replicas and the Uplifting of American Culture
Julie Codell

Through complex nineteenth-century transatlantic exchanges and relationships among dealers, collectors, and art works, many auto-graph replicas (a version of an art work made by the same artist that created the first version) found their way into American collec-tions and then subsequently into American museums. I will focus on the Winthrop collection left to Harvard's Fogg Museum and the Walters collection left to the Walters Museum in Baltimore. Both collections were foundations of their respective museums, further elevating the importance of the replicas these collectors gathered. I will argue that art works' transatlantic voyages had a profound effect not only on American art history, then a nascent discipline, and on American public art education through museums, but also on Americans' understanding of European, especially British and French, art culture, as these autograph replicas were recontextual-ized from European to American cultural narratives. Crossing the pond, replicas experienced processes of "displacement and resigni-fication" (Dzelzainis and Livesey 3). Works that would have been considered distinct from one another by style or nation were sud-denly yoked into one collection and equalized in a new American cultural narrative of purpose and value.

American collectors after the mid-nineteenth century were largely philanthropic collectors, who planned to give their collections to pub-lic museums in a manner similar to that of British middle-class indus-trialist collectors, and unlike aristocratic collectors whose collections went to their heirs or were put up for auction.[1] Autograph replicas collected by Americans were newly networked with other works in these collections and within a new cultural narrative. This narrative was further extended when the collections entered public institutions

that in turn historicized origins, motives, public taste, style lineages, and educational functions for these replicas. Replicas participated in the "narrative of transatlantic circulation and identity formation that goes beyond a simple export–import or exchange relation between nineteenth-century Britain and America" to generate "the reconfiguration and relayering that results from transatlantic thinking" by which art works "can be appropriated and given new meanings in the exchange across time, space and viewers" (Dzelzainis and Livesey 4–5). Autograph replicas were imbued with the aura of the canonic artists that American collectors energetically sought between roughly 1870 and 1930, although many of these artists had not yet become canonized or collected in America – Edward Burne-Jones, Jean-Baptiste-Camille Corot, Théodore Géricault, Eugène Delacroix, Jacques-Louis David, George Frederick Watts, Dante Gabriel Rossetti, Pierre-Paul Prud'hon, Jean-Auguste-Dominique Ingres – all still relatively young stars in the European firmament around 1900. Collectors, I argue, created their canonization through their collecting, which affected market values and provenance.

In the production of autograph replicas, however, artists and patrons intentionally obscured replica production chronology and redefined subsequent versions as new and improved works, with their own auras of originality and creativity. The production and uses of autograph replicas were different in Britain and France, but these differences were leveled as paintings acquired special cultural meanings for U.S. collectors and museums. Largely treated as original works, nineteenth-century autograph replicas endorsed collectors' idealizing motives to improve American culture by educating artists and public taste, and by constructing a canonic art history out of nineteenth-century artists, not only Old Masters, as these collectors helped determine the canon for American art historians, museums, and the public.[2]

Many American collectors believed that European culture would civilize America. Merchant ship owner and importer Robert Gilmor, Jr. (1774–1848), of Baltimore believed that "importing it [British culture] to the United States was central to American cultural development" (Humphries 147). Samuel Bancroft (1840–1915), who bequeathed his replicas to the Delaware Art Museum, wrote to his English agent, Charles Fairfax Murray, that English art in the U.S. would "really do more good to humanity by coming where they can illumine dark places than by staying in England" (Elzea 79). Baltimorean William Walters (1819–94) complained, "I have always been vexed at the backwardness of the appreciation of my countrymen for Tadema [Lawrence Alma-Tadema]

but I will guarantee their intelligence and good behavior after the inau-
guration of my new gallery."[3] Many other American collectors shared
this belief that the country lagged behind Europe and that European
art, including autograph replicas, could improve American culture. Dif-
ferences in taste between America and Europe were reflected in sharply
different market values. William Walters paid the enormous sum of
90,000 francs in 1871 for a work by Delaroche that was more touched
up than painted by the artist. Winthrop often paid higher prices for
Pre-Raphaelite works than such works would have garnered in Britain,
where the taste for Victorian art declined by the 1930s. Replicas, touted
as improvements over first versions, often cost more than first versions
(Macleod 16).[4]

The 1870s saw a rise in new American institutions: the Metro-
politan Museum in New York, Boston's Museum of Fine Arts, the
Philadelphia Museum, Chicago's Art Institute, and Andrew Mellon's
collection in the National Gallery in Washington, D.C. Some col-
lectors established their own museums: Isabella Stewart Gardner,
Henry Clay Frick, Pierpont Morgan, and Henry Huntington. David
Cannadine calls this "museumization" and it was pervasive among
American collectors.[5] As Neil Harris points out, "The major Ameri-
can purchasers – egotistic, competitive, grasping, crude as they may
have been – often merged personal assets with collective goals . . .
a mission, as cultural philanthropists, institutionalists . . . planning
their own galleries or providing stock for public museums, current
and future" (Harris 197).

British artists defended replicas as value-added, arguing that
subsequent versions reflected more knowledge and skill. William
Holman Hunt claimed his 1857 second version of *St. Agnes Eve*
was better "than circumstances and my feeble power would allow
in the first instance [1848]" (Bennett 66). He noted that dealers
told him "there was a great demand for replicas of works of mine
exhibited years ago, which when they first appeared had been much
abused" (Hunt 2:95). Replicas often varied from first versions.
Richard Redgrave's daughter insisted that his replicas were never
identical to first versions; *The Poor Teacher* was "repeated" four
times but "with alterations" (Redgrave 43). Frank Holl's "extraor-
dinary number of replicas"[6] led his daughter to insist they were
"never . . . mere dead copies of the original but . . . always literally
repaintings of the entire subject, from the same models posed afresh
. . . as fine as, if not finer than the original" (Reynolds 129–30).

Patrons, dealers, and museums encouraged replicas and such
requests meant success for artists, indicating the popularity of their

works and assuring the dissemination of these paintings. In Hunt's case, replica demand measured his rising reputation and changing British taste. About 15 percent of Rossetti's non-portraits were replicas, according to David Thomas (127). Two oil versions of Hunt's *The Shadow of Death*, painted together in Bethlehem and Jerusalem (1869–72), and completed in London, were both bought to be given to municipal museums.[7] Engravings of William Powell Frith's *The Railway Station* (1862) flooded the market, yet iron magnate Isaac Lowthian, sherry importer Frederick Cosens, and wool merchant David Price still wanted autograph replicas of it (Macleod 250).

Artists sometimes thought of replicas as potboilers, sometimes as serious investigations. Frith sold a small version and sketches of *Derby Day* and engraving rights to British dealer Ernst Gambart, calling them "replicas – to give them a fine name," hinting that they were potboilers.[8] He insisted they were always done with the first version's owner's consent, an important assurance but also a sign he painted from paintings, not reposed models, making his replicas more like copies (Frith I:318; Bills and Knight). Ford Madox Brown admitted, "I would paint as many Macbeths as any one choose to pay for – upright, lying down, or standing on their heads, if paid for accordingly" (Mills 34). To critic and friend F. G. Stephens, Brown wrote, "my own work for the last year has, with the exception of two children's head pictures, all been duplicate pieces."[9] Rossetti made replicas of at least fifty-four paintings, from two to nine or ten replicas for each painting in some cases, largely to fulfill patrons' commissions. Rossetti and G. F. Watts also made replicas to explore subjects, as did Vincent Van Gogh. Jean-François Millet's successive versions of peasant figures often gained monumentality and heroic scale in Millet's attempt to rethink his compositions (Kelly 54).

The rapid expansion of the art market after 1850 in France and new middle-class art consumers encouraged artists like Millet and Corot to produce replicas for this market (Kelly 59–60). French replicas bought by American collectors were often reductions, small copies of a work made for a printmaker to use to make prints. Paul Delaroche's *Hemicycle* reduction became a marketable object; once on the market, I would argue, a reduction became valued and priced as an autograph replica. On Delaroche's *Hemicycle* Edward Strahan (pseudonym of Earl Shinn) in 1882 wrote, "I have seen nothing in America which seems so perfectly to bridge the civilization of the two continents, and place the connoisseurship of the new world in connection with that of the old" (Strahan 1:82). America, the new world, considered not yet culturally equal to Europe, was becoming

a connoisseur through this replica, an 1853 reduction that Delaroche prepared for an engraver (Bann 34–5). For Strahan this work possessed Delaroche's aura (Bann 41), indicating the high value American collectors put on French Academic art, a new taste they transmitted to the public.

But this replica had a rocky history. Its loose brushwork was attributed to Delaroche's pupils, but a then-popular biography claimed Delaroche retouched the work, which Strahan interpreted as indicating the master did the work. Recent examination shows that Delaroche worked on it before signing it in 1853. But in the dealer Goupil's account books it is attributed to a pupil, Charles Béranger, who did the reduction around 1841. Béranger sold the work to Goupil in 1850 for 5,000 francs. After Béranger died in 1853, Delaroche heavily retouched it, making it worth much more. Delaroche kept the work until he died in 1856, when it was sold to Goupil for 43,900 francs, then bought by Art Nouveau designer Eugène Gaillard in 1860 for 50,000 francs, when the Goupil catalog described it as "entirely repainted" by Delaroche (Bann 38–9). American dealer George Lucas mediated between William Walters and Goupil, and bought it for Walters for an extraordinary 90,000 francs in 1871.[10]

Stephen Bann explains how replica production defined artists' identities. Jean-Léon Gérôme's *Duel after the Masquerade* was replicated many times, twice in 1857 alone. In 1859 Gambart commissioned a hand-colored lithograph. In 1867 the *Fortnightly Review* hailed Gérôme, and this work was reproduced in a lithograph, an engraving, and a play in 1881.[11] In 1867, Gérôme bought the replica's litho stone and republished the litho with some loss of landscape details (Bann 43). Gérôme assured Gambart that the third, smaller painting replica that Gambart sold to William Walters of Baltimore was an improvement, sharpening the image of the adversarial figure in the duel, the kind of argument British artists made about subsequent versions. Gérôme was glad Walters bought it: "I am told he can appreciate things seriously conceived and seriously executed" (Bann 43), underscoring the work's presumed originality.[12]

According to Bann, unlike Delaroche and Gérôme who pursued the new international patronage with replicas, Ingres retained unsold works, even buying some back for reworking, making replicas and variations that "have become integral to our perception of Ingres's distinctiveness as an artist" (46). In an 1856 posthumous retrospective of Delaroche's work, the organizers did not juxtapose replicas (46). In an 1867 posthumous exhibition of Ingres's works, however, three versions of *Oedipus* were shown, a conjunction that became the norm for documenting Ingres's work, beginning with Henri

Delaborde's 1870 catalog, which noted the long period, 1808–39, when these were reworked and made anew. One in London's National Gallery and one in the Walters Museum are called "reduced repetitions." Walters's version, painted from 1835 to 1864, has no distant figure, a right–left reversal, and the sphinx looking away from Oedipus (Bann 47). Bann argues that these reduced versions were not for engravers but for Ingres's own reference, as he expected engravers to prepare their own drawings. For Ingres the repeating image assumed "an existential rather than a purely commercial significance" that it had for Gérôme and Delaroche (Bann 47).

Autograph Replicas in the Walters Art Museum

Baltimorean George Lucas, an art agent with eclectic taste, a Paris address, and American clients, advised Walters on the purchases of nineteenth-century art. Unlike other American collectors, Walters, a grain merchant and then liquor wholesaler, and after the Civil War a banker and railroad investor, pursued contemporary European painting, not Old Masters. When he acquired *The Duel after the Masquerade*, Gérôme was still an emerging artist. Goupil had opened a gallery in New York in 1846 and in an early catalog claimed that a nation's greatness was determined by "the position the Arts have attained" in that nation (*Gérôme & Goupil* 32). Gérôme became known to Americans through the 1855 Exhibition, at which he was awarded the Legion of Honour, attracting the New York press and the American journal *The Crayon* (*Gérôme & Goupil* 33). Although *The Duel* was negatively reviewed, in 1859 Gambart brought an exhibition of European works to New York, and Walters bought Gérôme's painting for $2,500 (the third highest price in the Exhibition). Purchases by other collectors followed until, by the time of Gérôme's death, Goupil and his successor Knoedler had sold 144 paintings by Gérôme, about 25 percent of the artist's total output. Walters in 1873 purchased Gérôme's *Dead Caesar* for the Corcoran Gallery directly from the artist for 20,000 francs (*Gérôme & Goupil* 34).

Walters's very first purchase was a replica of E. A. Odier's *Retreat from Moscow* in the Amiens museum (Johnston 12). He commissioned works by American landscape artists Asher Durand and John Frederick Kensett (Johnston 13–14), and, influenced by John Ruskin's writings and foreign dealers in New York City, was drawn to nineteenth-century works (Johnston 17). Spending the Civil War in Paris and touring Europe from 1862, he bought many paintings in Paris through Lucas, some intended for resale in the U.S.

(Johnston 38–40).[13] Lucas provided access to artists' studios and works by Honoré Daumier, Corot, Antoine-Louis Barye (Lucas's and Walters's favorite sculptor), and others. Later Walters's son Henry (1848–1931), who had more modernist tastes, visited Lucas in Paris and on one occasion in 1903 bought a Degas and a Monet for 25,000 francs from Mary Cassatt (Johnston 139).

It is interesting to see which replicas William Walters bought, which ones he commissioned, and which ones his son Henry purchased.[14] William purchased replicas by several French Academic artists, such as Alexandre Cabanel's *Napoleon III* (c. 1877), a replica of Cabanel's large portrait commissioned in 1865 for the apartments of the Empress Mathilde in the Tuileries and exhibited in 1867 at the Exposition Universelle.[15] Thomas Couture's *The Prodigal Son* (1850) was a replica of a work exhibited in the Paris Salon of 1841 whose original version was destroyed in the Chicago Fire of 1871. Gérôme's *The Duel after the Masquerade* (1857–8), bought through Gambart's exhibition at the New York National Academy, has versions in the Musée Condé (first version, 1857) and the Hermitage Museum (1859).[16] Charles Gleyre's *Lost Illusions* (1865–7, with Léon Dussart), a replica of *The Evening*, exhibited in 1843 at the Salon, was commissioned by William Walters in 1865 through the dealer Goupil and received in 1867.

Walters also purchased and commissioned replicas from avant-garde artists: Puvis de Chavannes's *Ludus Pro Patria* (1883), commissioned for the staircase of the museum in Amiens, has a version in the Toledo Ohio Museum and a reduced version in the Metropolitan Museum, New York. Corot's *The Evening Star* (1864) has a prior version in the museum in Toulouse (1864), a private collection deposited at the St. Louis Art Museum, and an unknown location. In Paris Walters was taken with the painting but instead of buying the first version he commissioned Corot to paint a replica that Walters purchased in 1864 for 1,000 francs. Walters even suggested changes for the replica (Johnston 36). Delacroix's *Christ on the Sea of Galilee* (c. 1854), one of six versions painted between 1841 and 1851, and purchased by Lucas for Walters in 1886, has versions with a rowboat in the Nelson–Atkins Museum (a study, 1841), the Portland Art Museum (c. 1841), the Metropolitan Museum (c. 1853), and a private collection (1853), and two versions with a sailboat (Walters; E. G. Bührle Foundation, Zurich, 1853). Delacroix's *Collision of Arab Horsemen* (1843), purchased in 1883, replicated a painting the artist exhibited at the Salon in 1834. Ingres's *The Betrothal of Raphael and the Niece of Cardinal Bibbiena* (1813; Figure 3.1) is the first of two

Figure 3.1 Jean-Auguste-Dominique Ingres, *The Betrothal of Raphael and the Niece of Cardinal Bibbiena*, 1813-14. Oil on paper mounted on canvas. 23¼ × 18⁵⁄₁₆ in.

completed paintings, one of which is in the Fogg (Figure 3.2). Gilbert Stuart's *Portrait of George Washington* (1825) resembles the version in the Boston Athenaeum, commissioned in 1825 by Baltimorean Robert Gilmor, Jr.

Among Henry Walters's acquisitions is Ingres's *Oedipus and the Sphinx*, signed and dated by the artist (1864), acquired by Henry in 1908; other versions are in the Louvre (1808) and the National Gallery, London (c. 1826). Ingres's *Odalisque with Slave* (1842; Figure 3.3), acquired by Henry in 1925, was originally commissioned by King Wilhelm I of Württemburg. The Louvre has a version (1858), as does the Fogg Museum (1839; Figure 3.4). Several versions of Edgar Degas's *Before the Race* (1882–4) are housed in the Clark Art Institute (1882, possibly the prototype for other versions [Boggs 402]), the Paul Mellon collection, and formerly in the John Hay Whitney Collection (1881–5; Rewald 28); a pastel version is in the Rhode Island School of Design (RISD) Museum.

Figure 3.2 Jean-Auguste-Dominique Ingres, *The Betrothal of Raphael and the Niece of Cardinal Bibbiena*, 1864. Graphite, watercolor, and white gouache on tracing paper, laid down. (7¹³⁄₁₆ × 6⁵⁄₁₆ in.).

Figure 3.3 Jean-Auguste-Dominique Ingres; Jean-Paul Flandrin, *Odalisque with Slave*, 1842. Oil on canvas. 29¹⁵⁄₁₆ × 41⁵⁄₁₆ in.

Figure 3.4 Jean-Auguste-Dominique Ingres, *Odalisque with a Slave*, 1839–40. Oil on canvas. 28⅜ × 39½ in.

Henry acquired a version at the Cyrus Lawrence collection sale in New York in 1910.[17]

Millet's pastel *The Sower* (1865) exists in several versions done between 1850 and 1870: oil paintings in Boston's Museum of Fine Arts (1850; considered the first version); the Provident Trust, Philadelphia; the Carnegie Museum of Art, Pittsburgh (c. 1872); the National Museum of Wales (markedly different from the others, 1847–8); the Yamanashi Prefectural Museum of Art (1850), and pastels in the Clark Institute (1865), the Frick Museum (1865), and French & Company, LLC (c. 1866). Lucas bought *The Sower* for William Walters from dealer Montaignac in 1884 for 10,000 francs. Millet's *The Shepherdess with her Flock* (after 1864) is one of four pastels done between 1862 and 1867, after the 1863 oil in the Musée d'Orsay, Paris; another painting is in the Clark (1862–4).

The Walters collected replicas by both Academic and avant-garde artists who were equally willing to produce replicas. Most of the Walters replicas were second or third versions (an exception is Ingres's *The Betrothal of Raphael and the Niece of Cardinal Bibbiena*), and sometimes even replicas of works exhibited over ten years earlier

than the commission. Walters claimed his collection was "made by me personally" and the works

> brought me in contact with much that is beautiful and ennobling . . . I have visited every international art-exhibition for thirty-years, and have done all in my power in a practical way to promote the growth of art in this country. ("Art-Collector" 8; Johnston 108)

He opened his home to artists and on certain days to the Poor Association, raising $30,000 for that charity from 1884.

His other activities include being U.S. Art Commissioner to the Paris Exposition in 1867, the Vienna Exposition in 1873, the Paris Exposition in 1878; a permanent trustee of the Corcoran Gallery, for which he purchased artworks ("Art-Collector" 8); and later vice-president of the Peabody Institute (Johnston 108). He turned his townhouse into a private museum in 1874, as his collecting turned to Asian art. In 1889 he published a "lavish illustrated history of Oriental porcelain," written by a British physician who was also a Sinologist and collector, and whom Walters persuaded to write this history (Johnston 106). The result was an enormous publication with 400 black-and-white and 116 color illustrations, and beautiful covers for each of its ten sections (Johnston 107). William donated Japanese items to the Metropolitan Museum to celebrate its first Sunday opening, a cause he championed in the hopes of bringing more art to more people (Johnston 108). Henry, later a Metropolitan Museum trustee, shared his father's and Lucas's philanthropic motives (Johnston 127).

Envisioning his collection as a public service, Walters dedicated his book *Antoine-Louis Barye: From the French of Various Critics* to the "Young Artists of America" (Johnston 102). Seeing the catalogs that Cornelius Vanderbilt prepared for his collection, Walters began a series of catalogs for the periodic public openings of his collection, beginning in the 1870s. His 1884 reinstalled collection was opened in a gala affair with an elegant catalog and much press interest (Miner 282–3). He referred to his Oriental art collection as twenty years of "our efforts" (Miner 285). He was intensely self-educated through collecting European, Japanese, and Chinese art, and he shared his newfound knowledge in his catalogs. The catalog *Notes Upon Certain Masters* (1886) was based on an exhibition of a private French collection's catalog *Cent chefs d'œuvre* for the 1883 Paris exhibition. This was later issued in a deluxe English edition in 1885 through Knoedler's in New York with a text on Barye (Miner 291). The 1883 exhibition had a profound effect on American collectors who saw the Barbizon School and Romantic art for the first time there; several of these works

ended up in Walters's collection (Miner 291). In his catalog Walters identified Barye with the "remarkable group of artists who have marked our century with such distinction . . . Décamps, Delacroix, Rousseau, Troyon, Millet, Corot, Diaz, Dupré" (Miner 290), some of whose works were replicas he owned.

Walters was a taste-maker, generating the popularity and collecting of Gérôme's work with his purchase of a replica in 1859 and of a painting in 1873 for the Corcoran.[18] By the early collecting of Gérôme William Walters "provided a concise survey of the American taste for Gérôme" through the collection and the catalogs that brought sustained attention to the artist's work long after the artist's fortunes declined following his death in 1904. Walters's support was a foundation for art dealer Robert Isaacson's 1962 revival of Gérôme's reputation (*Gérôme & Goupil* 43). Later he supported Antoine-Louis Barye, whose work he collected in large numbers, buying 120 Barye bronzes for the Corcoran and encouraging his cohorts to buy Barye's sculpture. Walters gave five large bronzes to the city of Baltimore and co-organized an enormous exhibition of Barye's works at the American Art Galleries in New York on November 15, 1889, showing Barye's works alongside paintings by his cohorts named above, "the phalanx of 1830" (Johnston 104), whom Walters aligned with Barye. Exhibited works were loaned by prominent American collectors (Johnston 104). The catalog claimed, "In the gravitation to America of great works of art, a majority of the treasures of the great French school have been acquired. The choicest of them are among the hundred pictures now displayed" (Miner 294).

Autograph Replicas in the Fogg Art Museum

Many of the other versions of the Walters replicas were disseminated throughout the U.S. (New York, Providence, Portland, Kansas City, St. Louis, Boston, Pittsburgh, Philadelphia), reflecting the growing American desire for autograph replicas by certain artists. Grenville Winthrop shared several replica versions of works in the Walters collection. Winthrop did not want to collect Old Masters, but "wanted virgin fields to plow, and . . . did not want to collect in a mere desultory way" (Birnbaum 184). In this context Winthrop mapped a version of a linear art history of influences and successors. Winthrop and his agent Martin Birnbaum (Codell forthcoming) shared their cohorts' and predecessors' philanthropic motives to shape the country's cultural taste. Winthrop wanted his collection to sow seeds among the youth of America, primarily at Harvard,

"to shape the course of our artistic progress" (Birnbaum 220). It is worth noting, however, that collecting replicas meant a reliance on the taste of artists who produced replicas to investigate a subject or a reliance on the taste of patrons who commissioned replicas with the changes that patrons sometimes requested.

In his autobiography, *The Last Romantic*, Birnbaum detailed his career gathering European works for American collectors, especially for Winthrop. Birnbaum hoped to "introduce new figures and great masterpieces into this country and help furnish America with fresh inspiration" (Birnbaum 43–4). Winthrop and Birnbaum were especially set on collecting David and Ingres, whom they believed were the foundations of modern European art, and their collecting of these artists was innovative among American collectors.[19] Winthrop began collecting Ingres before the artist was well known or collected in the U.S. (Mongan 387). In this and his collecting of several other artists, such as Théodore Chassériau, and the innovative collecting of David's drawings and sketchbooks, Winthrop, like Walters, was a taste-maker.

But Winthrop, unlike Walters, had an art history education. He studied ancient and Italian Renaissance art with Charles Eliot Norton, who, as Ruskin's follower, promoted collecting and studying art as forms of public good (Birnbaum 180–1), driven by nationalist and philanthropic motives. Winthrop's planned gift of his collection to the Fogg Museum enabled Birnbaum to persuade owners to part with their works. He convinced Mary Watts that her husband G. F. Watts's works would become international in the U.S., something not possible in the village museum she was building for him. She hoped that the autograph replica *Sir Galahad* will add something to the strength of the bond that holds their two nations together (Birnbaum 206–7).

American elites determined taste through their social and cultural capital, a nexus of education, money, and knowledge. They imposed these values on the public by bequeathing their collections to museums. They defined the canon for Americans, since many nineteenth-century artists had not yet or had only recently been canonized. On Ingres's *Portrait of the Forestier Family* (1828[20]), a replica of a drawing in the Louvre perhaps done in preparation for an engraving (Wolohojian 178), Birnbaum wrote,

> we were already adding something to the artistic heritage of America, for Royal Cortissoz . . . in one of his reviews . . . reminded us that not so long before it had been impossible for an art student in America to examine an original work by Ingres. Soon that deficiency no longer existed. (Birnbaum 189)

So Ingres became part of America's heritage and an inspiration for budding American artists. Winthrop, enthralled by Ingres, "was not satisfied until he had examples covering the artist's entire career" (Birnbaum 189). Birnbaum bought from Ingres's nephews[21] "a superb small version of the *Grande Baigneuse*" (Birnbaum 190),[22] helping to establish Winthrop's Ingres collection as "one of the most remarkable artistic shrines in America" (Birnbaum 191). Ingres's *The Golden Age* (1862) was a reduction of a mural completed in 1847. The Fogg version of Ingres's *The Betrothal of Raphael and the Niece of Cardinal Bibbiena* (1864) was a watercolor version of the Walters version. On the Pre-Raphaelites, Birnbaum and Winthrop "agreed that only works of the greatest importance by the Brotherhood would henceforth be added" (Birnbaum 208). One such work was Rossetti's *Beata Beatrix*, so esteemed by Winthrop that he bought two autograph replicas of it.

The American narrative of art history was not identical to the European narrative. The Walters collection combined Academic and avant-garde modernists, two camps that co-existed only marginally and anxiously in the annual Salons more favorable to Academicism and in the commercial galleries more favorable to new movements. Winthrop's yoking of French Academic art and British Aestheticism juxtaposed two groups often opposed in European art histories of this period. By around 1900 these diverse styles, rooted in very different views of the nature of art, had become defined as national "schools" in the histories of modern art written by Germans Julius Meier-Graefe (1908) and Richard Muther (1896, 4 volumes), Frenchmen Ernest Chesneau (1891) and Robert de La Sizeranne (1898), and Britons Cosmo Monkhouse (1899) and M. H. Spielmann in Spielmann's catalog on British fine arts at the Franco-British Exhibition of 1908 (Codell 2009). In America these two groups were juxtaposed and made homogeneous, and scripted as a monolithic European culture in Winthrop's collection.

Changing Roles and Meanings of Autograph Replicas

Replicas played a role in art narrative emerging in nineteenth-century historicism in America to construct an American cultural heritage and challenge notions of patrimony, originality, creativity, and authenticity. For many artists replication offered a profound way of knowing, rethinking, adapting, and reusing information, as well as meeting market demands. Producing replicas, artists could archive

and retask remembered and forgotten knowledge, making the replica an archaeology of individual and cultural memories. Once in collections and museums, however, replicas acquired a more fixed, stable, and rigid interpretation and role in a rather linear art patrimony of artists and their followers, ignoring indeterminate and fluctuating social, economic, and political histories that shape the style and content of all art.

Replicas were done over decades, creating a replicatory chain. Eleanor Stansbie analyzes the receptions and contexts of Hunt's versions of *The Light of the World*, the first of which, from 1853, was attacked for Christ's androgyny and bejeweled robes, and viewed through British anti-Catholic hostility to the re-establishment of the Catholic hierarchy of bishops in Britain when this version was shown. The 1904 third version's masculinized Christ bespoke muscular Christianity, nationalism, and empire. It circulated to the white colonies in 1906 (Australia, New Zealand, South Africa, and Canada), and was displayed in Tasmania alongside the skeleton of Truganini, a woman wrongly considered the last Tasmanian, thus contributing to the imperialist "extinction discourse."[23] The display of a work gave it its own meanings and context by virtue of the historical period, political and social circumstances, and physical location of its display. These conditions created and shaped each autograph replica's own purpose, function, reception, context, and hermeneutics.

Studies of replicas' receptions, histories, and production endorse David Freedberg's belief that analyzing "copies and transformations remains one of the great tasks of the history of images" (Freedberg 121). Whitney Davis argues that "an image or an artifact cannot be understood on its own, divorced either from the replicatory chains to which it belongs historically or from the replicatory assemblages in which we discover, perceive, and interpret it" (Davis 2; see Sally Foster's chapter in this volume). Artists created replicating chains and American collectors built replicatory assemblages. These contexts remind us that the definitions of the word "replica" include "rejoinder" and "echo," responses to the past within reinventions whose contexts are often beyond artists' control. Replicas measure cultural history and map artists' appropriations of the past fitted not only to their contemporary social, economic, and political contexts but also to changes in public taste and expectations of art and to new contexts when these works are displayed in other geographies or time periods. Replicas map social networks and cultural relations that are themselves constructed by exchanges of images and things. In transatlantic exchanges, collectors believed they endorsed replicas' French and British cultural histories, but American collectors and

museums radically remade these works as American works, noted in Birnbaum's claim that the *Forestier* drawing overcame a deficiency and was a shrine for artists to replicate Ingres for America's artistic future.

Meaning, Davis insists, is "constructed cumulatively and recursively . . . in and through the structure and history of its replication," referring to meaning's replication. Replica chains are products not just of accrual and simulation but also of forgetting and transformation, to echo Freedberg's words. Davis goes further, to define culture itself as "socially coordinated replicatory histories" (Davis 4). Indeed, replicas were the social glue among American collectors, as Macleod has shown them to be for British collectors; British collectors sought replicas of each other's first versions.

Replicas are acts of similitude and variation but also of alienation. If done over time in different contexts, social networks, and historical resonances, the replicas can become estranged from first versions. American collectors transplanted European culture for purposes of American appropriation and nationalization, not just imitation. They actively sought replicas and, in the process, they shaped "the status of representational 'appearances' in art and their relationship to worlds both real and invented" (Halliwell 5). Goethe's view of mimesis as a "creator of an independent artistic heterocosm, a world of its own" (Halliwell 5) suggests replicas' repatriation of the past and its chain of permutations as illuminating creativity as cognition, collecting as cultural narrative, and replication as epistemology.

Notes

1. Americans behaved like British middle-class industrialists, in their non-dynastic, public-spirited approach to art collecting (Reise 3).
2. Old Masters, much more expensive and constituting a market notoriously full of forgeries, were suspected as workshop copies and shunned.
3. Letter from William Walters to Charles Deschamps, December 19, 1882, in Walters Museum Archives.
4. Dianne Macleod thinks use value in the first half of the century made replicas popular for narrative, didactic, and entertaining functions, for which the image, not the maker, determined value, generating an "industry of replication" (73). Once beauty became a function and was valued as unique, replication became problematized.
5. Robert Gilmor, Jr., said as early as 1840, "Our laws do not permit entail, and consequently our generations from their rise and their fall are not the safe depositories of such things as is the case in Europe and especially in England" (Cannadine 19).

6. Painted for Mr. Webster of Blackheath. Holl did *The Lord Gave* twice and *Gone*, a replica, sold to dealer Arthur Tooth for £400. Holl received £50 for a sketch of *Gone* and £50 for the copyright (Reynolds 147–8).

7. The prestigious art dealer Agnew's bought the 1869–72 version for £2,000 (Bronkhurst 1:221) but also bought both of them together for £10,500 paid in installments in 1873 (225). Agnew's then commissioned a third version by Hunt and two assistants in 1873–4, paying £2,100 (Bronkhurst 1:232). See William Michael Rossetti 241, n.1. Charles Maud of Bath commissioned a replica of just the sheep from *The Hireling Shepherd* (already replicated) for 80 guineas (Hunt 1:321); Hunt convinced him to buy an original instead, *Our English Coasts* (Hunt 1:327). Despite Hunt's brisk replica market, he called these patrons "timid purchasers" (Hunt 2:95).

8. He sold these to Gambart for £1,500.

9. Bodleian ms. don. e. 61, March 20, 1877, Bodleian Library, Oxford. For Stephens's letters see Macleod 191.

10. For comparison, Manet's *Luncheon on the Grass* was valued by the artist at 10,000 francs in 1872 (Bann 40; Cachin 294) but sold for 4,000 francs in 1873 to Faure, who sold it in 1894 to art dealer Paul Durand-Ruel for 22,500 francs (Cachin 294). Delaroche's piece by comparison was indeed much more costly.

11. Bann lists nine versions in lithography, etching, and photogravure, and its three sizes and prices in photography (Bann 42).

12. Walters anticipated the American popularity of Gérôme by a decade. According to Émile Zola, "there is barely a parlor in the provinces which does not have a print after *The Duel After the Masquerade*," a success at the 1857 Salon and Gérôme's most popular composition. Goupil published nine different reproductions in different sizes, formats, and techniques between 1859 and 1888. See Pierre-Lin Renié, available at <http://www.19thc-artworldwide.org/autumn06/49-autumn06/autumn06article/156-the-image-on-the-wall-prints-as-decoration-in-nineteenth-century-interiors> (last accessed November 25, 2016).

13. By December 1862 they had enough paintings for an exhibition at the Düsseldorf Gallery in New York, February 12–13, 1864, of 195 oils, watercolors, and prints, and the sale garnered $36,099. On Lucas, see Lilian M. C. Randall and Gertrude Rosenthal et al.

14. All my references in this section and its footnotes are from the Walters Art Museum Research files.

15. According to George Lucas's diary (Randall, *Diary*, 2:691), he paid Chevallier 350 francs for this Cabanel "sketch." Randall's index (1:77) lists Paul Chevallier as "Auct. 'commissaire priseur.'"

16. See the letter from Edward King, Director, Walters Museum, to Philippe Girard in Canada, dated March 21, 1961. This picture came from the artist (n.d.), and it was believed that Walters commissioned Gérôme to paint it in 1867 after seeing a previous version.

17. The Walters Museum archive has a letter from W. M. Ittmann, Jr., Assistant Curator, Sterling and Francine Clark Art Institute, November 2, 1967, about an almost identical version of this painting. Edward King, Director, Walters Museum, to Ittmann, November 6, 1967, cited several versions in the Paul Gallimard collection in Paris (King cites *Les Arts*, September 1908: 26), a third version, *Aux Courses: Avant le Départ*, owned by Mr. and Mrs. Paul Mellon, and a pastel from the Leonard Grow collection, sold at Christie's (King cites *Connoisseur* 100 [1937]: 55).
18. William Vanderbilt purchased a replica of Gérôme's *The Sword Dance at the Pasha's* for $10,000 in March 1878, from Knoedler (*Gérôme & Goupil* 38). After Gérôme's reputation had waned, Henry Walters nevertheless paid the excessive sum of $7,200 for the artist's *The Death of Caesar* in 1917 (*Gérôme & Goupil* 43).
19. Winthrop and Mrs. Potter Palmer collected Delacroix, another innovation.
20. The date has been given by Cohn and Siegfried (98), despite Ingres's date of 1804, no. 23.
21. The sons of Madame Ramel, Ingres's sister-in-law.
22. It was formerly in the collections of Carroll Tyson and Walters.
23. Patrick Brantlinger's phrase, first on p. 1 and then multiple times throughout his book.

Works Cited

"Art-Collector William T. Walters" (Obituary). *The Literary Digest* 10.6 (December 8, 1894): 8.

Bann, Stephen. "Reassessing Repetition in Nineteenth-Century Academic Painting: Delaroche, Gérôme, Ingres." *The Repeating Image: Multiples in French Painting from David to Matisse*. Ed. Eik Kahng. Exhibition catalog, The Walters Art Museum, Baltimore. New Haven, CT: Yale University Press, 2007: 27–52.

Bennett, Mary. *Artists of the Pre-Raphaelite Circle: The First Generation*. London: Lund Humphries, 1988.

Bills, Mark, and Vivien Knight, eds. *William Powell Frith: Painting the Victorian Age*. New Haven, CT: Yale University Press, 2006.

Birnbaum, Martin. *The Last Romantic*. New York: Twayne, 1960.

Boggs, Jean Sutherland, Douglas W. Druick, Henri Loyrette, Michael Pantazzi, and Gary Tinterow. *Degas*. Exhibition catalog, Galeries nationales du Grand Palais, Paris, and National Gallery of Canada, Ottawa. New York: Metropolitan Museum of Art, 1988.

Brantlinger, Patrick. *Dark Vanishings: Discourse on the Extinction of Primitive Races, 1800–1930*. Ithaca, NY: Cornell University Press, 2003.

Bronkhurst, Judith. *William Holman Hunt: A Catalogue Raisonné*. 2 vols. London: Mellon Centre, 2006.

Cachin, Françoise, and Charles S. Moffett. *Manet 1832–1883*. Exhibition catalog, Galeries nationales du Grand Palais, Paris. New York: Metropolitan Museum of Art, 1983.

Cannadine, David. "Pictures Across the Pond: Perspectives and Retrospectives." *British Models of Art Collecting and the American Response*. Ed. Inge Reise. Aldershot: Ashgate, 2014: 9–25.

Codell, Julie. "From Rebels to Representatives: Masculinity, Modernity and National Identity in Histories of Pre-Raphaelitism." *Writing the Pre-Raphaelites*. Ed. Michaela Giebelhausen and Tim Barringer. Aldershot: Ashgate, 2009: 53–79.

——. "Martin Birnbaum." *Art Market Dictionary*. Ed. J. Nathan. Berlin: De Gruyter, forthcoming.

Cohn, Marjorie B., and Susan L. Siegfried. *Works by J.-A.-D. Ingres in the Collection of the Fogg Art Museum*. Cambridge, MA: Fogg Art Museum, Harvard University Press, 1980.

Davis, Whitney. *Replications: Archeology, Art History, Psychoanalysis*. University Park: Pennsylvania State University Press, 1996.

Dzelzainis, Ella, and Ruth Livesey. "Introduction: Transatlanticism: Identities and Exchanges." *19: Interdisciplinary Studies in the Long Nineteenth Century* 9 (2009): 3, <www.19.bbk.ac.uk> (last accessed September 29, 2017).

Elzea, Rowland, ed. "The Correspondence Between Samuel Bancroft, Jr. and Charles Fairfax Murray 1892–1916." *Delaware Art Museum Occasional Paper* 2 (February 1980): 79.

Freedberg, David. *The Power of Images: Studies in the History and Theory of Response*. Chicago: University of Chicago Press, 1989.

Frith, William Powell. *My Autobiography and Reminiscences*. 2 vols. New York: Harper & Brothers, 1888.

Gérôme & Goupil: Art and Enterprise. Trans. Isabel Ollivier. Exhibition catalog. Paris: Réunion des Musées Nationaux, 2000.

Halliwell, Stephen. *The Aesthetics of Mimesis: Ancient Texts and Modern Problems*. Princeton: Princeton University Press, 2002.

Harris, Neil. "The Long Good-Bye: Heritage and Threat in Anglo-America." *British Models of Art Collecting and the American Response*. Ed. Inge Reise. Aldershot: Ashgate, 2014: 195–208.

Humphries, Lance, "British Aspirations on the Chesapeake Bay: Robert Gilmor, Jr. (1774–1848) of Baltimore and Collecting in the Anglo-American Community of the New Republic." *British Models of Art Collecting and the American Response*. Ed. Inge Reise. Aldershot: Ashgate, 2014: 147–62.

Hunt, William Holman. *Pre-Raphaelitism and the Pre-Raphaelite Brotherhood*. 2 vols. London: Macmillan, 1906.

Johnston, William R. *William and Henry Walters, the Reticent Collectors.* Baltimore: Johns Hopkins University Press, 1999.

Kelly, Simon. "Strategies of Repetition: Millet/Corot." *The Repeating Image: Multiples in French Painting from David to Matisse.* Ed. Eik Kahng. Exhibition catalog, The Walters Art Museum, Baltimore. New Haven, CT: Yale University Press, 2007: 53–81.

Macleod, Dianne Sachko. *Art and the Victorian Middle Class: Money and the Making of Cultural Identity.* Cambridge: Cambridge University Press, 1996.

Mills, Ernestine. *The Life and Letters of Frederic Shields, 1833–1911.* London: Longmans, Green, 1912.

Miner, Dorothy. "The Publishing Ventures of a Victorian Connoisseur: A Sidelight on William T. Walters." *The Papers of the Bibliographical Society of America* 57.3 (1963): 271–311.

Mongan, Agnes. "Drawings by Ingres in the Winthrop Collection." *Gazette des beaux-arts* 26 (July–December 1944): 387–412.

Randall, Lilian M. C. *The Diary of George A. Lucas, An American Art Agent in Paris, 1857–1909.* 2 vols. Princeton: Princeton University Press, 1979.

Redgrave, Frances Margaret. *Richard Redgrave, C.B., R.A.: A Memoir Compiled from his Diary.* London: Cassell & Co., 1891.

Reise, Inge. "Introduction." *British Models of Art Collecting and the American Response.* Ed. Inge Reise. Aldershot: Ashgate, 2014: 1–6.

Renié, Pierre-Lin. "The Image on the Wall: Prints as Decoration in Nineteenth-Century Interiors." *Nineteenth-Century Art Worldwide* 5.2 (Autumn 2006), <http://www.19thc-artworldwide.org/autumn06/49-autumn06/autumn06article/156-the-image-on-the-wall-prints-as-decoration-in-nineteenth-century-interiors> (last accessed November 25, 2016).

Rewald, John. *The John Hay Whitney Collection.* Washington, D.C.: National Gallery of Art, 1983.

Reynolds, Ada M. *The Life and Work of Frank Holl.* London: Methuen, 1912.

Rosenthal, Gertrude, Charles Parkhurst (Foreword), and Victor Carlson. *The George A. Lucas Collection of the Maryland Institute.* Exhibition catalog. Baltimore: Baltimore Museum of Art, 1965.

Rossetti, William Michael. *The Diary of William Michael Rossetti, 1870–1873.* Ed. Odette Bornand. Oxford: Oxford University Press, 1978.

Stansbie, Eleanor Fraser. "Christianity, Masculinity, Imperialism: *The Light of the World* and Colonial Contexts of Display." *Pre-Raphaelite Masculinities: Constructions of Masculinity in Art and Literature.* Ed. Amelia Yeates and Serena Trowbridge. Farnham: Ashgate, 2014: 189–212.

Strahan, Edward (pseud. Earl Shinn). *The Art Treasures of America.* 3 vols [1879–82]. Intro. H. Barbara Weinberg. Rpt New York: Garland, 1977.

Thomas, David Wayne. "Replicas and Originality: Picturing Agency in Dante Gabriel Rossetti and Victorian Manchester." *Victorian Studies* 43.1 (Autumn 2000): 67–102.

Wolohojian, Stephan. *A Private Passion: 19th-century Paintings and Drawings from the Grenville L. Winthrop Collection.* Exhibition catalog. New York: Metropolitan Museum, 2003.

"Petty Larceny" and "Manufactured Science": Nineteenth-Century Parasitology and the Politics of Replication

Emilie Taylor-Brown

At the end of the nineteenth century, the concept of replication took on a central role in the emergence of a new sub-discipline. Replication was both an important part of parasitology's scientific methodology and a locus of anxiety for its proponents, a professional network who, led by Nobel Prize-winning malariologist Ronald Ross, strove for individual recognition and priority. For Ross, a man obsessed with rewriting literary classics, reinventing visual technologies, and reimagining everything from phonetic spelling to mathematics, replication was a fraught concept determined largely by context. As an experimental procedure, it demonstrated consistency and signified truth. As an investigative tool, it embodied not just emulation but also modification and improvement. When used by his competitors, however, it also meant plagiarism, piracy, and fraud. Using Ross's mosquito–malaria work as a case study, I will explore the politics of replication in all its forms – as a scientific methodology, as an ideological motif, and as a framework that exposed the politics of this network of scientists, in their disputes over scientific priority. While in speeches Ross referred to priority as "petty inter-tribal advantage,"[1] it was a qualm that clearly haunted him for his entire career, leading him to write in 1924 that he regretted ever investigating malaria. "Humanity," he argued, "is not worth it!"[2]

Born to Scottish parents in 1857 in the foothills of the Himalayan mountains in India, Ronald Ross was the eldest of ten children. At the age of eight, he was sent back to Britain for health and education, and – as he tells us in his memoirs – he whiled away his time

reading Shakespeare, Milton, Tennyson, Byron, Homer, and the Bible. He struggled with, and eventually got the better of, Euclid. He had "a secret passion for music," and spent time painting, sketching, and experimenting with watercolor after the style of his father (Ross 1923: 22).[3] In his formative years – and, indeed, well beyond – he was obsessed with rewriting and reimagining famous works, acts that might be thought of as replication. He replicated Cuvier and Buffon's natural histories, drawing up his own taxonomies of the natural world with data "drawn" – probably directly copied – from editions of their books in his uncle, Dr. William Wilmott's, library. He rewrote several Greek myths, as well as reimagining William Gilbert's *Pygmalion and Galatea*. In Ross's version, called *Edgar; or the New Pygmalion*, when the statue (now called Niobelle) comes alive, she does not care for the sculptor at all and rejects him. His version also has an opening prologue borrowed almost directly from Goethe's *Faust* (see Ross 1883). Ross argues that Goethe had borrowed it from the Book of Job, noting: "I held (with Goethe) that an artist may borrow whatever he pleases if the perfection, which he is designing requires it" (Ross 1923: 45). This treatise on replication is interesting because it posits replication as a form of borrowing and legitimizes it as a methodology employed during the process of "improvement." This is an attitude that he does not apply with the same gusto to science, however, as I will argue throughout this essay.

In addition, Ross practices a lot of what we might call "soft" replication – writing poems in the style of Shelley and plays in the style of the Early Moderns. He tries his hand at what he refers to as "painful" verse using Byronic templates and has a brief affair with blow-pipe chemistry, where he could be seen puffing out his cheeks before the flame "in emulation" of his uncle (Ross 1923: 33).[4] Replication for young Ross means emulation, imitation, but also inspiration and modification, more congruous with the Middle French root "repliquer," meaning to reply or respond (*Oxford English Dictionary* n.p.). To replicate is, for Ross, to reproduce in modified form.

When applied to his own work, this philosophy is a positive, progressive methodology; however, when applied to that of others, it is often more dubious. The "Romanticists," he argues, are "only revenants of the Elizabethans" – a statement that seems both to praise and to criticize the replicative frameworks of literature and of literary style (Ross 1923: 31). For someone who invented a new diagnostic microscope, attempted to reimagine phonetic spelling, and closely criticized what he considered to be Dickens's "failed" attempts at replicating the working-class dialect, replication is evidently a significant act. He seems, even after the disputes to which I will refer at length in

this essay, to consider replication as a kind of necessary methodology, as the basis for improvement, and as the model by which progress is made. This methodology is also, however, the basis for intense professional anxiety. In the rest of this chapter I will explore the ways in which the socio-political pressures of parasitology contributed to anxiety about replication as a scientific and cultural methodology. Ultimately, I will conclude that replication was a highly politicized activity at the *fin de siècle*, which had the power both to confer and to undermine professional authority.

In 1880, when Charles Laveran found the protozoan parasite responsible for malaria in the blood of a patient, it seemed like a revolutionary moment. It was the first time that such an organism, which he characterized as an "animal" rather than "vegetable" parasite, had been shown to cause disease.[5] This revolutionary moment was, however, slow to come. For more than ten years the causative agent of malaria was hotly disputed. Those who doubted the identity of the malaria parasite did so owing to the difficulty in replicating it visually. Surgeon–Colonel Edwin Lawrie of the Indian Medical Service publicly denied the existence of the parasite, failing to find it under the microscope himself. He suggested, like many other microbiologists, that it was instead a degenerate red blood cell or a microscopy viewing error. Lawrie even referred to depictions of Laveran's bodies as "fanciful pictures . . . drawn from the imagination" (Lawrie 1896a: 1135). This demonstrates the significance of visual authenticity for tropical pathologists, who often relied on the subjective gazes of their peers. The subjectivity of observation was particularly contentious in the case of malaria, which in just the preceding year had had another contender for its causation.

In 1879 Corrado Tommasi-Crudelli and Edwin Klebs had isolated a bacterium from the Pontine marshes. They claimed that when they injected this bacterium into rabbits it caused the cyclic fevers and enlargement of the spleen indicative of malaria (Cox 2). They thus named the bacterium *Bacillus malariae*. Just as had been the case with previously suggested agents like Dr. Salisbury's "ague plants" (see Anon 1867: 588–9), however, investigators raised questions concerning the authenticity of the correlation. Was the bacillus to be found in the soil of other tropical regions as well as in Italy? Was it to be found in *all* malarious locales? What differentiated this bacterium from the hundreds that dwelt alongside it in the marshes (see, for example, Russell 725–6)? In 1881 Dr. Sternberg replicated Tommasi-Crudelli and Klebs's experiments with rabbits, only to find that their characteristic temperature spikes were obtainable by inducing a simple fear response. He also discovered that the anatomical changes that they had observed

were identical to those caused by septicemia (Anon 1881: 827). This suggested that Tommasi-Crudelli and Klebs's experimental methodologies were flawed. Dr. Charles MacMunn, however, countered Sternberg's experiments by presenting anecdotal evidence in support of the malaria bacillus. He argued that he had observed it in the blood of an African traveler, along with the patient himself and "a medical friend who happened to drop in soon after" (MacMunn 935).

Replication of the gaze is here offered as support for the authenticity of the observation. The reliability of this anecdotal evidence is clearly questionable but it illustrates some of the methodological problems that researchers faced. Replication was prone to error because those who were doing the replicating were not all operating within the same parameters. At no point does McMunn explain how he ascertained the specific identity of the bacterium, nor does he describe it at all; however, his letter to the editors of the *British Medical Journal* was enough to perpetuate the debate. The reticence then of microbiologists to accept Laveran's proposal in light of this developing trend for identifying and refuting new pathogenic organisms is understandable.

Laveran had observed three different forms of his organism in the blood of his patients: crescentic bodies, static pigmented bodies, and motile bodies that extruded flagella. He identified the crescentic bodies in 148 out of 200 malaria patients and never in a patient without the disease, strengthening his hypothesis (Cox 3). Unlike his rivals, Laveran had a relatively large sample size to back up his claims and he also noted that quinine, the popular treatment for malaria, removed the bodies from the blood. This was compelling evidence of its identity, and after some initial resistance, Laveran managed to convince influential microbiologists in France, Germany, Italy, and the U.K. that his organism was the causative agent of malaria. Thus, when Surgeon–Colonel Lawrie resurrected the debate in 1895, it was met with criticism from his peers. Tropical medicine heavyweight Patrick Manson was surprised at such an "extraordinary statement" published under Lawrie's name. "If Laveran's body is not a parasite," he asserted, "then it is the most wonderfully-contrived device in Nature for deceiving the pathologist" (Manson 394).

In a letter to *The Pioneer* in 1897, Lawrie again voiced his doubts as to the identity of the malaria parasite, highlighting the professional inconsistency regarding its specific nature:

> Having patiently plodded through the works of Laveran, Marchiafava and Bignami, and Mannerberg my doubts only increased, for while the above authorities agree that there is a malarial parasite, they differ on

almost everything else about it, *viz.* its situation with regard to the red corpuscle, its morphology, whether there is only one parasite causing all forms of malarial fever, or as many different and distinct forms of parasite as there are types of fever, which are the active and which are merely the degenerate forms of the parasite, &c.[6]

Ross responded to what he called the "considerable amount of gossip" about the malaria parasite that Lawrie had been spreading in the papers. Framing his objections in relation to the integrity of the field at large, he quoted Patrick Manson in saying that Lawrie's views were "manifestly wrong, retrogressive in tendency and their publication in *The Times* [was] calculated to check the slowly spreading belief in a great pathological fact."[7] He further elaborated on the dangerous nature of Lawrie's objections:

> Such a denial after fifteen years of minute study of the parasite by the most eminent microscopists is so ridiculous that it might safely be disregarded, but for the fear that it will weigh with those who are not familiar with the subject, just at a time when it is highly desirable that further enquiry into the parasite needs must be waged in India.[8]

The positions of Lawrie and Ross as physicians in the Indian Medical Service and their consequent physical location within that country were key components of this exchange. Lawrie resented the system of mentorship that Ross was benefitting from – a system that enabled him to gain the support of the British medical presses through Manson's influential position in Britain. This is something that Douglas M. Haynes describes as the "dialectical relationship" between Britain and her colonies. As Haynes argues in relation to Manson's initial filarial work, "their very social, not to mention geographical, marginality within British society as imperial servants placed [imperial doctors] in a dependent position vis-à-vis metropolitan investigators" (Haynes 54). Even though much investigative work relied on colonial spaces, as well as their geographically specific parasites and vectors, scientific authority was still constructed in tandem with metropolitan institutions. Lawrie clearly objects to the political implications of such a system. Criticizing what he sees as the medical press's unilateral support, he laments:

> Men who write of Laveran's bodies as "pets" "beasts" "brutes" or (save the mark) "bugs" have been extolled in the British Medical Journal as scientists in terms of the highest praise, while senior men of the calibre of J. M. Cunningham, Bryden, Rice, Marston, D. D. Cunningham, Crombie,

Sanders and a host of others whose names alone call up feelings of respect
and admiration throughout the length and breadth of this land, have been
as freely reprobated and lampooned. (Lawrie 1896b: 376)

These geopolitical tensions underpinned much of the dispute regard-
ing the causative agent of malaria – a dispute that was reprinted
to considerable readership in *The Times*. Having advised Lawrie to
improve his microscopy technique, Ross added, "I have lately found
the parasite in sixty-five cases of malarial fever, and I must beg leave
to laugh at anyone who disbelieves in it just as I would laugh at
anyone who disbelieves in the moon."[9] Ross's analogy exposes the
emotional politics behind the replicative frameworks at play here.
He elaborates:

> Any attempt to prove that the malaria parasite is not a degenerate red
> corpuscle is like an attempt to prove that the moon is not made of green
> cheese; most of us, I believe, are pretty confident that our satellite is not
> composed of that substance, but I fancy it would be somewhat difficult
> to prove the point, especially in the limits of a letter to the Daily Press,
> against a person obstinately possessed of the green cheese theory.[10]

Ross implies that the identity of the malaria parasite is something
that most investigators accept and that proving it is an exercise in
redundancy. His analogy, however, also illustrates the practical dif-
ficulties in demonstrating a connection between visual authenticity
(the morphological appearance of Laveran's body) and functional
identity (the role that that body plays in disease causation).

Lawrie responded using the language of taxonomy to slander
Ross's professional conduct: "this is a fine example of *Criticism
rossii*" (Lawrie 1900: 547). Such a quip implies that Ross typifies the
kind of investigator that Lawrie rallies against. In a further reference
to the institutional biases of the British medical press, and to European
investigators' supposed over-willingness to believe each other's theo-
ries, he signs off with a parody of Alfred Denis Godley's *Rubaiyyat of
Moderations*:

> 'Tis all they need, they are content with these:
> Not facts they want, but soft Hypotheses
> Which none need take the Pains to verify:
> E.g. the Theory of Anopheles. (Lawrie 1900: 547)

He objects here not just to the identity of the malaria parasite but
also to the theory of transmission by a mosquito vector. He suggests

that the "soft hypotheses" of European investigators, investigators whom he associates with institutional privilege, had not been verified by empirical study – that they were not able to be replicated. To his mind, the results lacked reproducibility.

As Laura Otis argues in her book, *Membranes*, microscopy was not an objective experience, and what scientists saw at the end of a microscope was influenced by their own preconceptions (1–9). Thus visual replication did not have the kind of legitimizing power that scientists liked to think it did. Ross himself had been a staunch disbeliever in the malaria parasite in the early 1890s. His change of allegiance by 1895 was a product not just of his improved microscopy training but also of his newfound friendships with parasitologists Charles Laveran and Patrick Manson, and a willingness to "see" the parasite within new frames of reference. In this way, the processes of replication that supposedly underscored good science were inseparable from the socio-political tensions of conferred authority. Throughout Ross's career he had many more disagreements with other investigators, and replication emerged as a phenomenon in these disputes that negotiated and encoded anxieties about authenticity, priority, credit, and professional integrity. These anxieties in turn were framed within wider discussions of national identity. Regenia Gagnier identifies the latter half of the nineteenth century as an epoch within which the relations of parts to wholes were being conceptualized. She talks about the "tension of independence versus interdependence, specifically of individual development threatening the very functioning of the whole" (3), a dynamic that might in the same way describe the tense relationship between British and European parasitologists in the context of emergent global modernity and cosmopolitanism.

At the end of the nineteenth century, parasitology was a fledgling discipline. Born during a period of increasing specialization in science, this important sub-field of tropical medicine was just gaining its professional identity. The Liverpool and London schools of tropical medicine were set up in 1898 and 1899 respectively as the first institutions in the world to offer specific research and training in tropical and parasitic diseases. Founded by merchant traders in the case of Liverpool, and with the support of Joseph Chamberlain (then Secretary of State for the colonies) in the case of London, the schools were unavoidably in dialogue with the British imperial project. Consequently – as I have outlined elsewhere – British parasitology was entrenched in and defined by British national and imperial identity. Moreover, parasitologists embellished this connection as a way of investing their own professional identities with

cultural authority. They used historic myths of nationhood – drawing particularly on Arthurian mythology – to steep their disciplinary discourse in the chivalry of Britain's imagined cultural homeland (Taylor-Brown 62–79).[11] What resulted, at least for some British parasitologists, was a tension between the need for international collaboration and the desire for national credit. This is clear in the rhetoric used to position parasitology in relation to imperialism.

Speaking about parasitology in 1900, colonial administrator William MacGregor used the analogy of construction workers to give credit to an international field: "It appears to me to be more or less like this: Manson was the surveyor, Laveran made the road, Ross built the bridges and laid the rails, and Grassi, Bastianelli, Bignami, and Celli provided the rolling stock" (980). This metaphor allows MacGregor to implicate a variety of European investigators in the literal building of empire. However, in reality, the field was fraught with a sense of national competition, as is clear from Ross's appraisal of it in 1905, when he asserts

> the new [tropical] knowledge is vastly more important to the British Empire than to any other State . . . German medicine is far ahead of us; however Liverpool and London, not Berlin and Vienna, are world centres of the study of tropical disease.[12]

Here he emphasizes British parasitology's entanglement with imperial politics in order to position Britain within a competitive global market.

The extent to which tropical research was a national concern is also reflected in private research correspondence in which Manson urges Ross to be wary of international competitors: "The Frenchies and Italians will pooh pooh it at first, then adopt it, and then claim it as their own. See if they don't. But push on with it and don't let them forestall you" (Bynum and Overy 55). Letters from Ross's friends congratulated him with the addendum "you have done the trick and I congratulate you heartily and I congratulate ourselves for do you not belong to us? And you are no Italian, French or German but a plain Briton!"[13] The prevalence of foreign research in the news was clearly a sticking point for many; another friend writes, "you are the first in the field and it is refreshing to find it made by a scientist who is not a Frenchman or a German."[14] Manson even warned Ross about advancements in foreign research on malaria, clearly making it about British priority, rather than about a solution to prevent human suffering:

It is evident the Italians are now on the scent. I do hope you will run into the quarry before them. Bignami is a clever little fellow and ambitious. Laveran is working up the Frenchmen. I do not hear that the Germans are moving but they will and so will the Russians. Cut in first. (Bynum and Overy 125)

It is just this sense of national competition that underscores Ross's anxieties about replication.

After years of research and many failed experiments, Ross eventually traced the malaria parasite to the salivary glands of the mosquito. Having been moved around with the Indian Medical Service, however, and finding it hard to procure cases of human malaria, he was forced to turn his attention to birds. In 1897, using these models, he demonstrated the mosquito–malaria connection by successfully infesting birds with avian malaria via bites from infected mosquitoes. This proved the mechanism by which malaria was transmitted, completing the life cycle of the malaria parasite. He was shortly moved on again, however, to study a kala-azar (now leishmaniasis) epidemic in Assam and was unable to prove his theory definitively in human beings. This task was taken up by some Italian investigators, who set about offering the final proof. This is also where the encoded anxieties concerning replication came to the fore. In Ross's initial statement regarding the mosquito–malaria discovery to the Secretary to the Director-General of the Indian Medical Service he gives due credit to all involved and demonstrates the legitimizing function of observation and repetition:

> My results have been accepted by Dr Laveran, the discoverer of the parasites of malaria; by Dr Manson who elaborated the mosquito theory of malaria; by Dr Nuttall of the Hygiene Institute of Berlin, who has made a special study of the relations between insects and disease; and, I understand, by M. Metchinkoff, director of the laboratory of the Pasteur Institute in Paris. Lately moreover, Dr C.W. Daniels of the Malaria Commission . . . ; while lastly, Professor Grassi and Drs Bignami and Bastianelli of Rome have been able, after receiving specimens and copies of my reports from me, to repeat my experiments in detail, and to follow two of the parasites of human malaria through all their stages in a species of mosquito called the anopheles claviger.[15]

The links in the chain and their multiple contributions to the discovery here offer validation. Later, however, these same links, and his penultimate position among them, form a source of intense

professional anxiety for Ross. Eager to be given full credit for the Nobel Prize, which was awarded to him in 1902, Ross spent years battling with Italian investigator Giovanni Battista Grassi over priority. His memoirs, which claim to provide a full account of the great malaria problem and its solution, dedicate a lot of time to the dispute. Using terms like "piracy" (1923: 403) and "robbery" (401), and phrases like "reconstruct the crime" (403), he differentiates what Grassi and colleagues were doing from the bona fide replicative frameworks needed for scientific progress. He writes, "all the work [the Italian investigators] did from beginning to end was suggested, assisted, and rendered possible by my previous work, my methods, my technique, my specimens, my descriptions, and my drawings" (403), and elsewhere, "their work has generally consisted merely of obvious verifications of the labours of others."[16]

This bespeaks an anxiety concerning attribution. At what point is a discovery made? Does its application to different environments or contexts constitute new ground? Certainly, Ross's own work was not independent of its previous inspirations. After all, it was the research carried out by Sir Patrick Manson in China that established that mosquitoes transmitted the filarial worm responsible for elephantiasis – a model used to reinforce the mosquito–malaria theory. This was itself an adage dating at least as far back as Aristotle. Ancient Roman writers connected malaria with swamps, which they argued engendered noxious creatures (Gorgas and Garrison 133), and references to biting insects appear in ancient Babylonian and Sanskrit texts on fever.[17] Giovanni Lancisi in 1717, Louis Daniel Beauperthuy in 1854, Albert King in 1883, and Charles Laveran and Robert Koch in 1884 had all offered support for the connection between malaria and mosquitoes (Gorgas and Garrison 133–4). What remained was not only to prove this connection empirically but also to elucidate the specific transmission route. Were mosquitoes responsible for transmitting the parasites from humans to marsh or from marsh to humans? William Gorgas and Fielding Garrison argued that Carl Gerhardt's demonstration that malaria can be transmitted directly via the blood in 1884 "abolished the Miasm Theory of malarial fever" (Gorgas and Garrison 138). The possibility of transmission via air and water droplets was, however, still a working theory in the 1890s. Ross even argued that Manson's belief in 1895 that malaria might be transmitted via spores released from infected mosquitoes or by ingesting mosquito-contaminated water demonstrated that he was "still under the influence of the miasmatic theory" (Ross 1930: 39). Indeed, Ross himself did not distance his discovery from the previous associations

of its namesake; rather he emphasized the continuity between these theories, concluding in information booklets that "malaria *is* due to a miasma given off by the marsh, but the miasma is not a gas or vapour – it is a living insect."[18]

Ross is clearly happy to acknowledge the theory's long history and to place himself within a series of successive paradigm shifts. When it comes to official recognition, however, he is not willing to share the limelight with Grassi. To deny Grassi's claim, he suggests that the latter's experiment and the data themselves were not just inspired by his own work but also a direct plagiarism of it. He insists, "many of the items in [Grassi's] *Studi* are directly pirated from my Sierra Leone results, and I recognize one of my Indian specimens in his plates. His figure of the attitudes of *Anopheles* and *Culex* is stolen straight from me" (Ross 1923: 408). For Ross, Grassi's experiments represent a "deliberate effort to pirate [his] work" (408). He further countenances this by drawing on the professional branding of parasitology to invest the incident with chivalric overtones. Accusing Grassi and his colleagues of dishonorable conduct, he writes,

> The thief must at least possess the virtue of energy, and the scientific thief, the virtue of scientific enthusiasm. Our Roman friends possessed both these virtues – so rare amongst the Sluggards, the Do-nothings, and the Think-nots! Great would have been their honour – if their honour had been greater. (Ross 1923: 410)

This kind of rhetoric is recognizable in much of the private correspondence between Ross and other researchers, suggesting that it is an ideology that has been, at least in part, internalized. Indeed, Dr. George Nuttall praised Ross in these terms in 1913, writing "you are the only man who shows the proper spirit of fair play. All the rest want to bag each other's game in a manner that disgusts me."[19] This sense of fair play supposedly underpins many of Ross's objections to what he sees as the bad behavior of other researchers. In defending his own research, however, he enacts the very censoring that he objects to by trivializing the inputs of the Italian investigators. He argues that his own work eclipses anything subsequent:

> [My] two observations solved the malaria problem. They did not complete the malaria story certainly; but they furnished the clue . . . The great difficulty was really overcome; and all the multitude of important results which have since been obtained were obtained solely by the easy task of following this clue – a task for children. (Ross 1905a: 551)

Elsewhere he rejects the replicative frameworks of science altogether by claiming that "the discovery of malaria being carried by mosquitoes was made not by observation, but by a process of induction."[20] By this he means to discount the significance of Grassi's replicative experiment in which he observed the same results as Ross, but in human subjects. In 1898 Nuttall had written to Ross to say that he had read some of Grassi's papers, in which he and Amico Bignami "confirm your observations and in one of them try to bag some of the credit from you."[21] This comment highlights the ambivalent position of replication in professional discourse. In this sentence we can read the anxieties that would underpin Ross and Grassi's later dispute. How do we approach, and what do we do with, such processes of confirmation?

Experimental replication is necessary to ascertain the truth of the discovery; however, for Ross, "repliquer" – the process of replying – is a politicized activity. Ross's use of the legal lexis of "larceny" and "piracy" reveals much about his understanding of replication as a methodology that is in dialogue with issues of copyright and intellectual property.

So famous was Ross for his priority disputes, first with Grassi and later with Manson, that in 1914 parasitologist Aldo Castellani wrote to him, requesting his advice over his own dispute regarding the discovery of *Trypanosoma* as the causative agent of sleeping sickness. Appealing to Ross's authority on the subject, Castellani lamented published correspondence put forward by Sir Ray Lankester, in which Lankester, according to Castellani, "misquotes, distorts, and purposely suppresses portions of the reports when quoting them, for the unscrupulous purposes of personal spite."[22] In 1902 George Carmichael Low, Aldo Castellani, and Cuthbert Christie had travelled to Uganda to investigate sleeping sickness. Initially, Castellani and Low thought that a strain of streptococcal bacteria was responsible for the disease; however, after finding trypanosomes in the blood and cerebrospinal fluid of 70 percent of cases, Castellani wondered about their involvement. In written correspondence with Ross he wrote, "the fact of finding tryp. in the cerebro-sp. fluid is I think too suggestive and means much more than simple coincidence."[23] David Bruce, who joined the commission in 1903, subsequently investigated this connection – efforts that led to its confirmation. Although in his commission report, Bruce admits that, without Castellani's initial observation, they "might have worked for months in the dark" (in Boyd 102–3), he argued that Castellani did not appreciate the significance of it and so should not receive the credit.

The dispute was taken up by the medical and lay press, with Lankester and Manson, among others, on the one side, and Albert Chambers, David Nabarro, and Ross on the other.[24] Nabarro, who was himself involved in the sleeping sickness commission, resented Lankester's attempt to minimize Castellani's role in the discovery. He assured readers of the *British Medical Journal* and *The Times* that Castellani should be awarded the credit of "having first observed the trypanosome in the cerebrospinal fluid of sleeping sickness patients; of having first connected it with the etiology of sleeping sickness, and of having first published it." To himself and David Bruce he gives credit for having "very greatly enlarged the researches on the trypanosome and of having first discovered that the parasite is carried by a tsetse fly" (Nabarro 374–5). Castellani insisted that Lankester abused his position as a member of the Royal Society to appear as their mouthpiece in his letters to the press. He also complained that Bruce was involved in the investigation into his own dispute and even served as a signatory on the committee's final decision – an incredible oversight of impartiality if true.[25] Clearly, the history of the discovery of the causative agent of sleeping sickness is complex and not easily narrativized. Indeed, Isabel Amaral argues that Portuguese investigators too laid claim to the elucidation of sleeping sickness (n.p.). What these disputes demonstrate, however, is that the process of replication, although empirically necessary, brings with it socio-political baggage that is inflected by the investigators' relationships with other researchers.

As a methodological tool, replication helped to confirm *Plasmodium* and *Trypanosoma* as parasites in their respective diseases, putting to bed many alternative hypotheses. The reverberations of the controversies produced by such a methodology were, however, felt for many years to come. In 1923 Ross was still bitter about the Italian claim to the mosquito–malaria discovery. In writing, he laments, "they have attempted the same thing with Koch. They have forgotten King. They have traduced Manson's theory. They have not given MacCallum's discovery sufficient prominence . . . they do not mention Daniels . . . they ignore Sakharoff" (Ross 1923: 18). This incomplete, unauthentic, or disingenuous replication is, for Ross and many others, an endemic problem. Priority disputes arose from almost every major discovery during this period – a phenomenon that is recorded in the *British Medical Journal*, in the lay press, in private correspondence, and in publications like *Science Progress*, which Ross edited.[26] Thus replication for parasitologists at the *fin de siècle* was a fraught concept – fraught chiefly through its

entrenchment in the methodologies of a newly emergent specialism at a time when foundational discoveries were being made yearly. A case study of Ross reveals that the process of replication was a highly politicized activity within the network of its specialists that had as much to do with the intricacies of narrative framing as it did with the competitive practicalities of verifiable scientific discovery.

Notes

1. London: London School of Hygiene and Tropical Medicine [hereafter LSHTM], The Ross Collection [hereafter RC]. Ross/28. Fever case-book, MS of speech note on back cover.
2. London: LSHTM, RC. Ross/152/14–17. Letter to Sir Richard Gregory, Editor of *Nature*, dated February 29, 1924.
3. His father, General Campbell Claye Grant Ross, painted the Indian landscape in watercolor "incessantly" – a morning ritual which sits vividly in young Ross's memory. Ronald, who learnt painting and music from his father, was bracketed first in England for drawing at the Oxford and Cambridge Local Examination in 1878.
4. Ross's uncle, Lieutenant-Colonel William Alexander Ross, a chemist, wrote several textbooks, including *Pyrology, Or Fire Chemistry* (1875), *Alphabetical Manual of Blowpipe Analysis* (1880), and *The Blowpipe in Chemistry, Mineralogy, and Geology* (1884). Young Ross admired his uncle with an intensity that he describes as "worship" (*Memoirs* 6). In his memoirs Ross recalls being mistaken for his uncle at the Congress of Arts and Sciences in St. Louis in 1904 by a "distinguished American chemist," who admired his uncle's books and his invention of the aluminum-plate support.
5. Protozoan parasites were often called "animal" parasites, while bacteria were known as "vegetable" parasites. This rhetoric had an impact on the consequent characterization of these organisms, with parasitologists like Ross using their apparent "animality" to emphasize the difference between parasites and bacteria.
6. London: LSHTM, RC. Ross/39/06. Clipping: *The Pioneer*, April 25, 1897: 7.
7. London, LSHTM, RC. Ross/39/03. Clipping: "The Existence of the Malaria Parasite," *The Pioneer*, September 28, 1897: n.p.
8. Ibid. n.p.
9. London: LSHTM, RC. Ross/39/03. Clipping: "Existence of the Malaria Parasite," *The Pioneer*, September 28, 1897: n.p.
10. Ibid.: n.p.
11. In his obituary for fellow parasitologist Joseph Everett Dutton, published in the *British Medical Journal* in 1902, Ross refers to the late researcher as a "Galahad" and a "true Knight of Science." This chivalric rhetoric is echoed in personal and professional correspondence, in speeches, and

in newspaper articles, in which tropical medical research becomes a "quest" and its proponents knight–adventurers. I argue that this mythic imagery formed a "branding" campaign in the late nineteenth and early twentieth centuries that functioned to lionize parasitologists and their profession. For more on the development of the quest narrative in relation to British parasitology, see Taylor-Brown (2014).

12. London: LSHTM, RC. Ross/113/23/24. Clipping: "Medicine and the Empire" from *The Outlook*, January 28, 1905.
13. London: LSHTM, RC. Ross/48/36. Letter dated September 31, 1898.
14. London: LSHTM, RC. Ross/29/84/01. Letter from E. Harold Brown.
15. London: LSHTM, RC. Ross/29/112/01. Letter to Secretary to the Director-General of the Indian Medical Service, Simla, dated February 16, 1899.
16. London: LSHTM, RC. Ross/57/06. MS: "Italian Dishonesty in Science."
17. See London: LSHTM, RC. Ross/103/03/12. Clipping: "Mosquitoes and Malarial Fever," *Agricultural News* (1908): 13.
18. London: LSHTM, RC. Ross/105/06/50. "The Practice of Malaria Prevention by Ronald Ross, Major I.M.S. Ret. Professor of Tropical Medicine, University of Liverpool," p. 3 [emphasis his own].
19. London: LSHTM, RC. Ross/6/05. Letter from George Nuttall dated April 13, 1899.
20. London: LSHTM, RC. Ross/102/53/25. Clipping: "Malaria and Mosquitoes," *Dublin Express*, June 27, 1905.
21. London: LSHTM, RC. Ross/6/05. Letter from George Nuttall dated December 21, 1898.
22. London: LSHTM, RC. Ross/141/01. Letter from Castellani dated January 15, 1903.
23. London, LSHTM. RC. Ross/141/01. Letter from Castellani dated May 10, 1903.
24. The dispute was covered in the *British Medical Journal, The Lancet,* and the *Journal of Tropical Medicine and Hygiene,* as well as *The Times.*
25. London: LSHTM, RC. Ross/141/01. Letter from Castellani dated January 15, 1914.
26. See, for example, Robert Boyce, Ronald Ross, and Charles S. Sherrington, "Note on the Discovery of the Human Trypanosome." *British Medical Journal* 2.2186 (1902): 1680. See also London: LSHTM, RC. Ross/77/07. Letter from George Nuttall dated January 24, 1903, in which he laments "being put in a false position" because some are claiming he should have full credit for research on blood and immunity. Ross also recounts Albert Grünbaum's (later Leyton's) claim on an agglutination test for diagnosing enteric fever (typhoid), which was eventually named after Fernand Widal. See Ronald Ross. "Albert E. F. Leyton." *Science Progress* 16.63 (1922): 441–3. In the same issue there is a note on Eli Metchnikoff's biography, written by his wife Olga, who argues that Metchnikoff discovered the alternation of generations in certain parasitic nematodes before Rudolf Leuckart, who "stole the credit" (446).

Works Cited

Amaral, Isabel. "Bacteria or Parasite? The Controversy over the Etiology of Sleeping Sickness and the Portuguese Participation, 1898–1904." *História, Ciências, Saúde-Manguinhos* 19.4 (November 2012), <http://www.scielo.br/pdf/hcsm/v19n4/en_ahop0512.pdf> (last accessed April 1, 2017).

Anon. "Microscopic Fungi as the Cause of Disease." *The Lancet* 90.2306 (1867): 587–9.

Anon. "The Malarial Poison." *British Medical Journal* 2.1090 (1881): 827.

Boyce, Robert, Ronald Ross, and Charles S. Sherrington. "Note on the Discovery of the Human Trypanosome." *British Medical Journal* 2.2186 (1902): 1680.

Boyd, John. "Sleeping Sickness: The Castellani–Bruce Controversy." *Notes and Records of the Royal Society of London* 28.1 (1973): 92–110.

Bynum, W. F., and Caroline Overy, eds. *The Beast in the Mosquito: The Correspondence of Ronald Ross and Patrick Manson*. Amsterdam: Rodopi, 1998.

Cox, Francis E. G. "History of the Discovery of Malaria Parasites and their Vectors." *Parasites and Vectors* 3.5 (2010): 1–9.

Gagnier, Regenia. *Individualism, Decadence and Globalization: On the Relationship of Part to Whole, 1859–1920*. Basingstoke: Palgrave Macmillan, 2010.

Gorgas, William C., and Fielding H. Garrison. "Ronald Ross and the Prevention of Malarial Fever." *The Scientific Monthly* 3.2 (1916): 132–50.

Haynes, Douglas M. *Imperial Medicine: Patrick Manson and the Conquest of Tropical Diseases*. Philadelphia: University of Pennsylvania Press, 2001.

Lawrie, Edwin. "A Lecture on Malaria Delivered at the Grant Medical College, Bombay on Monday 6th April 1896 by Surgeon–Lieut-Colonel Ed. Lawrie, Residency Surgeon, Hyderabad." *Indian Lancet* (April 16, 1896a): 375–80.

——. "The Cause of Malaria. Extract from an Address Delivered at the Grant Medical College, Bombay, April 4th 1896 by Surgeon–Lieutenant-Colonel E. Lawrie, M.B., Residency Surgeon, Hyderabad." *British Medical Journal* 1.1845 (1896b): 1135–8.

——. "Colonel Lawrie on Malaria." *British Medical Journal* 1.2044 (1900): 547.

MacGregor, William. "An Address on Some Problems of Tropical Medicine." *British Medical Journal* 2.2075 (1900): 977–84.

MacMunn, Charles. "Bacillus Malariae." *British Medical Journal* 2.1093 (1881): 935.

Manson, Patrick. "Malarial Parasites in the Blood." *British Medical Journal* 2.1806 (1895): 394.

Nabarro, David. "The Discoverer of the Cause of Sleeping Sickness." *British Medical Journal* 2.2959 (September 15, 1917): 374–5.

Otis, Laura. *Membranes: Metaphors of Invasion in Nineteenth-Century Literature, Culture and Politics.* Baltimore: Johns Hopkins University Press, 1999.

Oxford English Dictionary. "replicate, v." 3rd edn. Oxford: Oxford University Press, 2009, <http://www.oed.com/view/Entry/162881?rskey=SVMhr3&result=3#eid> (last accessed April 1, 2017).

Ross, Ronald. *Edgar; or the New Pygmalion, and the Judgement of Tithonus.* Madras: Higginbotham and Co., 1883.

——. "Researches on Malaria. By Major Ronald Ross C.B., F.R.S., D.Sc. Indian Medical Service. Being the Nobel Medical Prize Lecture for the year 1902, delivered at Stockholm December 12th." *Journal of the Royal Army Medical Corps* 4.4 (1905a): 450–74.

——. "Researches on Malaria. By Major Ronald Ross C.B., F.R.S., D.Sc. Indian Medical Service. Being the Nobel Medical Prize Lecture for the year 1902, delivered at Stockholm December 12th (cont'd)." *Journal of the Royal Army Medical Corps* 4.5 (1905b): 541–79.

——. "Albert E. F. Leyton." *Science Progress* 16.63 (1922): 441–3.

——. *Memoirs, With a Full Account of the Great Malaria Problem and its Solution.* London: John Murray, 1923.

——. *Memories of Sir Patrick Manson.* London: [privately printed], 1930.

Russell, E. G. "Malaria." *British Medical Journal* 1.1062 (1881): 725–6, <http://www.jstor.org/stable/25256871> (last accessed April 1, 2017).

Taylor-Brown, Emilie. "(Re)Constructing the Knights of Science: Parasitologists and their Literary Imaginations." *Journal of Literature and Science* 14.2 (2014): 62–79.

Portraying and Performing the Copy, c. 1900

Dorothy Moss

Lecturing to students at the Metropolitan Museum of Art in 1916, William Merritt Chase announced,

> I have been a thief. I have stolen all my life. I have never been so foolish and fool-hardy as to refrain from stealing for fear I should be considered as not "original." Originality is found in the greatest composite that you can bring together. ("William Merritt Chase as Teacher" 252)

In the years leading up to this statement, Chase's practice, like that of many of his contemporaries such as John Singer Sargent, Cecilia Beaux, and Thomas Eakins, included – in a variety of orders – painting copies of Old Master paintings, studying photographs of those paintings, staging models in live performances based on the paintings, and photographing the arranged models. Through their artistic training and processes, these artists and their peers engaged in acts of copying, translation, and replication across media in the wake of advances in imaging technologies (Figure 5.1). Beyond the practice of copying European masters as central to their formal academic training, they also photographed models and worked from both life and photographs to translate the images onto canvas. The merging of various identities in a contemporary model's face through the performance of copies of European paintings particularly seemed to intrigue Chase. His engagement with the highly popular activity of staging *tableaux vivants* – performances that replicated paintings and sculpture – combined with his arrangement of models, including family members, for photographs to be studied or published after the performances, allowed Chase to collaborate with his portrait subjects and audience in the making of living replicas of European portraits (Figure 5.2). The photographs indicate that he was thinking about experiments in

Figure 5.1 William Merritt Chase in his Tenth Street studio, New York City, with copies after Hals, Velázquez, and other Old Masters on the wall, c. 1895. Albumen print. 4½ × 7⅝ in.

Figure 5.2 Helen posed as Velázquez's INFANTA behind a frame for a *tableau vivant* with William Merritt Chase adjusting the frame, c. 1899. Gelatin printing-out paper, 3½ × 3½ in.

forms of portraiture, including photographic Pictorialist practices, and they also have a particular significance when considered in light of late nineteenth- and early twentieth-century dialogues surrounding the uses and meanings of photographic copies of paintings in museums in the wake of rapid advances in imaging technology.

Those who studied with Chase and who had attended his public lectures knew his theatrical teaching process and approach to infusing Old Masters with new ideas. They also understood the roots of the general, contemporary view of the act of copying or drawing from a multiplicity of sources in artistic production – from eighteenth-century artistic training and practice in Europe to early twentieth-century America. Sir Joshua Reynolds had explained to students in his *Third Discourse* that copying a master was a procedure to be used "in the attainment of mechanical dexterity" (Reynolds 26). Reynolds and other influential theorists emphasized the importance of making exact replicas in the development of academic art instruction. In nineteenth-century America, this practice continued in the studios of Chase and others, who were trained in Europe and learned from European educators the value of copies and copying. They were well aware of the high cultural value that the French placed on academic copies, for example. French students who won the *Prix de Rome*, which gave them five years in Rome fully subsidized by the French government, were expected to send a full-scale copy of a major work back to France, where it became part of the national collections.

The difference in approach by Chase and his contemporaries to the tradition of making copies as part of standard artistic instruction, however, was that the practice of copying did not always involve original European paintings and the outcome was often not an "exact" copy in Reynolds's terms. While young American artists with means traveled abroad to set up easels in front of paintings at the Prado and the Louvre, those whose study was confined to the U.S. relied on copying from photomechanical process prints or carbon prints of European paintings. Chase was creative and innovative in his practice and teaching, and he embraced these new technologies for the sake of his advancement and that of his students. He encouraged them to study various media to capture the *spirit* of an original painting and thus make an imitation rather than a copy, by creating composites of paintings based on commercial prints and photographs. The resulting third-generation composites in various media – from painted copies to photographs of live performances – were not copies, per se, but new translations with transformed meanings.

I will focus on an intriguing example of a series of photographic portraits that Chase staged for publication in the mass press. The images were published in 1905 in *Harper's Weekly* after an evening of *tableaux vivants* that the artist had directed at Philadelphia's Horticultural Hall as a benefit event for the Elberon Library (Figure 5.3). Each individual involved in this silent, motionless "performance art" was a prominent member of Philadelphia's civic and art scene in the early twentieth century. Among them were aspiring politicians, patrons of the Philadelphia Museum of Art, art collectors, associates of the city's major artists, and Chase's wealthy students. For example, Edward Lower Stokes (posed as Raphael's *Portrait of a Cardinal*) was a young investment broker who eventually represented Pennsylvania in the U.S. Congress; Mrs. Frederick T. Mason (as Gainsborough's *Queen Charlotte*) was an art collector whose gifts to the Philadelphia Museum of Art helped provide the foundation for the museum's decorative arts collection; Henry

Figure 5.3 "Famous Paintings Reproduced from Life in the Recent Art Tableaux at Philadelphia," *Harper's Weekly*, March 11, 1905. Photomechanical print after photograph by William Merritt Chase, 1905.

Rittenberg (as a pastiche of various Frans Hals portraits, including *Jester with a Lute*) was a friend and favorite student of Chase's who studied with him at the Pennsylvania Academy of the Fine Arts and at the Shinnecock Hills Summer School of Art, and who even paid his own way to Munich to copy Old Master paintings with his teacher; and Miss Louise Cassatt (as Maria Theresa in Velázquez's *Infanta Maria Theresa*) was a daughter of the President of the Pennsylvania Railroad and niece of artist Mary Cassatt. The portraits were published in a grid format on a single page without an accompanying article. The pages surrounding this image featured texts on a variety of topics from short stories to articles about contemporary sporting events. The juxtaposition of celebrity aspirations toward high art with images of athletes engaged in sports created an ironic effect on the pages of a magazine that had a readership that viewed both kinds of image as forms of entertainment.

Within the group portrait there are individual portraits that reveal something about the artist's play with replication in the image's departure from its source material. For example, Mrs. Mason emerges from a background shrouded in darkness. The shadowed interior and the close-up composition offer an intensely intimate relationship with her face, highlighting her dour expression, which is at odds with the contented expression of the portrait she mimics. In fact, Mason's sullen glare under strong lighting and the spare background more convincingly conjure the work of such contemporary American painters as Thomas Eakins than they do the lightness, ease, and grace of a work by Gainsborough. By portraying Mason as Gainsborough's *Queen Charlotte* in a "living" photographic translation, Chase reconnects to the long tradition of *portrait historié*. This type of portrait has been defined in recent scholarship as

> an artistic rendering of a certain individual in the guise of a figure who stems from the realm of storytelling. Whether the latter is an actual historical figure or an invented character seems irrelevant. In a broader and more modern understanding of the *portrait historié* there may even be more abstract figurations, more complex modes of self-fashioning or non-representational portrayals in which a 'portrait' of an individual is captured, albeit always within a historical or narrative framework. (Manuth et al. 6)

This tradition includes portraying aristocrats in the guise of gods or mythic figures, taking on such theatrical roles as portrayed in *Sarah Siddons as the Tragic Muse* (1783–4) by Sir Joshua Reynolds.

Reflecting on the relationship between the individual and their disguised, allegorical mode, philosopher and essayist George Santayana wrote in 1922:

> The portrait we paint in this way and exhibit as our true person may well be in the grand manner . . . but if this style is native to us and our art is vital, the more it transmutes its model the deeper and truer art it will be . . . Our animal habits become transmuted by conscience into loyalties and duties, and will become "persons" or masks. (cited in Manuth et al. 13)

Accordingly, as Volker Manuth, Rudie Van Leeuwen, and A. M. Koldeweij have discussed, painted *portraits historiés* typically present a layering of faces with the contemporary face of the sitter as the one that is recognized by the viewer. Chase's photographed *tableaux* also reveal the contemporary subject as himself or herself, despite the masking that occurs in the costume and pose.

Harper's readers would have been familiar with the imagery of members of elite Philadelphia society dressed in costumes. *Tableaux vivants* were customarily performed in a variety of environments, including art students' parties, popular burlesque commercial theater, costume balls, and parlor entertainment in private homes. These performances had been an established form of entertainment in the U.S. since the time of photography's invention in 1839, growing in popularity in the 1850s and 1860s, and continuing through the early twentieth century. *Tableaux vivants* that were performed in artists' studios and at museum benefits allowed the participants and observers to collaborate and temporarily become the art, artist, and owner of the work. This elaborate entertainment, an early form of performance art, thrilled the participants and the audience, and provided rich material for the conceptions of artists and writers of the day, including Edith Wharton, who describes the audience's exhilaration in a memorable scene from *The House of Mirth*, published in 1905, in terms of "magic glimpses of the boundary world between fact and imagination" (Wharton 132).

These elaborate entertainments were undoubtedly thrilling for the participants and the audience. As influential Philadelphians, Chase's actors, whose names appeared in captions under each photograph, were recognizable to *Harper's Weekly* readers who kept up with their social and philanthropic activities in the newspapers. The larger social group to which these museum patrons belonged maintained two goals: to achieve social improvement through their own education and to educate the new immigrant populations. This was an

elite group of northeastern, urban, economically privileged members of Gilded Age society. In discussing this broader class of people, historian Sven Beckert has referred to their shared cultural values as their "common cultural vocabulary" (Beckert 8). The group was by no means coherent and was marked by internal divisions owing to the fact that they had different types of capital, different religious beliefs, different levels of wealth, and variant ages and ancestral backgrounds, and belonged to different political parties. Yet, in the process of defining their identity and distinguishing themselves from other groups – notably workers and the lower middle class – they appeared to present a more or less cohesive public identity in appearance. Beckert describes this transcendence as manifesting in a class culture that

> emphasized rationality, discipline, and individual effort. It expressed itself in shared habits and manners (such as rituals of eating at the dining room table), preferences in interior design, definitions of "high culture," and gender roles (women occupying a "separate sphere" from men) . . . Eventually, all these identities and inclinations were institutionalized in clubs, debutante balls, voluntary associations and museums. (Beckert 9)

That Chase's photographs of this group of members of Philadelphia's elite society were taken was not unusual; nor was their publication in the mass press. A rich context for these photos and performances would be the contemporary debates about the uses and meanings of copies of European paintings in art museums at this time and in the preceding decades. As Robin Veder notes, "the direct appraisal of original works of art was less important to art appreciation than the ability to recognize aesthetic style, iconographic subject matter, literary allusions, and canonical works" (Veder 136). The distribution of reproductions of works of art in the form of prints and photographs of Old Master paintings in the late nineteenth century by museums and newly formed art history departments in colleges and universities fueled this priority. The urban, economically privileged members of Gilded Age society pictured here were part of the elite group who shaped the missions of those museums and college art departments, and who controlled the distribution of reproductions of works of art for educational purposes and moral and social uplift. Significantly, some of them, including Mrs. Frederick T. Mason, were also collectors and donors of major collections of art work to museums.

Chase's models for the *tableaux* reproduced in *Harper's* were active participants in the life of the Philadelphia museum and were

intensely committed to maintaining a standard of high culture through education while extending their standards of taste to a broader population. Mrs. Mason, for example, worked for several years to install an exhibition of American furniture in a gallery of the museum as a memorial to her sister. Around the time Chase's photographs were taken this social group was in the midst of discussions about the value of photographic reproductions of European paintings in American museums. Such discussions about the role of photographic copies of paintings in museums stretched back to the mid-nineteenth century, coinciding with the rise in popularity of staged photographs of *tableaux vivants*. When major museums were established in the U.S. – among them the Museum of Fine Arts, Boston; the Metropolitan Museum of Art, New York; the Philadelphia Museum of Art; and the Corcoran Gallery of Art, Washington, D.C. – museum administrators and patrons looked to the example of the way photographs were displayed and used for educational purposes in the Musée du Louvre, Paris, and Henry Cole's South Kensington Museum in London, now the Victoria and Albert Museum (V&A). Photography was subsequently incorporated into American museum collections and installations. In 1869 Charles Callahan Perkins, a promoter of arts education in Boston's public schools, chairman of the Boston Athenaeum's Fine Arts Committee, and President of the Boston Art Club, made plans to establish a museum in Boston that would be a descendent of the South Kensington (DiMaggio 41). This became the Museum of Fine Arts. "As its aims are educational," wrote Perkins, "and its funds are likely to be for some time limited," the objects in the museum's collections should be easy and inexpensive acquisitions (Whitehill 10).

The incorporation of photographs into museum collections in the U.S. shifted the meaning of objects in the galleries. Accordingly, the way photographs were installed and used in art museums and college galleries continually fluctuated from the late nineteenth century through the early twentieth century; photographs of European paintings changed from being displayed in galleries in elaborate frames to taking the form of installations on screens and in display cases, and beginning in the early twentieth century, separate study rooms. In 1883, for example, the Metropolitan Museum of Art displayed carbon prints of European paintings in gilded frames on the first floor of the museum. Photographs were also available for visitors to purchase at the Metropolitan and in other parallel museums. This accessibility allowed museum visitors and students a new sense of personal connection to the paintings pictured and instilled an intimate

status on photographic copies, such as collotypes and autotypes. It was an experience of the original work that was different from painted copies, which were understood as translations that did not possess the "spirit" of the original. This is because the medium of photography held a magical quality for nineteenth-century museum visitors (Young 235).

Yet the new medium had drawbacks that artists, critics, and museum officials recognized. In 1874, for example, English art critic John Ruskin wrote:

> [A] photograph necessarily loses the most subtle beauty of all things, because it cannot represent blue or grey colours, and darkens red ones; so that all glowing and warm shadows become too dark. Be assured, nevertheless, that you have in this photograph, imperfect as it is, a most precious shadow and image of one of the greatest works ever produced by man. (Ruskin 3:63)

While Ruskin's academic peers – such as Charles Eliot Norton, Harvard's first professor of fine arts – might have concurred about what photographs lacked, museum officials in the U.S. put aside worries about imperfections, focusing instead on the "most precious shadow and image" that photographs revealed. Unlike painted copies, the various types of photograph in circulation were considered direct transcriptions of the originals, the physical impressions of the objects they represented, and, as mechanical impressions, they retained the spirit of the original that painted copies, as translations in another artist's hand, lacked. Chase, as an artist and teacher, was privy to these discussions and one way he participated in them was through staging such performances of replicas of European paintings.

The rise of photography and the incorporation of photographs into museum collections in the 1870s thrilled museum patrons, much like the posed performance of paintings in the form of *tableaux vivants*, because photographs of distant works of art, even though still lacking color, brought a shadow of those masterpieces into immediate view and revealed the "exact spirit" of the original, as described in a passage from the *Boston Daily Globe*:

> [I]t is as a reproductive print by which the best paintings, decorations and drawings are reproduced, that the latest photography excels. Herein it excels engraving because it is a literal reproduction in black and white values, whereas the engraving is a translation made under certain technical limitations. You have the exact spirit of the original in the best

photograph and after all that is what is aimed at in any scheme of repro-
duction. ("Wonders of Photography" 34)

As Walter Benjamin famously discussed in his seminal text "The
Work of Art in the Age of Mechanical Reproduction," the intro-
duction of reproductive technology and mass production forced a
reconstruction of notions of authenticity in the nineteenth century
(Benjamin 219). While Benjamin assumed that the work's aura was
lost in reproductions of any kind, high-quality photographic repro-
ductions of European works of art held in European collections by
such publishers as Adolphe Braun and Company and the Alinari
Brothers were increasingly valued in America as technical achieve-
ments and as possessing their own aura. As traces or emanations of
the originals, these photographic copies were accepted and welcomed
as more useful and exciting educational tools than the painted copies
that had populated museum installations before them. Furthermore,
such photographs were highly valued in the scholarly realm and
were used by seminal art historians, including Bernard Berenson and
his academic peers, who relied heavily on photographs of artworks
by Alinari and Braun when assessing the quality and attribution of
works of art.

In the late nineteenth and early twentieth centuries, college
students actively engaged photographs of European paintings in
a variety of contexts. Consider, for example, this page in a stu-
dent scrapbook from the Smith College archives that includes
photographs of a student performance of William Makepeace
Thackeray's *The Rose and the Ring* in the living room of a student
house. On the walls behind the student actors are framed enlarge-
ments of details from Raphael's *Sistine Madonna* (c. 1513), likely
placed there by the college administration. The carbon prints form
a kind of backdrop for the student actors (Figure 5.4). Another
image from the Harvard University Archives shows a student
room where collotypes reproducing European paintings are lined
along the chair rail. The process of imbuing photographs and pho-
tomechanical process prints of European works of art with what
William James had described as the "warmth and intimacy" of lived
experience resulted in the students' development of a sense of own-
ership of the objects in the photographs and the agency to reinvent
and even contradict their meanings and significance. This interac-
tion between real and representational allowed for ironic juxta-
positions and playful dialogues between various forms of culture
at a moment when the cultural elite increasingly sought to invent

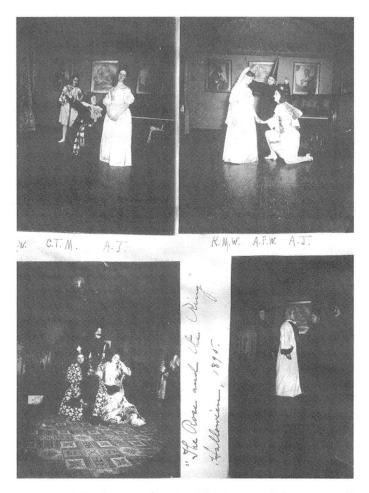

Figure 5.4 Students performing *The Rose and the Ring*, Halloween. From the photograph album of Agnes Jeffrey. Creator: unknown.

hierarchies and subsequently to fix boundaries between high and low culture. Influential American collectors around 1900, including Henry Clay Frick, John Pierpont Morgan, and Grenville Winthrop, shared this impulse to appropriate European culture through creating such hierarchies and classifications.

By 1905, when Chase published his series of living portraits in *Harper's*, the function of photographs of European paintings in art museums was still evolving. It was in this context that Chase's series of photographs, displayed in a grid on the pages of *Harper's Weekly*, appeared. This was also a moment when the practice of photographing scenes inspired by works of art had become a

hallmark of Pictorialism. This photographic style flourished from about 1880 to 1920 in response to the point-and-shoot approach to photography. Pictorialism yielded rich, tonally subtle photographic prints that were the result of labor-intensive processes and emphasized the role of the photographer as craftsman. They did not always imitate Old Master paintings but sometimes they did; such images by international artists included those by Italian photographer Guido Rey and the Netherlandish photographer Richard Polak, who were well known to American audiences through publications in Europe and America, and were frequently pictured on the pages of Alfred Stieglitz's Pictorialist quarterly, *Camera Work*.

In Chase's images we find the performance of various forms of reproduction. His examples show the bourgeois patrons who controlled the growing archives of photographs of European works of art emulating works of art as actors. When viewed together as a group of photographed imitations of paintings, the array of duplicated personalities gives way to a new form of portraiture. Chase's stiffly posed subjects seem mannequin-like; their heavily painted faces suggest masks. These *tableaux* were performance art for highbrows. Although members of an upper-class group who controlled Philadelphia's social and cultural life, in the photos they seemed to engage in a kind of parody of high art through excess of make-up and stiff poses, while at the same time embracing and emulating European culture through their imitation. In her photographed translation of *Queen Charlotte*, the frowning Mrs. Mason contradicts the character of her smiling, serene model as conceived by Gainsborough. Writing about an 1895 caricature exhibition, the critic Tudor Jenks observed, "In a really fine picture the qualities that make it are never those of which parody can lay hold. Burlesque separates the accidental from the essential, and permits the accidental to usurp the throne" (Jenks 25). Indeed, in the accidental or nonchalant deviation from the original paintings, in the actors' turns of pose or twists of expression orchestrated by Chase, lies the replication, a variation from the original that marks it as a classed appropriation of high culture. It is as if these otherwise more or less reserved personalities are playfully trying to act a part.

By the time these photographs were taken, in the first decade of the twentieth century, nineteenth-century notions of photography as a direct copy of reality competed and even combined with the idea of the photograph as a medium for offering imagined images of the world. In their reproduction in *Harper's Weekly*, Chase's photographs captured and articulated a distinctly different view of the *tableaux* from

what audiences would have seen on stage. The actors are not posed in front of backdrops; nor are they anchored within a gilded frame. Instead, the gridded layout on the printed page replaces the frame and emphasizes the individuals as social elites, part of the social content of newspapers, recalling the wildly popular celebrity *cartes de visite* that were endlessly reproduced, purchased, and circulated.

Elizabeth Siegel has discussed the circulation of *cartes de visite* on the market and the precarious balance of power and anxiety involved in this distribution of famous faces. Siegel references a story published in the *American Journal of Photography* in 1863 in which a man who has posed for his photograph loses control of the image and grows paranoid about the circulation of his face in areas of society over which he has no control (Siegel 56). Similarly, the power and prestige enjoyed by Chase's Philadelphia aristocrats and their associates was both promoted and undermined by the circulation of their images on the pages of the mass press, where they could be compared to all kinds of other faces and contexts.

The traditional size and format of the *Harper's* portraits staged by Chase, combined with the burlesque aspects of these animated portrait replicas, might have even echoed such well-known vaudeville mimics as Cecilia Loftus, whose face was also reproduced and distributed on *cartes* and on the pages of the mass press. Historian Susan Anita Glenn has described the early 1900s as vaudeville's "mimetic moment." Mimicry was so popular, in fact, that one musical revue playing in Chicago in 1908 featured several burlesques of the trend, including a song called "The Imitation Craze." As Glenn explains, Loftus and other vaudeville mimics often adopted the camera as a symbol in metaphorical discussions of the relationship between imitation and the reproductive technologies of modern life: "'[T]he imitator makes of herself a camera to photograph the imitated.' Like 'the development and toning of a role of film or a set of plates,' she insisted, the imitator must perfect the 'psychological chemistry,' necessary for making her imprint" (Glenn 58). The actor is thus a camera that becomes a photograph of the sitter for the original painting. According to Caroline Caffin, writing in 1914, "Just as the photographer, by focus and arrangement of light . . . can influence the result of his photograph, so too the vaudeville imitator may give us the result in differing ways, each way being none the less a true imitation" (Caffin 135–6). These layers of interconnections between vaudeville mimicry and the camera as a symbol of reproduction and the imitation of paintings in the *Harper's* images staged by Chase might be understood as the merging of the visual

and theatrical arts that was a central part of Chase's masterminding of public performances at this time. We know from Chase's letters that he enjoyed attending vaudeville performances in Europe and the U.S. (Roof 196). It is not surprising, then, that his *tableaux vivants* had as much an element of humor and playfulness to them as the mimicry of actors such as Loftus; yet they also maintained, like the performances of Loftus, a sense of seriousness in approach as the process of preparation required interpretation through study and careful attention to detail.

Similarly to the work of vaudeville actors, in preparing for *tableaux*, artists and actors would study photographs to get into character before their performances. Writers of countless manuals and articles in the popular press encouraged artists to use commercial photographs of works of art in preparing for *tableaux* to study the details of the photographs in perfecting their imitations (O'Sullivan 101). This aspect of the construction of the performances reveals a view of the photograph as a replacement for the original rather than as an object of imitation. It also complicates the position of the commercial art photograph in relation to other forms of reproduction. The resulting stage performances were actually animated copies of the photographic reproductions, and the photomechanical prints published in the mass press after performances were even further removed from the original paintings. The *tableau* provided a way of restoring life to an image flattened by photographic reproduction, and also allowed Chase to infuse the Old Master paintings with the spirit of his modern eye. As Erica Hirshler has noted, "Through his multiple performances of the old masters, Chase embraced the new" (Hirshler 21). In this way, the Chase portraits paralleled the performances of Cissie Loftus and other imitators, who used mimicry to produce humor and to challenge the tension between self and other.

In 1908 theater critic Alan Dale argued that those who felt "chained" to their own "individuality" were the prime audience for vaudeville mimicry performances. "Isn't it exquisite to be occasionally somebody else?" (cited in Glenn 49). As Glenn has observed, W. J. T. Mitchell suggests that theatrical role-playing, which involves degrees of both simulation and substitution, is one forum in which these two modes of representation can merge (Mitchell 11–22). Chase's embrace of performance, and his desire to infuse his work inspired by the Old Masters with the spirit of his time, played into the notion of simulation and substitution that is part of any act of role-playing not only on the part of the sitter but also on the part of the portrait artist. His work involves a kind of time traveling that

allowed what Hirshler has described as "the old masters to come to
life again, once more through the efforts of Chase's hand" (Hirshler
20). Chase orchestrated a new form of portraiture through experi-
mentation and translation of the Old Masters while his sitters, in
their playful roles as European paintings, simulated a form of Euro-
pean high culture that they sought to own in the U.S.

In the years leading up to 1905, imitation and replication in pho-
tography were highly charged topics of discussion, and photography
was undergoing a shift in cultural meaning. Chase's well-established
group grappled with how to control their image as well as the mean-
ings of the reproductions of European paintings in their charge when
advances in imaging technology allowed the images to be seen in
multiple contexts and discussed in a variety of ways. Debates about
the meaning of photographic copies of European paintings unfolded
in museum boardrooms and on college campuses. In the *Harper's*
image it is possible to see what was at stake laid out on the pages of
the mass press. Members of this social class sought to affirm their
identity as the cultural elite and used their image in the mass press
to exert their cultural influence in a shifting environment where new
media (including photographs and various forms of printmaking)
jostled the hierarchies they tried to maintain in the disparate yet
communicating spaces of the mass press, the museum boardroom,
and the college classroom, where art history was just becoming a
serious academic discipline.

In his essay "The Line of Sight" Jacques Lacan wrote,

> Mimicry reveals something in so far as it is distinct from what might be
> called an itself that is behind. The effect of mimicry is camouflage . . .
> It is not a question of harmonizing with the background, but against a
> mottled background, of becoming mottled. (cited in Bhabha 125)

Chase's *Harper's Weekly* photographs were situated within a cultural
moment in which replication was a topic of fascination that could be
explored on the mottled page of the mass press. The camouflaging
effect of a multiplication or layering of identities, and a variety of
types of reproductive technology available and in circulation, offers,
on the one hand, a playful view of an elite social group humorously
engaging in performance art and, on the other hand, a window into
one way in which this social group upheld standards of taste in the
wake of the machine age. As Henri Bergson put it in 1900, "Analyse
the impression you get from two faces that are too much alike. You
will find that you are thinking of . . . two reproductions of the same

negative – in a word, of some manufacturing process or another" (Bergson). In their social and historical context, Chase's photographs oscillated between portraiture and the "sacred" space of the art museum, between painting and photomechanical reproduction, between portraiture and performance, and between high art and low theater. Through their contexts, media, and broad circulations of images and their complex social and cultural referents, the "manufacturing process" may have been the bridge between such seemingly disparate worlds that were simultaneously colliding and merging on the pages of the mass press.

Works Cited

Beckert, Sven. *The Monied Metropolis: New York City and the Consolidation of the American Bourgeoisie, 1850–1896*. Cambridge: Cambridge University Press, 2001.

Benjamin, Walter. "The Work of Art in the Age of Mechanical Reproduction." *Illuminations*. Ed. Hannah Arendt. London: Fontana, 1973: 219–53.

Bergson, Henri. *Laughter: An Essay on the Meaning of the Comic* [1911], trans. Cloudesley Brereton and Fred Rothwell. Mineola, NY: Dover Publications, 2005.

Bhabha, Homi K. *The Location of Culture*. London: Routledge, 1994.

Caffin, Caroline Scurfield. *Vaudeville: The Book by Caroline Caffin, the Pictures by Maurice de Zayas*. New York: Mitchell Kennerley, 1914.

DiMaggio, Paul. "Cultural Entrepreneurship in Nineteenth-Century Boston." *Media, Culture, and Society* 4.1 (January 1982): 33–50.

Glenn, Susan Anita. "'Give an Imitation of Me': Vaudeville Mimics and the Play of the Self." *American Quarterly* 50.1 (March 1998): 47–76.

Hirshler, Erica E. "Old Masters Meet New Women." *William Merritt Chase: A Modern Master*. Elsa Smithgall, Erica E. Hirshler, Katherine M. Bourguignon, Giovanna Ginex, and John Davids. Washington, D.C., and New Haven, CT: Phillips Collection and Yale University Press, 2016: 17–29.

Jenks, Tudor. "Moral Reflections on Burlesque Art." *The Monthly Illustrator*, vols 4–5 (1895): 17–25.

Manuth, Volker, Rudie Van Leeuwen, and A. M. Koldeweij. *Example or Alter Ego?: Aspects of the Portrait Historié in Western Art from Antiquity to the Present*. Turnhout: Brepols Publishers, 2016.

Mitchell, W. J. T. "Representation." *Critical Terms for Literary Study*. Ed. Frank Lentricchia and Thomas McLaughlin. Chicago: University of Chicago Press, 1990: 11–22.

O'Sullivan, Philip. "A Chapter on Tableaux." *Scribners Monthly: An Illustrated Magazine for the People* 21.1 (November 1880): 91–104.

Reynolds, Joshua. *Fifteen Discourses Delivered in the Royal Academy.* London: J. M. Dent & Sons Ltd., 1906.

Roof, Katherine Metcalf. *The Life and Art of William Merritt Chase.* New York: C. Scribner's Sons, 1917.

Ruskin, John. *Fors Clavigera: Letters to the Workmen and Labourers of Great Britain.* 4 vols. Philadelphia: Reuwee, Wattley & Walsh, 1891.

Siegel, Elizabeth. *Galleries of Friendship and Fame: A History of Nineteenth-Century American Photograph Albums.* New Haven, CT: Yale University Press, 2010.

Veder, Robin. *The Living Line: Modern Art and the Economy of Energy.* Hanover, NH: Dartmouth College Press, 2015.

Wharton, Edith. *The House of Mirth.* Intro. Elizabeth Hardwick. New York: Modern Library, 1999.

Whitehill, Walter Muir. *Museum of Fine Arts, Boston: A Centennial History.* Vol. 1. Cambridge, MA: Belknap Press of Harvard University Press, 1970.

"William Merritt Chase as Teacher." *Bulletin of the Metropolitan Museum of Art* 11.12 (December 1916): 250–2.

"Wonders of Photography: How It Has Developed into One of the Fine Arts." *Boston Daily Globe*, November 7, 1897: 34.

Young, Paul. "Media on Display: A Telegraphic History of Early American Cinema." *New Media, 1740–1915.* Ed. Lisa Gitelman and Geoffrey B. Pingree. Cambridge, MA: MIT Press, 2003: 229–64.

Replication and Technology

Replicating Tennyson's
The Princess, 1847–1853

Linda K. Hughes

Demonstrating his faith in new technologies, Tennyson invested in a wood-carving enterprise meant to replicate mechanically hand-carved furniture in the 1840s (Hallam Tennyson 1:220–1). The business's failure left him depressed and in financial straits, but his faith in technology remained – appropriately so, for reliance on high-speed replication was essential for his first long poem to attain popularity. From the moment it appeared on Christmas Day in 1847, Tennyson's *The Princess* was at once welcomed and entirely unexpected. In 1842 Tennyson had become the foremost poet of his generation with his two-volume *Poems,* which included the dramatic monologues "Locksley Hall" and "Ulysses," and lyrics such as "Break, break, break." Five years later, no one expected a 164-page blank-verse poem with a prologue, conclusion, and seven-book inset tale. *The Princess,* ostensibly narrated by seven college men on holiday at a country estate, concerns a rebellious princess who spurns arranged marriage and establishes an all-female university from which men are excluded on pain of death, only to capitulate at the tale's end to impending marriage with the Prince.

Twenty-two years before the first woman's college opened at Cambridge, Tennyson had clearly taken up "the woman question," or how women's roles were to change in the face of democratic reforms and rapid developments in science and technology. By embedding his quasi-medieval tale within a prologue and epilogue that emphasized contemporary social change and technology, Tennyson could under-score the analogous juxtaposition in contemporary Britain of long-standing traditions and artifacts with startlingly diverse innovations from the rail system (begun only eleven years earlier) to the Chartist movement, which was led by workers and their allies who demanded

universal male suffrage along with other reforms. The prologue is accordingly set on a country estate but Sir Walter Vivian, the squire (father to one of the college men), has opened it to tenants and workers belonging to a neighboring Mechanics' Institute.[1] Inside Sir Walter Vivian's elegant home are displays of ancestral memorabilia and a connoisseur's collection of artifacts gathered from "every clime and age," but outside are scientific displays set up for workers' amusement and instruction, including a miniature steam paddleboat and steam railway, a telescope, and a cannon set off remotely by "knobs and wires and vials" (*The Princess* 1847: 2, 4).[2] When Sir Walter's daughter Lilia declares to the university visitors that she wishes she could be a great princess who founded her own university for women, the college men first spar with her, then light upon the idea of narrating a fantasy of this scenario, which they find ludicrous. Hence in *The Princess* the serious question of women's education jostles alongside a tale in which Princess Ida's spurned fiancé and his two friends enter her university in drag, and it is set in a frame that juxtaposes a carnivalesque holiday setting with attention to expanded opportunities for workers. Not surprisingly, Tennyson subtitled his work "*A Medley*."

For obvious reasons *The Princess* is most often approached in terms of its relation to Victorian gender ideology (see especially Sedgwick 118–33), though recent approaches include its relevance to Victorian liberalism (Barton 251–66) and to science. Rebecca Stott, for example, argues that *The Princess* is a response to the "Victorian Sensation" of 1844, Robert Chambers's *Vestiges of the Natural History of Creation*, and that the culminating commitment of the Princess and Prince to erotic union in wedlock, with its prospect of offspring, is the means to further evolutionary change in the future (Stott 13–34). My focus is on another distinctive feature of Tennyson's poem when it was introduced to audiences: the fact that in a space of just over five years, five new versions of *The Princess* appeared in rapid-fire succession. Though poetic revision and textual variants are as old as written poetry itself and comprise the focus of many textual studies, the transdisciplinary traveling concept of replication offers the most illuminating framework for situating these rapid iterations of the poem. Only in a time of technological innovation and widespread replication could Tennyson and his publisher successfully issue and market five different versions of a poem under the same title in five years. To underscore this approach, I abstain from the traditional literary term "edition" and instead adopt "version" or "iteration," this last drawn from "the repeated application of a formula" in mathematics, wherein the output of one equation is the starting point of a new one.[3]

James Secord applies the term "literary replication" (as well as "Victorian Sensation") to Chambers's anonymous *Vestiges of the Natural History of Creation*. For Secord, "literary replication" encompasses successive modified print editions of *Vestiges* and also supplemental texts that circulated Chambers's evolutionary argument, including advertisements and Chambers's book of 1845, *Explanations*. Secord likewise points to the enabling developments of the industrial revolution in nineteenth-century printing and distribution that Richard Altick first documented in 1957 (Secord 126–52). I share Secord's view of rapidly issued versions of print texts as "replicas" in which Victorian authorial interventions converged with new technologies of steam-driven presses and railroads, supplemented by a mass market for print and reviews in the daily and weekly press. But Secord's model cannot easily be mapped onto the high prestige form of the signed poem when the author is well known. Such poetry texts seek aesthetic validation rather than, as with Chambers's book, enhanced factual correctness, though poetry reviews often suggested improvements. Most crucially, the only authorized aesthetic interventions in the text are by the originating poet, whose altered versions can be construed as acts of ongoing creativity. *The Princess*, then, is related in its rapid reproduction to a scientific text such as *Vestiges* but in its creative model and aesthetics to the re-makings of Dante Gabriel Rossetti's replica paintings (see Julie Codell's chapter in this volume). Like *Vestiges*, *The Princess* inhabited the nexus of written texts and new technologies, but like replica paintings, *The Princess*'s successive versions were also "originals" – successive copies with variations – by the artist. Yet neither is a literary replication identical to one in painting, for a poet's successive interventions in his text (aside from deleted passages) are cumulatively integrated into the last-extant version.[4] Tennyson's final replica is thus new but also summative insofar as all prior changes are integrated into it simultaneously. The five rapid iterations of *The Princess* from 1847 to 1853 exemplify nineteenth-century replication, then, but are also highly specific in their generic modulations and temporality.

Because replicas of the *Princess* were literary texts and material objects – books with layout and paratexts – I want to incorporate both into the detailed analysis that follows. The first iteration released on Christmas Day 1847 was, like all first issues, deemed the "original work" and established a benchmark for audience reactions and critical reviews that framed responses to later versions. One of the most notable features of the new work, besides its length and subtitle, was that it was entirely written in blank verse, from the opening lines to the last page, a metrical practice for which there was no precedent in

Tennyson's published poems. On January 8, 1848, a review singling out this feature appeared in the progressive *Howitt's Journal*, edited by William and Mary Howitt, members of Tennyson's social circle at the time:

> The volume does not consist of a number of poems, it contains only one, and that in blank verse. Some therefore, will miss the usual variety, others still more the rich musical cadences of his lyrics. The whole here is blank-verse, even those portions which are said to be sung by characters in the poem. We, ourselves, should have been better pleased with these parts being thrown into a lyric form. But, passing over these particulars, the poem is one of the most original and beautiful that Tennyson has yet produced. (Review, January 8, 1848: 28)[5]

Unbroken blank verse not only was an unusual stylistic and rhythmic choice for Tennyson; it was also a cultural and ideological signifier intertwined with national identity. In his 1867 essay "Blank Verse," poet and scholar John Addington Symonds associated blank verse with both English national identity and Shakespeare: "The freedom of the renaissance created [blank verse] in England. The freedom of our own century has reproduced it. Blank verse is a type and symbol of our national literary genius" ([Symonds] 640, 624; see also Harrington 345 and M. Martin 88). In *The Princess* Tennyson further aligned himself with Shakespeare by naming *The Winter's Tale* (with its own dual timeframe) in the prologue. When, after Lilia contends that were she a great princess she "would build / Far off from men a college of my own" and "make it death / For any male thing but to peep at us" (1847: 7, 8), Lilia's brother reports that the college set had diverted themselves when studying with a tutor over Christmas by telling a tale "from mouth to mouth" (1847: 10). Lilia and her aunt then demand a similar tale in summertime: "'Why not a summer's as a winter's tale?'" (1847: 11).

To this point blank verse and the Shakespeare allusion suggest Tennyson's high ambition. But in mixing the feudal and modern, literature and science in the narrative of *The Princess* – "A Gothic ruin, and a Grecian house, / A talk of college and of ladies' rights, / . . . with shrieks and strange experiments" (1847: 12) – and subtitling the poem "*A Medley*," Tennyson offered critics a handle to devalue his work, and several asserted that he should seek grand unity rather than producing a mere medley.[6] The medley, however, was consistent with Tennyson's experimentation and innovation, as was the hybrid mix of artistic creativity and technology in its production.

An important material feature of the 1847 *Princess* was that the poem moved from prologue to first book and from book to book with minimal formatting, which emphasized the "bookness" of a book consisting of a single poem. The initial version of *The Princess*, that is, ended a book on one page and began the next on a new one, much as chapters are separated in fiction, and added only a numeral or "Conclusion" at the top. Such was the visuality to which Tennyson accustomed his readers who purchased or borrowed his 1847 volume.

The 1,500 copies printed by Tennyson's publisher Edward Moxon were quickly exhausted, and in March or April 1848 another 1,500 copies appeared in a second iteration (Shannon 118).[7] Though the second generally resembled the first, a significant authorial act changed the cultural signals given by the new iteration. In addition to the title page announcement of the volume's status as a second edition, Tennyson dedicated this replicated *Princess* to Henry Lushington, signing himself Lushington's friend and dating the dedication January 1848 (a tacit advertisement for the rapid sales of the 1847 *Princess*; see Figure 6.1). This difference in the two versions probably meant little to the patrons of Mudie's Lending Library, which

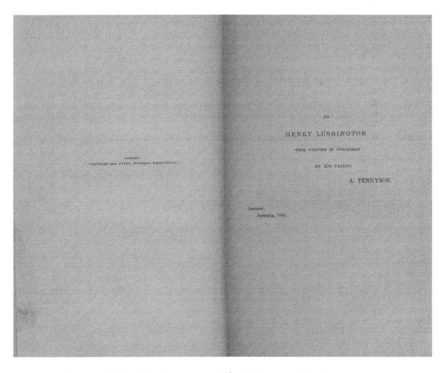

Figure 6.1 Dedication page, *The Princess*, 1848.

quickly added *The Princess* to its collection of "NEW and CHOICE BOOKS" (Mudie's 201), but it signaled to the literary world the poet's specific network of personal and political affiliations rather than a representative national identity. Henry Lushington, who met Tennyson in 1839, had published an 1837 pamphlet that critiqued aristocratic privilege and an 1844 book that criticized Britain's invasion of Afghanistan (Boase n.p.).[8] In coupling Lushington's name with his own on the dedication page, Tennyson implied his openness to change and willingness to question past authority. Henry's name was also an oblique allusion to the even closer connection Tennyson enjoyed with Henry's older brother Edmund, who attended Trinity College, Cambridge, when Tennyson did and like him was elected to the secret intellectual society, the Cambridge Apostles. In 1842 Edmund had married Tennyson's younger sister Cecilia, an event that figures prominently in the epilogue of Tennyson's most important contribution to British poetry, *In Memoriam*, published two and a half years after *The Princess*.

Mentioning a Lushington in the dedication functioned as a kind of double personal signature, for the Mechanics' Institute at which the poet–narrator is present in the frame closely follows the actual Mechanics' Institute that Edmund Lushington hosted on July 6, 1842, and at which Tennyson was present three months before the Lushington–Tennyson wedding in October. John Killham quotes the historical account reported in the *Maidstone and Kentish Advertiser* on July 12, 1842: "On Wednesday last the members of the [Maidstone Mechanics'] institution held their fourth annual festival, in the Park of E. L. Lushington, Esq." After mentioning dances, bands, and games including cricket, the newspaper continued,

> a cannon was occasionally fired off, ignited by a spark from an Electrical Machine at a distance of about 20 yards; at another part of the grounds a model of a steam engine was at work, turning a circular saw with great rapidity, and the model of a steam boat plying round a light house, a table spread with philosophical instruments, consisting of telescopes, microscopes, etc. etc. (qtd. in Killham 61–2)

Altogether 800 persons took tea at 5 p.m., after which "a large fire balloon ascended" (Killham 61–2). To mention a Lushington on the dedication page, then, not only linked Tennyson to progressive politics but also more closely tied Tennyson to the poem personally through an event reported in contemporary papers and the formal feature common to the first two iterations: an "I" who narrates the prologue and also narrates the first inset tale.

Coventry Patmore noted another change from the first to the second version. In the *North British Review* dated May 1848, Patmore reviewed *The Princess*, attempting to elevate Tennyson's poetic project by interpreting it as an allegory of the passive, feminine side of intellect in rebellion against authority – and therefore in error. Ida's tame leopards model in contrast, Patmore argued, the "lower powers of Nature in just submission to the enlightened Intellect" (Patmore 68–70). According to him, obtuse readers (that is, reviewers prior to Patmore) had missed this apparent design, and to lesson them (and lessen their ignorance), Patmore turned to a minor revision in the 1848 iteration of *The Princess*. The 1847 "Conclusion" mentions its "compound story which at first / Had only meant to banter little maids / With mock-heroics and with parody" (1847: 161). In a footnote Patmore commented,

> So the first edition. In the second the passage runs thus.
> "Here closed our complex story, which at first
> *Perhaps*, but meant to banter little maids, &c."
> Mr. Tennyson has been taught, by the reception of his first edition, a little of the wisdom which is commonly the last at which great writers arrive, namely, that of giving the "reading public" sufficient credit for obtuseness. (Patmore 66n.)

Patmore, by implication, contended that Tennyson's revision signaled a serious theme underlying the narrative's surface "banter." Equally telling, Patmore saw no difficulty in listing the 1847 volume as the work under review while quoting from the second version and treating them as "the same" even as he noted their divergences – a key feature as well of replication in paintings known by identical titles but variant in execution.

Only with the third iteration of *The Princess* appearing early in 1850 did Tennyson introduce substantial, extended changes that dramatically modified the text and its material embodiment. Once more, 1,500 copies were printed and sold well. As a text this third version changed Princess Ida in two disparate directions that are consistent with the peculiarities of this poem's history and the dialectical sensibility for which Tennyson is famous. On one hand, as Edgar Shannon establishes, Tennyson augmented Ida's intellectual force and independence. In earlier versions Ida's father, King Gama, told how Ida had come under the tutelage of the widows Lady Blanche and Lady Psyche, who "fed her theories" (1847: 18); in 1850 Ida claimed a passion for pursuing knowledge for herself – "knowledge, so my daughter held, / Was all in all." And even before establishing her

university she had proven herself as a poet who composed odes and lyrics "prophesying change" (1850: 20). The 1850 Ida also emerged as a woman of profound vision who sat apart while others engaged in academic debate:

> Rapt in awful dreams,
> The second-sight of some Astraean age,
> [She] Sat compass'd with professors: they, the while,
> Discuss'd a doubt and tost it to and fro:
> A clamour thicken'd, mixt with inmost terms
> Of art and science . . . (1850: 48)

Here, according to Shannon, "She becomes a dynamic figure, assuming leadership. The additions commence the process of making her intellectually heroic" (Shannon 135).

Even as Tennyson strengthened Ida, however, he constrained the possible success of her bold experiment by emphasizing women's maternal role. He thus inserted new references to children alongside Ida's rejection of childbearing in her own life's plans:

> knowledge, so my daughter held,
> Was all in all; they had but been, she thought,
> As children; they must lose the child, assume
> The woman: then, Sir, awful odes she wrote,
> About this losing of the child, – and rhymes
> And dismal lyrics prophesying change,
> Beyond all reason: these the women sang . . . (1850: 20)

In an earlier review of the poem's second iteration in the October 1849 *Edinburgh Review*, Aubrey de Vere discerned a "vindication of the natural ties against the arbitrary and the theoretical" in the "[m]any passages" that compose

> a remarkable reference to children. They sound like a perpetual child-protest against Ida's Amazonian philosophy, which, if realized, would cast the whole of the child-like element out of the female character, and at the same time extirpate from the soul of man those feminine qualities which the masculine nature, if complete, must include. (de Vere 400)

Shortly after the third version of *The Princess* was introduced to audiences, Tennyson wrote to his friend de Vere in late January to say, "I have in some measure adopted your suggestions – not entirely" (Alfred Tennyson, *Letters* 320).

Most famously, this third iteration changed the format, poetic sub-genre, and role of women by introducing new lyrics between each book, ostensibly sung by the female auditors of the masculine narrative. As the newly fashioned prologue stated,

> ' . . . we [the male narrators] will say whatever comes.
> And let the ladies sing us, if they will,
> From time to time, some ballad or a song
> To give us breathing-space.'
> So I began,
> And the rest follow'd: and the women sang
> Between the rougher voices of the men,
> Like linnets in the pauses of the wind:
> And here I give the story and the songs. (1850: 13)

As in references to children, this new iteration underscored a heterosexual binary between male and female bodies and voices that paralleled de Vere's insistence on women's versus men's binary reproductive functions.

But the changes also entailed creating a new visual material object. Tennyson and his publisher Edward Moxon took care to emphasize the new version's changed material and visual features. The first two pages differed little from the 1848 *Princess*, except for "Third Edition" and revised Roman numerals on the title page. There was a subtle change on the first page of the poem, though. The 1848 *Princess* featured a straight line with a small circle or enlarged point at the center and, underneath "PROLOGUE," a shorter straight line (Figure 6.2). In 1850 double scored lines extending beyond the word "PROLOGUE" appeared below the title and sub-title, and a design under "PROLOGUE" like that beneath the title and sub-title in 1847 and 1848 (Figure 6.3). The double scored lines perhaps signaled a doubling of form or added meters in what followed, for the exclusively blank-verse poem now became a metrically hybrid work in keeping with other medley features. Readers of the poem's 1850 version finished the first book, turned the page, and found something quite new. Announcing itself as something apart from blank verse yet embedded as a value-added essential feature of the newly recast poem was a lyric with dividing lines above and below. "Sweet and low," placed at the end of the second book (Figure 6.4), began in common or ballad meter (alternating tetrameter and trimeter lines) but shifted into further metrical virtuosity visible on the page since the two pentameter lines concluding each stanza extended almost across the width of the text. In the second stanza,

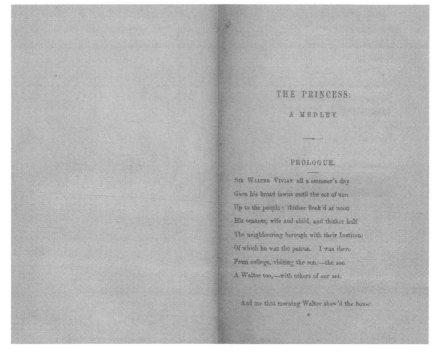

Figure 6.2 "Prologue," decorative format, *The Princess*, 1848.

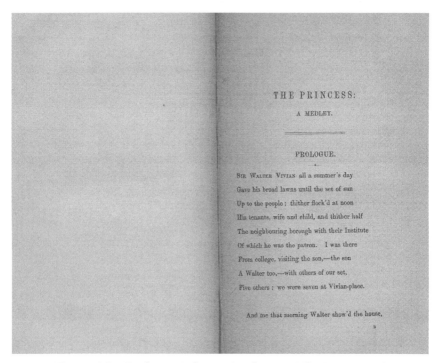

Figure 6.3 "Prologue," decorative format, *The Princess*, 1850.

Figure 6.4 Inserted lyric, "Sweet and low," *The Princess*, 1850.

moreover, Tennyson remixed elements of ballad meter into yet another variant (two tetrameter lines followed by a trimeter). Further variant meters and layout appeared in succeeding books of the newly iterated *Princess*.

Book IV marks a crucial turning point in all versions of the embedded narrative, when the young men in drag inadvertently unmask themselves and the outraged Ida is thrown into the river after her horse stumbles as she rushes to leave the men's presence. The Prince saves her life and is expelled rather than put to death after being brought before Ida and further angering her by declaring love and proposing marriage. War now looms since the Princess's realm has been violated and the Prince's father has taken Ida's father hostage as security for his son. But in 1850 the disruptions in Ida's realm became newly mirrored in the frame, for in addition to introducing mixed meters into lyrics that punctuated a blank-verse narrative, Tennyson now hybridized lyric and narrative by mixing them as Book IV closed. A tetrameter battle song (with a concluding flourish of "Tara ta tantara!" [1850: 100]) was set off from the narrative by a dividing line above, but before it concluded the frame narrative erupted into the tale itself when Lilia was identified as the singer: "So Lilia sang: we thought her half-possess'd / She struck such warbling

fury through the words" and "cried for war, / Or some grand fight to kill and make an end" (1850: 100). Even as Ida's formerly secure realm had been fractured, so the frame was fractured and mixed with the inset tale's ironic courtship of Book IV, since Lilia directed the succeeding narrator to "Fight" and he pleaded for her favor should he succeed (1850: 101).

Another change in the poem's third iteration was that Lilia and her aunt were no longer exceptional in being the sole female auditors present, two women as against seven college men. Tennyson now added "lady friends / From neighbour seats" (1850: 5), augmenting the representation of women but also of privileged ranks in the frame. These added squires' daughters were assigned the role of hearing and collectively responding to the college men's narrative in song. As with Lilia and the narrator she enlisted to "Fight," the women's conjoined voices in the frame narrative exerted "soft power" on the college men:

> The women . . . perhaps they felt their power,
> For something in the ballads which they sang,
> Or in their silent influence as they sat,
> Had ever seem'd to wrestle with burlesque,
> And drove us, last, to quite a solemn close. (1850: 171–2)

At the same time, just as the 1850 Ida was increasingly linked to the figure of the child, so Tennyson linked the frame-tale women's songs principally to children and tacitly to women's biologically determined maternity. The first lyric represented a husband and wife's quarrel that was resolved as they stood together over the grave of the child they had lost; the second was a lullaby sung by a mother to her baby ("Sweet and low"); the third summoned up a sunset landscape and echoing bugle song ("The splendour falls on castle walls"); in the fifth a new widow was released from stunned grief only when the nurse placed her child on her knee; and the sixth was a love song that seemed to promise heterosexual union and the engendering of a child.

Significantly, it was only after he had radically revised his poem in its third iteration and written his friend Aubrey de Vere to thank him for highlighting the role of the child figure in the narrative that Tennyson began to assert, "The child is the link thro' the parts as shown in the songs which are the best interpreters of the poem" (Hallam Tennyson 1:254). Hallam Tennyson pointed to another source of this emergent interpretation when he excerpted a passage

from Charles Kingsley's review of the 1850 *Princess* in a note to his father's remark. Kingsley, in registering the impact on readers of Tennyson's newly hybridized blank verse, reported that he initially found the added songs distracting until he saw that they served to tie women more closely to their biological functions as potential mothers:

> The songs themselves, which have been inserted between the cantos in the last edition of the book, seem, perfect as they are, wasted and smothered among the surrounding fertility; till we discover that they stand there, not merely for the sake of their intrinsic beauty, but serve to call back the reader's mind, at every pause in the tale of the princess's folly, to that very healthy ideal of womanhood which she has spurned. ([Kingsley] 251)[9]

If the incorporation of lyrics into blank verse satisfied the earlier wish expressed in *Howitt's Journal* for greater lyric virtuosity, the 1850 iteration also acted to hold women more firmly in check to their biological destiny.[10]

Tennyson rewrote *The Princess* in a final notable way in 1850. The first iteration had appeared against the backdrop of Chartism, the progressive workers' movement seeking representation in Parliament and the franchise. The second version appeared some time between January and February 1848, just before the February Revolution in France that led in June to pitched battles between workers and the government in Paris, Louis-Philippe's abdication, the birth of the Second French Republic, and Louis-Napoleon Bonaparte's election as president. Tennyson pinpointed the potential effect of these events on his poem's political valences in his February 1850 letter to de Vere cited earlier: "Don't you think too that the Dedication to Harry Lushington looks very queer – dated January –48, the French row taking place in the February following: and such allusion to it and the subsequent ones, made in the Epilogue?" (Alfred Tennyson, *Letters* 320). Tennyson obscured the link of *The Princess* to Chartism and the 1848 revolutions in his third version by excising the dedication's date. His refashioned epilogue of 1850 likewise backtracked from worker-aligned politics. The epilogue to the 1847 and 1848 versions of *The Princess* ran to just over three pages and placed the poet–narrator among the workers exiting the estate gates at day's end – "I and some went out, and mingled with them" (1848: 162) – and suggested that parks such as Sir Walter's should be opened to mechanics and tenants more often: "Why don't these acred Sirs / Throw up their parks some dozen times a year / And let the people breathe?

So thrice they cried, / I likewise" (1848: 163). In 1850, the conclusion featured an extended metapoetic passage in which the college men and visiting women debated what form the tale should take when written down. When the workers and tenants left, the college friends no longer mingled with them. Instead they elevated themselves above the crowd:

> the crowd were swarming now,
> To take their leave, about the garden rails.
>
> So I and some went out to these: we climb'd
> The slope to Vivian-place, and turning saw
> The happy vallies half in light and half
> Far-shadowing from the west, a land of peace . . .
> Trim hamlets; here and there a rustic tower. (1850: 173)

Then they looked across the channel to France. Walter, the son of a Tory Member of Parliament, congratulated himself and his nation on having escaped such anarchy and violence, and identified both those misfortunes with Ida herself. But Tennyson's political retreat was uneven since his poet–speaker urged a more inclusive view: "'Have patience,' I replied, 'ourselves are full / Of social wrong; and maybe wildest dreams / Are but the needful preludes of the truth'" (1850: 174–5). Even with the date removed from the dedication, the new changes to the epilogue registered the imprint of altered social and political conditions on Tennyson's creativity and material production between 1847 and 1850.

The 1850 version again sold out quickly, and Tennyson, still rethinking the poem, generated a fourth iteration; his publisher Moxon placed 2,000 new copies on the market in late March or early April 1851 (Hagen 79). In this new version there was another radical, if much briefer, change. The Prince who pursued Ida and pledged companionable union with her at the end had been effeminate from the very first – "fair in face, / With lengths of yellow ringlets, like a girl" (1847: 13); nor did he hesitate to dress in drag to breach the walls of Ida's university, guarded by robust farmers' daughters. In 1851, after the circulation of 4,500 copies of *The Princess* altogether and audiences' three-year experience of reading about a merely feminized Prince, the Prince was rendered triply emasculated by a new psycho-physiological flaw that Tennyson placed at the center of the Prince's psyche.

After the newly iterated Book I mentioned the Prince's yellow ringlets and blue eyes, the stanza broke to introduce the legend of a

sorcerer and his curse that no members of the Prince's line "should know / The shadow from the substance" and that one of their house would fall in battle. As the Prince then announced, "truly, waking dreams were, more or less, / An old and strange affection of the house. / Myself too had weird seizures" (1851: 14); he then proffered a modern–medieval diagnosis: "Our great court-Galen poised his gilt-head cane, / And paw'd his beard, and call'd it catalepsy" (1851: 15). By this means Tennyson refashioned the Prince just as he had refashioned Ida in 1850. In this fourth version the Prince fell into confusion at key moments due to his disability, first when he was thrust from the gates at the end of Book IV (1851: 102–3) and most crucially when he prepared to enter battle with the Princess's brother Arac and was defeated (1851: 130–4).

Twentieth-century critics seem embarrassed by this strange permutation (as if Rossetti had painted a replica of, say, *Lady Lilith* with a mustache, as Marcel Duchamp did the *Mona Lisa*, or with squinting eyes).[11] I have located no nineteenth-century reviews that discussed this change, most likely because the appearance of *In Memoriam* on June 1, 1850, which led to Tennyson's appointment as poet laureate, captured public attention and better suited the news cycle as a novel literary event. Possibly Tennyson was evening the odds between the claims of masculinity and femininity as he moved from one iteration of the poem to another. If the 1850 version's insistence on the tie between women and maternity constrained possibilities of women's autonomy and independence, the fourth version demonstrated male vulnerability and imperfection. Tennyson added the reference to catalepsy in the poem on January 21, 1851 (Hoge 23), and I suggest that this striking alteration was another form of time signature related to events in Tennyson's life and the concepts of evolutionary reproduction embedded in both *The Princess* and *In Memoriam*. Tennyson's father, George Clayton Tennyson, was epileptic, a disorder sometimes linked in Victorian medical reports to catalepsy (Milner 319), and Tennyson had always been struck by his close resemblance to his parent (R. B. Martin 25). By this point in time, furthermore, one of Tennyson's brothers had been permanently consigned to an asylum. In June 1850 Tennyson married Emily Sellwood, and in January 1851, when he added the reference to catalepsy, she was far along in her first pregnancy.[12] Tennyson himself was now implicated in evolution and reproduction, and his resulting anxieties about his personal evolutionary legacy may have suggested the passage on the Prince's vulnerability to hereditary seizures. Certainly, this new feature was important enough to Tennyson to remain a permanent part of the poem.

Yet again, the fourth version sold well, paving the way for a fifth in February 1853, which introduced less dramatic alterations. Tennyson now added fourteen lines to the prologue that readjusted the work's gender politics once more, further strengthening the claims for female agency. The new lines provided Lilia with a genealogy of female resistance, power, and triumph in her doughty ancestress, who armed herself and issued from the gates to protect her castle when, like Ida in the inset tale, she was "strait-besieged / By [a] wild king to force her to his wish" and fought with "eyes on fire." The fictional medieval chronicle in which the narrating poet found this legend thrice praised her as a noble "miracle of woman" (1853: 3). But audiences' attention had moved on, and though another twelve reprintings would appear from 1853 to 1882, this fifth version was the sole early iteration that took more than a year to sell out (Hagen 79). This change too passed without comment in the press.

Perhaps the most notable feature of Tennyson's replicated narrative poem was how readily audiences accepted altered iterations as a matter of course and continued to purchase copies. Positioning the rapidly evolving *Princess* within a culture of replication makes the phenomenon both more legible and more comprehensible. Certainly, readers took the rapid iterations in stride, despite the poem's radical alterations in little over five years. At the London Library, for example, founded by Thomas Carlyle in 1843, patrons could read an 1847 or an 1851 copy of *The Princess*.[13] How would a patron react who first read the 1847 version, then revisited the poem in its 1851 iteration and discovered that now women singers played an important new role and that the Prince suffered from catalepsy? Which was the "real" Prince, the one familiar from 1847 to 1850, or the new one? Shannon notes how often Tennyson's changes in the poem corresponded to reviewers' complaints or suggestions. Such responsiveness to critical interventions is inimical to authorial prestige in author-centered approaches. Within the context of replication, however, Tennyson's alterations might reasonably be viewed as analogues to an original painter's changes in response to patrons' requests. Tennyson retained the role of creator and original artist throughout and made his changes a source of added value to his readers by their novelty and to himself and his publisher by placing each new version under copyright.

Yet another factor in the ready acceptance of rapidly produced variant but equally authentic copies was, as this collection of essays demonstrates throughout, the audience's very habituation to replication. D. G. Rossetti had not yet begun his remarkable series of replicated paintings, but the notion of legitimate copies that varied

from each other was also popularized by Robert Chambers's *Vestiges of the Natural History of Creation* and by the customary issuing of morning and evening editions, and metropolitan and provincial editions, of newspapers. All were authorized copies produced by the same creative forces but variant in detail. Intellectually, aesthetically, and materially, replication was an essential feature of Victorian England. And we can better understand the replicated *Princess* by seeing its unusual publishing history in this context.

Notes

1. Hundreds of Mechanics' Institutes, designed to make education available to workers, were founded in the nineteenth century, including the forerunner of Birkbeck College, University of London.
2. All citations of Tennyson's poem are given by year and page number.
3. The complete definition of a mathematical iteration given in the *Oxford English Dictionary* is as follows: "The repetition of an operation upon its product, as in finding the cube of a cube; *esp.* the repeated application of a formula devised to provide a closer approximation to the solution of a given equation when an approximate solution is substituted in the formula, so that a series of successively closer approximations may be obtained; a single application of such a formula; also, the formula itself." Using the more conventional literary term, Killham points out that a total of seventeen editions of *The Princess* appeared between 1847 and 1882 – evidence of the poem's popularity (Killham 5).
4. In textual editing associated with Fredson Bowers and many current scholarly editions, the final version is deemed definitive because it represents the author's last intention.
5. Since one of the blank-verse lyrics was one of Tennyson's most highly regarded poems, "Tears, Idle Tears," the Howitts' judgment on that point has not been borne out. As John Addington Symonds remarked in "Blank Verse," "Tennyson has not only created for himself a style in narrative and descriptive blank verse, but . . . he has also adapted this Protean metre to lyrical purposes. Three songs in the *Princess*, 'Tears, idle tears,' 'Now sleeps the crimson petal,' and 'Come down, O maid,' are perfect specimens of most melodious and complete minstrelsy in words" ([Symonds] 639).
6. See, for example, John Forster's unsigned review in the *Examiner* ([Forster] 21) and the anonymous notice in the *Rambler* (Review, March 11, 1848: 210).
7. Further confirmation that the second edition appeared no later than April comes from Coventry Patmore's review of the poem in the May 1848 *North British Review*, a monthly magazine. Patmore worked from a second edition in his review, and copy for the May issue would have had to be written and printed in April.

8. See Lushington, *A Great Country's Little Wars*.
9. Kingsley's was not the only possible response. Elizabeth Cady Stanton, who alluded to *The Princess* in her 1848 feminist "Address" delivered several times after the Seneca Falls convention, was still quoting *The Princess* in 1885. See Harris and Hughes 2:93–4 and Gordon 460.
10. For further details on Tennyson's responses to reviewers in his revisions, see Shannon 98–140.
11. Shannon's remarks are representative: "Another unfortunate after-thought was the introduction, in the fourth edition in 1851, of the 'weird-seizures' . . . [W]ith the 'weird-seizures' of the Prince, he merely added a truly grotesque and disconcerting feature to an already over-burdened structure" (Shannon 130–1). See also Sedgwick 119, 128.
12. Tragically, Emily Tennyson gave birth to a stillborn child, strangled by the birth cord, on April 20, 1851 (R. B. Martin 359; Hoge 26).
13. Online catalog, London Library. Available at <http://www.londonlibrary. co.uk/> (last accessed October 30, 2014).

Works Cited

Altick, Richard. *The English Common Reader: A Social History of the Mass Reading Public, 1800–1900.* 2nd edn. Columbus: Ohio State University Press, 1998.

Barton, Anna. "Long Vacation Pastorals: Clough, Tennyson and the Poetry of the Liberal University." *Victorian Literature and Culture* 42 (2014): 251–66.

Boase, G. C.; revised Lynn Milne. "Lushington, Henry (1812–1855)." *Oxford Dictionary of National Biography.* Oxford: Oxford University Press, 2004, <http://www.oxforddnb.com.ezproxy.tcu.edu/view/article/17211> (last accessed October 19, 2014).

[De Vere, Aubrey.] Review of *The Princess* [1848]. *Edinburgh Review* 90 (October 1849): 388–433.

[Forster, John.] Review of *The Princess. Examiner* (January 8, 1848): 20–1.

Gordon, Ann D., ed. *The Selected Papers of Elizabeth Cady Stanton and Susan B. Anthony: When Clowns Make Laws for Queens, 1880–1887.* New Brunswick, NJ: Rutgers University Press, 2006.

Hagen, June Steffensen. *Tennyson and his Publishers.* University Park: Pennsylvania State University Press, 1979.

Harrington, Emily. "The Measure of Time: Rising and Falling in Victorian Meters." *Literature Compass* 4.1 (January 2007): 336–54.

Harris, Sharon M., and Linda K. Hughes, eds. *A Feminist Reader: Feminist Thought from Sappho to Satrapi.* 4 vols. Cambridge: Cambridge University Press, 2013.

Hoge, James O., ed. *Lady Tennyson's Journal.* Charlottesville: University Press of Virginia, 1981.

Killham, John. *Tennyson and The Princess: Reflections of an Age.* London: Athlone, 1958.

[Kingsley, Charles.] "Tennyson." *Fraser's Magazine* 42 (September 1850): 245–55.

Lushington, Henry. *A Great Country's Little Wars, or, England, Afghanistan and Sinde.* London: John W. Parker, 1844.

Martin, Meredith. *The Rise and Fall of Meter: Poetry and English National Culture, 1860–1930.* Princeton: Princeton University Press, 2012.

Martin, Robert Bernard. *Tennyson: The Unquiet Heart.* Oxford: Clarendon Press, 1980.

Milner, Dr. Ebenezer. "On Catalepsy or Trance." *Edinburgh Medical and Surgical Journal* 74 (October 1850): 318–35.

Mudie's advertisement. *Athenaeum* (February 26, 1848): 201.

[Patmore, Coventry]. "Tennyson's *Poems – The Princess.*" *North British Review* 9 (May 1848): 43–72.

Review of *The Princess. Howitt's Journal* 3 (January 8, 1848): 28.

Review of *The Princess. Rambler* (March 11, 1848): 210–13.

Secord, James A. *Victorian Sensation: The Extraordinary Publication, Reception, and Secret Authorship of Vestiges of the Natural History of Creation.* Chicago: University of Chicago Press, 2000.

Sedgwick, Eve Kosofsky. *Between Men: English Literature and Male Homosocial Desire.* New York: Columbia University Press, 1985.

Shannon, Edgar F., Jr. *Tennyson and the Reviewers.* Cambridge, MA: Harvard University Press, 1952.

Stott, Rebecca. "'Tennyson's Drift': Evolution in *The Princess.*" *Darwin, Tennyson and Their Readers: Explorations in Victorian Literature and Science.* Ed. Valerie Purton. London: Anthem Press, 2013: 13–34.

[Symonds, John Addington.] "Blank Verse." *Cornhill Magazine* 15 (May 1867): 620–40.

Tennyson, Alfred. *The Letters of Alfred Lord Tennyson, 1821–1850.* Ed. Cecil Y. Lang and Edgar F. Shannon, Jr. Cambridge, MA: Harvard University Press, 1981.

——. *The Princess.* London: Moxon, 1847.

——. *The Princess.* London: Moxon, 1848.

——. *The Princess.* London: Moxon, 1850.

——. *The Princess.* London: Moxon, 1851.

——. *The Princess.* London: Moxon, 1853.

Tennyson, Hallam. *Alfred Lord Tennyson: A Memoir.* 2 vols. London: Macmillan, 1897.

Paisley / Kashmir: Mapping the Imitation-Indian Shawl

Suzanne Daly

Introduction

The growing popularity of Indian textiles in the early nineteenth century prompted efforts by British manufacturers to capture a portion of the lucrative import market by imitating Indian shawls, most notably the exquisite patterned shawls of Kashmir. Although imitation-Indian shawls eventually proved enduringly popular and commercially successful, they were frequently derided as inferior in quality and workmanship (Martineau 553). Their ascendancy, driven by changes in taste and technology, was aided by the burgeoning culture of commodity consumption and the work of mid-century design reformers including Henry Cole. It coincided, moreover, with changing perceptions of both India and Scotland, home to the best-known imitation-Indian shawl manufactories.

Although imitation-Indian shawls were initially produced in several British cities, they were soon identified with Paisley, Scotland, where their quality and complexity of design had increased significantly by 1850. In his 1857 history of Paisley, John Parkhill wrote,

> In 1805, the manufacture of shawls was introduced, and gradually became, and continues to be, the staple trade of the town. Imitation shawls of all kinds . . . have at different times been made here, such as thibet and cashmere shawls . . . Paisley may be said to be without a British rival [for imitation-Kashmiri shawls] . . . none but an experienced dealer can distinguish between a French and a Paisley shawl. (Parkhill 94)

The fame of Paisley's Kashmiri-derived shawls was such that "Paisley" quickly became a shorthand term for any imitation-Indian shawl, and

Figure 7.1 Handwoven Kashmiri shawl with classic *boteh* pattern, early nineteenth century.

eventually came to designate the teardrop-shaped design element properly known as the *boteh* (Figure 7.1). My analysis will therefore focus primarily on Paisley and on Kashmiri imitations. In tracing the varied and contradictory Victorian conceptions of Paisley shawls, I will sketch the industry's beginnings, examine the discourse of shawls in periodical literature, and consider the convergence of political, moral, and aesthetic issues touching shawl production in India and Scotland in John Ruskin's work. Analyzing the valences of the terms "imitation" and "copy" in discussions of authenticity, taste, and nationhood raised by Kashmiri and Paisley shawls, I argue, makes visible emergent conceptions of British and Scottish national identity that were inherently imperial in nature.

Victorian writers most frequently referred to Paisley imitations as "imitation-Indian," "imitation-Cashmere," or "Paisley Cashmere." These terms implicitly placed domestically made shawls in opposition to the originals from which they derived: handloomed South Asian shawls, particularly those of Kashmiri origin, which were frequently termed "genuine Cashmeres" (W. M. W. 68; "Cashmere" 514).

Genuineness would therefore seem to derive from the shawls' inherent qualities, specifically the superior patterns, dyes, materials, and spinning and weaving techniques that were unique to Kashmir. In context, however, "genuine" (not unlike the notoriously slippery "authentic") instead connotes a combination of aesthetic, cultural, and monetary value both more subjective and more culturally specific than first appears. Although Kashmiri shawls are certainly genuine in the dictionary-definition sense of "being that which [something] claims to be," it remains true that, like authenticity, genuineness alone neither confers nor automatically translates to aesthetic *or* monetary value, although it is often spoken of as if it does. While Kashmiri shawls were indeed a highly realized form, they were by no means universally valued or admired, and their fortunes as commodities rose and fell over the course of the century.

A further reason to press the genuine / imitation and original / copy binaries is that these concepts translate imperfectly to the realm of craft textile production, in which weavers often produced pairs, multiple copies, or variants of the same patterns. Because Paisley's shawl designs were frequently based on pirated patterns originally commissioned by manufacturers in Norwich or France, Paisley shawls could be termed second-order copies, or "an imitation of the imitation" ("Cashmere Shawls" 315). Questions of originality and aesthetic value are further complicated when a textile's meanings are overdetermined from the start, as with Indian and imitation-Indian shawls, which frequently served as vehicles for conveying a range of cultural and economic concerns. Suchitra Choudhury has recently analyzed the ways in which class politics and conceptions of "taste" inflected discussions of imitation-Indian shawls in nineteenth-century novels and the writings of the design reformers:

> The imitation shawl's association with the lower-middle and the working classes made it an open focus of hostility . . . the industrial enterprise of textile imitation was easily adaptable to the idiom of "emulation" in which the less privileged were seen as competing for social power. (Choudhury 207)

The compound origins of imitation-Indian shawls further allowed them, at different moments, to stand as examples of both good and bad design principles, to suggest the glittering future of industrial capitalism, or to embody fears about Great Britain's ability to compete against India in the textile trade. Arguments about an item of women's clothing, in other words, provide an object lesson in the

ways that competing visions of Britain's identity as an empire and as an exemplar of industrial capitalism subtended Victorian political economies of taste.

Kashmiri Shawls and their Paisley Imitations

Although India produced hundreds of types of shawl, the finest were of Kashmiri origin. Kashmiri shawls, whose popularity with wealthy British women dates to the late eighteenth century, were woven on handlooms using a complex and labor-intensive twill-tapestry method known as *kanikar*. The most valuable specimens, woven in intricate patterns from the highest grade of Asian goats' fleece, could take up to eighteen months to produce (Irwin 2; Karpinski 119; Figure 7.2). Their combination of softness, lightness, and warmth was unrivalled. Initially, European demand spurred the Kashmiris to increase production, and to create plain and simply patterned shawls that could be made more quickly. But first French, then British industrialists capitalized on the demand for Kashmiri shawls by producing imitations domestically (Zutshi 425). As historians have long

Figure 7.2 Handwoven Kashmiri shawl, early nineteenth century.

argued, the nineteenth-century rise of the textile industry in Great Britain to some degree was predicated upon the concomitant decimation of Indian hand-weaving industries. Writing in 1966, Arthur Silver observes,

> Until the Revolutionary Wars at the end of the eighteenth century India had been a source of luxury goods for British home consumption and for her foreign trade. In the course of the late eighteenth and early nineteenth centuries there was a complete reversal of this relationship. From a source of trade goods India became a market for Britain's manufactures and a source of raw material for her expanding industries. (Silver 26)

While Kashmiri shawls remained popular in Britain through the 1860s, Silver's narrative otherwise accurately describes Kashmir's shawl industry, which declined as the production of imitations exploded. British imitations may have outnumbered Kashmiri originals by 1810 (Ribeiro 125), and the French had begun to produce high-quality imitations on Jacquard looms a few years earlier. In Britain, Edinburgh produced the first imitation-Kashmiri shawls, followed by Norwich, which had twenty manufacturers by 1800 (Clabburn 244–8). Paisley, previously a producer of silk and muslin, came next, and quickly became competitive because its highly skilled weavers could imitate many types of patterned Indian shawl on drawlooms, a form of handloom. Although capable of producing more intricate patterns than the power looms then in use, drawlooms could not replicate the more complex Kashmiri designs (Harrison 1949; Figure 7.3).

Early on, Paisley manufacturers' notoriety for stealing patterns from the Norwich manufacturers, who produced higher-quality imitation-Kashmiri shawls, contributed to their unsavory reputation (Karpinski 121). Paisley shawls' inferiority in texture and design to both their Norwich and their Indian forebears soon became an article of faith, even to supporters of the industry, and that reputation lingered even as quality improved (Figure 7.4). Writing in 1852, Harriet Martineau asserted that by working from examples of Kashmiri shawls, "the manufacturers of Norwich and Paisley devise such beautiful things that, but for the unaccountable and unrivalled superiority of the Orientals in the production of this particular article, we should be all satisfaction and admiration" (Martineau 553). (Martineau's "unaccountable" signals a chauvinistic astonishment, frequently expressed in commentaries on the Great Exhibition, that British commodities were not inevitably superior.) Despite such appraisals, the perception that Paisley shawls were marred by garish

Figure 7.3 Woven pieced shawl, probably made in Paisley between 1827 and 1833.

Figure 7.4 Woven wool and silk shawl manufactured by James Barton, Paisley, c. 1826.

colors, crude designs, and coarse textures remained entrenched, and the ability to demonstrate one's refinement by distinguishing a Kashmiri shawl from a Paisley became a popular trope, thanks in part to the works of Walter Scott. In *St. Ronan's Well*, an uncultured ship captain's widow naively asserts that "there are braw shawls made at Paisley, that ye will scarce ken fra foreign." A nabob retorts, "'a blind man could tell [Paisley shawls from Kashmiri] by the slightest touch of his little finger'" (Scott 1871: 2.22). Conversely, the humorous closing frame narrative of Scott's 1831 novella *The Surgeon's Daughter* features an old woman wearing a "rich Kashmire" who mocks her young companion's claim that "the imitation shawls now made at Paisley [are] not to be known from the actual Country shawl, except for some inimitable cross-stitch in the border." "It is well," the old woman responds drily, "that there is some way of knowing a thing that cost fifty guineas from an article that is sold for five; but I venture to say that there are not one out of ten thousand that would understand the difference" (Scott 2003: 287). This passage, a bit of comic business in which the self-important narrator, Chrystal Croftangry, is yet again derailed by his auditors, also offers a subtle gloss on the central story, in which the ambitious and amoral Richard Middlemas deserts his virtuous Scottish fiancée and goes to India to make his fortune. There he concocts a scheme to lure the fiancée to India so he can sell her to an Indian rajah (a fictionalized Tipu Sultan). For his gross violations of both British and Indian mores, however, Richard is summarily executed by the rajah's father (a fictionalized Hyder Ali), who has him trampled by an elephant.

The shawl passage within the frame narrative, by alluding to both Richard's ignorance of India and his inability or refusal to value his fiancée according to her true worth, raises questions about the knowledge of value and the value of knowledge in an imperial context (while obliquely comparing the fiancée to a Kashmiri shawl). While Scott's somewhat contradictory truisms regarding shawls – that anyone could effortlessly tell Kashmiri shawls from Paisley and that most people could not – did not originate with him, he undoubtedly helped to popularize them. For the next several decades, magazine articles on Kashmiri or Paisley shawls would repeat one or both of these claims in some form. An 1865 *Once a Week* article titled "Cashmere Shawls: Of what are they Made?" stated that "every lady who counts amongst her accomplishments the art of shopping" might easily distinguish genuine from imitation-Kashmiri shawls (W. M. W. 68). Yet an unsigned 1858 article titled "Cashmere Shawls and Where They Come From"

asserted that British women were being widely deceived by merchants selling imitations as the genuine article (313). Both truisms ultimately denigrate Paisley shawls, by suggesting either that Paisleys were vulgar imitations, or that the likeness between Paisley and Kashmiri shawls was so strong, and the fraudulent labeling of Paisley shawls so prevalent, that Paisleys might justifiably be labeled counterfeits. It is impossible to say whether Paisley shawls were produced with the intent to deceive; certainly, no manufacturer ever conceded such intent.

The shawl merchants were, apparently, a different case. Michelle Maskiell notes, "With so many marketing efforts to mislead the unwary and with astronomical prices charged for shawls made in Kashmir, the verification of Kashmiri shawl 'authenticity' became ever more acute for wealthy consumers" (Maskiell 48). Once Kashmiri shawls entered the British market as commodities, their aesthetic value as singular objects artfully handcrafted from rare materials was necessarily translated into monetary value. To the degree that Paisley imitations could be passed off as genuine Kashmiri shawls, they posed a threat to both kinds of value. Yet wealthy women represented a tiny minority of the population, so over-emphasizing these anxieties distorts the picture to some degree.

Criticisms ultimately proved no impediment to the Paisley shawl industry's economic success. It flourished between 1820 and 1840, and although devastated by an economic crisis in 1841–3 that bankrupted many manufacturers (Dickson and Clarke 49; Brown 221–3), Paisley's manufactories rebounded and once again became profitable, in part by mass-producing a wider variety of imitation-Indian shawls to be sold at different prices. Technological innovations improved Paisley's fortunes both aesthetically and economically: Jacquard looms replaced Paisley's drawlooms in the 1830s and 1840s, enabling the swifter production of more complex and therefore more costly designs. Aiding this effort were competitions and prizes such as those announced in the 1826 *Transactions of the Society Instituted at London for the Encouragement of Arts, Manufactures, and Commerce*:

> *Shawls of Cachemire Wool.*
> 236. For a shawl made of Cachemire wool, and which shall be the best imitation of the real Indian shawls made from the same material;— *the Gold Medal, or Thirty Guineas . . .*
> *Shawls in imitation of Cachemire.*
> 237. To the person who shall manufacture, of any material, except Cachemire wool, and produce to the Society a shawl equal in beauty, and in fineness of texture, to the best Indian shawls made of Cachemire wool;—*the Gold Medal, or Thirty Guineas.* (*Transactions* xxx)

That the industrialists who supported these contests sought both to perfect the spinning, dyeing, and weaving of Kashmiri goats' fleece, and to imitate Kashmiri shawl fabric closely enough to capture the upper end of the imitation-Kashmiri market, suggests the height of that market's perceived value and the intensity of the competition for it.

The story of Queen Victoria's Paisley shawls suggests how broad the imitation-Indian shawl market had become by 1840. During the economic crisis of 1841–3, the Queen sought to encourage the trade by purchasing eighteen better-quality Paisley shawls, which ranged in price from £2 10s. to £12 10s. Paisley shawls were becoming ubiquitous (Lochrie 95–111); according to Valerie Reilly, "By the 1850s the majority of shawls available in any [British] draper's shop would have been made in Paisley" (Reilly 70). In the 1860s, Paisley found a new market by mass-producing cotton shawls with printed, as opposed to woven, patterns, which sold for as little as 3s 6d. Imitation-Indian shawls were now within the reach of working-class women (Reilly 25–6, 42).

The usurpation of its shawl industry devastated Kashmir culturally and economically, and it is historical fact that Europeans specifically intended to imitate Kashmiri shawls and that these acts of appropriation had terrible consequences. From this perspective, the existence of originals and copies is undeniable. When viewed as material objects, however, Paisley and Kashmiri shawls have little in common. The Paisley shawl industry attained market dominance largely through innovations in spinning, weaving, and printing processes that enabled the mass production of cheaper shawls and refined the quality of higher-priced shawls. This rapid evolution increased the differences between Paisley and Kashmiri shawls. Paisley's ascendancy was founded not only on new technologies but also on the new forms of labor to which those technologies gave rise. It was true from the industry's beginnings that "weaving a shawl" did not mean quite the same thing in Paisley as it did in Kashmir. The various blends of silk, cotton, and domestic sheep's wool of which Paisley shawls were woven differed significantly from Kashmiri goats' fleece. Paisley's looms were unlike Kashmir's, and Paisley's machine-spun yarn and fabric-printing processes represented new combinations or hybridizations of tools and machines. Paisley's pirated patterns, which provoked such outrage among the Norwich manufacturers, were created by British designers. Mid-century Paisley shawls were thus in some real sense at once imitations and originals, like replicas in art or literature (see chapters by Codell and Hughes in this volume), a category or genre of their own; it is therefore not surprising

that they shortly began to be collected and displayed in exhibitions celebrating the burgeoning arts of industry in Great Britain.

In claiming that Paisley shawls were a unique type of textile, I wish neither to restate a critical commonplace regarding the instability of hierarchical categories nor to assert an equivalence of quality between Paisley and Kashmiri shawls. Paisley shawls were conceived as a derivative form, and it is fair to say that their materials and workmanship were inferior to those of handloomed Kashmiri shawls. Yet Victorian England was awash with copies, replicas, and imitations of every sort, professional and amateur, in painting, sculpture, architecture, and the decorative arts, and these copies were by no means universally reviled, even by cultural authorities. In terms of the retail market, sales records suggest that the elites who sought to browbeat the public into rejecting mass-produced goods such as Paisley shawls enjoyed little success. Their harangues were ignored, or more likely unheard altogether, by the vast majority of shawl purchasers, to whom such culturally loaded concepts as authenticity, uniqueness, and purity of design held little relevance (Reilly 42).

Aesthetic and Economic Critique

The question of quality that dogged the Paisley shawl industry related to broader concerns about the skill and education of Great Britain's workers and the caliber of its manufactured goods. One solution that emerged in the early 1820s was adult education, either through Mechanics' Institutes, which were intended to increase the technical skills and general knowledge of artisans and working men, or through schools of art and design for industrial workers. Proponents frequently framed their project in explicitly nationalist terms: in quality of workmanship and design, Great Britain's industrial products should be superior. But they understood that many British products, including textiles, lagged behind. Testifying before Parliament in 1835, Charles Toplis, Vice-president of the London Mechanics' Institute and Director of the Museum of National Manufactures, explicitly linked workers' skill and talent with taste:

> Our national greatness rests on the skilled industry of our people; it must be a part of sound domestic policy to foster . . . the talent which gives currency and importance to our indigenous products, and draws within the vortex of British manufacture the raw material of other climes, to be spread again over the world, enhanced in value by the labour, skill and taste of British artisans. (Toplis 116)

Anticipating Silver's trade-reversal model, Toplis figured Great Britain as a vortex of industrial and merchant capitalism sucking in "raw material" from across the globe to transform and recirculate; the appropriation of British India's indigenous industries, coupled with the pursuit of profit through an ongoing process of primitive accumulation, was imagined as an inevitable process in which British workers alone possessed the "skill and taste" to "enhance" India's raw material.

Yet Toplis's immediate aim, which prefigured the concerns of the mid-century design reformers, was to convince Parliament that funding schools of design for British workers served the national interest. Because "some practical skill in the arts of design is either . . . needful, or . . . useful" for artisans and mechanics alike, he argued, "the formation of schools of elementary science, of academies for the arts of design, and of museums [of industrial arts] . . . cannot fail to advance . . . both the fine and useful arts of the country" (Toplis 116). British workers, this rhetoric implies, needed extensive education in order to match their Indian counterparts. The means by which the Mechanics' Institutes and schools of design strove to impart "taste" included public exhibitions of industrial products, including textiles. Paisley was part of this movement; its School of Design opened in December 1848 with 109 students (Brown 317). Its founders argued that Paisley was well suited for such an institution, as it "contains a population of 60,000, chiefly employed in the manufacture of shawls, muslin, and other fancy figured fabrics . . . in all of which the art of design is of the utmost importance" (Brown 316). This statement gives a sense of the textile industry's centrality to the town and, therefore, Paisley's vulnerability should anyone usurp its market. The desire to improve was driven not only by the desire for profit but also by fear of being left behind.

In his 1829 essay "Signs of the Times," Thomas Carlyle decried "the Mechanical Age . . . the Age of Machinery" (Carlyle 100) brought into existence by new forms of production and labor. It was now undeniable that mechanized factories were decisively reshaping British social and economic relations, and, to some minds, corrupting British taste as well. Domestic factory production, celebrated as beneficial to the nation by proponents of industrialism, including Martineau and Andrew Ure, was elsewhere decried as deleterious to workers, consumers, and British culture in general (Ketabgian 1–14). From this period virtually every discussion of Indian and Paisley shawls' aesthetic qualities resonated with larger debates on mechanization, mass production, imperial politics, or national

identity. The battle lines were not cleanly drawn, however: those who most valued handmade Indian shawls on aesthetic grounds often promoted the production of domestic imitations, while critics of the factory system's human costs or shoddy goods were unlikely to embrace foreign competition or to consider the plight of Kashmir's weavers. To champion one type of shawl was not necessarily to reject the other, and vice versa.

The design reformers in some sense mediated between pro- and anti-factory factions, as they strove to improve the quality of factory-made commodities by teaching design principles gleaned from art, architecture, and handmade craftwork, including Indian textiles. As recent work by art historians Tim Barringer, Julie Codell, and Lara Kriegel has shown, the valorization of Indian art and design in the writings of design reformer Henry Cole and his collaborators, particularly Richard Redgrave and Owen Jones, was no disinterested analysis, but part of a project to aid British economic and industrial progress by improving the "arts of industry" and instructing public taste (see Barringer Ch. 5; Barringer et al; Codell 2009; Codell and Macleod; Kriegel). Cole's efforts to promote and improve British industrial design included organizing the 1851 Crystal Palace Exhibition, establishing the Museum of Ornamental Art, and co-founding, with Richard Redgrave, the *Journal of Design and Manufactures*.

As both Kriegel and Choudhury have documented, the writings of Cole and his cohort on Kashmiri shawls were not entirely celebratory, although Kriegel records several instances in which they either championed Indian art and design or suggested that British manufacturers could profit from its study (Choudhury 193–200; Kriegel 140–4). Objectors framed their arguments in moral as well as aesthetic terms: to celebrate Indian textiles, detractors claimed, was to align oneself with inferior design as well as elitism, despotism, and infidelity to nature (Kriegel 143–4; Sloboda; Crang and Ashmore 9; Driver and Ashmore; Prasch). Codell notes that such critics were the "minority" (Codell 2009: 228), but it was a minority to whose views no less than John Ruskin gave voice.

Ruskin stands as perhaps the best example of a profoundly influential mid-Victorian critic whose work traverses aesthetics and political economy, critiquing art, design, and the division of labor through recourse to such concepts as morality and truth. Although Ruskin wrote little about shawls specifically, his persistently multivalent analyses of art, ethics, and labor, informed by a fairly stable set of core beliefs, shaped both the terms and the tenor of future debates

(see Codell 2008: 27–9, 34–5). The moral element of his writings, inextricable from his fierce opposition to the modernizing, mechanizing aspects of Victorian culture, serves as a through-line connecting the realms of aesthetics, economics, and culture.

Ruskin's "opposition to modernity," moreover, was fundamental to his critical idiom (Löwy and Sayre 128, 129). His most famous defense of handcraft on aesthetic as well as ethical grounds appears in "The Nature of Gothic" (Ruskin, *Stones of Venice* [vol. 2] *Works* 10: 180–269): "You must either make a tool of the creature [by demanding mechanistic perfection], or a man of him [by allowing him scope for creativity] . . . You cannot make both" (*Stones of Venice* 192). Ruskin was equally unrelenting on imitation, calling it degraded. "Never encourage imitation or copying of any kind," he writes, "except for the sake of preserving records of great works" (*Stones of Venice* 197). Characteristically, these statements refer to painting and architectural ornament and not specifically to textile design. Ruskin was unlikely, however, to have viewed the craftsmanship of any shawl-weavers favorably. In his withering critique of Gaspar Poussin's "View Near Albano" in *Modern Painters*, weaving exemplifies activity devoid of creative spirit; Poussin's trees, Ruskin writes, are painted with "about as much intelligence or feeling of art as . . . a weaver [has] in repeating an ornamental pattern" (Ruskin, *Modern Painters*, *Works* 3:591). Ruskin saw no contradiction in celebrating the creativity and craftsmanship of medieval artisans while condemning contemporary handloom weaving. In Paisley, as elsewhere, most handloom weaving was performed in factory settings by workers who, although highly skilled, had little say in what they produced, and whose skill and labor power were themselves commodities. For Ruskin, repetition in the contemporary context was nothing more than the mindless copying of patterns radically unmoored from nature.

Yet echoes of Ruskin's paeans to handcraft may be heard in Matthew Blair's elegiac history of the Paisley drawloom weavers, written to accompany a 1901 exhibit of Paisley shawls in Glasgow. Asserting a "deterioration" among contemporary factory laborers in contrast to the educated, highly skilled Paisley weavers of former days, Blair, the head of Glasgow's Weaving, Dyeing, and Printing College, wrote,

> Handicraft is an education. The hand worker has scope to exercise taste, invention, harmony, art, and genius, in a way that the worker who simply tends a machine can never have. He has therefore opportunities of being a far more cultured man, and this is well illustrated in the weavers of Paisley. (Blair 45–6)

Although Ruskin was unlikely to have concurred with this encomium, or with Blair's characterizing drawloom weaving as "handicraft," his view of the Scottish people was distinctly favorable. Scotland assumed a prominent place in Ruskin's writing, but it was a highly selective Scotland of rough, poetic places and people, drawn from life but filtered through his childhood memories and the works of Walter Scott. Scottish manufactories and industrial workers formed no part of it. Paisley had long been known for its radicalism and union activity; its weavers were reputed to be skilled, educated, and politically contentious in equal measure (Parkhill 88–90, 92; Dickson and Clarke 54). These qualities Ruskin ignored, focusing instead on the Scottish "national character," the existence of which was axiomatic to the British. Although Scotland had technically ceased to be an independent nation with the 1707 Acts of Union, English readers avidly consumed works that emphasized Scottish difference, such as Edward Bannerman Ramsay's enduringly popular *Reminiscences of Scottish Life and Character*. Full of rough-hewn, eccentric characters, *Reminiscences* went through twenty-one editions between 1858 and 1872.

Such characterizations were not limited to the realm of humorous popular literature. Even in Ruskin's work, Scotland often appears through a romanticized and sentimental haze. The index to Ruskin's *Complete Works* lists hundreds of references to Scotland, and the entry on "National character, history, etc." alone gives thirty-eight entries spanning twelve volumes. The descriptors are telling: loyalty, independence, intellect, fidelity, persistence (Index, *Complete Works of Ruskin*, Works 39:536–7).

Although Ruskin's autobiographical writings account for many entries on Scotland, *Fors Clavigera: Letters to the Workmen and Labourers of Great Britain* contains a total of fifteen references to Scottish national character, as well as scores of other references to Scotland and its people. Clearly, Scotland held didactic as well as personal significance for Ruskin, as evidenced in the 1858 lectures published as *The Two Paths*. In the inaugural lecture, Ruskin argued that the superiority of Europe's arts to India's could be demonstrated by elucidating "the relations *between art and mental disposition* in India and Scotland" (Ruskin, *Two Paths*, Works 16:265; emphasis mine). Indian art and design, he claimed, had no place in schools of design (*Two Paths* 261) and should not be celebrated by the likes of "Mr. Redgrave and Mr. Cole" (*Two Paths* 265). Although highly developed, Indian art and design were corrupt; they provided pleasure but failed to convey truth or represent "natural fact[s]" (*Two Paths* 265). This was because they were the

productions of a "race rejoicing in art, and eminently and universally endowed with the gift of it" (*Two Paths* 262), yet defined by "treachery, cruelty, cowardice, idolatry, bestiality – whatever else is fruitful in the work of Hell" (*Two Paths* 263). Writing the English out of the Uprising of 1857, Ruskin used textiles metonymically to contrast Indian rebels' barbarity (accounts of which were later disproved) with the "moral character" of the Scots, a people "incapable of" art but possessed of "faith, courage, self-sacrifice, purity, and piety, and whatever else is fruitful in the work of Heaven" (*Two Paths* 263). "We are thus urged naturally to inquire," he wrote, "whether those rude chequers of the tartan, or the exquisitely fancied involutions of the Cashmere, fold habitually over the noblest hearts?" (*Two Paths* 262).

Patrick Brantlinger aptly labels this rhetoric "racist hysteria" (Brantlinger 470), and as such it problematizes Ruskin's habit of linking taste and morality. Significantly, though, Ruskin compared the "Cashmere" not to its well-known Paisley imitations but to the tartan, a textile so closely associated in the eighteenth century with Highland Jacobites that it was banned by the British government until 1782 in the aftermath of the '45 Rebellion. Ruskin's contrast of Indian savagery and Scottish valor exemplified the extent to which Scotland's reputation had been recuperated by mid-century. No longer bloodthirsty, treasonous rebels who would gladly strike at the heart of the British monarchy itself, the Scots were reimagined as a rugged, independent, and deeply moral people whose lack of artistry itself constituted a virtue. It is understandable that Ruskin declined to offer the Paisley imitation-Kashmiri shawl as emblematic of the Scottish character. That he could offer the tartan in its place, however, suggests that the discursive terrain around rebellion and treason had shifted dramatically in the aftermath of the Uprising, and that the very existence of British India had altered the ways that England imagined the Scottish people and the material objects with which they were most closely associated.

Certainly, Walter Scott's influence on British perceptions of Highlanders contributed to this shift (Morrison 47–64), as did the banal fact that the Scots were seen to be less alien than England's Indian subjects, but Scotland's recuperation is bound up as well with its crucial role in the making of the British Empire. Over the past twenty-five years, numerous scholars have demonstrated that, from the early eighteenth century, Scots were disproportionately represented in imperial endeavors, particularly the shipping trade and the military (e.g. Colley 124–32; Devine 2008: 102–6; Mackenzie

714–39; Mackenzie and Devine; McGilvary; Spiers). As T. M. Devine observes, "the reputation of the Scots as the hard men of empire was no myth . . . the Scottish nation reveled in its status as the martial spearhead of the empire, with the Highland regiments as the cutting edge" (Devine 2011: 42). Ruskin referred specifically to this aspect of Scottish culture, telling his readers, "Among all the soldiers to whom you owe . . . your avenging in the Indies, to none are you bound by closer bonds of gratitude than to the men who have been born and bred among those desolate Highland moors" (*Two Paths* 263). In singling out the Highland Scots as the group to which all of Great Britain should feel gratitude, Ruskin tightened the metonymic connection between the tartan and the Highland regiments as the "hard men of empire"; both were rough, coarse, and unartistic, but also strong and serviceable. This iconography had a long history, dating at least to Sir David Wilkie's famous painting of General Sir David Baird of the 73rd Highlanders standing over the vanquished body of Tipu Sultan, the son of Baird's former captor Tipu Sultan, at the storming of Srirangapatna (then Seringapatam), which closed the third Anglo-Mysore war in 1799. In this earlier representation of Scottish valor vanquishing Indian savagery, the soldier to Baird's left can clearly be seen wearing the same McLeod Harris tartan kilt that would be worn by the 73rd in 1858 when they were deployed to India to quell the Uprising.

Ruskin's claim that barbarity is woven indelibly into India's character and its textiles alike presumed that textiles (or any craft production) reflect their cultures of origin in a uniform and uncomplicated way, and that textiles' design and materials congeal or condense essential truths about those cultures. The design reformers whom Ruskin opposed in *The Two Paths* subscribed to a different nationalist mission: to invigorate British arts of industry with "new blood" through industrial–cultural exogamy. They sought new ideas and new models with which to illustrate design principles and were considerably less concerned with analyzing art or craft as a reflection of its culture or a barometer of its culture's value (and values). Beyond their philosophical or ideological underpinnings, the two approaches differ in another important sense. The design reformers were not unlike the German philologists of the period who sought to trace the convergences, borrowings, and divergences of world languages through time and space. Redgrave's exhibitions, as well as works such as Owen Jones's *The Grammar of Ornament*, considered design elements in a somewhat analogous manner, uncovering evidence of borrowing and cross-pollination throughout the

Mediterranean world and across South and East Asia (Jones 66). Ruskin's concern with the morality of art led him to reject hybridizing approaches, instead positing a direct relation "between art and mental disposition" in all culture (*Two Paths* 265).

In valorizing the tartan, however, Ruskin neglected to consider that tartans were no longer precisely what he assumed them to be: by 1858, tartans had been mass-produced in Paisley for some time and constituted a significant percentage of its trade. An unsigned 1847 article in *Sharpe's London Magazine* titled "The Shawl Manufacture of Paisley" described a vast room in Robert Kerr's factory containing numerous looms "in full operation upon tartans" (291), which were "one and all, fine in texture to an extreme" (293). A decade later, Parkhill noted that in Paisley, "Next in importance to the Indian imitation shawls, are tartan and woollen shawls, which has [sic] reached to be a large trade in the course of a very few years" (Parkhill 94). In other words, imitation-Kashmiri shawls and tartans, Ruskin's rough-hewn Scottish national textile, now shared a place of origin: the Paisley manufactory. With this convergence, Ruskin's evaluation of the tartan begins to unravel, as the factory replication of tartans complicates any attempt to associate them with rugged Highlanders. Contrasted with handloomed specimens, Paisley's soft-textured factory-made tartans had as much reason to be called imitations as the other replica shawls produced in Kerr's factory. Yet if we define tartans as wool garments woven in Scotland from specific patterns, then Kerr's tartans were as authentic as any others. It is striking that women's tartan shawls gained popularity throughout Great Britain just as the tartan became more strongly identified with imperial glory than with Highland lawlessness. Imitation-Indian and tartan shawls thus refract both England's imperial identity and the cultural identities it imposed on its subjects.

In 1882, William Morris, socialist and avatar of the Arts and Crafts movement, expressed a view of Indian art that radically reframed the questions of aesthetics, morality, and labor raised by Ruskin. The design reformers, he noted, had promoted the study of Indian arts just as "the advance of western conquest and commerce" (Morris 49) was decimating them. Morris observed, "Englishmen in India are . . . actively destroying the very sources of that education . . . all the famous and historical arts . . . [are] to be thrust aside for the advantage of any paltry scrap of so-called commerce" (49–50, 51). For Morris, artistic genius belonged to India, destructiveness (intentional or otherwise) to British imperialists; "real" art, moreover, conveyed neither an artist's nor a culture's morality but the happiness derived from pleasure in one's work (58).

Conclusion: *St. Ronan's Well*

While the periodical press showed interest in both Kashmiri and imitation-Kashmiri shawls, the latter appeared far less frequently in canonical nineteenth-century novels than did the former. In this regard, Scott's *St. Ronan's Well* would seem to be a notable exception but for one problem: the plot turns on an apparently minor conflict over a genuine Indian shawl. The "imitashion" shawl is offered by the guileless widow Mrs. Blower to Clara Mowbray because Clara has lent her valuable Indian shawl, a gift from her brother, to her neighbor Lady Penelope, who has no intention of returning it. Dining among her betters, Mrs. Blower notices that Clara is without her much remarked-upon shawl and offers one of her own in its place, asking

> "why Miss Clara Moubrie didna wear that grand shawl she had on at the play-making, and her just sitting upon the wind of a door. Nae doubt it was for fear of the soup, and the butter-boats and the like;—but *she* had three shawls, which she really fand was ane ower mony—if Miss Moubrie wad like to wear ane o' them—it was but imitashion to be sure—but it wad keep her shouthers as warm as if it were real Indian" . . .
>
> "Much obliged, Mrs. Blower," said Mowbray, unable to resist the temptation which this speech offered; "but my sister is not yet of quality sufficient, to entitle her to rob her friends of their shawls."
>
> Lady Penelope coloured to the eyes. (Scott 1871: 2.54)

As Choudhury observes, this passage displays Mrs. Blower's "mercantile mindset" and "*nouveau riche* status," to the sardonic amusement of her dining companions (Choudhury 202). But the scene holds further significance: it advances the plot by providing the motive for revealing a secret, thus far withheld, that holds the key to the entire story. The revelation, moreover, has deadly consequences. In retaliation for Mowbray's slight, and for his making it impossible through his public mockery for her to retain possession of the coveted shawl, Lady Penelope circulates the story of Clara Mowbray's long-ago secret midnight wedding, at which she was tricked into unknowingly marrying her fiancé's half-brother. Shattered, Clara dies soon afterward, devastating her still-faithful fiancé and further unraveling the fragile social order of St. Ronan's well. While the "imitashion" shawl provides a moment of comedy at the expense of a socially inferior minor character, its central purpose is to provide narrative momentum by pointing out the absence of, and then failing to substitute for, the genuine article. Although having Mrs. Blower's kindly

intended offer of her third Paisley shawl lead to the death of a major character may seem overwrought on Scott's part, nineteenth-century fiction provides countless other examples of material objects that carried contradictory and overdetermined meanings assuming outsize thematic, structural, or narrative significance. Seen in this context, the passage reminds us that although "genuine" Kashmiri shawls appeared far more frequently in Victorian fiction, their Paisley counterparts held equally complex and contradictory cultural meanings. The two shadow one another through Victorian writing, put to many uses but inevitably vexing the terms original, copy, unique, mass-produced, handcrafted, factory-made, domestic, foreign. The cultural, geographical, and definitional contradictions of Paisley / Kashmir / paisley / cashmere carry forth into the present, in which Kashmiri and Paisley shawls survive enshrined in museums, together and separately, their precise patterns, colors, and textures virtually impossible to reproduce.

Works Cited

Barringer, Timothy. *Men at Work: Art and Labour in Victorian Britain.* New Haven, CT: Yale University Press, 2005.

——, Geoff Quilley, and Douglas Fordham, eds. *Art and the British Empire.* Manchester: Manchester University Press, 2007.

Blair, Matthew. *The Paisley Shawl and the Men who Produced It.* Paisley: Alexander Gardner, 1904.

Brantlinger, Patrick. "A Postindustrial Prelude to Postcolonialism: John Ruskin, William Morris, and Gandhism." *Critical Inquiry* 22.3 (Spring 1996): 466–85.

Brown, Robert. *The History of Paisley, from the Roman Period down to 1884.* Vol. 2. Paisley: J. and J. Cook, 1886.

Carlyle, Thomas. "Signs of the Times." *Critical and Miscellaneous Essays.* Vol. 2. Boston: James Munroe and Co., 1838: 143–71.

"Cashmere." *The New American Cyclopedia: A Popular Dictionary of General Knowledge.* Ed. George Ripley and Charles M. Dana. Vol. 4. New York: D. Appleton, 1863.

"Cashmere Shawls and Where They Come From." *The Eclectic Magazine of Foreign Literature, Science, and Art* 45 (November 1858): 311–15.

Choudhury, Suchitra. "'It Was an Imitashon to be Sure': The Imitation Indian Shawl in Design Reform and Imaginative Fiction." *Textile History* 26.2 (2015): 189–212.

Clabburn, Pamela. "British Shawls in the Indian Style." *The Kashmir Shawl and its Indo-French Influence.* Ed. Frank Ames. Woodbridge: Antique Collector's Club, 1997: 237–50.

Codell, Julie F. "From Culture to Cultural Capital: Victorian Artists, John Ruskin, and the Political Economy of Art." *The Political Economy of Art: Making the Nation of Culture.* Ed. Julie Codell. Madison, NJ: Fairleigh Dickinson University Press, 2008: 27–39.

——. "Vulgar India from Nabobs to Nationalism: Imperial Reversals and the Mediation of Art." *Victorian Vulgarity: Taste in Verbal and Visual Culture.* Ed. Susan David Bernstein and Elsie Michie. Farnham: Ashgate, 2009: 223–39.

Codell, Julie E., and Dianne Sachko Macleod, eds. *Orientalism Transposed: The Impact of the Colonies on British Culture.* Houndmills, Basingstoke: Ashgate, 1998.

Colley, Linda. *Britons: Forging the Nation 1707–1837.* New Haven, CT: Yale University Press, 1992.

Crang, Philip, and Sonia Ashmore. "The Transnational Spaces of Things: South Asian Textiles in Britain and *The Grammar of Ornament.*" *European Review of History* 16.5 (2009): 655–78.

Devine, T. M. *Scotland and the Union, 1707–2007.* Edinburgh: Edinburgh University Press, 2008.

—— "Enlightening Strikes: The Refurbished National Museum of Scotland reveals how a Small Nation Helped to Reshape the Modern World." *New Statesman* (August 22, 2011): 42–3.

Dickson, Tony, and Tony Clarke. "Social Concern and Social Control in Nineteenth Century Scotland: Paisley 1841–1843." *The Scottish Historical Review* 65.179, Part 1 (April 1986): 48–60.

Driver, Felix, and Sonia Ashmore. "The Mobile Museum: Collecting and Circulating Indian Textiles in Victorian Britain." *Victorian Studies* 52.3 (2010): 353–85.

Harrison, Edward S. "The Paisley Shawl" (1949), <http://www.tartansauthority.com/resources/archives/the-archives/harrison/the-paisley-shawl/> (last accessed September 29, 2017).

Irwin, John. *The Kashmir Shawl.* London: Her Majesty's Stationery Office, 1973.

Jones, Owen. *The Grammar of Ornament.* London: Day & Sons, 1856.

Karpinski, Caroline. "Kashmir to Paisley." *The Metropolitan Museum of Art Bulletin* n.s. 22.3 (November 1963): 116–23.

Ketabgian, Tamara. *The Lives of Machines: The Industrial Imaginary in Victorian Literature and Culture.* Ann Arbor: University of Michigan Press, 2011.

Kriegel, Lara. *Grand Designs: Labor, Empire, and the Museum in Victorian Culture.* Durham, NC: Duke University Press, 2007.

Lochrie, Maureen. "The Paisley Shawl Industry." *Scottish Textile History.* Ed. John Butt and Kenneth Ponting. Aberdeen: Aberdeen University Press, 1987: 95–111.

Löwy, Michael, and Robert Sayre. *Romanticism against the Tide of Modernity.* Trans. Catherine Porter. Durham, NC: Duke University Press, 2001.

McGilvary, George K. *East India Patronage and the British State: The Scottish Elite and Politics in the Eighteenth Century.* London: I. B. Tauris, 2008.

Mackenzie, John M. "Essay and Reflection: On Scotland and the Empire." *International History Review* 15 (1993): 714–39.

Mackenzie, John M., and T. M. Devine, eds. *Scotland and the British Empire.* Oxford: Oxford University Press, 2011.

Martineau, Harriet. "Shawls." *Household Words* 5.127 (August 28, 1852): 552–6.

Maskiell, Michelle. "Consuming Kashmir: Shawls and Empires, 1500–2000." *Journal of World History* 31.1 (2002): 27–65.

Morris, William. *Hopes and Fears for Art.* New York: Longmans, Green, & Co., 1901.

Morrison, John. *Painting the Nation: Identity and Nationalism in Scottish Painting, 1800–1920.* Edinburgh: Edinburgh University Press, 2003.

Parkhill, John. *A History of Paisley.* Paisley: Robert Stewart, 1857.

Prasch, Thomas. "'A Strange Incongruity': The Imaginary India of the International Exhibitions." *Nineteenth-Century Contexts* 34.5 (2012): 477–91.

Ramsay, Edward Bannerman. *Reminiscences of Scottish Life and Character.* 21st edn. London: Gall and Inglis, 1871.

Reilly, Valerie. *The Paisley Pattern: The Official Illustrated History.* Layton, UT: Peregrine Smith, 1989.

Ribeiro, Aileen. *The Art of Dress: Fashion in England and France, 1750–1820.* New Haven, CT: Yale University Press, 1995.

Ruskin, John. *The Complete Works of John Ruskin.* Vols. 3, 5, 10, 16, 39. Ed. E. T. Cook and Alexander Wedderburn. London: George Allen, 1903–12.

Scott, Walter. *St. Ronan's Well* [1823]; rpt Boston: James R. Osgood, 1871 (2 vols in one).

—— "The Surgeon's Daughter." *Chronicles of the Canongate.* New York: Penguin, 2003: 147–288.

"The Shawl Manufacture of Paisley." *Sharpe's London Magazine* 13.4 (March 6, 1847): 290–3.

Silver, Arthur. *Manchester Men and Indian Cotton, 1847–1872.* Manchester: Manchester University Press, 1966.

Sloboda, Stacey. "*The Grammar of Ornament*: Cosmopolitanism and Reform in British Design." *Journal of Design History* 21.3 (2008): 223–36.

Spiers, Edward M. *The Scottish Soldier and Empire, 1854–1902.* Edinburgh: Edinburgh University Press, 2006.

Toplis, Charles. "Report from the Select Committee on Arts and Manufactures" [September 2, 1835]. *Selection of Reports and Papers of the House of Commons* 37: *Arts Connected with Trade.* London: 1836: 113–18.

Transactions of the Society Instituted at London for the Encouragement of Arts, Manufactures, and Commerce. Vol. XLIV (1825). London: 1826.

W. M. W. "Cashmere Shawls: Of what are they Made?" *Once a Week* (January 7, 1865): 68–70.

Zutshi, Chitralekha. "'Designed for Eternity': Kashmiri Shawls, Empire, and Cultures of Production and Consumption in Mid-Victorian Britain." *Journal of British Studies* 48 (2009): 420–40.

Chapter 8

William Morris and the Form and Politics of Replication
Elizabeth Carolyn Miller

Replication is a key feature across William Morris's work and thought in the decorative arts and the art of the book. Patterns of rhythmic, repeating structures, mostly botanical in form, populate the surfaces of his designs, and while Morris and his subsequent critics have frequently discussed the affective quality of this formal emphasis on replication, there has been less discussion of its politics.[1] In Morris's 1888 essay "Textiles," he invites his readers to

> go to the South Kensington Museum and study the invaluable fragments of the stuffs of the 13th and 14th centuries of Syrian and Sicilian manufacture, or the almost equally beautiful webs of Persian design, which are later in date, but instinct with the purest and best Eastern feeling. (1888b: 1134)

What kind of "feeling" was woven into these centuries-old textile patterns? Morris describes it as a pleasing sense of geometrical fitness that comes from reflection upon a well-conceived structure: "it is just this logical sequence of form, this growth which looks as if, under the circumstances, it could not have been otherwise, which prevents the eye wearying of the repetition of the pattern" (1135). Elsewhere, in an 1884 essay titled "Textile Fabrics," he similarly explains the affective appeal of such patterns in terms of the agreeable contemplation of sound structure: "the beauty of the drawing and the ingenuity of the pattern combined give us that satisfying sense of ease and mystery which does not force us to keep following for ever the repetition of the pattern" (45). Critics and admirers of Morris's work today continue to express such feelings about the patterns that Morris himself designed. A. S. Byatt, for example, in her 2016 volume *Peacock*

Figure 8.1 William Morris, *Honeysuckle*, 1876, block-printed fabric.

& Vine: On William Morris and Mariano Fortuny, describes the specific kind of enjoyment found in the contemplation of Morris's patterns *Honeysuckle* (fabric, 1876; see Figure 8.1) and *Willow Bough* (wallpaper, 1887):

> I remember being overcome with delight when I first realised how rigorously the geometry of plants worked among the apparently accidental forms of particular flowers or leaves. There are plants which grow according to the Fibonacci spiral – 1, 1, 2, 3, 5, 8, etc. – which always seemed to me a peculiarly human construction – each number being the sum of the previous two numbers – and not a growth pattern at all. In the Honeysuckle and the Willow Boughs the feeling of free growth is contained in the geometrical repetitions. (107)

If patterned, structured replications can evoke such a feeling, can they not also evoke a politics? For this sense of ease and fulfillment generated by a satisfyingly corporate structure, one that achieves a well-designed balance between the part and the whole, may be extended to Morris's vision of socialism, too: a vision of a well-organized social

structure that produces pleasure and ease for the humans that live in it. In "The Manifesto of the Socialist League," which ran in the first issue of the *Commonweal* (the socialist journal edited by Morris) in February 1885, Morris defines socialism as a "change in the method of production and distribution [that] would enable every one to live decently, and free from the sordid anxieties for daily livelihood which at present weigh so heavily on the greatest part of mankind" (1). In a socialist society, each individual member would thrive under the over-arching social arrangement, in the same way that in a well-structured pattern each iteration of the replicated image would fit in a satisfying way into the overarching structure.

My argument here is influenced by the politico-formalist method-ology that Caroline Levine advances in her book *Forms*, according to which "we can use our understanding of the affordances of aesthetic rhythms ... to understand social rhythms" (53). Morris, I argue, made just such a connection between the rhythms of labor and life in a socialist arrangement of society and the rhythms and patterns of his replicated designs. By interpreting his patterns in this way, my reading of Morris's repeated designs departs from those of many critics; Nicholas Frankel, for example, in an insightful article on the ecology of Morris's decorative work, argues that in Morris's "designs for textiles and wallpapers," a "preoccupation with form and pat-tern" and an "increased emphasis upon structure and the repeat at the expense of naturalism" represent a disavowal of politics (75). I will argue here, in contrast, that in a range of Morris's work – from wallpaper and textiles to the pages of the Kelmscott Press – a politics of non-singularity and non-mimesis inheres in his aesthetic of repli-cation. This politics is simultaneously collectivist, revolutionary, and anti-progressive: collectivist in that it emphasizes the group and the common rather than the exceptional; revolutionary in that it rejects a mimetic recreation of present reality; and anti-progressive in that it draws on the past as an aesthetic resource, replicating older aesthetic forms for modern audiences. While Morris's patterns alone may not articulate this political argument about replication, in conjunction with his surrounding writings and lectures about art, craft, and aes-thetics, they do. We might even say, indeed, that in a sense replication undergirds Morris's entire critique of capitalist modernity, a critique that he articulated most fully after converting to socialism in the early 1880s, but which was evident from his earliest work as a student at Oxford.[2] Rebelling against the privileging of the new that was cen-tral to capitalist modernity, and championing instead the older forms and techniques of pre-modern societies, Morris employed replication

not only as a visual trope and a craft method but also as an aesthetic, historical, and political philosophy.

Replication, as the editors and authors in this study all suggest, connects in complex ways to nineteenth-century culture, values, and politics. If *replication* denotes an original that is also a copy, or perhaps a copy that is also an original, it also suggests repetition and the repeated instances of a pattern, which is the primary sense in which I will be using the term in this essay. Still, it is important to recall at the outset that *replication* is also suggestive of the replica, the duplication that calls into question the very nature and value of originality.[3] The significance of the copy or the imitation has been a central preoccupation of aesthetics at least since Plato, but as this volume illustrates, debates about replication took on new dimensions in the nineteenth century. Morris's aesthetic interventions, I want to suggest, played a crucial part in this shift. Robert Macfarlane has argued that "From the late 1850s onwards, received notions of originality (as the pre-eminent literary virtue) and plagiarism (as the pre-eminent literary sin) came under increasingly skeptical scrutiny. Victorian writers and thinkers began to speak out against the overvaluation of originality." At the same time, emerging aesthetic models that were less grounded in originality "envisaged creativity as a function of the selection and recombination of pre-existing words and concepts" (8). Although Macfarlane is focusing here on literary culture, he extends his observations to other fields of Victorian aesthetics, too, which, he says, saw a general shift from a "hallowed vision of creation as generation" in the Romantic period to an "account of creation as rearrangement" in the latter half of the century. While "the former conventionally connotes some brief, noumenal moment of afflatus or inspiration," "the latter has the tang of the atelier about it" (6). Macfarlane's use of the term "atelier," or workshop, implies the significance of Morris's place in this aesthetic shift toward a more collaborative and labor-based – and less individuated and inspirational – conception of the work of art.

Morris is perhaps best remembered as a leader of the nineteenth-century Arts and Crafts movement, and in this role he advocated for the elevation of craft to the status of art, which was also, of course, a transformation in ideas about art itself. *Craft* is a term that denotes process as much as product, suggests repetitive movement, and invokes an activity or labor of replication rather than the mere singular act of invention or origination. Morris and his decorative arts firm Morris, Marshall, Faulkner & Co., which was founded in 1861 and later changed to Morris & Co., were responsible for reviving

a number of nearly forgotten craft methods from the pre-industrial past, and Morris learned and mastered these craft methods himself, subscribing to the notion that the replicative physical labor involved in such methods was as much worthy of revival as the objects that the labor produced. As E. P. Thompson describes in his biography of Morris, the rhythmic practice of older forms of craft production was an established part of Morris's aesthetic method and was crucial to Morris's labor- and materials-based theory of craft:

> From the foundation of the Firm until the end of his life, Morris was continually busy with close study, experiments, and practical engage-ments with the materials of his craft. Glass-firing, the glazing of tiles, embroidery, woodcutting and engraving, pottery and book-binding, weaving and tapestry-work, illuminating – all these were among the skills he mastered to a greater or lesser degree . . . Study and practice he regarded as inseparable. (101–2)

Morris valued the kinetic knowledge that came from physical repeti-tion and muscle memory, as well as the more historical and theoreti-cal forms of aesthetic knowledge available through study, and indeed he saw the hand piece as inseparable from the brain piece. His non-dualistic conception of theory and practice was a cornerstone of his socialist politics since it lent itself to a broad respect for the expertise of hand-workers and laborers, as we see, for example, in his 1882 lecture "The Lesser Arts of Life," which was given around the time of his conversion to socialism:

> Men whose hands were skilled in fashioning things could not help think-ing the while, and soon found out that their deft fingers could express some part of the tangle of their thoughts, and that this new pleasure hin-dered not their daily work, for in the very labour that they lived by lay the material in which their thought could be embodied; and thus, though they laboured, they laboured somewhat for their pleasure and uncom-pelled, and had conquered the curse of toil, and were men. (1914a: 236)

As a leading voice of the nineteenth-century craft revival, Morris advocated for an aesthetic grounded in the practiced rhythms of pre-industrial labor of the past. The centrality of replication as action or process within his aesthetic philosophy can be gleaned from his reorienting of ornamentation toward the maker, not just the user, as in an 1877 lecture titled "The Lesser Arts": "To give people plea-sure in the things they must perforce *use*, that is one great office of decoration; to give people pleasure in the things they must perforce

make, that is the other use of it" (1973: 33). Replication of forms, as opposed to mere repetition of tasks, makes for pleasurable labor, and for Morris this was a fundamental difference between pre-industrial craft labor and the repetitive processes of industrial labor.

To identify the significance of replication in Morris's theory of production, we can look across the continuum of his work, from wallpapers and textiles to the art of printing, for Morris's interest in the replicative, reproducible processes of printing is apparent not only in his contributions to print literature and the art of the book, but also in his wallpaper and fabric designs as well. In his 1888 essay "Textiles," Morris lists the several traditional means "of ornamenting a woven cloth: (1) real tapestry, (2) carpet-weaving, (3) mechanical weaving, (4) printing or painting, and (5) embroidery" (1888b: 1133). The presence of "printing" in this list provides a clue to how Morris's interest in fine printing emerged from his earlier interests in the textile arts. Such craft processes were ripe for reinvention, given that, in Morris's view, "no textile ornament has suffered so much as cloth-printing from . . . commercial inventions" (1134). The making of books was another craft, Morris felt, which had fared exceptionally poorly under commercialism: in an unpublished essay titled "Some Thoughts on the Ornamented Manuscripts of the Middle Ages," he argues that "the utilitarian production of makeshifts, which is the especial curse of modern times, has swept away the book producer in its current" (1982: 1).

Hand-printing, by contrast, whether of wallpaper, textiles, or books, strikes a vital balance between repetition and non-reproducibility, and I would suggest that such a balance establishes a clear through-line from the firm's wallpapers of the 1860s and 1870s, such as *Acanthus* (1875) (Figure 8.2), to block-printed fabrics such as *Strawberry Thief* (1883) (Figure 8.3), to the Kelmscott Press books in the 1890s, such as John Ruskin's *The Nature of Gothic* (1892) (Figure 8.4). In keeping with his craft method, Morris's wallpapers were hand-printed, and the Kelmscott Press books were printed using the Albion hand-press rather than the newer, faster, steam-powered presses that were dominant by the end of the century. Both the firm and the press, then, engaged in craft operations premised on the production of replicated design over a flat material surface. Since the designs were printed, they were reproducible, but – and here lies the difference – they were printed in a slow, hand-worked fashion which lent individuality and distinction to each printed iteration. In Morris's championing of such methods, we can see how his vision of socialism and non-alienated labor helped produce a design aesthetic that privileged collectivity as well as individual difference in the context

Figure 8.2 William Morris, *Acanthu*s, 1875, block-printed wallpaper.

Figure 8.3 William Morris, *Strawberry Thief*, 1883, block-printed fabric.

Figure 8.4 William Morris, Kelmscott Press edition of John Ruskin, *The Nature of Gothic*, 1892.

of collectivity. Each printing bore the trace of the worker and the process in its distinct reception of the ink, design, or color, and yet no wallpaper, fabric, or book was produced singly, in the same way that every Morrisian pattern replicated multiple versions (each alive with subtle distinctions) of the same design. The patterns themselves are replicated through printing, but each instance of each pattern is distinct in minor ways. The Ruskinian trace of the worker's hand, the individuality of each iteration, was key to the work's appeal, as Caroline Arscott notes of Morris's wallpapers:

> The surface of the hand-printed [wallpaper] retains evidence of the viscosity of the ink and the firm downward pressure exerted onto the printing block. The ink can be seen to have been squeezed towards the sharp edge of the block where it sometimes dries into a slight hump or ridge. (2008: 29)

At the firm, Morris initially attempted to print his own wallpapers from etched zinc blocks, but after he was unable to produce satisfactory results

with his first wallpaper design, *Trellis*, he began contracting out the work to a specialist firm, Jeffrey & Co., for his next wallpapers, *Daisy* and *Fruit*. Jeffrey & Co. printed the wallpapers using woodblocks cut with Morris's designs to Morris's specifications by a block-cutting firm called Barrett's.[4] Although machine printing was standard by this time and was much less expensive, "Morris preferred," as Arscott notes, "the dense colour, and the deliberate placement of the elements that could be achieved with hand printing" (2008: 29). Morris's printed textiles, on the other hand, were eventually block-printed in house, under Morris's control, but in the early days of the firm they were initially hand-printed by a firm called Bannister Hall Print Works near Preston, and then, after 1875, by Thomas Wardle's works in Leek. These firms used, as Linda Parry writes, the "ancient technique of block-printing . . . in preference to engraved rollers which, by the mid-nineteenth century, had been adopted by most of the leading commercial textile manufacturers" (36). After moving the firm to Merton Abbey in 1881, Morris was finally able to undertake his own block-printing and dye-making in house; Merton Abbey was a seven-acre site on the River Wandle with its own dye-room, and the entire upper floor of the largest workshed on site was dedicated to the block-printing of fabrics.[5] Here, the "thump-thump of the printers' blocks" became "one of the most characteristic noises of the works" (Parry 51). In moving the firm to Merton Abbey, Morris intended to evoke guild-like conditions of labor for the workers and to maximize the firm's self-sufficiency in terms of craft labor, including the block-printing of fabrics.

Critics have discussed the various concessions to nineteenth-century social arrangements that the firm made even after the move to Merton Abbey, but none denies that Morris's workers were paid well, for the time, and that many visitors described the Abbey as delightfully situated and a pleasant place to work.[6] While acknowledging that the "general environment" at Merton was "far and away more pleasant than the norm," that there was a "geniality about the enterprise" and "a sense of the skills of the workmen being valued," Fiona MacCarthy nonetheless wonders why "there was no serious attempt to bring out the latent creative talent of each workman." She quotes one of the block printers as saying that "Mr. Morris believes in us men using our brains as well as our hands and does not want to turn us into machines," and yet, she notes, their work was always done to Morris's specifications, which surely made their craft labor less creative and more monotonous (453). This contradiction has led Linda Dowling to suggest that

the social and moral benefits that both Ruskin and Morris identified in handwork are nowhere to be found in Morris's actual procedures: hand printing . . . did not provide his workmen with opportunities for greater freedom, delicacy, or initiative. Its advantage was wholly technical and aesthetic. (58)

The counter-argument, from Morris's point of view, would be that, given what he saw as the death of the decorative arts in the industrial era and the alienation of the workman from production, a more democratic distribution of creativity could not be achieved until art was reborn. That rebirth of art became, for Morris, one of his central themes after his conversion to socialism: in his 1888 lecture "Art and Its Producers," for example, he wrote that, "craftsmanship is now all but extinct" among the working classes, and described his commitment to "keeping alive the spark of life in these [crafts] for a better day," lest they be "wholly extinguished by commercial production" (1888a: 232).

While the firm did take on the hand-printing of fabrics, as part of its effort toward keeping alive that spark of life, it never printed its own wallpapers, and even after the move to Merton Abbey the cutting of designs was not done in house but was sent out to Alfred and James Barrett. This was in contrast to the Kelmscott Press, where Morris maintained greater control of the means of print production by keeping more of it in house. Certainly, on the one hand, there is an uneasy balance between Morris's socialist politics and his role at the firm, but, on the other hand, no critic believes that if Morris had single-handedly run his firm on communist lines it would have made a dent in Victorian capitalism; Fiona MacCarthy writes, indeed, that such a move would have likely run the firm into the ground, given the context of capitalist competition in which Morris was forced to operate.

I would suggest that Morris's patterns are themselves a reminder of the inseparability of the firm from its context: Morris was as embedded in nineteenth-century social conditions as a leaf in his *Acanthus* pattern was twined around its neighbors, and his patterns themselves embody the case for a comprehensive collective approach to redesigning social arrangements. Moreover, if we conceive of his career in printing as a through-line from the woodblock-printed wallpapers and fabrics of the firm forward to the Albion press-printed books at Kelmscott Press, we can imagine Kelmscott as Morris's cumulative effort, in his socialist phase, to maximize his responsibility for the labor conditions that figured in all aspects of his craft production.[7]

For the Kelmscott workers were unionized and the head Kelmscott printer was Thomas Binning, a stalwart trade unionist and a member of the Socialist League. In establishing the configuration of labor at the press, Morris drew on his experience of moving the firm to Merton Abbey, but now he would print books instead of fabrics.

In the Kelmscott books, the borders and frames that Morris employed to contain illustrations and initial pages mirrored the replicated botanical patterns that characterize Morris's designs for the wallpapers and fabrics of the firm – another mark of the continuity between the two projects. Such patterns have the effect of integrating the text within Morris's dense and interwoven botanical patterning. Morris often spoke of each of these various print-based craft endeavors – wallpapers, fabrics, books – in terms of living bodies and organisms. As he put it in his 1881 lecture "Some Hints on Pattern Designing," "it will be enough for us to clothe our daily and domestic walls with ornament that reminds us of the outward face of the earth" (1914b: 177). Likewise, in "Some Thoughts on the Ornamented Manuscripts of the Middle Ages," Morris reflects on the medieval book as "a comely body fit for the habitation of the dead man who was speaking to them: the craftsman, scribe, limner, printer, who had produced it had worked on it directly as an artist, not turned it out as the machine of a tradesman" (1982: 2). Morris's patterns likewise modeled and embodied holistic interrelation by way of the interwoven botanical organisms depicted on their surface, which reflected Morris's concern for the well-being of the individual within the wider social organization of which the individual is a part. If physical well-being and vigor are embedded in these patterns, then the patterns reflect the key principle of socialism that was at the heart of Morris's idea of craft.

The living vividness of the leaf and floral arrangements in the Kelmscott borders has led some critics to read them in terms of replication in the biological sense of expansion and generation. The spectacle of botanical reproduction portrayed in the floral patterns, with the close attention to the sex organs of plants that we see in *The Nature of Gothic* border, for example, sharpens this sense of the ongoing, flourishing propagation of life. Holbrook Jackson, an important early critic of Morris, commented in 1913 on the Kelmscott aesthetic of botanical replication and what he saw as its seeming potential for endless reduplication: "The Kelmscott books look not only as if letter and decoration had grown one out of the other; they look as if they could go on growing" (qtd. in Peterson 133). If the decorative borders, as I am suggesting, help us perceive the underlying connection between robust

individual life and the healthy arrangement of society and labor, we can see how other aspects of Kelmscott's methods also made a case against social forms of production that diminish the human worker. This is evident, for example, in the press's revival – or preservation – of the art of hand-engraved wood-block illustrations as superior to the new mechanical–chemical process of zincography that emerged in the 1880s. As William S. Peterson has described, zincography

> bypassed the human engraver entirely, since the artists' design was transferred photographically on to a zinc plate, which was then engraved by immersion in a chemical bath. An illustration that previously had been engraved by hand over several days could now be prepared for the press in a few hours. By the time the Kelmscott Press came into existence, wood-engraving had disappeared almost overnight.

Morris, unsurprisingly, "held zincography in contempt," and preferred illustrations engraved in wood block by hand (21). His chief engraver at Kelmscott, William Harcourt Hooper, was a master of facsimile engraving in wood as well as a committed socialist; the two men were, however, prone to disagreement over the Kelmscott illustrations, which is itself a mark of Morris's effort to produce humane labor arrangements at the press, for such inconvenient differences of personality were one of the liabilities of human workers that mechanization and industrialization sought to overcome.

Printing is, of course, itself an art of replication, but more than that, the texts Morris chose to print at Kelmscott were often works from the past that he considered significant, such as *The Golden Legend*, *The Recuyell of the Historyes of Troye*, *The Order of Chivalry*, *Utopia*, *The Tale of Beowulf*, and, most famously, *The Works of Geoffrey Chaucer*. Here, as with his elevation of older craft methods at the firm, replication emerges as a historical as well as an aesthetic strategy. As a writer and an artist, Morris's use of the past as an aesthetic resource was a form of historical replication: rather than attempting to create wholly new aesthetic forms, Morris was interested in reviving older aesthetic forms and making them relevant and powerful for modern audiences. His books, like his textiles and wallpapers, enact a refusal of a modernist aesthetic of newness in favor of an aesthetic of replication. This was an argument against the capitalist ideology of progress and its presumption of a supposedly endless trajectory of improvement through the expansion of markets. It was also characteristic of what E. P. Thompson has called Morris's "powerful historical imagination,"

which "was perhaps his greatest single intellectual strength. In his youth, this faculty was quickened to intensity by his growing hatred of his own civilization" (28).

In hearkening back to the past, Morris's forms of historical replication can also be read as a revolutionary rejection of the present, a claiming of earlier aesthetic models to eschew the kind of mimesis that would reflect the nineteenth-century present and its post-industrial conditions of life. Literary critics have long discussed Morris's rejection of realism, and such a rejection is evident in his typical choices for subject matter in his writings: poetry volumes such as *The Defence of Guenevere* or *The Earthly Paradise* that take place in a legendary or mythic past; utopian works such as *News from Nowhere* or *The Tables Turned; Or, Nupkins Awakened* that are set in the future; or a medieval alternative history such as *A Dream of John Ball*.[8] But Morris's work in the decorative arts is, perhaps, even more decidedly anti-realistic because it enacts by way of Morris's heavy reliance on pattern an aesthetic of internal replication over and above mimesis.[9] The art copies itself, in other words, rather than copying nature. In a lecture titled "Some Hints on Pattern Designing" given at the Working Men's College on December 10, 1881, Morris defined pattern specifically in terms of its non-mimetic quality: "By the word pattern-design, of which I have to speak to you to-night, I mean the ornamentation of a surface by work that is not imitative or historical at any rate not principally or essentially so" (1914b). Morris's conception of pattern is thus grounded in its rejection of mimesis more than in any aspect of its material form. Pattern design can, he says, be worked in many different materials, but is never mimetic:

> such work is often not literally flat, for it may be carving or moulded work in plaster or pottery, but whatever material relief it may have is given to it for the sake of the beauty and richness, and not for the sake of imitation, or to tell a fact directly. (175)

Morris went further in "Some Hints on Pattern Designing" to make a more general statement against realism, or rather against its possibility: "Of course you understand that it is impossible to imitate nature literally; the utmost realism of the most realistic painter falls a long way short of that" (178).

That Morris described his work in the replication of patterns in terms of its non-mimetic, non-imitative essence is key, for it suggests the revolutionary quality of his rejection of the present day as a basis for artistic representation. Morris developed such a critique,

in some sense, from his early association with Pre-Raphaelitism; it is well known that Dante Gabriel Rossetti, for example, rejected modern life as a subject unfit for artistic representation, and his paintings could be said to anticipate Morris's non-mimetic direction with patterns, although the comparison is a partial one from a political point of view. E. P. Thompson, for one, has represented the Pre-Raphaelites as strikingly democratic in their aesthetic sensibility, and quotes this recollection of a conversation between Holman Hunt and Millais in the early days of the Brotherhood: "'It is simply fuller Nature that we want. . . . Why should the highest light be always on the principal figure?'" (50–1). Although this might seem at odds with Rossetti's painterly emphasis on "stunners" – the handpicked models, including Morris's wife Jane, who were chosen for their singularity – Henry James saw something in these paintings that conveyed broad pattern rather than individuated subjects. His famous account of Jane Morris in a March 1869 letter follows up a discussion of William Morris's pattern design (which Morris works, James reports, "stitch by stitch with his own fingers") with a discussion of Morris's wife: "It's hard to say [whether] she's a grand synthesis of all the pre-Raphaelite pictures ever made – or they a 'keen analysis' of her – whether she's an original or a copy" (23).

The point I wish to make, here, is that while both Morris and Rossetti can be said to have elaborated an anti-mimetic aesthetic that made a pointed rejection of nineteenth-century modernity and raised a host of questions about originality, replication, artistic influence, and the relation of the past and the present, the fact that Morris combined his anti-present, anti-mimetic aesthetic with a critique of capitalism gave his pattern work an added political force. His rejection of realism and his internal replication of repeated forms take on a revolutionary quality in their disavowal of present society and their comprehensive reimagining of arrangements and experiments in balancing the part with the whole.

Formally, replication might seem in some sense to privilege continuity over revolutionary rupture, which would conflict with Morris's revolutionary, anti-reformist beliefs after his conversion to socialism in the early 1880s. The anti-mimesis of Morris's decorative patterns, however, makes a case against the replication of the present, a utopian argument for something *better* than the present, for the present is not worth being represented in art. Morris's famous conversion to socialism might be read, similarly, as a rupture rather than a replication, a break rather than a repetition, but we must remember that he considered the primary work of socialism to be the business of "making

socialists."[10] He sought to replicate conversion to craft socialists in the way that one might craft a decorative object. In this way, his conversion was a submersion of the self into a larger historical pattern; his conversion was one iteration of the making of socialists, the great political project that he hoped would facilitate the creation of a healthier, better-structured social arrangement.

Read in this light, replicated form takes on a socialist politics that it has not always been understood to inhabit, and indeed form itself emerges as a central term for early Marxist aesthetics. Caroline Arscott, in a volume on Marxism and the history of art, notes the "marked focus in much twentieth-century Marxist art history and literary history on iconography and the identification of ideological positions," but suggests that

> by turning afresh to Morris as one of the first Marxist commentators on the making and the study of art we can see that there was, from a very early stage, the articulation of another way of approaching art and its history, one where the primary emphasis was on aesthetics and form. (2006: 27)

If Morris traveled a seemingly unlikely journey from wallpapers to the Second International, there are indications in his pattern work and in his writings about pattern work of his developing point of view. Decoration for Morris, as Nicholas Frankel writes, "embodies a mode of perceptual experience, with the potential to transform the perceiver's relation to the world and to other human beings" (64). Replicated aesthetic form and the rhythmic repetitions of craft labor provide a way of seeing the world anew, of rearranging the world in miniature, of experimenting with new forms of distribution, new rhythms of labor, and new forms of balance between the part and the whole.

Notes

1. Eve Kosofsky Sedgwick alludes, for example, to "the characteristic Morris pattern of equidistant, unforegrounded, unbroken, and perspectiveless ornamentation drawn 'from nature'" in her study of affect, *Touching Feeling* (16).
2. For evidence of this early commitment, see, for example, Florence Boos, *History and Poetics in the Early Writings of William Morris, 1855–1870*.
3. The *Oxford English Dictionary* lists "repetition" as the oldest meaning of the term, dating to at least the fifteenth century, followed by the sense of "copy" or "replica" emerging in the seventeenth century ("Replicate, v.").

4. See Charles Harvey and Jon Press, *William Morris: Design and Enterprise in Victorian Britain* (46) and Arscott, *William Morris and Edward Burne-Jones* (2008: 29).
5. See MacCarthy 433.
6. See Parry 52–3.
7. Of course, even at Kelmscott, Morris did not produce his own paper or ink, but instead had it made to his specifications by specialty producers; there were limits to the lengths he could go to control all aspects of production.
8. See, for example, Brantlinger; Miller; Sypher; or Vaninskaya.
9. This rejection of realism in crafts, of course, preceded Morris and can be understood as an outcome of the 1851 Great Exhibition and, more broadly, of Eastern influence on British design; such a craft aesthetic was articulated, for example, by Owen Jones in *The Grammar of Ornament* (1856). Morris's contribution was to extend the meanings of non-realist craft into the political and social domains.
10. The phrase is Morris's, and has recently been repurposed for the title of Mark Bevir's *The Making of British Socialism*. (Bevir discusses Morris's well-known use of "making socialists" on p. 101.) Despite the fact that many critics have found much to discuss in Morris's use of the phrase, the connections back to Morris's craft work and the culture of making that he engendered have been insufficiently remarked upon.

Works Cited

Arscott, Caroline. "William Morris: Decoration and Materialism." *Marxism and the History of Art: From William Morris to the New Left*. Ed. Andrew Hemingway. Ann Arbor: University of Michigan Press, 2006: 9–27.
——. *William Morris and Edward Burne-Jones: Interlacings*. New Haven, CT: Yale University Press, 2008.
Bevir, Mark. *The Making of British Socialism*. Princeton: Princeton University Press, 2011.
Boos, Florence. *History and Poetics in the Early Writings of William Morris, 1855–1870*. Columbus: Ohio State University Press, 2015.
Brantlinger, Patrick. "'News from Nowhere': Morris's Socialist Anti-Novel." *Victorian Studies* 19.1 (1975): 35–49.
Byatt, A. S. *Peacock & Vine: On William Morris and Mariano Fortuny*. New York: Knopf, 2016.
Dowling, Linda. *The Vulgarization of Art: The Victorians and Aesthetic Democracy*. Charlottesville: University Press of Virginia, 1996.
Frankel, Nicholas. "The Ecology of Decoration: Design and Environment in the Writings of William Morris." *The Journal of Pre-Raphaelite Studies* 12 (Fall 2003): 58–85.

Harvey, Charles, and Jon Press. *William Morris: Design and Enterprise in Victorian Britain*. Manchester: Manchester University Press, 1991.

James, Henry. *Henry James: Selected Letters*. Ed. Leon Edel. Cambridge, MA: Belknap, 1987.

Levine, Caroline. *Forms: Whole, Rhythm, Hierarchy, Network*. Princeton: Princeton University Press, 2015.

MacCarthy, Fiona. *William Morris: A Life for Our Time*. London: Faber and Faber, 1994.

Macfarlane, Robert. *Original Copy: Plagiarism and Originality in Nineteenth-Century Literature*. Oxford: Oxford University Press, 2007.

"The Manifesto of the Socialist League." *Commonweal* 1.1 (February 1885): 1.

Miller, Elizabeth Carolyn. *Slow Print: Literary Radicalism and Late Victorian Print Culture*. Palo Alto: Stanford University Press, 2013.

Morris, William. "Textile Fabrics." Lecture delivered at the International Health Exhibition July 1884. *The Architect* (19 July 1884): 43–5, (26 July 1884): 50–3.

——. "Art and Its Producers." *Transactions of the National Association for the Advancement of Art and Its Application to Industry, Liverpool Meeting*. London: 1888a: 228–36.

——. "Textiles." Originally printed in Arts & Crafts Exhibition Society: Catalogue of the First Exhibition (1888b); rpt in *Journal of the Society of Arts* (19 October 1888): 1133–5.

——. "The Lesser Arts of Life." Lecture originally presented January 21, 1882 to the Birmingham and Midlands Institute under the title "Some of the Minor Arts of Life." *The Collected Works of William Morris*. Vol. 22: *Hopes and Fears for Art; Lectures on Art and Industry*. Cambridge: Cambridge University Press, 1914a: 235–69.

——. "Some Hints on Pattern Designing." Lecture originally presented December 10, 1881 at the Working Men's College, London. *The Collected Works of William Morris*. Vol. 22: *Hopes and Fears for Art; Lectures on Art and Industry*. Cambridge: Cambridge University Press, 1914b: 175–205.

——. "The Lesser Arts." Lecture originally presented April 12, 1877 to the Trades Guild of Learning in the Co-operative Hall of London under the title "The Decorative Arts." Printed in *The Political Writings of William Morris*. Ed. A. L. Morton. New York: International Publishers, 1973: 31–56.

——. "Some Thoughts on the Ornamented Manuscripts of the Middle Ages." *The Ideal Book: Essays and Lectures on the Arts of the Book*. Ed. William S. Peterson. Berkeley: University of California Press, 1982: 1–6.

Parry, Linda. *William Morris Textiles*. London: Weidenfeld and Nicolson, 1983.

Peterson, William S. *The Kelmscott Press: A History of William Morris's Typographical Adventure*. Oxford: Clarendon, 1991.

Sedgwick, Eve Kosofsky. *Touching Feeling: Affect, Pedagogy, Performativity*. Durham, NC: Duke University Press, 2003.

Sypher, Eileen. *Wisps of Violence: Producing Public and Private Politics in the Turn-of-the-Century British Novel*. London: Verso, 1993.

Thompson, E. P. *William Morris: Romantic to Revolutionary*. 2nd edn. New York: Pantheon, 1976.

Vaninskaya, Anna. *William Morris and the Idea of Community: Romance, History and Propaganda, 1880–1914*. Edinburgh: Edinburgh University Press, 2010.

Text and Media Replication During the U.S.–Mexican War, 1846–1848

Kathryn Ledbetter

The search for national identity in the U.S. spurred an expansive cultural movement to market patriotism during the 1840s. A brief, bloody war of aggression between the U.S. and Mexico (1846–8) served as a testing ground for the nation's power.[1] Early victories at Palo Alto and Resaca de la Palma near Brownsville, Texas, on May 8 and 9, 1846, made General Zachary Taylor an instant hero and prompted President James K. Polk to declare war on Mexico a few days later, on May 13. The rapid spread of war news produced a viral phenomenon that responded to and helped to shape American desires for westward expansion, individual heroism, and indigenous democratic myths of the common man.[2] Newspapers replicated battlefront reportage in cut-and-paste fashion, cross-pollinizing books, magazines, and commemorative objects such as "Palo Alto Hats" advertised in the *New York Herald* on June 16, 1846. Robert L. Johannsen describes the scene as a "war mood that approached hysteria":

> Heroes were molded and cast in the battle reports, the dispatches of newspaper correspondents, the soldiers' letters, and the plethora of publications which the conflict generated. Their stories were told and retold until they became independent of reality. Their deeds were celebrated in poetry and song and were reenacted on the stage. When they were martyred, they were mourned with striking intensity. The first encounters with the enemy in May 1846 produced the war's first heroes and virtually every engagement after that added to the list. (Johannsen 11–12, 113)

Artists at lithography firms in New York and Philadelphia contributed to the effort by reimagining Mexican War scenes from the newspaper reports and replicating their art in lithographs to sell as individual prints or for use in other printed media or objects.

Mapping the migration of a specific set of images depicting the battle at Resaca de la Palma on May 9, 1846, demonstrates this process of replication across media and shows how replication by varied social networks of authors and artists produced the desire and meaning necessary for nation building and a sense of national identity.

The war became America's biggest commodity for producers of print. Tom Reilly states that the *New York Sun* increased its daily circulation from 45,000 at the start of the war to 55,000 by the war's end in 1848 (n5, 249). On May 1, 1846, the *Sun* exclaimed: "Our extras over the past few days have averaged over 22,000 copies per day, making, with our regular daily edition, nearly 70,000 copies issued from our steam presses for several days in succession" (qtd. in Reilly 2). East Coast newspapers relied on reprinting stories from New Orleans dailies for their success, because papers such as the New Orleans *Picayune* had quick access to dispatches and vivid descriptions of the front from their own reporters, who were the country's first full-time war correspondents. After the battles of Palo Alto and Resaca de la Palma, battlefront observers shared, compared, and posted notes and hastily drawn maps of troop formations. According to Rick Stewart, reports

> often consisted of information synthesized from several eyewitness accounts by the correspondent in the field. Solitary accounts were filed as well usually for the sake of speed, as editors back home realized that whoever reached the streets first with the latest news reaped the benefits of increased circulation and advertising revenues. (6)

In some instances, artists accompanied reporters to the battle scenes, where their quickly sketched drawings later became paintings that might then be freely engraved, lithographed, colored, cheaply printed, and sold by East Coast print sellers and book dealers. A report from the Washington *National Intelligencer* on October 1, 1846, confirms that "The complaints, sufferings and achievements of [the] army . . . have been given to the public by almost as many pens as there are bayonets among its numbers" (qtd. in Reilly 23–4).

News created anxiety among an array of social networks, as depicted in one of over 14,000 lithographic replications of Richard Caton Woodville's 1848 painting, *War News from Mexico* (Figure 9.1). All participants in this illustration are consuming matters of national importance translated through several layers of newspaper reportage and interpretive networks. The newspaper *Extra* is at the center of the image, as varied social groups react to the news from the shabby, worn porch of

Figure 9.1 "War News from Mexico," lithograph after an 1848 painting by Richard Caton Woodville.

the appropriately named American Hotel. The woman leaning out the window and the African–American man and his daughter at the steps are significantly outside the center and off the porch, marginalized by race and gender; although part of the larger group of citizens intensely interested in the war, they are unable to participate in the political process that will direct the outcome. Shelley Streetby explains that the 1840s were

> marked by increasing sectionalism, struggles over slavery, the formation of an urban industrial working class, and nativist hatred directed at the new, mostly German and Irish immigrants . . . If the war sometimes concealed these divisions by intensifying a rhetoric of national unity it could also make differences of class, religion, race, and national origin more strikingly apparent. (Streetby 39)

Yet myth building continued to expand in popular culture during the Mexican War era for many different social groups through the penny press, sensational literature, and other printed items such as the replicated lithographic depictions of American heroism discussed in this essay.

Technologies for Cross-Medial Replication in the Mexican War Era

Innovations in printing presses such as the steam-driven rotary press enabled viral replication of news and mass circulation of newspapers during the 1840s. Getting the news from New Orleans to the East Coast, however, was challenging. Telegraph lines were extended to Fredericksburg, Virginia, by 1847, but a yellow fever epidemic slowed further construction and prevented the telegraph line through the Deep South from being completed until after the war (Reilly 165). Once Southern messengers on horseback reached the nearest mail station, however, trains, ships, or river boats could carry the reports on to East Coast publishers. The New Orleans *Picayune* sped up news delivery by installing a typesetter on mail steamers to facilitate faster printing upon arrival, and *The New York Herald* kept a ship ready to accept southern news bags as they came off the steamships from New Orleans.

Lithography firms in New York and Philadelphia also depended on rapid updates provided by New Orleans newspapers to East Coast publishers because sales of individual colored pictures of the battle scenes were in high demand throughout the country. The Mexican War was the first to be portrayed in lithographic prints for a mass readership. Lithography replaced the slow and tedious copper and steel-plate engraving process as the most suitable medium for mass production, and it easily allowed for last-minute changes in response to news updates. Magazines used steel-plate etched or engraved illustrations as well as monochrome or colored lithographs, but newspapers did not mix relief printing with other processes involved with engravings and lithographs until after 1850. James Gordon Bennett's *New York Herald* was one of the first newspaper publishers to feature wood-engraved maps and battle scenes on his front page; replication of a crudely drawn illustration of military encampments near Matamoros, Mexico, appeared as early as two weeks after the fighting began. The Mexican War was also the first to be photographed, although photography was not yet practical for newspapers, either. Daguerreotypists often accompanied soldiers to make a visual record, but very few daguerreotypes from the Mexican War era survive.

Other new technologies contributed to rapid transmission of war-era images, such as a burgeoning American cotton industry and innovations in cylinder printing for textiles, which enabled faster production of printed fabrics for all types of commemorative object.

Designers (called delineators) could replicate an image by drawing or tracing the design directly onto a metal plate for an engraver to scratch with a burin; the plate would then be attached to a cylinder about 15 inches in diameter, where it was inked and rolled onto the fabric by means of compression forced by other cylinders against the inked plate. Roller-printing technology replaced older methods of textile printing that entailed laborious hand-stamping with large wood blocks. By 1846 separate cylinders could print different colors and apply background patterns, but the need for speed during the war era was more important than variety or clarity of color and patterns; thus many of the images from American textile producers are aesthetically crude.

Eyewitness Replication

Thomas Bangs Thorpe, correspondent for the New Orleans *Tropic* and the *Courier*, is reported to be, with Captain William Seaton of the U.S. Army, the only eyewitness at Resaca de la Palma on May 9, 1846. Thorpe rushed to capitalize on demand by replicating his own reportage in cheap, illustrated book productions. He managed to publish *Our Army on the Rio Grande* in August 1846, only three months after Resaca de la Palma. His Preface is problematic:

> The author was among those who were deeply excited by the stirring incidents connected with our little army on the Rio Grande, in the months of April and May, 1846, and he was on the battle fields, and among the heroes, almost immediately after the occurrences that have rendered them immortal in the history of the country. (Thorpe iii)

The author's presence at the scene "almost immediately after the occurrences" makes an eyewitness account of the battle impossible, for, by his own admission, he was not there: everything he reported is a compilation of second-hand stories and constructed military summaries.

Nevertheless, Thorpe's story of Captain Charles May's charge on the Mexican batteries was most often used in newspapers published in the weeks after Resaca de la Palma. According to Thorpe, Captain May was commanded by General Taylor with the following words: "'Capt. May, you must charge the enemy's batteries, and take them *nolens volens*.'" The popularity of this phrase is demonstrated by its prolific repetition in popular print culture during the weeks after the battle. A simple translation might be: like it or not, willy-nilly, you

must go forward at the risk of horrible suffering and perhaps death. In the account, May spurs his horse and dashes down the road, followed by soldiers in columns of four, to face 6,000 Mexicans. Captain Ridgely says, "'Wait, Charley, until I draw their fire,'" while May and his dragoons charge out to defeat their foes (96). I quote a lengthy passage here to aid comparisons with subsequent replications:

> It was a soul-stirring sight to witness that charge. The dragoons were stripped of every unnecessary encumbrance, and brandished their weapons with their naked arms that displayed the well-filled muscle, glittering like the bright steel they wielded. May, far in the advance, seemed to be a living messenger of death that Ridgely had sent from his battery at its last discharge. His long hair and beard streamed beneath his gold-tasselled cap, like the rays of a comet; and upon his cimetar the tropical sun glistened with burning effulgence . . . As his tall form rose and fell on the gigantic leaps of his charger, the Mexicans shrunk from his powerfully-dealt sword, as if they had been assailed by lightning. One Mexican kept his ground and vainly tried to rally his men; despairing of success, with his own hand he seized a match, when May ordered him to surrender. Discovering the command came from an officer, the Mexican touched his breast, and said, "Gen. La Vega is a prisoner;" he then handed Capt. May his sword. (97–8)

Details such as May's long, flowing hair, gigantic charger, superior horsemanship, cap, and his height and towering dominance over the guns captured the public imagination, as demonstrated in viral texts widely replicated in the U.S. immediately after the battle.

On June 1, the *Boston Courier* reprinted a *New Orleans Courier* story that included the detail of May's long hair and described him as a "most singular being" on horseback:

> With a beard extending to his breast, and hair to his hip-bone, which, as he cuts through the wind on his charger, streams out in all directions, he presents a most imposing appearance. His gait on foot is awkward, and that of his horse (an immense one) is the rack of the Canadian pony. ("Captain May" 1)

On June 9, the Philadelphia *Public Ledger* expanded the story of May's hair and added romantic appeal for women readers:

> He is over six feet high, wears his hair long, so that it nearly reaches his hips; his beard falls below his sword belt, and his moustache is unshorn . . . It will interest some of your fair readers to hear that he was crossed in love some years ago. Since that time he has never allowed his hair or beard to

be touched by a barber . . . [In charging] May is in advance of them all, on his noble black steed, standing up in the stirrups, his head bent forward, his long hair streaming out behind like the tail of a comet, and his whole appearance viewed from the head, looking like one of those celestial visitants. (qtd. in Lewittes 214)

The *Ledger*'s account contributes personal details that depict May as a Byronic warrior "crossed in love" and a man who recklessly challenges death on a "noble black steed." The story suggests a superhuman role as a "celestial visitant" from an otherworldly universe of heroes. Another myth-making report is picked up from the Baltimore *Sun* within weeks of the battle about Washington native May, who,

for a bet of wine, with some gentlemen, . . . rode his horse up the steps, and into the passage, of the City Hotel;–having accomplished this, it was suggested that he could not ride down again. He immediately turned his horse and rode down, jumping his horse over the iron railing. ("Gallant" 1)

The reporter also recommends that the Mayor of Baltimore immediately remit a fine levied "some time ago" on the "gallant Captain" for "leaping his horse over a cord of wood" at the Baltimore City Hall. The account adds to May's growing reputation as a courageous American individualist and informs renditions of his physical stature in lithographic art.

Printed Images and Replication

At least ten Mexican War lithographs printed in the weeks following news of the battle at Resaca de la Palma replicated the details of a long-haired Captain May charging a cannon on a horse of very large proportion, in front of a background of soldiers fighting with either swords or rifles amidst dead or dying men from both sides of the battle in the foreground. Nathaniel Currier produced three lithographs of this scene. His print titled "Battle of Resaca de la Palma May 9th 1846. Capture of Genl Vega by the Gallant Capt. May" (Figure 9.2) is unique among groups of early lithographs depicting the charge in that Captain May is pointing a pistol at General Vega instead of a sword, and rifles, rather than swords, appear to cause the Mexicans to shrink in fear in the smoky battle in the background. Captain May is holding Vega's arm to keep him from lighting the cannon, a pose that is unique to Currier replications, while lithographs from other

BATTLE OF RESACA DE LA PALMA MAY 9TH 1846

Figure 9.2 "Battle of Resaca de la Palma May 9th 1846" by Nathaniel Currier, 1846.

firms show May reaching out to Vega or holding a sword above the cannon, ready to strike at General Vega. May's grasp on Vega's wrist causes the general to drop the match away from the cannon and gives May a powerful dominance over the Mexican general. Vega is proportionately larger than May in this and other Currier images, making the Captain's feat of forcing the hand of a man who outranks him in military status as well as size more courageous; Vega's stance is open and vulnerable, while May closes his arms around the horse on both sides in full control of beast and man. May's position on his huge horse dominates Vega as they look eye to eye.

Details in the Currier print and other Mexican War lithographs changed in response to newspaper updates. Bryan F. Le Beau describes the process of production for at least seventy Mexican War prints from the firm:

> Currier occasionally acquired a sketch from the front, but more often his shop artists worked from newspaper accounts and modeled their portrayals after European battle prints. Few were accurate in their details; most were of such a general nature, focusing on common aspects of battle, that only their titles and inscriptions allow the viewer to identify them in time and place. But accuracy was not their purpose. (Le Beau 64)

The Currier lithograph in Figure 9.2 was one of the earliest, if not the first, of the war prints hurriedly published within weeks of the battle. The incomplete hand-coloring and unfinished details in the drawing, as well as an amateurish quality to the faces of May and Vega, indicate a need to rush print production to reflect the latest newspaper update. In a later print (not shown) Currier reverses the direction of May's horse in response to reports that he and his dragoons advanced so rapidly that they outran the Mexican guns and had to whip around to complete their attack. May is also shown in the second print with a massive sword at the ready, a missing detail in the first print but described in Thorpe's account. The sword points ominously toward the general as it hangs on the saddle gear between May and General Vega's arm. In the later print, Vega's face is somewhat kindly and submissive, but he nearly matches May's enormous horse in stature. The Mexican general's face replicates Thorpe's report that Vega recognized an equal in May's status as an officer, causing him to surrender.

Le Beau points to the power of networks in circulating images and confirms that lithography was in the business of commodifying myths for consumption by mass readers hungry for an American identity. He explains that Currier sought "not only to picture those battles but also to interpret them in a manner consistent with public expectations, so that they could become part of the nation's usable past" (64). Such prints romanticized war for many impressionable young future heroes of Confederate and Union armies, such as Robert E. Lee, Ulysses S. Grant, and Jefferson Davis. Some felt that unrealistic lithographs led to disillusionment; indeed, Civil War photography depicted a much harsher reality than the hand-colored scenes of heroism from the Mexican War.

Like his former associate Nathaniel Currier, Napoleon Sarony and his partner Henry Major produced several prints of the battle at Resaca de la Palma, including a reproduction similarly titled "The Capture of General Vega, in the act of discharging a cannon, by the gallant Capt. May of the US Army, during the engagement of the 9th of May" (Figure 9.3). An advertisement for Sarony and Major printed in *The New York Herald* on June 9, 1846, announces: "PICTURES OF AMERICAN VICTORIES. JUST PUBLISHED, four beautiful Pictures, illustrating the late victories over the Mexicans, viz: Battle of Palo Alto, Bombardment of Matamoros, Capture of General La Vega by Captain May, and Death of the gallant Major Ringgold" (Advertisement 3). The advertisement promotes their pictures as "the best and most faithful of the kind published" and invites orders from

Figure 9.3 "The Capture of General Vega, in the act of discharging a cannon, by the gallant Capt. May of the U.S. Army, during the engagement of the 9th of May." Lithograph by Sarony and Major, 1846.

any part of the U.S. at $6 per hundred. In Sarony and Major's reproduction of the Currier print in Figure 9.3, Captain May holds no visible weapon to force General Vega to surrender except a hard stare from his towering position on a gigantic black horse. The fallen hero at the side of the cannon is Lieutenant Z. M. P. Inge of the Second Dragoons, whose dead body lies sprawled on the ground beside the cannon in every depiction of this scene that I have examined. Johannsen writes that Sarony rushed his prints onto the market before accurate information was received and, like Currier and other lithographers, Sarony depicted Mexican battles being fought in tropical greenery unlike the territory of the Rio Grande area at Resaca de la Palma, meaning "dry ravine." Johanssen also suggests that Sarony's later print of street-fighting in Monterey was influenced by Delacroix's scenes of the 1830 revolution in Paris, reminding us that accuracy was of secondary importance (226). Sarony's lithograph probably appeared after Currier's first print because, like Currier's second print, it picks up reports that May overshot and returned to the battery line.

Gender and Genre in Replication

The market for purchasers of such prints was restricted to anyone with enough money to spare, such as middle-class readers who might also purchase magazines and women's periodicals. The *Columbian Magazine* features yet another image of Captain May's charge at Resaca de la Palma (not shown), designed by artist Jonathan Ludlow Morton and engraved by Henry S. Sadd "expressly for the *Columbian Magazine*" for publication in the August, 1846, issue. Although its subtitle is "Lady's and Gentleman's Magazine," offerings such as poetry, piano music, fiction, engraved illustrations, and elegant hand-colored fashion plates mark the *Columbian* as a genre for women's consumption, much like other publications of the period that combined elements of literary annuals with fashion and light news for domestic women. The image depicting Captain May's charge, however, displays many of the features common to the previous figures, and its presence in a woman's monthly magazine demonstrates ways that women were contributing war discourse. In this example, myths of Captain May's heroism are being expanded in a publishing genre far above the sensational penny press in price and sophistication. The image of Captain May's charge is adjacent to the monthly fashion plate and an article by Fanny Forrester that indirectly responds to and creates ideology about national identity also associated with the image.

During the Mexican War, music became a vibrant source for transferring nationalist values and war fever, and women's periodicals offered printed sheet music for middle-class women readers who often entertained visitors and family members at home. As noted by Johannsen,

> hundreds of poets and composers sought to oblige a public that saw in music a reflection of itself, its values, aspirations, and national character. Indeed, it has been said that the history of early 19th-century America can be told in terms of its music. (231)

Musicians accompanied special events organized to support the war effort and played commemorative music, often a form of viral replication since each performance was slightly different. As an unspoken conversation, music has the power to create meaning through emotional response. Compositions such as John Schell's "The Battle of Resaca de la Palma," published soon after the battle in 1846, served to further circulate for mass audiences the sensational newspaper reportage of Captain May's heroic role in the event.

Replication in Domestic Artifacts

Some voices from 1846 evidently insisted that Captain May's claim of capturing General Vega and his cannon was false; these reports said that the cannon and General La Vega were actually taken by the company bugler. Career army veteran Abner Doubleday's reminiscence of Captain May's charge mentions that "Another account says he [General Vega] was captured by a bugler before May's arrival" (59). John Chance offers as marginal evidence a brief reference in Samuel Chamberlain's bawdy, gossipy memoir of the frontier titled *My Confessions: Recollections of a Rogue* (posthumously published by Harper in 1956):

> All the buglers of the two Dragoon regiments hated May for claiming the capture of General La Vega at the Battle of Resaca de la Palma, when it was one of their own – Winchell of Company H, 2nd Dragoons – who took the Mexican prisoner. (Doubleday 102)

Chance corrects Chamberlain's memory by noting that the only bugler in the company with a similar name is Private Frederick Wonsell of May's 2nd Dragoons; thus the opposing perspective of May's unheroic theft of the bugler's victory is articulated by a man with a cloudy memory who self-identified as a rogue and whose evidence was "another account." Yet his story continues to reappear; a Time–Life book on the Mexican War, published in a 1978 series about the Old West, reprints an uncredited lithograph from the battle at Resaca de la Palma. In caption notes beside the illustration, author David Nevin writes: "Actually, May failed to hold the cannon and it was an obscure bugler who captured the general" (33). Under a cameo illustration of Captain May on the same page, Nevin continues with some degree of spite: "The boastful Captain May . . . undeservedly became a popular hero and was promoted to lieutenant colonel for his flashy but bungled attack at Resaca de la Palma" (33).

The textile used on a common Mexican War-era household comforter confirms the story with a detail from Sarony's lithograph of Captain May at Resaca de la Palma (Figure 9.4). Upon examination of the image one notices an obvious difference from the Sarony print: the presence of a man in musician's uniform placing a U.S. flag in front of the Mexican cannon. This cameo image is repeated every 13.5 inches on panels of the front side of a rare artifact, 80 × 85 inches in size, constructed around 1847–50 and held at the Dolph Briscoe Center for American History at the University of Texas at

Figure 9.4 Focus scene replicating the Sarony and Major lithograph on one side of the Winedale comforter textile, c. 1848.

Austin. This replication does not appear in any extant commemorative image I have viewed. Of the few surviving textile samples that depict battle scenes and heroes from the war, most are made from chintz fabric, which was thinner, more finely printed, and thus more expensive than the thick, coarse cotton displayed on the comforter in Figure 9.4. The coarse textile and primitive construction of the artifact indicate that it was printed for rapid, cheap distribution and made for utility, in contrast to the elegant quilted objects created by many accomplished needleworkers during the 1840s. Its drab color palette of brown, olive, gold, cream, peach and tan is common to cheap textiles produced by American printers during the 1840s. The red wool tufts connecting the layers together are easy and quick to make, thus suggesting that the comforter's maker was either unskilled or hurried. The overall printed pattern on the textile further contributes to the comforter's status as a common utility object; the design is occasionally scarred by narrow blank strips where no printing occurred because the loose, coarse weave of the cheap fabric caused it to fold over as cylinders rapidly pressed against the engraved plates and prevented the cloth between the folds from being printed.

In her study of Mexican War-era quiltmakers, Teri Klassen concludes that women of the 1840s identified themselves as patriotic citizens of

the new republic by glorifying "the nation and domesticity simultaneously" with their beautiful quilts (85). Uniquely American quilt patterns such as *Whig's Defeat, Mexican Rose, Harrison Rose, Democrat Rose*, and *Pride of Iowa* demonstrated women's desire to "support the prevailing social order" and "be recognized as active participants in society," as well as to show their support of the Mexican War effort (78). Klassen's fancy quilts are, however, aesthetically far superior in construction and materials to the rough utility comforter displayed in Figure 9.4. The comforter was not made as a keepsake to last for generations; nor was it an obvious symbol of feminine accomplishment. As Elaine Freedgood claims, though, domestic goods such as quilts and comforters represent "something that is and is not immediately clear to its beholders" (28). The rugged, humble comforter most certainly contributed to promoting the recent heroism of presidential candidate General Zachary Taylor for the election of 1848, and by some miraculous intervention it remains for us to examine, in spite of a depression in the cotton industry during the Civil War that designated all such utility items as war goods for heavy use in hospitals and battle zones.

The textile artist who helped to produce this unique replication moved Lieutenant Inge's dead body, evident in all other examples of the scene, to the lower left corner to make room for the bugler and his flag. Colors cannot be seen in my black-and-white illustration, but the lack of printed color in the soldier's brown uniform, compared to the green evident in other uniforms of soldiers in the foreground, is important as an indicator of the textile manufacturer's rush to print the replication without taking time to process another layer of color; sensational reportage about the bugler evidently reached the textile designers, who decided that a replication with the bugler detail must be distributed. Through the comforter, incontrovertible evidence remains, not of the truth of Captain May's charge but of replication across media for new social networks during the Mexican War era.

Replicating Women's Work

The alternate side of the comforter offers another example of replication that does not speak directly to Captain May's charge at Resaca de la Palma. It does, however, articulate a feminine language of domesticity and women's history that parallels the bloody effort of war. Although quilt patterns evolved from designs and techniques inherited from the mother country into distinctive all-over patchwork styles unique to the U.S. during the 1840s, the most common

form of patchwork in Britain and the U.S. during the nineteenth century was the mosaic hexagon style replicated on full panels of the Mexican War-era comforter (Figure 9.5). Quilters came to call this type of textile "cheater cloth" because it does not entail the handwork of piecing; rather, the textile replicates the handwork of piecing in a relationship similar to that of handwoven tapestry Kashmir shawls with factory-made imitations, as Suzanne Daly discusses in this volume. The hexagon design on the comforter and imitations of Kashmir shawls are printed replications of handwork and demonstrate nineteenth-century industrial-era responses to a growing market for affordable domestic goods that appealed to middle-class women's notions of class and beauty.

The textile shares a color palette with the commemorative fabric on the opposite side of the comforter, as well as its coarse weave, indicating that both came from the same manufacturer. The origins of the two textiles cannot be confirmed, but Florence M. Montgomery places this Mexican War fabric among "American Plate- and Cylinder-Printed Textiles" (343), making it a product native to the U.S. and an artifact of American work. New England textile manufacturers were in close proximity to lithographic and newspaper firms in New York, Philadelphia, and Boston, and the convenience of such

Figure 9.5 Replicated patchwork displayed on textile of the alternate side of the Winedale comforter, c. 1848.

resources would be essential for rapid production of images on fabric. Both textiles on the comforter in Figure 9.4 and 9.5 replicate meaning created by networks that included an American textile manufacturer, an American seamstress, and a distinctly American image that transforms the popular depiction of courageous Captain May's charge against the powerful Mexican battery into a democratic effort of officer and common man (and woman), sanctified by the powerfully iconic U.S. flag at the center of the object.

As Captain May's solo heroic effort is translated into a democratic display that unites the war effort with a common bugler through replication in the nineteenth century, a rough, plain, brown utility comforter becomes an icon of Texas pride and stubborn frontier individuality in the twenty-first, thanks to the efforts of a woman who was anything but common. Texas philanthropist and Governor's daughter Ima Hogg (1882–1975) purchased the comforter for use as a period bed cover in a restored 1830s house she relocated to her property, now known as the Winedale Historical Complex. According to the Dolph Briscoe Center for Texas History,

> Miss Hogg donated the Winedale campus to the university in 1967, envisioning a "laboratory for students in college to explore many fields associated with the history and culture of ethnic groups who migrated to Texas in the early part of the 19th Century." ("Winedale")

An image that contributed to the nineteenth-century nationalist ideology of Manifest Destiny and territorial aggression against Mexicans is now an artifact of cultural diversity.

Notes

1. In the negotiations leading to the Treaty of Guadalupe Hidalgo, signed at the war's conclusion on February 2, 1848, Mexico was forced to acknowledge Texas's independence and subsequent annexation, cede its claims to parts of what is now called the American Southwest (California, Nevada, Arizona, New Mexico, Colorado, Wyoming, and Utah), and accept $15 million as full settlement for war-related damages in Mexico just in time for the California Gold Rush of 1849. I am grateful to my colleague in Texas State University's History Department, J. F. de la Teja, Jerome and Catherine Supple Professor of Southwestern Studies and Director, Center for the Study of the Southwest, for details of the Treaty of Guadalupe Hidalgo.

2. The modern Internet term "viral" is used to describe rapidly propagating texts that circulated "promiscuously through the print market and were often revised by editors during the process." See Shaobin Xu, David A. Smith, Abigail Mullen, and Ryan Cordell, "Detecting and Evaluating Local Text Reuse in Social Networks," *Proceedings of the Joint Workshop on Social Dynamics and Personal Attributes in Social Media* (Baltimore: Association for Computational Linguistics, 2014): 51.

Works Cited

Advertisement, *The New York Herald*, June 9 (1846): 3.

"Captain May." *Boston Courier*, June 1 (1846): 1.

Doubleday, Abner. *My Life in the Old Army: The Reminiscences of Abner Doubleday from the Collections of the New-York Historical Society*. Ed. Joseph E. Chance. Fort Worth: Texas Christian University Press, 1988.

Freedgood, Elaine. *Ideas in Things: Fugitive Meaning in the Victorian Novel*. Chicago: University of Chicago Press, 2006.

"The Gallant Capt May." *The New York Tribune*, May 29 (1846): 1.

Johannsen, Robert L. *To the Halls of the Montezumas: The Mexican War in the American Imagination*. New York: Oxford University Press, 1985.

Klassen, Teri. "Polk's Fancy: Quiltmaking in the Mexican War Era." *Uncoverings* 27 (2006): 59–89.

Le Beau, Bryan F. *Currier & Ives: America Imagined*. Washington and London: Smithsonian Institution Press, 2001.

Lewittes, Esther. "The Mexican War on Printed Cottons." *Antiques* (October 1941): 212–15.

Montgomery, Florence M. *Printed Textiles: English and American Cottons and Linens 1700–1850*. New York: Viking Press, 1970.

Nevin, David. *The Mexican War*. Alexandria, VA: Time–Life Books, 1978.

Reilly, Tom. *War with Mexico! America's Reporters Cover the Battlefront*. Ed. Manley Witten. Lawrence: University Press of Kansas, 2010.

Stewart, Rick. "Artists and Printmakers of the Mexican War." *Eyewitness to War: Prints and Daguerreotypes of the Mexican War, 1846–1848*. Fort Worth: Amon Carter Museum, Smithsonian Institution Press, 1989.

Streetby, Shelley. *American Sensations: Class, Empire, and the Production of Popular Culture*. Berkeley: University of California Press, 2002.

Thorpe, Thomas Bangs. *Our Army on the Rio Grande*. Philadelphia: Carey and Hart, 1846.

"Winedale Historical Complex." Briscoe Center for American History, <https://www.cah.utexas.edu/museums/winedale.php> (last accessed May 16, 2017).

Xu, Shaobin, David A. Smith, Abigail Mullen, and Ryan Cordell. "Detecting and Evaluating Local Text Reuse in Social Networks." *Proceedings of the Joint Workshop on Social Dynamics and Personal Attributes in Social Media*. Baltimore: Association for Computational Linguistics, 2014.

Part III

Replication and Authenticity

Literary Replication and the Making of a Scientific "Fact": Richard Owen's Discovery of the Dinornis

Gowan Dawson

The nineteenth-century press's perpetual reprinting of extracts, abstracts, and other forms of syndicated text has been termed "literary replication" by the historian of science James Secord. Emphasizing how, in this complex process, "textual stability" is "difficult to achieve," Secord proposes that reprinted texts often become radically unstable and are denuded of the same range of meanings they previously held (126). Such instability might even be assumed to be a necessary component of Secord's model of literary replication, with the book historian Leslie Howsam, for instance, suggesting the "metaphor" that "like cells, texts replicate themselves, but with variants" (3). As I will demonstrate, however, the original meanings of reprinted texts do not inevitably mutate and can instead be retained, albeit with a great deal of supervision and even some morally dubious journalistic practices. The particular instance of literary replication I explore is that which occurred in the wake of Richard Owen's identification of the extinct struthious bird named the dinornis, or moa as it was called in indigenous traditions, whose discovery in 1839 was widely hailed as one of the greatest scientific accomplishments of the nineteenth century.

What was striking about Owen's discovery of the dinornis was that he predicted its erstwhile existence in New Zealand from only a broken piece of femur bone. Owen contended that his extraordinary prediction was accomplished through the law of correlation. This law, which had been formulated by Georges Cuvier in the 1790s, proposed that each element of an animal corresponds mutually with all the others, so that a carnivorous tooth must be accompanied by a particular kind of jawbone, neck, stomach, and so on that facilitates

the consumption of flesh, and equally cannot be matched with bones and organs adapted to a herbivorous diet. As such, a single part, even the merest fragment of bone, necessarily indicates the configuration of the whole. Owen's identification of the dinornis from a single "fragment of bone" was soon eulogized by his contemporaries as the "most striking and triumphant instance of the sagacious application of the principles of the correlation of organic structure enunciated by the illustrious Cuvier,—the one that may be regarded as the *experimentum crucis* of the Cuvierian philosophy" (Mantell 225–6).[1] There was, however, a problem with Owen's putative triumph of inductive reasoning.

The man who had brought the femur bone to him, a naval surgeon named John Rule, claimed that it was he who had first alerted Owen to the fact that the bone came from a bird. In fact, Rule published his own account of the dinornis in an article for the *Polytechnic Journal* in July 1843, in which he presented the much-heralded discovery of the giant bird as the result of a scientific collaboration with Owen in which his own contribution had been decisive. Explaining how a "large portion of femur was brought to me" when he was employed as a surgeon in the Antipodes before subsequently returning to London, Rule asserted that the "great care and circumspection with which Professor Owen described this interesting article has my warmest acknowledgements," but he nonetheless insisted that even before he "placed this rare specimen in natural history in the hands of Professor Owen," the "fragment of bone under consideration" was "clearly that of a bird of very great strength. It evidently did not belong to beast, fish, nor amphibious creature." In attempting to "prove the ornithic character of the fragment," Rule avowed that it was he, rather than Owen, who had "direct[ed] attention to the characteristic cancellous structure so prominently developed on its external surface." In fact, before meeting Owen he had already "sought, without finding, for the bone of some bird that might equal it in size . . . in the public and private rooms of the British Museum," and rather than then simply entrusting the fragment to Owen's specialist expertise, the two men had "together compared it with the largest thigh bones of the ostrich in the Museum of the College of Surgeons" (3, 7, and 8). The suggestion that it was Rule who first noticed the ornithic character of the fragmentary femur cast considerable doubt on Owen's insistence that his acclaimed inference instead relied solely on the Cuvierian law of correlation.

Yet, with hardly any exceptions beyond Rule's article in the *Polytechnic Journal*, the primacy of the law of correlation in the dinornis's identification remained uncontested throughout the nineteenth century.

It was not until the 1960s that Rule's contribution was again brought to light, and Owen's ostensibly "brilliant anatomical prediction" revealed to be "less simple and more interesting than at first appeared," although, as will be discussed at the end of this paper, Rule's vital role in the famous discovery continues to be overlooked even in the twenty-first century (Pantin 19). This enduring and almost universal acceptance of Owen's highly questionable version of the discovery was far from fortuitous. Rather, it is testament to the remarkably scrupulous control that Owen and his supporters exercised over how the dinornis's discovery was represented in all sectors of the Victorian print media, from the proceedings of specialist societies to mass-circulation magazines. Owen and his friends assiduously tracked the reprinting of texts relating to the dinornis, and helped ensure the replication of their own version of the discovery in various print formats. In fact, the proliferation of literary replication in the industrialized print culture of the nineteenth century allowed certain ideas to become settled and established, and others to be disregarded, and was integral to the construction of what counts as a scientific "fact." Such apparent facts rely on an acceptance of the authenticity of the claims on which they are based, although, significantly, authenticity needs to be acknowledged as something that is made rather than merely being inherent in particular objects or phenomena. The authenticity of Owen's claims were created, in part, by the control of their representation, with his highly partisan rendition of the dinornis's discovery becoming enshrined as an incontrovertible reality through a process of literary replication.

An Unpromising Fragment

On October 18, 1839, Owen, the Hunterian Professor at the Royal College of Surgeons, received a letter from Rule "offer[ing] for Sale a portion or fragment of a Bone" recovered from the "mud of a river . . . in New Zealand." The letter included the "six inches" of fragmentary bone which was valued at "ten guineas" with a request that "no injury be done to it, should it be rejected" (letter to R. Owen, October 18, 1839). A further enclosed missive from February 1837 explained that the broken femur had originally been sent to Rule, who had not yet visited New Zealand, by a relation in the colony. Recently returned from New South Wales, Rule had initially offered the bone to the British Museum, where John Edward Gray, the keeper of the zoological collections, recommended that he take it to Owen. As an Edinburgh-trained surgeon and a former member of the Royal

College of Surgeons (having been released in 1826 in order to join the Royal College of Physicians), Rule considered it unnecessary for an intermediary to contact the renowned Hunterian Professor on his behalf.

The Royal College of Surgeons declined the purchase of the bone, as the "price asked . . . was deemed too high," but not before Owen had made an "exhaustive comparison" of the "unpromising fragment," initially with "similar-sized portions of the skeletons of the various quadrupeds," and then with the "skeleton of the Ostrich." Here, it was at once apparent that, as Owen later recalled, "'The bone' tallied in point of size with the shaft of the thigh-bone in that bird," as well as exhibiting the same "reticulate impressions." Having been "stimulated to more minute and extended examinations," Owen eventually "arrived at the conviction that the specimen had come from a bird" as large as an ostrich, although with the "striking difference" that the "huge bird's bone had been filled with marrow, like that of a beast." While no other birds of comparable dimensions had hitherto been found in New Zealand, which had been settled by British traders and missionaries only since the end of the eighteenth century, it was clear that the fragmentary femur must have belonged to a flightless bird of extraordinary and unparalleled stature. Contradicting Rule's account in the *Polytechnic Journal*, Owen implied that these deliberations were undertaken alone, and it was only when the bone's "owner called the next day [that] I told him, with much pleasure, the result of my comparisons" (1879: 1:149n., iii, and iv).

On November 12, 1839, barely three weeks after receiving Rule's letter, Owen "exhibited the bone of an unknown struthious bird of large size, presumed to be extinct" before the fellows of the Zoological Society. He began by acknowledging that it "had been placed in his hands for examination by Mr. Rule, with the statement that it was found in New Zealand, where the natives have a tradition that it belonged to a bird of the Eagle kind" (1840: 169). This was a relatively accurate précis of the section of Rule's letter in which he alluded to the indigenous beliefs that "it was a bird of flight, not a bird of passage, as it never quitted the New Zealand forests." Significantly, however, Owen made no mention of Rule's own empirical observations on the fragment in the same missive, where he noted: "That it was a bird of great size and strength, the bone is evidence . . . Inspection shows that it belongs to a bird—and not a beast, nor a fish, nor amphibious animal" (statements later repeated in his *Polytechnic Journal* article) (letter to R. Owen, October 18, 1839). Denuding him even of his Edinburgh M.D., Owen presented "Mr. Rule" as merely the unwitting purveyor of a largely fallacious native tradition.

Instead emphasizing his own exhaustive process of comparison, Owen concluded that

> So far as a judgement can be formed of a single fragment . . . [and] so far as my skill in interpreting an osseous fragment may be credited, I am willing to risk the reputation for it on the statement that there has existed, if there does not now exist, in New Zealand, a Struthious bird nearly, if not quite, equal in size to the Ostrich. (1840: 170–1)

Owen's bold conjecture and dramatically avowed risking of his reputation was finally vindicated when, three years later, Owen received a consignment of miscellaneous bones from a missionary stationed in New Zealand. From these bones, Owen was able to reconstruct a giant wingless bird that appeared to confirm his earlier inference to a remarkable extent. When Owen announced his discovery to the Zoological Society in January 1843, he omitted all mention of Rule, even of the indigenous tradition that the bone belonged to an eagle he had previously been willing to acknowledge.

When, in later years, it became necessary for Owen to refer occasionally to Rule, he pointedly refused to name him, instead alluding loftily to merely "A correspondent of the 'Polytechnic Journal'" (1846: 326n.).[2] Rule was subsequently depersonalized still further, becoming only "an individual" in Owen's *Memoirs on the Extinct Wingless Birds of New Zealand* (1879: I:iii). This haughtiness towards Rule did not go unnoticed. In the 1930s the New Zealand politician Lindsay Buick remarked of Owen: "curiously enough . . . he is singularly reticent and indefinite regarding his dealings with this gentleman. When he does refer to him, it is merely as 'Mr. Rule', or as 'an individual', or as the 'vendor' of the bone." Buick, as his puzzled tone makes evident, did not realize the precise reason for this reticence, and he suggested, rather implausibly, that Owen might have deferentially "regarded him [i.e. Rule] as a surgeon rather than as a doctor of medicine, and as surgeons affect the title of 'Mr.' and not that of 'Dr.', Owen naturally gave him the surgeon's prefix" (51 and 59). The intimation that there was something "singularly . . . indefinite" about Owen's treatment of Rule nonetheless suggests an uneasiness about his conduct towards someone whom Buick considered a gentleman.

The putative prediction of the dinornis's erstwhile existence from the evidence of just a single bone became one of the most sensational and widely reported events of the entire nineteenth century, establishing Owen's reputation as the pre-eminent comparative anatomist in Europe. From *The Times* to *Chambers's Edinburgh Journal*, Owen's

remarkable feat of paleontological reconstruction was heralded in the press as one of the greatest scientific accomplishments of recent times. The discovery of the dinornis, however, could only be so strategically cultivated as the result of both scientific genius and pure philosophical induction if Rule's contribution was entirely expunged from the historical record. Rule's de facto rejoinder in the *Polytechnic Journal* to Owen's accounts of the discovery showed that his contribution to this extraordinary zoological feat could not be suppressed without considerable effort. And with the aggrieved surgeon still awkwardly haunting the margins of London's scientific society with his scandalous secrets into the 1840s and beyond, it was necessary for Owen's particular version of events to be adopted elsewhere in the press.

A Wonderful Bone

Commercial periodicals that attracted plebeian readers by their strikingly cheap cover prices were often unable to fill their pages with costly original copy. It was therefore common practice to supplement leading articles with reprinted passages extracted from noteworthy recent books, lectures, or reports in other journals. This "scissors-and-paste school of authorship," as Charles Knight dismissively termed it, originated in the eighteenth century, although it became more prominent with the weekly miscellanies that began in the 1820s and sought to keep readers abreast of the latest intellectual fashions and tastes (241). By the 1840s the practice was used more discreetly as particularly egregious instances drew widespread criticism, with *Chambers's Edinburgh Journal* condemning the "loose 'scissors and paste' style of publication . . . of the present day" ("A Newcastle Paper" 106). Despite these animadversions, however, *Chambers's* was not itself entirely averse to filling occasional columns with intriguing excerpts from other publishers' wares.

In the early 1850s, with Rule still at large and repeating his claims to whoever would listen, accounts of the dinornis's discovery that bore Owen's distinctive imprint began to appear in books by his close friends. In a philosophical treatise entitled *The Intellectual and Moral Development of the Present Age* (1853), the Welsh lawyer Samuel Warren insisted that, back in "the year 1839," an unnamed "shabbily-dressed man" had announced only that "he had got a great curiosity, which he had brought from New Zealand." There was no question, according to Warren, that "Professor Owen considered" the "fragment" without any prior indications as to "whatever animal it might have

belonged." It was only by not even deigning to acknowledge the existence of Rule's insinuations that Warren could maintain that his friend had undertaken a rigorously philosophical induction which "carried comparative anatomy much beyond the point at which it had been left by his illustrious predecessors" (59 and 55). Warren was a close friend of Owen's, and his account of the dinornis certainly included particular details of the disputed encounter with Rule – such as the spitefully specific avowal that the surgeon was "shabbily-dressed" – which only Owen could have told him.

The same source of inside information also enabled Warren to proffer an exclusive titbit to readers eager actually to encounter the famous fragment: "Any one in London can now see the article in question, for it is deposited in the Museum of the College of Surgeons in Lincoln's Inn Fields." It was, paradoxically, the very drabness and diminutive size of "this old shapeless bone," which, by making tangible the audacious and dramatic character of Owen's "immense induction of particulars," rendered it one of the exciting spectacles of metropolitan science, rivalling the more exceptional visual pleasures available at the capital's other sites of scientific instruction and entertainment (59 and 60).

When couched in such vivid language and accompanied by confidential details of the famous bone's whereabouts, Warren's partisan rendition of Owen's discovery of the dinornis proved irresistible to periodicals with spare column inches to fill. Soon after the publication of his *Intellectual and Moral Development*, Warren wrote to Owen relating how during a railway journey

> a stranger in the carriage was reading the monthly no. of "Chambers' Journal":—& he called my attention to an article entitled "*A Wonderful Bone*"—& behold, there appears *my* account (duly acknowledged) of *your* old bone!! It's in the no. for 12 March 1853. The gentleman was quite enchanted & said "I'm going tomorrow to Lincoln's Inn Fields to see the bone," & he added that he supposed thousands would now go to see it. Chambers' Journal sells they say (I believe) 60,000 if not more, a week. (letter to R. Owen, April 7, 1853)

Later in the letter, Warren complained that his book had been "*burked* by the London press," suggesting that it had suffered the same dismemberment as the cadavers supplied to anatomists by the notorious murderer William Burke (letter to R. Owen, April 7, 1853). His evident exhilaration at the no less brutal severing of a particular section from the book in an Edinburgh-based periodical, especially one notable for its large circulation but also able to attract

gentlemanly readers, suggests that, notwithstanding his fears of being "burked," Warren recognized the advantages of the "scissors and paste" system of reprinting extracts for generating publicity and increased sales.

With *Chambers's* titling their extract "A Wonderful Bone," a phrase more hyperbolic even than those actually used by Warren, the same advantages would have been no less apparent to Owen. After all, the passage from *Intellectual and Moral Development* reprinted in "A Wonderful Bone" retained and perpetuated the denigration of Rule, based on private information supplied by Owen, in Warren's book. The gentlemanly periodical reader in Warren's railway carriage certainly seemed convinced, even "enchanted," by the integrity of Owen's induction, and, along with thousands of other potential visitors, planned to come and witness for himself the spectacle of the diminutive bone from which the inference was made. The process of literary replication, which Warren hyperbolically likened to being "burked" by the press, enabled the carefully honed version of the events surrounding the dinornis's identification to permeate into mass-circulation periodicals like *Chambers's*.

Our Friend Dickens

Surveying the popular press in the mid-1850s, Charles Knight nominated as the two "most successful periodical works above a penny— 'Chambers' Journal', 'Household Words'" (288). The first of these bestselling journals had been induced to notice Owen's audacious prediction of the dinornis's past existence only via the convoluted "scissors and paste" system of reprinting extracts from books. With the second of Knight's nominations, the process was considerably smoother and much more direct. A year before "A Wonderful Bone" appeared in *Chambers's*, Owen received an urgent request from the office of *Household Words*, a new weekly costing 2d and with the considerable selling point of being edited by Charles Dickens. Owen had been a friend of the famous novelist since the mid-1840s, and on July 1, 1852, the sub-editor of *Household Words*, William Henry Wills, sent him the incomplete proofs of a prospective article, stating:

> I have bottled up as well as I was able what you were good enough to tell me. Will you kindly fill up the blank I have left & correct the errors which I fear I have made. The messenger will wait. The passage occurs in the last two paragraphs. (letter to R. Owen, July 1, 1852)

The text that Owen hurriedly corrected and completed as the messenger waited was published nine days later as "A Flight with the Birds" and, notably, its final paragraphs, precisely where Wills had left the blank for Owen to fill, featured an account of the dinornis, beginning indicatively, "About this gigantic bird we have a good deal to say" ([Morley and Wills] 383).

With license to amend and supplement what Wills had already gleaned from their conversations, Owen could surreptitiously enforce his own version of the contentious story of the struthian's discovery. The still unnamed Rule was relegated from a naval surgeon to a mere "sailor . . . dealing in . . . marine stores" (he was defamed still further in other periodical accounts, which labelled him an "illiterate seaman") ([Morley and Wills] 383; qtd. in Buick 50). The circulation of *Household Words* was only slightly smaller – at about 40,000 – than that of *Chambers's*, which had so impressed Warren. Wills's rushed request therefore represented an unmissable opportunity for Owen to ensure once again that it was his sanctioned interpretation of events which reached such a large readership.

Access to this increasingly important popular audience was by no means a given for men of science in the 1850s. When, for instance, Thomas Henry Huxley wished to influence the press coverage of a proposal for dispersing the British Museum's natural history collections, he told a correspondent, "I have written to Rob. Chambers requesting he will give us an article in Chambers Journal to show the advantages of our plan for the people—Can you get at the 'Household Words'? If one only knew that snob Dickens" (letter to J. D. Hooker, December 2, 1858). Huxley, like Knight, recognized which were the most influential of the cheap periodicals but his lack of personal contact with the haughty novelist meant that *Household Words* remained beyond his reach (and nor was he any more successful with *Chambers's*). Owen himself conceded, in private, that "Dickens has grown so arrogant," although he was prepared to overlook this exasperating pomposity while he was afforded the kind of access to *Household Words* that Huxley could only yearn after (qtd. in Adrian 134). In fact, within three months of Wills's request, Dickens had asked Owen to "write some familiar papers on Natural History, yourself, for this Journal" (6:780). Unsurprisingly, he once more availed himself of the chance to acclaim coyly that "eminent gentleman in charge of the unrivalled museum of . . . the College of Surgeons," as well as endorsing the validity of the method by which the "anatomist . . . is able to divine from a mere fragment of the skeleton, the nature and affinities of the animal of which it has formed part" (1853: 374).

The final paragraphs of "A Flight with the Birds" certainly attracted the attention of Owen's close friend William John Broderip, even if he did not realize who had actually written them. He remarked gleefully to Owen on July 12, 1852, "Look in the Times of to-day—paragraph headed 'a bird *twenty* feet high' with a voucher by our friend Dickens in 'Household Words.'" Just as *Chambers's* reprinted passages from Warren's *Intellectual and Moral Development* under its own improvised title, "A Wonderful Bone," so *The Times*, deploying the same practices of "scissors and paste" journalism, had extracted the particular paragraphs from *Household Words* relating the story of the dinornis's discovery. Although not knowing of Owen's direct involvement with the original article, Broderip, who as a magistrate helped Dickens to find female miscreants for his reformatory for fallen women at Urania Cottage, intimated that it was their mutual friendship with the campaigning novelist that had facilitated the dissemination of their particular version of the events of 1839, denigrating Rule and affirming the inductive credentials of Owen's inference, into the pages of Britain's most influential daily newspaper.

Owen's friendly relations with editors extended even across the Atlantic, where such informal contacts similarly enabled him to exert control over how the story of the dinornis's discovery was represented when it was reprinted in the American press. At the end of a long, convivial letter to Owen from July 1843, Benjamin Silliman, the Yale professor who both edited and financed the *American Journal of Science*, promised, "We shall always be happy to do any thing in our power to promote your important researches & the pages of the Am. Jour. are at your service" (letter to R. Owen, July 14, 1843). In the light of such an offer, it is hardly surprising that when an annotated abstract of Owen's next article on the dinornis, an offprint of which he himself had forwarded to Silliman, was carried in the *American Journal of Science* its readers were assured that Owen originally "received from New Zealand the single shaft of a femur" and made his inference "on this evidence alone." With Rule expurgated even more abruptly than he was in British accounts, the abstract was categorical in its assessment of the article's most salient contribution to science: "*This paper . . . affords us some beautiful and instructive examples of the wonderful principle of the correlation of structure in animals*" ([Hitchcock] 194). Notably, the *American Journal of Science*'s anonymous commentary was written by the New England geologist Edward Hitchcock, whose controversial interpretation of fossil footprints found in the Connecticut Valley as the only surviving remnants of unprecedentedly gigantic birds was dramatically corroborated by the advent of the dinornis.

Hitchcock's partisan glossing of Owen's article ensured that readers across the Atlantic received precisely the same sanctioned account of the dinornis's identification as their British counterparts.

The *American Journal of Science*'s annotated abstract of Owen's paper reveals that, even when literary replication occurs on a transatlantic scale, the original meanings of reprinted texts do not, as James Secord and Leslie Howsam suggest, inevitably mutate and instead can, with careful supervision, be retained. The private correspondence of both Warren and Broderip similarly shows how they assiduously tracked the reprinting of texts relating to the dinornis in *Chambers's* and *The Times*, evidently approving of the replicated versions that continued to propagate their own particular interpretation of the bird's disputed discovery. The original texts, moreover, had, unbeknownst even to Broderip himself, actually been either written by Owen or, as with Warren's book, prepared with his confidential advice.

Owen and his supporters engaged in a carefully orchestrated attempt to exercise control over the burgeoning range of meanings entailed in the process of literary replication, and, notably, they were successful in inducing publications as influential and widely read as *The Times* and *Chambers's*, or as geographically distant as the *American Journal*, to reprint what were, in effect, highly partisan and even deliberately distorted accounts of the dinornis as if they were merely exciting reports from impartial sources. The elaborate mechanisms of puffery and self-promotion facilitated by the conventions of "scissors and paste" journalism, anonymous authorship and the covert bonds of personal friendship ensured that certain forms of literary replication could be designed and deliberate as much as variable and volatile.

Conclusion: The Proverbial Dinornis

Emphasizing the difficulty of maintaining stable textual meanings in the process of literary replication, Secord notes that the "problem of stability extends far more widely, for attempts to reproduce the work also extended beyond the original bookseller, printer, or publisher" (126). In this formulation, literary replication takes place almost exclusively at a spatial level (after all, it happens "widely"), with a privileging of the process of extension in space at the expense of its occurrence in time. The long posterity of Owen's partisan account of the dinornis's discovery, however, indicates that literary replication occurs not only synchronically but also diachronically. Indeed, the story had become so established and authenticated by the final

decades of the nineteenth century that the *Pall Mall Gazette* could describe it as how "Professor Owen inferred the proverbial dinornis" ("Names of Novels" 10). There is no inevitable cutoff point for when textual material can be or is replicated, and often it continues to reappear in new print contexts for a very long time, contravening convenient – as well as largely arbitrary – historiographic boundaries. And a high degree of textual stability can be maintained even in such temporally distanced literary replications.

Nor have literary replications of Owen's putative discovery of the dinornis ended even now. In 2012 the Natural History Museum in London opened a new permanent exhibition displaying some of the most exceptional objects and specimens in the museum's extensive collections. In pride of place at the entrance to the "Treasures" gallery is the fragment of bone from which Owen ventured his daring inference of the past existence of the dinornis. As the electronic display next to the fragment, as well as the museum's website, explains to visitors under the heading "bold prediction":

> Owen's most dramatic scientific triumph came in 1839 when he studied a short fragment of bone discovered a few years earlier in New Zealand . . . Owen deduced it must have belonged to an . . . extinct flightless bird. Four years later the world was astonished when more bones revealed he was right . . . No one in Europe had seen anything like this monstrous bird before. By the time Europeans first arrived in New Zealand in the 1760s, they had already been hunted to extinction . . . It took Owen's genius to resurrect them.[3]

This, notably, is precisely the same version of the disputed events, with the drama of Owen's predictive genius foregrounded and the contribution of Rule entirely expunged, that Owen, his closest supporters, and their acolytes in the press had strategically propagated in the 1840s and 1850s. Their highly partisan rendition of the dinornis's discovery, which was central to establishing its authenticity as a scientific "fact," still persists in the digital media of the twenty-first century, and continues the very same process of literary replication that began 170 years earlier.

Acknowledgments

Parts of this paper were originally published in Chapter 3, "Discovering the Dinornis," of Gowan Dawson, *Show Me the Bone: Reconstructing Prehistoric Monsters in Nineteenth-Century*

Notes

1. Gideon Mantell, however, subsequently changed his opinion of Owen's apparent discovery of the dinornis when he heard John Rule's side of the story at first hand.
2. Rule's article in the *Polytechnic Journal* was signed, making Owen's omission of its author's name a clear snub.
3. From <www.nhm.ac.uk/nature-online/collections-at-the-museum/museum-treasures/moa-bone-fragment/> (last accessed September 29, 2017).

Works Cited

Adrian, Arthur A. *Mark Lemon: First Editor of "Punch."* London: Oxford University Press, 1966.

Broderip, William John. Letter to R. Owen, July 12, 1852. Richard Owen Papers 5:220, Natural History Museum, London.

Buick, T. Lindsay. *The Discovery of Dinornis: The Story of a Man, a Bone, and a Bird*. New Plymouth, New Zealand: Thomas Avery, 1936.

Dickens, Charles. *The Letters of Charles Dickens*. 12 vols. Ed. Madeline House, Graham Storey, and Kathleen Tillotson. Oxford: Clarendon Press, 1965–2002.

[Hitchcock, Edward]. "Bibliographical Notices: On Dinornis (I)," *American Journal of Science* 48 (1845): 194–201.

Howsam, Leslie. "Literary Replication: Jim Secord's *Victorian Sensation* and Models of Book History," *SHARP News* 15 (2006): 3–4.

Huxley, Thomas Henry. Letter to J. D. Hooker, December 2, 1858. Thomas Henry Huxley Papers 2.39, Imperial College of Science, Technology, and Medicine Archives, London.

Knight, Charles. *The Old Printer and the Modern Press*. London: John Murray, 1854.

Mantell, Gideon. "On the Fossil Remains of Birds Collected in Various Parts of New Zealand," *Quarterly Journal of the Geological Society* 4 (1848): 225–38.

[Morley, Henry, and William Henry Wills]. "A Flight with the Birds," *Household Words* 5 (1852): 381–4.

"Names of Novels." *Pall Mall Gazette*, September 11 (1867): 10.

"A Newcastle Paper in 1765–6." *Chambers's Journal* 17 n.s. (1852), 105–7.

Owen, Richard. "Exhibition of a Bone of an Unknown Struthious Bird from New Zealand," *Proceedings of the Zoological Society* 7 (1840): 169–71.

——. "On *Dinornis*, an Extinct Genus of Tridactyle Struthious Birds (II)," *Transactions of the Zoological Society* 3 (1846): 307–30.

[——]. "Justice to the Hyæna," *Household Words* 6 (1853): 373–7.

——. *Memoirs on the Extinct Wingless Birds of New Zealand.* 2 vols. London: John Van Voorst, 1879.

Pantin, C. F. A. *Science and Education.* Cardiff: University of Wales Press, 1963.

Rule, John. Letter to R. Owen, October 18, 1839. Richard Owen Papers 22:444(a), Natural History Museum, London.

——. "New Zealand," *Polytechnic Journal* 9 (1843): 1–13.

Secord, James A. *Victorian Sensation: The Extraordinary Publication, Reception, and Secret Authorship of "Vestiges of the Natural History of Creation."* Chicago: University of Chicago Press, 2000.

Silliman, Benjamin. Letter to R. Owen, July 14, 1843. Richard Owen Papers 24:34, Natural History Museum, London.

Warren, Samuel. *The Intellectual and Moral Development of the Present Age.* Edinburgh: William Blackwood, 1853.

——. Letter to R. Owen, April 7, 1853. Add. 39954, British Library, London.

Wills, William Henry. Letter to R. Owen, July 1, 1852. Add. 39954, British Library, London.

Copying from Nature: Biological Replication and Fraudulent Imposture in Grant Allen's *An African Millionaire*

Will Abberley

In his insightful study of "the copy" in Western culture, Hillel Schwartz observes that "The more adroit we are at carbon copies, the more confused we are about the unique, the original, the Real McCoy" (11). Although the original might exist theoretically, reproductions are liable to become so precise that we lose the ability to discriminate between original and copy. This vertiginous confusion is reflected in Grant Allen's detective novel *An African Millionaire* (1896) when a sting is organized to catch a shape-shifting conman known as Colonel Clay. The mining magnate Sir Charles Vandrift and his secretary Wentworth, who narrates the tale, have been defrauded several times by Clay. After meeting a suspicious art dealer named Dr. Polperro, however, who offers to sell them a portrait by Rembrandt, Vandrift and Wentworth believe they have finally seen through one of Clay's disguises. Having been scammed by Clay with similar offers in the past, Vandrift employs an expert to assess the painting's authenticity. The expert duly reports that the painting is, in Wentworth's words,

> not a Rembrandt at all, but a cunningly-painted and well-begrimed modern Dutch imitation. Moreover, he showed us by documentary evidence that the real portrait of Maria Vanrenen had, as a matter of fact, been brought to England five years before, and sold to Sir J. H. Tomlinson, the well-known connoisseur, for eight thousand pounds. Dr. Polperro's picture was, therefore, at best either a replica by Rembrandt; or else, more probably, a copy by a pupil; or, most likely of all, a mere modern forgery. (70)

Convinced that they have the elusive Clay in their grasp, Vandrift and Wentworth arrange to buy the painting and have Polperro arrested for fraud at the moment of the transaction. Hearing that a real art dealer named Dr. Polperro exists, they assume that Clay has stolen the man's identity. The would-be detectives are, however, grossly mistaken. Their case falls apart in court as the man they arrested is revealed to be the real Polperro, his picture a genuine Rembrandt, and the supposed original bought by Tomlinson a different painting sold under false pretenses. The "expert" who claimed to have exposed the inauthenticity of Polperro's picture, Wentworth explains, "turned out to be an ignorant, self-sufficient quack" (76). Vandrift has to compensate Polperro for false imprisonment and suffer a taunting letter from Clay, who hears of Vandrift's mistake and promises to continue to swindle him.

This episode resonates with prevalent anxieties near the end of the century about consumers' inability to distinguish copies from originals, which compelled them to trust specialists to judge for them (see, for example, the "refinement" associated with distinguishing Kashmiri shawls from Paisley "imitations" in Suzanne Daly's chapter). Although Allen suggests that a sufficiently educated and sensitive eye can determine authenticity of art works, in his fictional world most people lack such judgment and cannot even differentiate experts from charlatans. Various commodities and identities in the novel are misrepresented or misperceived as part of, or as a reaction to, Clay's deceptions. Although Allen's characters refer to the "genuineness" and "reality" of objects and people rather than their authenticity, the concern is always for origins (63, 51). The fake expert's speculation that the painting could be a replica, copy, or forgery illustrates the difficulty of discriminating between these statuses, which confer different proportions of authenticity and inauthenticity. A replica (in the strict sense), although not an original, can boast of proceeding from the same hand that made the original, while a pupil's copy at least came from someone who worked alongside the artist. A forgery, by contrast, is a mimicry that either resembles a particular work or reproduces common stylistic elements of an artist's output. Such mimicry is a form of replication with variations, and the task of differentiating the mimic from the original depends on detecting subtle differences beneath the obvious resemblances. While mimicry is a production or performance, resemblance is a matter of reception, and Allen's novel is more morally concerned with the latter than the former. Instead of condemning Clay for his fraudulent mimicries, Allen invites the reader rather to criticize Wentworth and Vandrift's

lack of discrimination, which causes them to mistake the fake for the authentic or, in the case of Polperro, the authentic for the fake. The victims' weakness, as the latter case shows, lies not only in their sloppy observations, which cause them to miss crucial details, but also, moreover, in their failure to interrogate the preconceptions on which their inferences are based.

Drawing on his extensive knowledge of evolutionary theory, Allen's novel conceptualizes fraud as an environmental adaptation comparable to protective mimicry, the tendency of animals to develop deceptive resemblances to other species or objects. Animal mimicry could consist of resembling another creature that had special defenses against predators or blending in with vegetation (a kind of organic camouflage). Such "mimicry" depended less on any intentions on the part of the animals than on other creatures' perceptions of them. Allen's conflation of commercial human society with the natural world served his socialist agenda, critiquing capitalism as a system built upon primitive foundations. Allen suggests that fraudsters like Clay are able to prosper only because the current order encourages ruthless competition and promotes mediocre philistines like Vandrift, who are no better than animal predators at distinguishing originals from mimetic replications. Allen implies that fraudulent mimicries (both of commodities and of identities) will be overcome only through the further development of science and civilization. Inspired by Herbert Spencer's model of progressive evolution, Allen envisaged a future of intellectual refinement and social cooperation in which deceptive mimicry would be both impossible and unnecessary. Allen was unclear about how this state could be achieved, however, and such teleology conflicted with his parallel commitment to Darwinian evolution, which was more open-ended. Reflecting this tension, Allen's novel often presents humanity as fated to live in fraudulent, inauthentic relations with itself.

Deceptive Mimicry as a Law of Nature

Grant Allen was born in Canada and studied at Oxford before working as a teacher in England and Jamaica. He broke into the London literary market as a science popularizer, then turned to the more lucrative field of fiction. Fired up by socialism and scientific naturalism, he sought to promote these radical ideas through novels such as *Philistia* (1884), *The British Barbarians* (1895), and his notorious "New Woman" tale *The Woman Who Did* (1895). Yet he

also complained that he was unable to write with sincerity, forced by market demands to pander to conventional morality. Conversely, Allen sometimes seemed to his contemporaries the archetype of the cynical hack, sacrificing artistic ideals for financial enrichment. Critics have often identified Allen as the model for Jasper Milvain in George Gissing's *New Grub Street* (1891), who boasts of making his fortune by churning out formulaic dross (see Morton 2; Rodgers and Greenslade 4–7). Allen had a strong grounding in biology and was on personal terms with many of its leading practitioners in Britain, including Alfred Russel Wallace and Henry Walter Bates, the men who had first theorized protective mimicry as a phenomenon. When Bates died in 1892, Allen praised him as "one of the profoundest scientific intellects I have ever known" (1892b: 798). Protective mimicry was a topic which Allen returned to repeatedly in his science writing, and I will outline the details of this theory, and Allen's response to it, before tracing its presence in *An African Millionaire*.

Naturalists have long recognized that many animals resemble things they are not: stick-insects merge with vegetation, and numerous moths and butterflies mirror other species. Before the nineteenth century, naturalists usually regarded these resemblances as insignificant aesthetic flourishes in God's creation (Blaisdell 14–16). The arguments of figures such as William Paley for understanding nature as a unified system, however, spurred a new emphasis on the adaptation of organisms to their environments. Natural historians increasingly considered how animals' resemblances to their surroundings or other species helped them survive, enabling them to hide from predators or sneak up on prey (Komárek 23–5). Charles Darwin's theory of evolution by natural selection, made public in 1859, offered a logical mechanism by which such resemblances might develop and be preserved due to their survival value. Darwin noted examples of protective coloration:

> When we see leaf-eating insects green, and bark-feeders mottled-grey; the alpine ptarmigan white in winter, the red-grouse the colour of heather, and the black-grouse that of peaty earth, we must believe that these tints are of service to these birds and insects in preserving them from danger. (84)

During the long gestation of Darwin's argument, Bates and Wallace had been in the Amazon, noting hundreds of uncanny resemblances between different moth and butterfly species of the country. More importantly, they realized that the mimic forms in a given area were always outnumbered by the models they copied. Bates and Wallace concluded that the models were protected by noxious tastes, which taught predators to avoid them. The more closely other insects

replicated these models' appearances, the more they would enjoy the same protection. The parasitic nature of the mimics, however, ensured that this protection worked only as long as there were fewer mimics than models. The more the mimics multiplied, the more they undermined the association between their appearance and inedibility, as predators discovered that they were actually edible. Hence, Bates noted, deceptive mimicry formed part of "the economy of nature" (558). Such theories about the animal world would catalyze the development of khaki military uniforms and, ultimately, camouflage techniques (Elias 73–4; Shell 25–6).

Recently, critics have explored how scientific studies of vision inflected Victorian literature, foregrounding the unreliable, inferential nature of sight (see Willis, Smajić). Allen was specifically interested in how vision, with all its partiality and unreliability, acted as a factor in the co-evolution of interacting species. His first books, *Physiological Aesthetics* (1877) and *The Colour-Sense* (1879), argued that animals' visual apparatuses had shaped many organisms' colors and morphologies, from the enticing hues of fruit to brightly patterned fur and feathers that attracted mates. He wrote the definition of "Mimicry" (in the biological sense) for the ninth edition of the *Encyclopædia Britannica* and repeatedly discussed the adaptive value of misperception in his science writing. Pastoral and Romantic traditions had frequently figured nature as truthful and authentic, in contrast to dishonest, corrupt human society (J. Miller 283–4; Pilkington 55). Allen contradicted this tradition, however, declaring:

> Human life and especially human warfare are rich in deceptions, wiles, and stratagems . . . Trade in like manner is full of shams . . . But Nature we are usually accustomed to consider as innocent and truthful. Alas, too trustfully: for Nature too is a gay deceiver. There is hardly a device invented by man which she has not anticipated: hardly a trick or ruse in his stock of wiles which she did not find out for herself long before he showed her . . . It is a fact in nature as in human life that to be successful is to have many imitators. (1901: 29)

Allen's description of animal disguises as humanlike "shams" might seem the kind of breezy metaphor that was common to late nineteenth-century popular science. Nonetheless, further examination of his comments on this topic suggests that his thinking went beyond mere metaphor and closer to literal equivalence. He repeatedly conflated human and animal deceptions, implying that they were governed by the same fundamental laws and could each be understood in terms of the other. Not only were mimetic animals comparable to human charlatans,

his readers were invited to think, but charlatans were comparable to mimetic animals.

Yet was not human imposture distinct from animals' protective resemblances by virtue of its deliberateness? In the twentieth century, Jacques Lacan would argue that only humans could consciously "play" with their appearance while animal camouflage and mimicry were fixed or automatic (107), a dichotomy that would be challenged by Jacques Derrida (119–25). The Darwinian paradigm of mimicry as an adaptation rendered this distinction irrelevant, however, by conceptualizing deception as primarily not the conscious transmission of a signal but the interpretation of it by a receiver (Maran 2–3). Wallace emphasized this point, writing that by *mimicry* he meant "that close external likeness which causes things really quite unlike to be mistaken for each other," a phenomenon separate from "voluntary imitation" but for which "there is no word in the language that expresses the required meaning" (17). The agency of the signaler mattered little in the struggle for survival. The crucial factor was the ability of the receiver to discriminate between true and false signals, between actual identities and misleading resemblances.

In this way, Bates's and Wallace's work remodeled deception from an individual, conscious vice to a semiotic arms race between animals' (including humans') discriminatory faculties and ever-finer resemblances. Investigators of protective mimicry noted that such resemblances fooled humans as often as they did animals, and Allen viewed the public's obliviousness to most animal impostures as evidence of humans' imbrication in the same world of adaptive deception. He remarked that, like the animals duped by these false resemblances, "Unobservant people see only the obvious . . . But the world about us teems with unobtrusive, skulking life" (1901: 115). Allen further accentuated the animal–human parallel in a description of mantises, whose close resemblance to termites enabled them to enter termite nests and eat individual inhabitants without attracting the attention of the majority. Like humans baffled by the repeated disappearance of members of their own community, Allen wrote, the termites would perhaps become more vigilant and

> carefully avoid all doubtful looking mantises; but, at the same time, they would only succeed in making the mantises which survived their inquisition grow more and more closely to resemble the termite's pattern in all particulars. For any mantis which happened to come a little nearer the white ants in hue or shape would thereby be enabled to make a more secure meal upon his unfortunate victims . . . The more cunning you get your detectives, the more cunning do the thieves become to outwit them. (1887: 152)

Allen's comparison of the mantises and termites to thieves and detectives absorbs human "cunning" and its associated agential actions into the Darwinian paradigm of predictable adaptation. Elusive criminals become mere extensions of the animal mimic, surviving through false resemblances that are too fine for their victims to discriminate. Again, what matters is less the agency of the deceivers than the inability of the deceived to differentiate false signals from genuine ones.

Development through Discrimination

Allen imagined discrimination as a key factor in human progress and the lack of it as a symptom of primitiveness. He developed this notion through his reading of Spencer, who claimed that each organism's sensations grew increasingly subtle along with its general complexity (Taylor 84–5). Allen once hailed Spencer as "the greatest philosopher that ever drew breath," and echoed his mentor's view in his early science writing (1904: 613). "The simplest aesthetic feelings precede the more complex, and the vivider precede the fainter," Allen asserted, arguing that animals, "children and savages" perceived mainly bold colors and forms while only civilized adults appreciated "more delicate shades" (1879: 233). Precise scientific instruments seemed to herald the next stage of this perceptual evolution as Allen celebrated "the man of science, accurately measuring everything" with a "delicately discriminative sense of sight" refined by "microscopes and micrometers" (1881: 470).

Allen viewed this growth of discrimination as a moral as well as mental development, linking it with self-restraint and an increasingly selfless commitment to truth. The Victorian man of science was often idealized as a paragon of self-control, suppressing the temptation to make unsupported inferences and austerely limiting his interests to verifiable facts (White 77–8; Levine 3–5). Allen illustrated this ideal in his early tale "Our Scientific Observations on a Ghost" (1884b, first published in 1878), in which a man of science, Harry, encounters an apparition but refuses to concede that he has seen a ghost because he is unable to test such a perception. Harry explains:

> At the best we can only say that we saw and heard Something . . . To leap at the conclusion that the Something was therefore a ghost, would be . . . a most unscientific and illogical specimen of that peculiar fallacy known as Begging the Question. (337)

The highly evolved eye both discriminates fine visual differences and reflects critically on itself, parsing sensory data from chains of inference.

Discriminating between originals and imitations, authentic identities and imposters, had grown in urgency through the century as developing urban life and global networks of exchange created new opportunities for deception. This problem was captured in the public imagination throughout the century by accounts in the periodical press of "protean swindlers," for whom "Court rooms, prison cells and scaffolds became stages" to show off their acting skills to "appreciative onlookers" (Brewer 4). The fragility and replicability of identities in the modern world was highlighted most famously in the Tichborne case, which related to the baronet Roger Tichborne, who had been lost at sea in 1854. More than a decade later, a butcher from Australia presented himself to Tichborne's mother, who instantly accepted him as her lost son. Although the subsequent inquiries and court case eventually concluded that the man was not Tichborne, thousands of people donated money, signed petitions, and protested to support his claim, while the claimant toured the country addressing crowds (see McWilliam 2–3). The case demonstrated the potential difficulty of discriminating forged identities from genuine ones as lawyers argued over the supposed resemblances and differences between an old daguerreotype of the young Tichborne and the claimant's current features. While counsel for the Tichborne family claimed that Tichborne's ears had been visibly different to those of the defendant, the claimant's lawyers exhibited a blended image of the daguerreotype with a photograph of the claimant, which supposedly showed the consistency of their features (Higgs 31–2).

Allen's *An African Millionaire* refracts these anxieties about forged identities through its criminal protagonist. After Wentworth and Vandrift have been defrauded by Clay for the first time, a police official explains to them that the man earned this sobriquet

> because he appears to possess an India-rubber face, and he can mould it like clay in the hands of the potter. Real name, unknown. Nationality, equally French and English . . . Profession, former maker of wax figures to the Musée Grévin. Age, what he chooses. Employs his knowledge to mould his own nose and cheeks, with wax additions, to the character he desires to personate. (19)

Clay's accent, hair, eyebrows, complexion, eyes, nose, and even his height are constantly changing. He enters Vandrift's orbit in a variety

of guises, as a young curate, an old German chemist, a Spanish mind-reader, an Austrian prince, an American doctor, and an English poet. Many of these personas are not merely disguises but also precise mimicries of real, living people, as Wentworth and Vandrift discover when they finally catch Clay and put him on trial. The imposter defends himself by asking Vandrift if he recognizes a photograph of Clay in his disguise as a curate. When Vandrift confirms that he does, the curate pictured in the photograph rises to his feet in the court gallery. The narrator comments:

> It was – to all outer appearance – the Reverend Richard Brabazon *in propriâ personâ*. Of course I saw the trick. This was the real parson upon whose outer man Colonel Clay had modelled his little curate. But the jury was shaken. And so was Charles for a moment. (304)

Clay's final imposture is of Vandrift himself, when Clay appears at the millionaire's bank and withdraws thousands of pounds in his name. Like an insect adapting to its environment by mimicking other species, Clay adapts to the capitalist struggle for survival by mimicking other people.

The comparison between Clay's social parasitism and the parasitism of mimic butterflies is made explicit in one episode when Clay strands Vandrift on a remote island and taunts him from a boat. Declaring himself "your parasite," Clay notes that his defrauding of Vandrift depends on the latter's inability to detect his disguises, just like a mimetic animal's relationship to its antagonists. He explains:

> The fact of it is, sir, your temperament and mine are exactly adapted one to the other . . . I can catch you just where you are trying to catch other people . . . There, sir, you have the philosophy of our mutual relations. (129)

Wentworth directly invokes Wallace's lepidoptera when he describes Clay as "polymorphic" (158, 272). Wallace had coined this term to denote butterflies that mimicked multiple species, sometimes as many as seventeen, depending on their environment (Mallet 108). Clay functions similarly, adapting his disguises to different locales. In places where Vandrift is frequently surrounded by sycophantic harpies and snake-oil salesmen, Clay appears as innocent characters uninterested in money such as a curate or scientist. Polymorphism also ensures that mimicking species remain rare enough to enjoy the protection of their models. Equally, Clay's myriad metamorphoses

leave Wentworth and Vandrift in perpetual uncertainty. Several times, Clay's previous disguises cause them to accuse innocent parties (such as the art dealer Polperro) of being Clay simply because they are types of people that he previously mimicked. Upon meeting the criminologist Dr. Beddersley, who helps finally to arrest Clay, Wentworth confesses: "I suspected [him] at sight of being Colonel Clay himself in another of his clever polymorphic embodiments" (272). As in nature, deceptive mimicry occurs in shifting networks of perceptions and associations. Like predators searching for food, humans are compelled to trust unexamined appearances in order to get on with the business of life. Mimics can successfully hide within the economy of appearances as long as they are not too prolific or consistent.

Numerous critics have argued that the genre of detective fiction responded to modern anxieties about imposture and fraud by idealizing science as a means of discovering and policing true identities (Moretti 135–7; D. A. Miller 69; Pittard 106). Ronald Thomas observes that, through the century, emphasis shifted in the judiciary from witness testimony to material, circumstantial evidence as moral judgments of defendants' characters were supplanted by efforts to verify identities objectively (10–12). In this context, the literary figure of the detective used "strategies of interpretation and authentication" in a fantasized unmasking of the deceptive criminal body (3). Detective fiction promised to restore the stability of identity that modern conditions had disrupted. *An African Millionaire* ultimately conforms to this tendency, ending with the chameleonic Clay being convicted and imprisoned for fraud. This end is achieved thanks to the piercing gaze of science, which penetrates Clay's various disguises to reveal his real face underneath. Similarly to the way naturalists used methodical study to distinguish mimetic specimens from their models, the professional criminologist Beddersley compares photographs of Clay in different guises to reconstruct his true, underlying features. Beddersley pierces through Clay's make-up and prostheses using a combination of Galton's composite photographs and Alphonse Bertillon's criminal biometry. By comparing Clay's many, altered replications, Beddersley is able to sketch a "compound face" of consistent features (263). Wentworth observes,

> though he [Clay] could make up so as to mask the likeness to his other characters, he could not make up so as to mask the likeness to his own personality. He could not wholly get rid of his native build and his genuine features. (281)

Further, the photographs echo the naturalists' method of unmasking mimics by dissection, literally probing beneath their surfaces. Allen wrote of insect mimicry:

> It is only in external matters, however, that the appearance of such mimetic species can ever be altered. Their underlying points of structure and formative detail always show to the very end (if only one happens to observe them) their proper place in a scientific classification. (1887:153)

The investigators in Allen's story similarly dissect Clay by using a fictional photographic process that "reveals textures" (276). This technology penetrates the layers of make-up and India rubber, discovering the deeper structures of Clay's face. Like an anatomist revealing the contents of a specimen's body, Beddersley states, "Look here; that's an artificial scar, filling up a real hollow; and this is an added bit to the tip of the nose; and those are shadows, due to inserted cheek-pieces, within the mouth, to make the man look fatter!" (280). Clay echoes the notion of science overcoming nature's deceptions, remarking when the protagonists arrest him, "If you've tracked me strictly in accordance with Bertillon's methods, I don't mind so much. I will not yield to fools; I yield to science" (286). As in many of Conan Doyle's detective stories, science seems to function to reassure the reader that all deceptive replications will ultimately be detected and true identities restored.

Nonetheless, this ending lies deeply at odds with the majority of the novel, which generally revolves around the failure of would-be detectives to discriminate genuine identities from contrived replications. The narrative begins with Wentworth and Vandrift attempting to expose a man who claims to possess psychic powers. The sensation of the mysterious seer, however, turns out to be merely a ruse by Clay to draw in the proud skeptic Vandrift and defraud him while his attention is diverted. The novel continues through various episodes in which Vandrift and Wentworth watch out for Clay, only for him to swindle them repeatedly with fresh personas and misdirections. Unlike Allen's ideal scientific researcher, Wentworth and Vandrift draw inferences based upon superficial impressions and stereotyped preconceptions. In this way, they resemble the animals deceived by protective mimicry, which failed to distinguish between models and mimics because they failed to look carefully or critically enough. For example, in one of his disguises as an old chemist, Clay appears to Wentworth as "a remarkable-looking man, once tall, I should say, from his long, thin build, but now bowed and bent with long devotion

to study and leaning over a crucible" (143). We later learn, however, that Clay "produced the illusion of a tall bent man" by "imitating a stoop with padding at his back" (169). Wentworth's perceptions of Clay are shown to be impressionistic rather than objective, noticing mainly deviations from population norms. "The Colonel in his simple disguise" is described uselessly as "a bland-looking young man, with no expression worth mentioning" (19). Wentworth also despairs that he and Vandrift are constantly "slaves of preconceptions" as they fail to spot Clay in his new disguises because they expect him to resemble previous incarnations. Clay's use of a wig for one disguise causes them later to suspect another man with similarly thick, shaggy hair and attempt to pull off what they believe is a wig. The hair turns out to be real, though, causing much embarrassment to Vandrift and Wentworth, and preventing them from realizing that Clay is in their presence again. Their assumption that authentic identities could be distinguished from contrived ones by the mere presence or absence of a wig testifies to the men's simple-mindedness, proceeding through trial and error rather than systematic reasoning.

Capitalism as Darwinian Deception

Wentworth and Vandrift's lack of discrimination and reflection forms part of Allen's general critique of capitalism as a primitive state of existence. Allen's essays frame capitalism as a system that relies upon and encourages mindless, indiscriminate impulse-gratification. For example, in "Democracy and Diamonds" (1891), he presents the public's reverence for diamonds as symptomatic of their inability to discriminate originals from imitations and the beautiful and useful from futile baubles. Diamonds had no special luster that could not be replicated by paste, Allen states, as most people's inability to distinguish the two showed. The popularity of diamonds, then, proceeds from a "vulgar," "barbaric" attraction to eye-catching objects and "monopolistic" urge to possess anything rare (670–1). Socialism will be achieved, Allen writes, only when humans have transcended these primitive "Monopolistic instincts . . . The test of a man's place in the scale of being is how far he has outlived them. They are surviving relics of the ape and tiger" (1894: 80). By linking lack of discrimination with avarice, Allen frames the consumer as the opposite of the disinterested scientist: while the scientist cares only for objective truth, consumers care only for their primitive, egoistic desires for power, status, and bodily pleasure.

Allen claimed that humans' aesthetic senses, along with their reasoning powers, evolved towards ever-increasing "disinterestedness"

(1879: 244). While primitive organisms' perceptions were closely linked to immediate, physical urges such as hunger and sex, civilization appreciated beauty and truth as ends in themselves. The cultivation of art, Allen wrote, showed the aesthetic sense "becoming more and more divorced from life-serving functions." In contrast to the restrained, discriminating aesthete or scientist, he continued, "babies automatically strive to place every bright object which they see between their lips" (1879: 222, 237). This image of primitive, indiscriminate omnivorousness is echoed in Allen's description of the Victorian public, whose consumption is similarly indiscriminate with regard to jewelry. Presented with paste, he wrote, the public would still declare, "How it shines! How it sparkles!," convinced that they beheld a diamond (1891: 668). In these ways, Allen suggested an equation between capitalist philistinism and the uncritical, undiscriminating primitive mind.

This equation is fundamental to the satire of *An African Millionaire*. Vandrift's vulnerability to Clay stems from his monopolistic impulsiveness. His urge to dominate others renders him unable to assess situations calmly and objectively, and sends him rushing into Clay's traps. For instance, Clay steals diamond cuff-links from Vandrift and then wears them in his persona as a curate, who claims that they are mere "paste" (36). This ruse causes Vandrift to buy the diamonds back, believing he is cheating the innocent curate out of their true value, while failing to notice discrepancies in the curate's story. Vandrift is similarly conned into parting with money supposedly to buy a castle. In one of his later taunting letters, Clay points out that his disguise as an Austrian aristocrat, the supposed seller, was flawed by an imperfect accent. Any suspicions that Vandrift might have had are overcome by his impulsive greed, however, as he surveys the building and exclaims, "I must and will have it!" (88). Allen further highlights Vandrift's primitiveness when the magnate seizes Clay's hair, mistaking it for a wig, during one of the Colonel's impostures. With tufts of torn-out hair in his fist, Vandrift can only stammer the apology: "It was an impulse . . . An instinctive impulse!" Clay (disguised as an American) rebukes him with the Spencerian dictum, "Civilised man restrains his impulses" (229). The notion that Vandrift's gullibility proceeds from his barbaric hunger for power and status is voiced explicitly when Clay strands Vandrift on an island. Taunting the millionaire, Clay explains:

> I can catch you just where you are trying to catch other people . . . I lead you on, where you think you are going to gain some advantage over others; and by dexterously playing upon your love of a good bargain, your innate desire to best somebody else – I succeed in besting you. (129)

Vandrift resembles an animal pouncing impulsively at shadows, unable to hold back and evaluate his perceptions. Clay, despite his criminality, embodies the force of progress, exposing the primitiveness of capitalism that recapitulates the conditions of nature's struggle for existence (and therefore also its chaotic deceptions and inefficiencies).

Nonetheless, Allen struggled to articulate how primitive capitalism might be replaced by a new order of cooperation, discernment, and disinterested intellectual inquiry. However revolutionary and detached Clay might seem, he still remains embedded in the struggle for survival, seeking to extract money from Vandrift. The fraudster proposes no alternative system to ruthless capitalism, in which he has merely carved out a special niche. Indeed, Clay revels in his criminal deceptions, taunting Vandrift:

> I have chosen to fasten upon you. Regard me, my dear sir, as a microbe of millionaires, a parasite upon capitalists . . . As long as I find such good pickings upon you, I certainly am not going to turn away from so valuable a carcass. (129)

Clay's combination of advanced intelligence with self-professed parasitism resonates more with Darwin's non-teleological view of evolution than Spencer's vision of progress towards physical, mental, and moral perfection. Clay's impostures recall the endless arms race described by Allen, in which the mantis "criminals" work to escape the discriminating eyes of the termite "detectives." As long as humans are forced to compete with each other, it seems, their perceptual and mental acuity will only produce subtler forms of deceptive mimicry. To transcend nature's cycle of dishonest replication, Allen argued that humans needed to exorcize their selfish "monopolistic instincts."

Yet he was often pessimistic about the attainability of such progress by mere education and social engineering. Primitiveness was as much hereditary as sociological, he maintained, and therefore could not be overcome in one generation. Allen expressed this sentiment in a review of the American social theorist Lester Ward's *Dynamic Sociology* (1883), which argued that a better society could be rapidly built through universal scientific education. Currently, Allen declared, too many people were too stupid to recognize the value of such education or to benefit from it. He concluded, "Only by gradual increase of the knowing few at the expense of the ignorant or wrongheaded many can a public opinion arise which would even tolerate

a national system of scientific education." This change would be a matter not of changing minds, he wrote, but of allowing the duller ones to die out in "the slow action of that wasteful genetic process" (1884a: 310). Although interested in eugenics, Allen was skeptical of its feasibility. Progressive social critics, he wrote, could therefore observe the world around them only with "an attitude of 'refined despair'" (311). Capitalism, and the deceptive replications that came with it, seemed to Allen inescapable, at least in his own lifetime.

This political pessimism fitted with a more general cynicism about his work as a novelist. Allen complained that the literary market demanded conformity to the tastes of morally conventional readers, imaged in the matronly stereotype of "Mrs. Grundy" (see Allen 1892a). Yet the problem was not only conventional morality, Allen claimed, but also a more general lack of discrimination and reflection. While authors tried to stimulate fresh thought, he claimed, most readers sought and recognized only triggers to physical excitement. "The purpose of fiction is to interest and amuse the reader," Allen told an interviewer. "Most novelists are bursting with ideas which they wish to impart to the world; but the world doesn't want their ideas; it wants a good, rousing, rattling, sensational story" (qtd. in Richards 267). Allen's description frames the mass reading public as akin to the impulsive, undiscriminating animals manipulated by protective mimicry. Popular authors, he implied, captured audiences with purple prose and melodramatic incident, as unsubtle in their way as the dazzle-colors on an animal's body. Allen showed that he viewed the relationship between authors and readers in biological terms in an 1885 letter to his friend George Croom Robertson, writing: "I shall make novels pay. I'm almost sure I have ability enough to accommodate myself to the environment" (1885: n.p.).

Allen's professional novelist seemed a parasite upon the masses in a similar way to how Clay figured himself as a parasite upon millionaire philistines. Although Allen stirred up controversy with novels such as *The Woman Who Did* and *The British Barbarians*, he always found himself returning to conventional potboilers to pay the bills. In an article called "The Trade of the Author" (1889), he expressed resignation about the insincerity of popular literature, writing,

> If you don't supply what the public wants, somebody else will step in and oust you; and the somebody else will survive in the struggle for life, while you go to the wall or into the workhouse. That is the gospel according to Darwin and Malthus applied to art. (269)

While scorning the public's indiscriminateness, he also felt reliant upon it as he survived through a kind of literary mimicry. "For years," he told an interviewer from the *Pall Mall Gazette*, "I have been trying hard as a matter of business to imitate the tone of the people from whom I differ in every possible idea" ("'Colin Clout'" 2). Like Clay, far from transcending nature's deceptive replications, Allen found himself living off them.

Allen's engagement with these issues shows how evolutionary thought had the potential to complicate ideas of replication and authenticity. From the perspective of Darwinian survival and adaptation, the origin of an object mattered less than its effect on viewers and its capacity to trigger perceptual cues. Far from being an aberration, then, the fraudulent imposter could be reconceptualized as an inevitable by-product of a competitive environment in which different parties possessed imbalanced powers of resemblance and discrimination. Allen dreamed of a future in which humans might outgrow nature's arms race between imposters and detectives, but he failed to sketch a clear path for making this ideal a reality. His novel of criminal imposture ultimately sounds a pessimistic note on the matter, suggesting that humans are doomed for the foreseeable future to be either the dupes or the purveyors of deceptive replications.

Acknowledgments

The research for this chapter was funded by a Leverhulme Trust Early Career Fellowship.

Works Cited

Allen, Grant. *Physiological Aesthetics*. London: H. S. King, 1877.
——. *The Colour-Sense: Its Origin and Development. An Essay in Comparative Psychology*. London: Trübner & Co., 1879.
——. "Sight and Smell in Vertebrates." *Mind* 6 (October 1881): 453–71.
——. "*Dynamic Sociology, or Applied Social Science, as Based upon Statical Sociology and the Less Complex Sciences* by Lester F. Ward." *Mind* 9 (April 1884a): 305–11.
——. "Our Scientific Observations on a Ghost" [1878]. *Strange Stories*. London: Chatto and Windus, 1884b: 321–40.
——. Letter to George Croom Robertson, February 23, 1885. Robertson Papers, University College Library, University of London. MS.Add.88/12.

——. "Strictly Incog." *Cornhill Magazine* 8 (February 1887): 142–57.

——. "The Trade of Author." *Fortnightly Review* 51 (February 1889): 261–74.

——. "Democracy and Diamonds." *Contemporary Review* 59 (May 1891): 666–77.

——. "Fiction and Mrs. Grundy." *Novel Review* 1.4 (July 1892a): 294–315.

——. "Bates of the Amazons." *Fortnightly Review* 58 (December 1892b): 798–809.

——. *Post-Prandial Philosophy*. London: Chatto and Windus, 1894.

——. *An African Millionaire* [1896]. London: G. Richards, 1898.

——. *In Nature's Workshop*. Toronto: William Briggs, 1901.

——. "Personal Reminiscences of Herbert Spencer." *Forum* 35 (April 1904): 610–28.

Bates, Henry Walter. "Contributions to an Insect Fauna of the Amazon Valley. Lepidoptera: Heliconidae." *Transactions of the Linnean Society* 23.3 (1862): 495–566.

Blaisdell, Muriel. *Darwinism and its Data: The Adaptive Coloration of Animals*. London: Garland Publishing, 1992.

Brewer, William D. *Staging Romantic Chameleon Imposters*. Basingstoke: Palgrave Macmillan, 2015.

"'Colin Clout' at Home: An Interview with Mr. Grant Allen." *Pall Mall Gazette*, November 4, 1889: 1–2.

Darwin, Charles. *On the Origin of Species*. London: John Murray, 1859.

Derrida, Jacques. *The Animal That Therefore I Am*. Trans. David Wills. New York: Fordham University Press, 2008.

Elias, Ann. *Camouflage Australia: Art, Nature, Science and War*. Sydney: Sydney University Press, 2011.

Higgs, Edward. *Identifying the English: A History of Personal Identification, 1500 to the Present*. London: Continuum, 2011.

Komárek, Stanislav. *Mimicry, Aposematism, and Related Phenomena: Mimetism in Nature and the History of its Study*. Munich: Lincom, 2003.

Lacan, Jacques. *The Four Fundamental Concepts of Psychoanalysis*. Trans. A. Sheridan. London: Penguin, 1977.

Levine, George. *Dying to Know: Scientific Epistemology and Narrative in Victorian England*. Chicago: University of Chicago Press, 2002.

McWilliam, Rohan. *The Tichborne Claimant: A Victorian Sensation*. London: Continuum, 2007.

Mallet, James. "Wallace and the Species Concept of the Early Darwinians." *Natural Selection and Beyond: The Intellectual Legacy of Alfred Russel Wallace*. Ed. Charles Hyde Smith and George Beccaloni. Oxford: Oxford University Press, 2010: 102–13.

Maran, Timo. *Mimicry and Meaning: Structure and Semiotics of Biological Mimicry*. Cham: Springer, 2017.

Miller, D. A. *The Novel and the Police*. London: University of California Press, 1988.

Miller, James. "Authenticity, Sincerity and Spontaneity: The Mutual Implication of Nature and Religion in China and the West." *Method and Theory in the Study of Religion* 25 (2013): 283–307.

Moretti, Franco. *Signs Taken for Wonders: Essays in the Sociology of Literary Forms*. Trans. Susan Fischer. London: NLB, 1983.

Morton, Peter. *The Busiest Man in England: Grant Allen and the Writing Trade, 1875–1900*. New York: Palgrave Macmillan, 2005.

Pilkington, A. E. "'Nature' as Ethical Norm in the Enlightenment." *Languages of Nature: Critical Essays on Science and Literature*. Ed. L. J. Jordanova. London: Free Press, 1986. 51–85.

Pittard, Christopher. *Purity and Contamination in Late Victorian Detective Fiction*. Farnham: Ashgate, 2011.

Richards, Grant. "Mr. Grant Allen and His Work." *Novel Review* 1.3 (June 1892): 261–8.

Rodgers, Terence, and William Greenslade. "Resituating Grant Allen: Writing, Radicalism and Modernity." *Grant Allen: Literature and Cultural Politics at the Fin de Siècle*. Ed. Terence Rodgers and William Greenslade. Aldershot: Ashgate, 2005: 1–22.

Schwartz, Hillel. *The Culture of the Copy: Striking Likenesses, Unreasonable Facsimiles*. New York: Zone Books, 1996.

Shell, Hannah Rose. *Hide and Seek: Camouflage, Photography and the Media of Reconnaissance*. New York: Zone Books, 2012.

Smaji , Srdjan. *Ghost-seers, Detectives, and Spiritualists: Theories of Vision in Victorian Literature and Science*. Cambridge: Cambridge University Press, 2010.

Taylor, Michael W. *The Philosophy of Herbert Spencer*. London: Continuum, 2007.

Thomas, Ronald R. *Detective Fiction and the Rise of Forensic Science*. Cambridge: Cambridge University Press, 1999.

Wallace, Alfred Russel. "Mimicry, and Other Protective Resemblances among Animals." *Westminster Review* 88 (July 1867): 1–43.

Ward, Lester. *Dynamic Sociology; or Applied Social Science*. 2 vols. New York: D. Appleton & Co., 1883.

White, Paul. *Thomas Huxley: Making the "Man of Science."* Cambridge: Cambridge University Press, 2003.

Willis, Martin. *Vision, Science and Literature, 1870–1920: Ocular Horizons*. London: Pickering and Chatto, 2011.

The Failure of Replication in Nineteenth-Century Literature: Why It All Just Comes Out Wrong

Daniel Bivona

"Hegel remarks somewhere that all great world-historic facts and personages appear, so to speak, twice. He forgot to add: the first time as tragedy, the second time as farce."

Marx, *The Eighteenth Brumaire of Louis Napoleon* (Marx 1)

"What IS the use of repeating all that stuff . . . if you don't explain it as you go on?"

The Mock Turtle, *Alice's Adventures in Wonderland* (Carroll 140)

In nineteenth-century British fiction, replication, in the sense of both repetition and duplication, seems to be a common feature, especially of the fiction we now classify as canonical. In this essay I will mainly be using the term "replication" interchangeably with "repetition" but will argue that both differ from the semantically close term "representation" for the obvious reason that a "representation" need not resemble what it represents. It merely has to signify what it represents, and the form that signifier takes need not resemble what it represents any more closely than Ferdinand de Saussure's drawing of a tree in his *Course in General Linguistics* "resembles" the English word "tree." Iconic representation, in other words, is by no means the only form of representation, as the American pragmatist philosopher C. S. Peirce noted some time ago (Peirce).

A structural feature of much novelistic plotting but particularly prominent in the *Bildungsroman*, repetition, as Peter Brooks argues, is central to establishing metaphorical meaning effects generated at the level of plot (Brooks 503–5). At the level of character in nineteenth-century fiction, doubled characters are often used to insinuate a close thematic linkage between seemingly opposite character traits, such as,

for instance, respectability and monstrosity. To list prominent examples of doubled characters in nineteenth-century British fiction is virtually to name a good portion of the classic novels that comprise the canon: for example, Frankenstein and his monster in the novel *Frankenstein* (1818), Charlotte Brontë's Jane Eyre and Bertha Mason in *Jane Eyre* (1847), Emily Brontë's Catherine and Heathcliff in *Wuthering Heights* (1847), Pip and Magwitch in Charles Dickens's *Great Expectations* (1861), Robert Louis Stevenson's Dr. Jekyll and Mr. Hyde (1886) and James and Henry in *The Master of Ballantrae* (1889), Oscar Wilde's twinned doubles – Basil / Dorian and Lord Henry / Dorian – in *The Picture of Dorian Gray* (1890), the twins in Sarah Grand's *The Heavenly Twins* (1893), Jude Fawley and Sue Bridehead in Hardy's *Jude the Obscure* (1895), Van Helsing and Count Dracula in Bram Stoker's *Dracula* (1897), and Marlow and Kurtz in Conrad's *Heart of Darkness* (1898). All these novels – and there are many more – feature a thematic preoccupation with the troubling issue of replication as failed reproduction or the deliberate generating of opposition between twinned characters. While doubled characters in canonical nineteenth-century fiction seem initially to replicate each other, their dramatic interest for readers often lies in the way the novels dramatize the failure of replication, sometimes with tragic implications (*Frankenstein*), sometimes parodic (*Dorian Gray*), and sometimes civilization-saving (*Dracula*). In other words, no matter what pleasurable effects for the reader are generated by repetition at the level of plot and close resemblance at the level of character, readerly interest in doubled characters often lies less in observing resemblance than in enjoying the drama generated by mistaken resemblance, in scrutinizing twinned characters for signs of barely perceptible discrepancy between the two, or in watching an initial resemblance be converted over the course of the narrative into rooted opposition between the two characters.

My goal is not to try to account for the widespread use of doubling in nineteenth-century literature. Instead, I narrow my focus to a novel that makes abundant use of doubling in order to pose troubling questions about what it means to be human. I deal most closely with a brief interpretation of one of the most interesting uses of replication in Victorian fiction: Lewis Carroll's *Alice's Adventures in Wonderland*, published in 1865. Space limitations mean that I will not be discussing the sequel, *Alice Through the Looking-Glass*, published in 1871 (or, for that matter, doing full justice to the Wonderland book). It should be noted in passing, however, that *Alice Through the Looking-Glass* also makes abundant use of doubled characters and mirror-style reflection, albeit in a narrative whose Alice character

is comfortably integrated into chessboard life at the end, when she is crowned a queen. The earlier Alice is, by contrast, alienated from the world in which she finds herself and which she disrupts in a fit of frustration at the end of the trial of the Knave of Hearts. *Alice's Adventures in Wonderland* offers an exemplary fictional treatment of a main character whose *Bildung* process is best characterized as a failure, a figure subjected to repeated testing that fails to establish her species designation. Chapter 5 in particular is notable for dramatizing both Alice's failure to repeat or replicate and her failure to explain in a metalanguage that does not simply amount to a "repetition" of the narrative's language. In other words, by insinuating relationships of resemblance between Alice, virtually the only easily recognizable "human" in the piece, and those beings she almost invariably imagines to be less rational or logical than herself, and whom she often insults by calling them "creatures," *Alice's Adventures in Wonderland* concerns itself both with whether "creatures" share any affinities with "humans" – physiological, cultural, emotional, or logical – and with whether the interpretive metalanguages we often deploy to make sense of troubling, unusual behavior share features with the narratives they interpret: in short, with whether the language game of interpretation is simply another form of storytelling pretending to a special "meta" status. These two concerns are both related to the issues raised by replication and they are interrelated for the reason that the ability to form narratives and the ability to interpret narratives both seem to be crucial to performing humanity convincingly.

Like many English readers of his generation, Alan Turing, inventor of the Turing Test and, many would argue, the father of the computer, was an avid reader of Lewis Carroll's work (Schieber). The Turing test which he developed is a thought experiment designed to determine, one day, when an intelligent machine has surpassed a human being in reasoning power (Turing 433–60). Not surprisingly perhaps, Turing was also a reader of Carroll's *Alice* books. We know, for instance, that both Carroll and Turing spent significant amounts of time in Guildford (100 years apart, of course) and, thanks to investigative work by Stuart Schieber, we have evidence from the nearby Sherborne School in Dorset that Turing, as a student at that school, checked out Carroll's *Alice* books from the library once in 1930 (Schieber). In light of his later career, it goes without saying that Turing had a particular interest in intelligence as a marker of the category of the "human," and so it is no surprise that he might well have been drawn to Carroll's character Alice, who is repeatedly subject to tests of her ability to reason throughout all the *Alice* books, most obviously in *Alice's Adventures*

in Wonderland, where she repeatedly fails to exhibit the logical reasoning skills on which many of the creatures test her. In short, Alice finds herself in a world full of "creatures" who, in many cases, are unwilling to grant her human status.

Chapter 5 of *Alice's Adventures in Wonderland* accelerates Alice's problems with identity and self-knowledge, problems that afflict her from the moment she falls down the rabbit hole into the strange new world of Wonderland in the beginning of the novel. The identity problems Alice faces in Chapter 5 are actually category issues that highlight Lewis Carroll's interest in the issues of replication and doubling. Despite being only 3 inches high as she approaches the 3-inch-high Caterpillar at the beginning of the chapter, Alice appears intent on resisting claims of kinship or resemblance with him, and she also distances herself from the other beings by calling them "creatures." Resemblance, in fact, in this novel repeatedly generates antagonism: Alice is unable to use her size to coerce or bully anyone in this chapter – least of all the Caterpillar (she succeeds in doing a bit of bullying earlier in the novel when she is a larger, monstrous Alice filling the space of an entire house and kicking the Lizard Bill up the chimney [Carroll 62]). Complaining to the Caterpillar about the changes she has had to endure over the course of her adventures in Wonderland, Alice then begins lecturing him about what he is certain to feel when he finds himself, one day, turning into a butterfly, as he inevitably will. To Alice's rather rude claim that he will find it very confusing to be so many different sizes in one day, he responds curtly: "Not a bit." To this rather unpromising beginning, she replies: "Well, perhaps *your* feelings may be different . . . All I know is, it would feel very queer to *me*" (Carroll 68).

Among other things, what is in play here is readily identifiable as a nineteenth-century literary commonplace: the problem of sympathy. More interested in mastering the strange Wonderland world than in sympathizing with its inhabitants, Alice extends only a very modest amount of fellow feeling toward the "creatures" and they, in turn, extend little to her. Indeed, double relationships throughout this text almost always generate antagonism rather than sympathetic identification in this book. Like much of the rest of the book, this episode foregrounds the problems that arise in attempting to establish what in the nineteenth century Victorians would call sympathetic relationships among fellow humans, even though scholars of nineteenth-century literature tend to speak more commonly about sympathy's bearing on realist fiction than on fantasy or dystopian literature such as Carroll's *Alice* books.

Alice the ostensible "human" in Wonderland signally fails to establish sustained sympathetic relationships with anyone here, with

the possible exception of the Cheshire Cat, and only later, briefly, with the Mad Hatter after his nervous cross-examination at the Trial of the Knave of Hearts (Carroll 146–9). The text foregrounds the vexed issue of what we can know of other minds by representing Alice as repeatedly failing to understand (or sympathize with) others even when, as in the Mad Tea Party chapter, she appears to achieve something that looks like mutual understanding with the "creatures." In Chapter 5, nonetheless, she is rebuffed by the Caterpillar, who rejects her awkward attempt at sympathizing with him; his claim that "three inches" is "a very good height indeed!" is his annoyed response to Alice's claim that being three inches high must feel "queer" (Carroll 72).

Adam Smith is the best-known theorist of a late-eighteenth-century tradition that locates the grounds of human sociality in sympathy rather than in simple moral obligation enforced by a rule-giving god, and his influence was powerfully felt well into the nineteenth century. In the sympathetic tradition, the true test of identification with an other occurs when we recognize a fellow human who is visibly suffering. This theoretical preoccupation with the suffering of the other shifts the grounds for understanding human social bonds. The human, presumably, must compel our feelings of sympathetic engagement in order to be classified as human. In the *Theory of Moral Sentiments* (1759), however, Smith highlights the difficulties that beset the attempt to bind ourselves to other humans, to know whether the feelings of the other who suffers are actually felt by the observer or spectator of suffering. Most importantly, if our identification with the other who suffers binds us to a moral duty to alleviate his suffering, we are led to address a further cognitive question: whose suffering should claim our attention? Moreover, is it any easier to feel the other's pain than it seems to be to look inside the other's mind? Smith's claim is that we never can know for sure whether we feel the other's pain because the spectator's relationship to the other who suffers is purely metaphorical, ultimately based in the spectator's recollection of how he or she has suffered in the past:

> The compassion of the spectator must arise altogether from the consideration of what he himself would feel if he was reduced to the same unhappy situation, and, what perhaps is impossible, was at the same time able to regard it with his present reason and judgment. (Smith I.1.11)

All humans, according to Smith, nonetheless share a moral obligation to assume themselves capable of all the feelings our fellow sufferers

are capable of, for all humans are presumably endowed with an identical sensorium and an identical ability to feel pain.

David Marshall calls our attention to the theatrical structuration of this Smithian scene of sympathy, for its theatricality necessarily implies some distance between the feelings of the one in distress and the feelings of the one who observes suffering by the other. In other words, no sooner is a double relationship established than it begins to be undermined. In Marshall's view, it is all like attending a play: "For Smith, acts of sympathy are structured by theatrical dynamics that (because of the impossibility of really knowing or entering into someone else's sentiments) depend on people's ability to represent themselves as tableaux, spectacles, and texts before others" (Marshall 5). In other words, since inner states of mind and feeling can be plumbed only by those who read and interpret the behavior of the sufferer, decoding the scene of sympathy accurately becomes the central problem in the sympathetic tradition. Hence the disciplinary function of reiterated scenes of sympathy, which appear especially in nineteenth-century realist fiction. These scenes repeat literary lessons designed to teach readers about their moral obligation to recognize themselves in the other and thus to practice the Golden Rule (or the Kantian Categorical Imperative). The novel itself, then, is crucially important in rendering inner states of mind and feeling accessible to readers, albeit in metaphorical form, the form of fictional narrative. In Frank Christianson's words, "Not a feeling, then, but a way of communicating feelings . . . explains the emergence of sympathy as a literary idea and its subsequent appeal for nineteenth-century fiction writers" (Christianson 33). Policing the boundaries of the category "human" turns out to be anything but easy to do. In *Alice's Adventures in Wonderland*, Lewis Carroll complicates the issue of sympathy significantly by overlaying what we might call the nineteenth-century's "species problem" or "classification problem" on the fraught relationships between Alice and virtually every "creature" in the text. Presumably, to acknowledge the other's humanity is to acknowledge, by extension, one's moral obligation to sympathize with his or her plight. Are all the beings Alice calls "creatures," then, actually human in some substantial sense? One hesitates to say yes despite the fact that they all appear to be speaking English. We might agree with Peter Singer's extension of the Smithian obligation of sympathy to other animal species that, he claims, deserve protection (including protection from being eaten by us) simply because their neural organizations have a close evolutionary relationship with our own (Singer 1–23). In other words, they can feel pain that is akin to what we claim to feel when we are in pain. If we accept Singer's arguments, we might find it

easier to imagine them to suffer the way we suffer and thus to imagine we have a responsibility to minimize that suffering. Unless we are all to become Jains, however, hesitant to walk the streets lest we accidentally step on an ant, we need, if only for practical purposes, to draw a boundary line around our numerous sympathetic obligations. What is the community to which we owe the ethical obligation of assistance? Is it merely the human species or, as Singer argues, does it extend well beyond the human species to feeling sympathy with animals from lab rats to bonobos, if not to all sentient life forms? Moreover, in a natural world in which amoebas appear to "choose" particles to incorporate and each new generation of earthworms "relearns" the most efficient means of grasping leaves to protect itself from predators, we might even hesitate to apply the "sentient" criterion to disqualify anyone, no matter how "primitive" their neural organization may be (Hansell 946; Darwin 1890: 8–54).

Lewis Carroll has, if I may use the term, "peopled" his book with an impressive array of representatives of what one might call *species* who insist on asserting claims to the other's attention linguistically, even as they exist in an antagonistic relationship with the main character and are often provoked by her. These species range from insects whose neural organizations are presumably rather different from our own (the Caterpillar), to impossible hybrids (the Mock Turtle), to recognizable, if rather mythological, characters (the Gryphon), a somewhat hapless lizard (Bill), an anally retentive rabbit always fussily checking his pocket watch, and a species category that appears nowhere in Linnaeus: playing cards (the King, Queen, and Knave of Hearts).

The species problem I allude to manifests itself in Alice's encounters with the "creatures" in Wonderland who force her to confront (and occasionally attempt to avoid) the troubling issue of species mutability, of the vexing – indeed, threatening – possibility that all species, including *Homo sapiens*, have evolved out of other, ancestral forms, an issue that would haunt the nineteenth century from the time of Lamarck through the Darwinian Revolution and beyond. The ethical issues that preoccupy both Adam Smith and, later, Peter Singer are highlighted by the presence of "creatures" in *Alice's Adventures in Wonderland*. To put the problem briefly: in a world of constant metamorphosis, how are we to recognize to whom we owe sympathetic engagement? How are we to recognize the group which has the right to lay a claim on our sympathetic instincts, a group whose boundaries may not even be stable? Should we sympathize with playing cards but not with insects? The issue rests just under the surface here simply because *Alice's Adventures in Wonderland* is full of "creatures" impossible to classify using a Linnaean schema.

Interestingly, Daniel Dennett has recently argued that, despite having named his most important work *On the Origin of Species by Means of Natural Selection*, Darwin himself does not succeed in that book in accomplishing what would appear from the title to be his main objective: defining species and identifying their origins. Instead he produces a theory of natural disorder in which natural selection operates as an agent of ruthlessly incessant species change. Moreover, as Dennett argues, defining species remains an elusive goal of biological science today, a problem solved neither by Darwin nor by contemporary science (Dennett 99). If Dennett is correct, then Alice's attempt to classify the beings she calls "creatures" is inevitably doomed to fail. This is why the book is packed with instances in which the canons of polite behavior, which Alice repeatedly treats as universally binding, are constantly debated and violated (Bivona (145). Her naming of the others as "creatures" is bound to reinforce their otherness without allowing her entrée to "understand" them, in effect locking her into perpetual verbal conflict with her many doubles until the end of the Wonderland narrative, when that conflict takes an alarming turn toward literal violence as Alice suddenly grows to become the largest predator in Wonderland. My claim has implications for what I have called the code of the human, which allows us to identify by distinguishing impersonated humanity from "creatures," even when the impersonator is a machine, even when the issues at stake are not so much about feeling as they are about the ability to reason – or to fall into unreason and speak "nonsense."

Rather than having been settled beforehand, the question of what species Alice herself belongs to seems to be in contention throughout the book. For example, the next episode in Chapter 5 finds Alice growing an immensely long neck that allows her to reach up into the trees, thus appearing to threaten the chicks of a pigeon. As she often does in Wonderland, she exhibits annoyed resentment at being misrecognized and miscategorized by the "creatures" – in this case, by the angry mother pigeon who calls her a "serpent." Moreover, her tone-deaf confession that she likes to eat eggs does her no good at this point, simply reaffirming to the mother pigeon that if what Alice calls "little girls" actually eat eggs, then they are nothing but serpents (Carroll 76). Of course, serpents are nothing but relatively recent branches off the evolutionary tree that, nearer its trunk, contains the common ancestor of reptiles and mammals, and thus Alice's encounter with the pigeon again reinforces what is at stake in the failure to find one's replica: virtually everyone who is not Alice in this book is either an argumentative annoyance to her, a threat to her bodily integrity, or – at least potentially – a welcome meal.

Speaking of meals, in Chapter 9 Alice meets the "Mock Turtle," a bizarre hybrid of tortoise and calf, who sounds a lot like Alice in Wonderland, his doubling of her with his incessant challenges generating parodic effects to which she seems to be oblivious. As I have argued elsewhere, a mock turtle is nothing but the making of a meal for a girl like Alice: "it is the thing Mock Turtle Soup is made from," the Queen tells Alice (Carroll 124). Tellingly, in this episode, the Mock Turtle is shedding tears. His crying prompts Alice to attempt to be sympathetic initially, although the story he tells to explain the onset of his sadness notably fails to authenticate his ability as a teller of moving tales: "'Once,'" said the Mock Turtle at last, with a deep sigh, 'I was a real turtle'" (Carroll 126). This promisingly melodramatic opening is followed by a very long, unbroken silence that prompts Alice to thank him disingenuously, if ostensibly politely, for his "very interesting" story. What follows is a Carrollian tour de force, an intense exchange of pun-riddled testiness ("We called him Tortoise because he taught us"; "No wise fish would go anywhere without a porpoise" [127–8]) that ends when the Mock Turtle and Gryphon invite Alice to tell her story in what has by now become a contest. They predictably tire quickly of her mere narration of a confusing set of logically inexplicable and seemingly unconnected events in Wonderland, the significance of which she fails to grasp. Of course, failing to understand is more often than not precisely what she accuses the "creatures" of doing throughout the Wonderland adventures. The Mock Turtle and Gryphon beg her for an explanation rather than a recitation here (or, as the Victorians would say, a "repetition"). Reluctantly succumbing to their pleas for an explanation of her adventures from the time she dropped down the rabbit hole, Alice instead begins to retell the narrative of her adventures in Wonderland to this point.

The recitation of her disjointed story, however, merely causes the Gryphon, in bored frustration, to set up a test of her ability to "repeat" by reciting "'Tis the voice of the sluggard" (139), an order that she obeys only because she is beginning to fear that her compliance is being increasingly demanded rather than requested. The lines that all come out wrong are the following:

"I passed by his garden, and marked, with one eye,
How the Owl and the Panther were sharing a pie:
The Panther took pie-crust, and gravy, and meat,
While the Owl had the dish as its share of the treat.
When the pie was all finished, the Owl, as a boon,
Was kindly permitted to pocket the spoon:
While the Panther received knife and fork with a growl,
And concluded the banquet by —" (140)

The uncompleted final line – "eating the Owl" – of course raises the stakes in what is becoming a deadly serious contest for oral supremacy, lugubriously disguised as a philosophical debate about the difference between repeating and interpreting. It highlights the Darwinian reminder that there is more at stake in drawing species lines than just civilized mutual understanding: species boundaries, among other functions, serve a crucial ethical function, marking off who may be killed and who may be eaten from who is entitled to kill and eat. Indeed, the Panther here seems to understand quite well what is expected of him in his role as a large predator. In connection with this it is worth calling attention to what I believe to be the most lugubrious consolation Darwin ever drew from his own work. In the second edition of *Origin of Species*, Darwin appears to attempt to soften the negative impressions generated by his Hobbesian picture of a war of all against all that some contemporaries saw as the chief lesson taught by the theory of natural selection:[1]

> When we reflect on this struggle, we may console ourselves with the full belief, that the war of nature is not incessant, that no fear is felt, that death is generally prompt, and that the vigorous, the healthy, and the happy survive and multiply. (Darwin 2008: 62)

Anyone who has watched a housecat play with a mouse before pouncing on it and gobbling it up might question Darwin's too-confident claim that "no fear is felt" and that "death is generally prompt." The final claim about how the "vigorous" survive and multiply can, I fear, provide only a small dollop of what we might call tautological comfort since the survivors who pass on their genes to the next generation (as we now say) will generally have been, by definition, "the vigorous, the healthy, and the happy" survivors.

The Mock Turtle's exasperation with Alice's failure to explain the meaning of her experience successfully in this chapter ("What IS the use of repeating all that stuff . . . if you don't explain it as you go on?" [140], he says) parodies Alice, the annoyingly persistent questioner, whose attempts at interpretation simply "repeat" the language of the original. Those of us who teach literature know quite well what it is like to be caught in the position of the Mock Turtle, as we exasperatedly scribble "Explain all that!" in the margins of undergraduate student papers where we claim to perceive plot summary – that is, repetition – rather than argument and evidence – that is, explanation. We want our students to explain rather than simply repeat "all that." *Alice's Adventures in Wonderland*, however, raises larger questions

than those about where one draws the line between narrative and the metalanguage of interpretation.

By parodying Alice, the Mock Turtle highlights her role as the would-be interpreter of cultural differences caught up in the very story she attempts to interpret from a more objective distance (Carroll would much prefer the metaphor "in a treacle well"): stomping through Wonderland rudely demanding "explanations" while receiving what appear to her to be only repetitive narratives in response (Carroll 100). Alice is standing in the treacle well while claiming to be outside it. This is a position which would seem to violate the rules of detached "objectivity" associated with Victorian pre-relativity science as George Levine has summarized them in his book *Dying to Know* (2002), although standing simultaneously inside and outside the treacle may well be a perfectly apt literary metaphor for the sad condition of the category of humanity and the all-too-human belief in the value of his or her prized possession – intelligence (Levine 14). Of course, it is important to emphasize that even nineteenth-century science did not fully commit to a belief that humans have a monopoly on intelligence. G. J. Romanes, for instance, argued what only some Victorians disputed in the 1880s: that dogs were evolutionarily closest to humans in intelligence because smart enough to be strategically compliant with human wishes (now, I suppose, we have to admit that dogs have been bred to be almost parasites, carefully attentive to their hosts' changing moods and wishes [Ritvo 40–1]). In his last published work, Darwin celebrated the lowly earthworm whose "intelligence" is manifest in the way each individual relearns in every new generation how to protect itself from predators by pulling leaves into the wormhole in such a way as to block the hole after it, thus providing itself with protection from predators (Darwin 1890: 55–80). Moreover, the final work to be published after Darwin's death, *Animal Intelligence*, co-authored with Romanes, provides an ample inventory of the impressive variety of forms of animal intelligence.

The extensive use of doubling in *Alice*, whether parodic or not, raises fundamental questions about how we are to recognize any species boundary, including that which marks off the human in a world of perpetual metamorphosis. The novel sharply differentiates between what we might call Alice's rule of thumb – "creatures" are recognized by their illogic; humans presumably by the exercise of logic – and what we might call Carroll's viewpoint – "humans" are capable of only occasional lapses from illogic into momentary and purely accidental moments of logical lucidity. Eighteenth- and nineteenth-century sentimentalism attempts to circumvent the problem

by basing true humanity on the ability to sympathize with the other, but in doing so offers no way out of what I am calling the "species problem" that *Alice's Adventures in Wonderland* highlights, precisely because the sentimental tradition eliminates the markers of the distinctively human in favor of a more general sentience common to many species. If anything, the sentimental tradition, in rooting resemblance in bodily "feeling," tends to blur, if not erase, species distinctions. Even if "creatures" do not think or do not think well, they do at least feel. Fundamentally, Carroll suggests that to be human is not to *be* human but to perform humanity convincingly.

The significance of issues raised by literary replication goes well beyond the problems of one small fictional girl. The treacle well at the bottom of which we stand as we try to convince ourselves we are surveying all from Olympian heights may well inhibit our attempts to define the human in a way that separates us, putting us at a comfortable distance from the hungry panther invited to dinner or Watson, the autonomous computer that will soon be laying a claim to near-human status and – ultimately, perhaps – my job. In fact, if the nineteenth century is largely responsible for passing on to us what I am calling the "species" problem, grounded in a Darwinian picture of the natural world as inhabited by monstrous animal and plant forms to which we are all ultimately related, even if distantly, the Industrial Revolution introduces a different kind of doubling: that of the human with the machine. To be sure, it was a nineteenth-century satirist, Samuel Butler, who made the first argument for seeing the evolving machines of the industrial age as the Lamarckian form that technological evolution would assume hereafter, as massive technological evolution at first redirects, and then ultimately supersedes, human biological evolution. Beginning with a famous pseudonymously authored newspaper article entitled "Darwin among the Machines" (1863) and including a chapter in his satirical novel *Erewhon* (1872) entitled "The Book of the Machines," Samuel Butler warns his Victorian audience about the imminent threat posed by intelligent machines to the integrity of the category of the human.

Today, what Ray Kurzweil and other prophets of the coming "Singularity" share with Butler is a recognition that the speed of technological change in the industrial world is extremely rapid; the logarithmic pace of improvements in digital technology is moving forward the day when an artificially intelligent machine will pass the Turing Test. As he puts it, "within several decades information-based technologies will encompass all human knowledge and proficiency, ultimately including the pattern-recognition powers, problem-solving skills, and

emotional and moral intelligence of the human brain itself" (Kurzweil 8). Certainly Watson exhibited an impressively humanlike ability to decode irony when he defeated the two greatest *Jeopardy* champions on television in 2011. Since decoding irony requires a knowledge of contextual features of language use rather than features of syntax and semantics inherent in the utterance itself, such an accomplishment is impressive indeed – a technological miracle achieved through Watson's ability to search massive databases rapidly. The main difference between Butler and a present-day artificial intelligence prophet like Ray Kurzweil, however, is that Butler is a satirist and critic of human arrogance, prophetically warning his readers about the unwelcome day to come when the enhanced self-regulatory aspects of machines will render humans as nothing but parasitical "aphids" living on the machines that have become their hosts (Butler 123).[2] A pioneer developer of optical character recognition (OCR) software who now works for Google, Kurzweil is warning his readers not to destroy the machines as the Erewhonians did but instead to embrace them. He has argued in a number of his books that the "Singularity" is nigh and ought to be welcomed. The latter claim about the "emotional and moral intelligence of the human brain itself" clearly confesses, however inadvertently, to an Idealism lurking at the heart of this "Singularity" theorist's discussions of "intelligence": rather than being an open question, the human brain's powers, its multiple parallel processing magnificence, Kurzweil assures us, offer a useful model of intelligence designed by natural selection that we might emulate in our machines. The result, he predicts, will be to match and ultimately to supersede human abilities.

One of the most interesting thought experiments of the twentieth century, the Turing Test was designed to identify the presence of humanity's proudest possession and most troublingly difficult to define trait, intelligence, operating in smart computers. As an invitation to explore what such a moment might be like, Ray Kurzweil has created a chatbot on his website (her name is Ramona) who, he hopes, will one day pass the Turing Test. The test itself is based on the idea of replication: if a machine can replicate human intelligence sufficiently to convince a human being located in a different room, that machine will have earned the status of humanity – or, at least, be proud to wear the badge of honor.

The claims Kurzweil makes rest on a model of human intelligence that, among other things, anchors the source of "knowledge" in the brain, a claim which has been challenged by any number of thinkers ranging from Thomas Nagel to John Dupré or any number of

poststructuralist theorists over the years. The question of whether we can replicate human intelligence or the human brain in all its multiply parallel computational complexity is, however, barely a concern of Kurzweil's any longer, since the logarithmic development pace of improvements in computer memory combined with the rapid development of genetic algorithms will soon, he contends, lead to the building of machines whose intelligence far exceeds human intelligence in many different respects. Indeed, we may one day find ourselves judging whether we are speaking to a machine by realizing that the "creature" in the other room is too intelligent to be considered human, too readily able to recall and organize instantaneously data the rest of us have long since forgotten, if we ever harbored it in memory. Instead, Kurzweil would have us prepare for the Singularity by readying ourselves to embrace what Butler warns us about in his satire: our own subjection to the rule of machines that will one day be much more intelligent than humans. We will soon enough, Butler warns us, not just be welcoming machines into the category of the "human" as our equals, readjusting the boundaries of the category to accommodate the new technological achievement they represent in the process, but also prostrating ourselves before them and hailing them as our new masters.

Now, as we await the coming Singularity, we might prepare for it by running what might be called an inverse Turing Test. All beings claiming to be human in the twenty-first century can already experience what it feels like to fall out of the category of the human anytime they want to – they can fail the Turing Test, not by deliberately acting ignorant, although we can certainly do that, but by engaging in everyday computer activities that put us in an embarrassingly thoughtless situation before our masters. Every time we attempt to authenticate ourselves at a website by typing in a distorted word or phrase – a captcha – and our response fails to be successfully converted by OCR because we have sloppily copied the phrase wrongly, we are, like Frankenstein's monster, consigned to non-human status by the website's software – even if only temporarily, until our next successful encounter with a captcha. Our "masters," the machines in these cases, have decreed us to be non-human because we have failed at the simple task of replicating a simple transcription.

Kurzweil's Ramona chatbot[3] cannot yet pass the Turing Test. She remains, for now, a mere "creature," perhaps because her impressive explanatory abilities are not matched by any evident ability to tell biographical stories. Her failure thus far may be because, while she seems adept at offering "explanation" in abundance, she has yet to

master the intricacies of repetitive tale-telling. She remains, for the moment at least, a mere "creature" (in Alice's sense) or, at best, a "monster" (in Victor Frankenstein's), perhaps because the quality of "intelligence" she possesses may be no more stable or easy to measure than the category "human" is susceptible to being delineated. What seems clear these days, as figures like Kurzweil pursue the goal of preparing a computer to pass the Turing Test, is that when the day comes, the computer that passes will not so much resemble humanity as it will surpass humanity. It will be recognized as "human" only by surpassing any human being's abilities.

Notes

1. The common Victorian caricature of natural selection as a war of all against all is based on a misreading of Darwin. Natural selection posits that selection operates most intensely between more closely related species than among those more distant from each other in Linnaean terms. After all, the more closely we are biologically related, the more likely we are to compete directly for the same sources of sustenance. The corollary, as Darwin puts it, is that cooperation between species is more common if the species are not very closely related: "The dependency of one organic being on another, as of a parasite on its prey, lies generally between beings remote in the scale of nature" (Darwin 2008: 60).
2. In his book *Out of Control*, Kevin Kelly argues that the autonomy achieved by machines is a function of the "emergent" nature of intelligence: "We now know that self-control and self-governance are not mystical vital spirits found only in life because we have built machines that contain them. Rather, control and purpose are purely logical processes that can emerge in any sufficiently complex medium, including that of iron gears and levers, or even complex chemical pathways. If a thermostat or a steam engine can own self-governance, the idea of a planet evolving such graceful feedback circuits is not so alien" (Kelly 83).
3. http://www.kurzweilai.net/Ramona4.2/ramona.html

Works Cited

Bivona, Daniel. "Alice the Child-Imperialist and the Games of Wonderland." *Nineteenth-Century Literature* 41.2 (September 1986): 143–71.
Brooks, Peter. "Repetition, Repression, and Return: *Great Expectations* and the Study of Plot." *New Literary History* 11.3 (Spring 1980): 503–26.
Butler, Samuel. *Erewhon*. Ed. Kathy Casey. Toronto: Dover Publications, 2002.

Carroll, Lewis. *The Annotated Alice*. Ed. Martin Gardner. New York: New American Library, 1960.

Christianson, Frank. *Philanthropy in British and American Fiction: Dickens, Hawthorne, Eliot, and Howells*. Edinburgh: Edinburgh University Press, 2007.

Darwin, Charles. *The Formation of Vegetable Mould through the Actions of Worms with Observations on their Habits*. New York: Appleton, 1890.

——. *On the Origin of Species by Means of Natural Selection*. Ed. Gillian Beer. Oxford: Oxford University Press, 2008.

Dennett, Daniel. *Darwin's Dangerous Idea: Evolution and the Meanings of Life*. New York and London: Simon and Schuster, 1994.

Hansell, Mike. *Built by Animals: The Natural History of Animal Architecture*. Oxford: Oxford University Press, 2007: 59.

Kelly, Kevin. *Out of Control: The New Biology of Machines, Social Systems, and the Economic World*. New York: Basic Books, 1994.

Kurzweil, Ray. *The Singularity is Near*. New York: Penguin, 2005.

Levine, George. *Dying to Know: Scientific Epistemology and Narrative in Victorian England*. Chicago: University of Chicago Press, 2002.

Marshall, David. *The Surprising Effects of Sympathy*. Chicago: University of Chicago Press, 1988.

Marx, Karl. *The Eighteenth Brumaire of Louis Napoleon*. Trans. D. D. L. New York: Mondial, n.d., <https://www.marxists.org/archive/marx/works/1852/18th-brumaire/ch01.htm> (last accessed June 29, 2017).

"Peirce's Theory of Signs." *Stanford Encyclopedia of Philosophy*, <http://plato.stanford.edu/entries/peirce-semiotics/> (last accessed October 2, 2015).

Ritvo, Harriet. *Noble Cows and Hybrid Zebras*. Charlottesville: University of Virginia Press, 2010.

Romanes, George J. *Animal Intelligence*. The International Scientific Series XLIV. New York: Appleton and Co., 1884.

Schieber, Stuart. "The Two Guildford Mathematicians." *The Occasional Pamphlet on Scholarly Communication* (February 18, 2015), <https://blogs.harvard.edu/pamphlet/2015/02/18/the-two-guildford-mathematicians/> (last accessed March 16, 2017).

Singer, Peter. *Animal Liberation*. New York: HarperCollins, 2009.

Smith, Adam. *The Theory of Moral Sentiments* [1759]. 6th edn. London: A. Millar, 1790.

Turing, A. M. "Computing Machinery and Intelligence." *Mind* 49 (1950): 433–60.

Replication and Time

"Seeking Nothing and Finding It": Moving On and Staying Put in *Mugby Junction*

James Mussell

Mugby Junction was the 1866 Christmas number of Charles Dickens's weekly periodical *All the Year Round*.[1] As per tradition, *Mugby Junction* was an ensemble piece organized around a theme, and this time Dickens chose a lightly fictionalized railway junction (Mugby stands for Rugby). Exploiting the railway's propensity to gather people together only to move them on, Dickens used Mugby to accommodate the various spooky tales contributed by himself and his fellow writers. *Mugby Junction* is about movement and things that move, whether trains and those who travel, the telegraph and the signals it relays, or the post and letters that circulate. But this concern with media and mediation also makes *Mugby Junction* peculiarly reflexive. The railways and their attendant technologies transformed print culture, and at the heart of *Mugby Junction* is a consideration of the specific kinds of movement enabled by industrial print. As was traditional at Christmas, these tales concern the haunted, the ghostly, and the compulsive, but the repetitions that mark the gothic also describe the rhythms of the press. Reading printed material is to read one copy of many, and the seriality of key print genres of the period – the periodical, the newspaper, and the part issue – meant that each issue was haunted by its predecessors even as it anticipated the issue to follow. Gothic economies of return threaten stasis, yet *Mugby Junction* illustrates the way that repetitive motion can be translated into a particular means of forward propulsion.

In this chapter I examine the way material media move in *Mugby Junction*, whether through space over the rails; through time, as one thing succeeds another; or through affect, as people are moved by what they receive. My argument, though, concerns the way this

discussion of movement is framed. Dickens's first two contributions to *Mugby Junction* set up the conceit, telling us of a man called Barbox Brothers, the "gentleman for Nowhere," who gets off the train at Mugby but travels no further (1866a: 7). In dramatizing Barbox Brothers's state of mind as he wanders up and down the platform, Dickens insists on the continuities between the steam engine and the heart, both mechanisms for repetitive motion that nonetheless move things on. In the first section of my chapter I explore these continuities as set out in the frame narrative. In part two I focus on the best known of the tales in *Mugby Junction*, Dickens's short story "The Signal-Man." In this tale of animated media, the origins of messages become uncertain as agency is distributed between sender and medium, the living and the dead. In part three, I address the way things move through the post: in "The Signal-Man," narrative movement is achieved by putting things in their place, but in Hesba Stretton's "The Travelling Post Office," the very mechanism for sorting, the postmaster himself, becomes imperilled, misdirecting his letters as he misdirects his affections. In the final part I return to Barbox Brothers. Rather than the models of connection and movement offered by telegraph, railway, and post, Barbox Brothers finds a different way of moving on. *Mugby Junction* is a Christmas number of a weekly periodical and, in working out Barbox Brothers's story, Dickens provides an analysis of periodical form. Inherently repetitive, serials like periodicals and newspapers blend sameness and difference in every issue: a kind of remaking in which new content is mediated by known forms. It is replication that allows serials to move on by staying put, each issue new, yet a version of the one before. In *Mugby Junction*, this serial that is no serial, Barbox Brothers does the same. Telling tales of the lines might prolong the limbo of Barbox Brothers's procrastination, but it also becomes the means of a profound transformation: rather than introduce difference by moving on, Barbox Brothers decides to settle in Mugby, turning his haunt into his home.

Lines

Dickens contributed four of the eight stories that make up *Mugby Junction*. The first two, "Barbox Brothers" and "Barbox Brothers and Co.," set out the narrative frame for the number; "The Boy at Mugby," which follows, is the "Main Line," and "The Signal-Man" is the first of the four branch lines (Figure 13.1). Betrayed by his lover and his best friend, Barbox Brothers, originally called Young

MUGBY JUNCTION.

THE EXTRA CHRISTMAS NUMBER OF **ALL THE YEAR ROUND.**

CONDUCTED BY CHARLES DICKENS.

CONTAINING THE AMOUNT OF TWO ORDINARY NUMBERS.

CHRISTMAS, 1866.

Price
4d.

BARBOX BROTHERS.

I.

" GUARD! What place is this?"

" Mugby Junction, sir."

" A windy place!"

" Yes, it mostly is, sir."

" And looks comfortless indeed!"

" Yes, it generally does, sir."

" Is it a rainy night still?"

" Pours, sir."

" Open the door. I'll get out."

" You'll have, sir," said the guard, glistening with drops of wet, and looking at the tearful face of his watch by the light of his lantern as the traveller descended, "three minutes here."

" More, I think.—For I am not going on."

" Thought you had a through ticket, sir?"

" So I have, but I shall sacrifice the rest of it. I want my luggage."

" Please to come to the van and point it out, sir. Be good enough to look very sharp, sir. Not a moment to spare."

The guard hurried to the luggage van, and the traveller hurried after him. The guard got into it, and the traveller looked into it.

" Those two large black portmanteaus in the corner where your light shines. Those are mine."

" Name upon 'em, sir?"

" Barbox Brothers."

" Stand clear, sir, if you please. One. Two. Right!"

Lamp waved. Signal lights ahead already changing. Shriek from engine. Train gone.

" Mugby Junction!" said the traveller, pulling up the woollen muffler round his throat with both hands. " At past three o'clock of a tempestuous morning! So!"

He spoke to himself. There was no one else to speak to. Perhaps, though there had been any one else to speak to, he would have preferred to speak to himself. Speaking to himself, he spoke to a man within five years of fifty either way, who had turned grey too soon, like a neglected fire; a man of pondering habit, brooding carriage of the head, and suppressed internal voice; a man with many indications on him of having been much alone.

He stood unnoticed on the dreary platform, except by the rain and by the wind. Those two vigilant assailants made a rush at him. "Very well," said he, yielding. "It signifies nothing to me, to what quarter I turn my face."

Thus, at Mugby Junction, at past three o'clock of a tempestuous morning, the traveller went where the weather drove him.

Not but what he could make a stand when he was so minded, for, coming to the end of the roofed shelter (it is of considerable extent at Mugby Junction) and looking out upon the dark night, with a yet darker spirit-wing of storm beating its wild way through it, he faced about, and held his own as ruggedly in the difficult direction as he had held it in the easier one. Thus, with a steady step, the traveller went up and down, up and down, up and down, seeking nothing and finding it.

A place replete with shadowy shapes, this Mugby Junction in the black hours of the four-and-twenty. Mysterious goods trains, covered with palls and gliding on like vast weird funerals, conveying themselves guiltily away from the presence of the few lighted lamps, as if their freight had come to a secret and unlawful end. Half miles of coal pursuing in a Detective manner, following when they lead, stopping when they stop, backing when they back. Red hot eyes showering out upon the ground, down this dark avenue, and down the other, as if torturing fires were being raked clear; concurrently, shrieks and groans and grinds invading the ear, as if the tortured were at the height of their suffering. Iron-barred cages full of cattle jangling by midway, the drooping beasts with horns entangled, eyes frozen with terror,

Figure 13.1 First page of *Mugby Junction* showing the list of contributors and the beginning of "Barbox Brothers" (1866).

Jackson, has worked so long that he has become indistinguishable from the firm; however, in one last effort, Barbox Brothers breaks free of the company and projects himself into the world. Arriving at Mugby to change trains, he changes his mind and stands, instead, on the windy, rainy platform. Dickens describes him as "a man within five years of fifty either way, who had turned grey too soon, like a neglected fire" (1). Prematurely aged, Barbox Brothers is haunted by a life he never had: by throwing off his old identity he has liberated

himself from the firm but, by keeping its name, the past remains with him even as he tries to find a future. "With a steady step," Dickens writes, "the traveller went up and down, up and down, up and down, seeking nothing, and finding it" (1). Barbox Brothers exists in stasis: a neglected fire, but one that could, perhaps, be reignited.

Mugby Junction is a junction but Barbox Brothers does not know which line to take. Staying overnight in a hotel, he is haunted by memories from his past: his mother, his schoolmaster, his superior at the firm, and, most bitterly, the "deceit of the only woman he had ever loved, and the deceit of the only friend he had ever made" (3–4). Wandering around the countryside, Barbox Brothers in turn haunts Mugby, his daily walks taking him to the railway junction and, eventually, the home of a disabled girl called Phoebe and her father, known as Lamps. To help decide where to go next, Barbox Brothers travels each of the lines and returns to them both with a tale. The stories that follow – the "Main Line" and the five "Branch Lines" – are those that Barbox Brothers brings back but, crucially, it is not these journeys that have the potential to transform him, to introduce the singular difference that can reignite his inner engine, but their retelling back at Mugby. The railway might mediate Barbox Brothers, moving him up and down the lines, but it is his own role as medium, as teller of tales, that moves him on. The railway lines at Mugby Junction become the printed lines in *Mugby Junction*, each of which puts off the eventual departure as it brings it closer.

The railway junction provides Dickens with a promising narrative structure, but for Barbox Brothers the challenge is to give the junction narrative shape. When he looks down at the lines, he is bewildered by their complexity. "But there were so many Lines," Barbox Brothers reflects, "there was no beginning, middle, or end, to the bewilderment" (4). Not knowing where to start, Barbox remains transfixed as he, too, takes on the form of the junction:

> Barbox Brothers stood puzzled on the bridge, passing his right hand across the lines on his forehead, which multiplied while he looked down, as if the railway Lines were getting themselves photographed on that sensitive plate. (4)

This transference marks Barbox Brothers's dehumanized condition, mechanically reproducing the scene while also taking on its muddle. But immediately he rubs his hand across his forehead the junction springs to life:

Then, was heard a distant ringing of bells and blowing of whistles. Then, puppet-looking heads of men popped out of boxes in perspective, and popped in again. Then, prodigious wooden razors set up on end, began shaving the atmosphere. Then, several locomotive engines in several directions began to scream and be agitated. Then, along one avenue a train came in. Then, along another two trains appeared that didn't come in, but stopped without. Then, bits of trains broke off. Then, a struggling horse became involved with them. Then, the locomotives shared the bits of trains, and ran away with the whole. (4)

The short sentences, each beginning with "then," combine mechanical repetition with succession, producing movement as one thing follows the next. If Barbox Brothers is trapped in repetitive stasis, walking aimlessly about, this scene is animated, alive in a way that he is not. It may be a muddle but there is system here, and it is one that links together human and machine. The railway can provide matter for telling, but to do so Barbox Brothers needs to be able to become part of it, to insert his body into the system and become mediated, so that he can mediate in turn.

A junction is a nowhere place, neither origin nor terminus, and when he first arrives Barbox Brothers, in his own living death, is startled by Mugby Junction's periodic resurrections. "A place replete with shadowy shapes," trains "covered with palls and gliding on like vast weird funerals" convey themselves about "as if their freight had come to a secret and unlawful end" (1). This funereal, silent motion is contrasted with the noise of the engines, which shriek and groan "as if the tortured were at the height of their suffering" (1). On the carriages, cattle, presumably on their way to die, are mute, "eyes frozen with terror, and mouths too," the long icicles hanging from their lips ("or what seems so") like sound frozen in silence (1–2); in contrast, the lights of the signals write themselves in unknown languages, "conspiring in red, green, and white, characters" (2). Such confusions – between the human and non-human, the organic and the mechanical, those who tell and those who provide matter for telling – are precisely the point. Alluding to a Midlands railway junction, Mugby might not be the heart of the rail network but it did evoke the industrial heart of England. The link between the heart and the steam engine was often made, not least by Dickens himself, and while Barbox Brothers's fire is neglected his engines are well stoked. Both the engine and the heart operate on the principle of repetition, beating out pulses that keep the mechanism moving. This mechanical body might alienate the human body, threatening

to render it mere machine, but at the same time it offers the possibility of life to the inorganic productions of the industrial age.

Neglected fires and shadowy shapes, brooding carriages and shrieking engines, the steam engine and the heart: just as material media of various kinds make content reproducible, so Barbox Brothers has to play his part in passing on messages, even if they have non-human origins. Industrial mechanism can be deadening, degrading human life in repetitive labour, but at Mugby Junction it is vital and alive. Barbox Brothers must travel the lines if he is to move on, and yet it will not be the journeys that will affect a transformation but their retelling. Barbox Brothers must learn to be a conduit for other stories, messages from the rails, if he is to overcome the repetition in which he is trapped and so translate repetition into motive force.

Signals

The best-known story in *Mugby Junction* is Dickens's "The Signal-Man."[2] In the story, the narrator – presumably Barbox Brothers, although he is never named – visits a signalman at his post in a damp, desolate railway cutting. Bounded by a "dripping wet wall of jagged stone," the cutting is tomb-like, pervaded by an "earthy, deadly smell" (1866c: 21). The trains pass through but the signalman remains in place, the line "a crooked prolongation of this great dungeon" in one direction and terminating in the "gloomy red light" that marks the start of the "gloomier entrance" to the tunnel in the other (21). When he first meets him, the signalman has been twice warned by a ghostly figure of some impending tragedy that has subsequently occurred. In the first instance, the ghost cried out "Hulloa! Below there!" and then "Look out! Look out!"; six hours later there was an accident and "the dead and wounded were brought along through the tunnel over the spot where the figure stood" (23). The second time the ghost appeared it was silent, but in the attitude of a figure on a tomb; later that day a young woman died instantaneously on a train, her body brought into the signalman's hut. The signalman is troubled as the figure has returned again, crying out "Below there! Look out! Look out!", ringing his telegraph bell, and making a gesture that the narrator interprets as "For God's sake clear the way" (23). The previous visitations have convinced the signalman that the specter is a harbinger of disaster, but he is frustrated that, once again, the warnings do not contain anything on which he can act. At the conclusion of the story, the signalman is struck down and killed by a train, the driver signalling for him to get out of the way in the manner of the ghostly warnings.

"The Signal-Man" concerns questions of termination: suspended, the signalman lacks the ending that would allow him to put things in place; the narrator, on the other hand, can exploit the signalman's demise to account for the various signals in the story, regardless of their origins. Repetition disrupts linear temporality, the ghostly warnings rightly coming before the accidents but making sense only in retrospect. For Jill Matus, this points to trauma, affect without cognition that allows traumatic experience to escape the system of memory that would keep it past.[3] Yet the narrator does manage to tell the tale, filling the various signals with content in such a way that effaces their troubling otherness.

Mediating objects are intentional: if used correctly, it is as if they are not there at all, leaving only an apparently unmediated connection between sender and receiver. In this way, mediating objects can act as surrogates (the letter as its sender's representative) or prostheses, extending human faculties across time and space. Even when working as intended, however, media technologies never really divest themselves of their materiality, their otherness, as they depend upon their material features to function. Content is produced and moved by mediating bodies, not despite them, and there is always the potential for the production of other messages and so the corresponding propagation of senders and receivers, too.[4] The telepathic touch of mind on mind – the medial imaginary – depends upon a kind of repression, as mediating bodies, and all those hands through which they have passed, are cast aside in order to liberate content apparently as sent. Just as messages can mean many things depending on the hands into which they fall, so too can the bodies of media enable all sorts of connections, whether intended or otherwise.

Dickens was acutely aware that he depended upon other people's handling of his works, relying on his printers and publishers for how they looked, for instance, and his readers for how they were read. In other words, Dickens knew that he himself was partly made by others. *Mugby Junction* is significant among the Christmas numbers as it was the first in which Dickens abandoned anonymity. The Christmas numbers were lucrative: at 4d they were twice the price of regular issues of *All the Year Round* and, whereas weekly sales were around 100,000, the Christmas numbers could be expected to sell between 200,000 and 250,000.[5] As ensemble pieces, however, they were an editorial headache and Dickens was often frustrated by his collaborators' contributions.[6] For *Mugby Junction*, not only did he make clear the parts that he had written but also he advertised them in advance. The first advertisements appeared on November 3 and contained the

titles of Dickens's sections; it was not until November 24, just a couple of weeks before publication, that the rest were advertised.

In its exploration of the origins of messages, "The Signal-Man" figures authorship as one mediated presence among others. Ill-disciplined media derail messages, confusing sender and receiver, and Dickens had experienced a literal derailment at Staplehurst in June 1865, eighteen months before the publication of *Mugby Junction*.[7] Traveling back to London from Folkestone, his train jumped the rails, the rear carriages falling from the bridge into the fields below. He had just been in Paris with his lover, Ellen Ternan, and Dickens made sure to get her and her mother discreetly back to London before attending to his fellow passengers. Dickens knew that his fame meant he would become part of the account of the accident, but he also made sure to provide his own textualized account of himself. In the "Postscript" appended to both the final installment of *Our Mutual Friend* and the two-volume book, Dickens alluded to the accident, claiming he was accompanied by Mr. and Mrs. Boffin "in their manuscript dress" (1865: 309). After doing what he could to help others, Dickens tells his readers that he clambered back into the train "to extricate the worthy couple" (309). "I can never be much nearer parting company with my readers for ever, than I was then," he writes, "until there shall be written against my life the words with which I have this day closed this book: – The End" (309). *Our Mutual Friend*, concerned as it is with death and resurrection, is full of endings and this postscript – the second time we have read the words "The End" – is another. Replacing the earlier removal of Ellen Ternan with a later rescue of the Boffins allows Dickens to appropriate their narrative ending and insert himself into his work, as both originating author and character, to efface any marks left by himself as man.

Misbehaving media in "The Signal-Man" also need rewriting. The signalman is frustrated as the ghost's appearances become warnings only after each accident occurs; beforehand, they are experienced merely as the empty forms of their media, whether shout, gesture, or ringing bell. Neither channel nor content is clear, and this uncertainty as to what might constitute a message, as well from where the message has originated, pervades the story. When the narrator first meets the signalman, the signalman mistakes him for the ghost because of the narrator's cry, "Halloa! Below there!" (20, 22). Yet the narrator, looking at the signalman's "fixed eyes and [. . .] saturnine face," suspects that he too "was a spirit, not a man" (21). Unsure of the narrator's mortality, the signalman avoids touching him when they first meet, and so withholds his tale. Eventually convinced of their mutual corporeality, they agree to meet again and, as he recounts his tale, the

signalman repeatedly touches the narrator's arm, establishing a contact between man and man that creates a channel for whatever it is the ghost has to tell. The uncertainty of these intermittent connections is also represented typographically. In both the story and the table of contents, "signalman" is always written as one word, reducing the signalman to his role. In the story's title, however, it is given as "Signal-Man," directing the reader's attention to the space between signal and man, rather than the signalman himself. In the text, the signalman, one word, is a defective agent, unsure of the signals he receives and sends; the title, however, signals the spaces in between, insisting that it is connection that is important as it puts everything into line.

Unsure of what to make of the warnings, the narrator finds himself in the same dilemma as the signalman but, at one more remove, he has another troublesome medium to consider. Recognizing the signalman's distress and the fact it might jeopardize public safety, he asks himself "how ought I to act, having become the recipient of this disclosure" (24). Rather than worry about any accident that might occur, the narrator first considers reporting the signalman to his superiors before deciding to encourage him to seek medical advice instead. This all comes too late, of course, and when he returns the next night the signalman is dead and the narrator has another message to relay. In the final paragraph of the story he admits his complicity in this spectral circuit, this transference and counter-transference, noting that the words of the train driver immediately before he struck the signalman, "'Below there! Look out! Look out! For God's sake clear the way!'", combine the words of the ghost (which were also called out by the narrator), "'Halloa! Below there! Look Out!'", with the narrator's verbal description of the ghost's gestures, which he interpreted as "'For God's sake clear the way!'" (25). Misbehaving media mean that nobody can be certain what messages they are conveying, nor from whom they come. While the signalman lives, the narrator too is trapped, paralyzed by uncertainty as to where the messages originate and what they might mean. The death of the signalman, however, ends the narrator's uncertainty and allows him to tell all to the reader. After leaving the signalman's hut after his first visit, the narrator tells us he felt "a very disagreeable sensation of a train" behind him (22). Only the signalman is unfortunate enough to feel a real train at his back and this absolute difference, dividing the living and the dead, allows the narrator to tell his story.

The signalman's account is disrupted, derailed, but the narrator places the events in order, filling the signals – the ghost's, the signalman's – with content. Narrative is itself a form of media, allowing the same story to be told over and over again, but, crucially, it

avoids repetition through the introduction of difference. The train that kills the signalman ends his haunted condition and so frees the narrator from his own haunting. No longer troubled by what to do with the signalman and his ghostly messenger, the narrator turns the signalman's death into a narrative ending and so breaks the spell of repetition. The signalman remains haunted, but only within the bounds of the narrator's narrative; if they still double one another, such doubling is mitigated by the narrative ending that differentiates them. This is repetition made replication, sameness made safe by the introduction of difference.

Transport

The telepathic promise of unmediated communication was both realized and imperiled by the postal system. On the one hand, its cheapness, utility, and relative security meant that it was the most ready means of linking people together; on the other, private messages were entrusted to a vast state-run bureaucracy, vulnerable to prying eyes and light fingers. Heralded as a triumph of Victorian civilization, the post office dealt rigorously in exteriors, every letter sorted according to what was written on its envelope with (supposedly) no interest in what it might contain. To open a letter is to reveal its true nature and read words written for the intended recipient. Such words might be meant to be shared, they might be about public business, they might even be the same words as mailed to many other people; regardless of what they say, the letter's identity creates the impression of contact while repressing the means through which it reached its destination.

The reliance on outsides to direct letters to their recipients meant that there was plenty of potential for things to go wrong, for letters to move in unexpected ways and so produce strange moments of contact. Hesba Stretton's "The Travelling Post Office," the fourth "Branch Line," focuses on the theft of some letters to meditate on the troublesome relationship between envelopes and the letters they contain. The story itself concerns a clerk, Wilcox, who sorts mail on board a train. Wilcox has been carrying on a mild flirtation with what he thinks are three sisters, the Cliftons, exchanging notes back and forth but never meeting. When charged with carrying the Prime Minister's despatch box back to London, a young lady, claiming to be one of these sisters (with a signed order from Wilcox's superior, Huntingdon, to prove it), accompanies him for the journey. The train is held at a signal at Camden Town, the young woman gets off, and the despatch box is nowhere to be found.

Although the young woman is suspected, nobody can see how she got the despatch box out of the train and the case goes no further. A few years later, however, Wilcox is sent to Egypt to assume control of the post office at Alexandria from Huntingdon's dying son-in-law, Forbes. On arrival, Wilcox discovers the despatch box and the mysterious young woman, now Forbes's wife. She tells all, explaining that she passed the box out of the window for money to marry, and the story ends with Wilcox returning home to marry a genuine Miss Clifton, after sending the false Miss Clifton, now Mrs. Forbes, to a convent.

The post not only provided means of interconnection, erasing space under the master sign of the penny, but also allowed things to move. A nervous system, it flashed thoughts across the country; a circulatory system, it put feeling into motion. The postal system's disregard for content, sending any letter any distance for the same price, ought to function perfectly, but no system is perfect and Wilcox, its representative worker, has a heart that can be tempted. As he sorts letters, he puts into practice the system's reliance on outsides, differentiating between envelopes that look more or less alike on the basis of how they are addressed. Yet the story shows Wilcox sending the wrong people messages all the time: not only does he think he has been corresponding with three Clifton sisters when one of them is actually their mother, but also the Miss Clifton he meets that night is no Miss Clifton at all.

When he first meets the false Miss Clifton, he is too ready to believe that the "small slight creature" (36) was one of the originators of the messages in a "clear, delicate, and educated" hand that passed between him and the real Miss Cliftons (35). Earlier, Wilcox had explained that when he first started working on the travelling post office, he suffered "from a hurry and tremor of nerve" (35). Over time he overcame these symptoms but, working in the presence of the false Miss Clifton, they return. "'You had better not talk, or you'll be making mistakes,'" she warns, and Wilcox confirms, it "was quite true; for, a sudden confusion coming over me, I was sorting the letters at random" (36). Wilcox has learned how to deal with movement, but what he has to learn is how to manage the way he becomes moved by the woman he thinks stands next to him.

Both motion and emotion unsettle Wilcox and his ability to sort, but he is also misled by those who forge or otherwise pretend to be other than they are. The false Miss Clifton carries a letter, signed by his superior, Huntingdon, and in the handwriting of his clerk, Forbes, that testifies that she is who she says she is and justifies her irregular ride on the travelling post office. When Huntingdon later

inspects this letter, he suspects Forbes's writing was forged but cannot determine whether or not he signed it. From his daughter, we learn that the signature was genuine – when she presented it to him to be signed he was distracted by gout – but the letter was not: his signature, in other words, authorized instructions from elsewhere.

Forgeries always trouble notions of authenticity, and in "The Travelling Post Office" what things are is difficult to establish. For instance, when Wilcox first sees the despatch box, he notes it was "very similar in size and shape to the old-fashioned workboxes used by ladies" (35). Later, Wilcox finds that the box is actually being used by the false Miss Clifton (now Mrs. Forbes) as a workbox. And it is not just containers that become something new. When challenged, Mrs. Forbes defends herself by insisting the letters were worthless: "I would never, never have taken a registered letter, or anything with money in it you know. But all those papers could be written again quite easily" (41). While this is intended to show her naivety, Mrs. Forbes is, in a way, right: the letters could be reproduced, containing exactly the same information as those that were stolen. What she inadvertently reveals, though, is that what makes those letters valuable is not the hand that wrote them, or what they contain, but when they were written and for whose eyes. The letters become very different when diverted to a different address.

Such questions of authenticity – how to sort one thing from another – are linked to the sexual economy of the story. The next time the forged letter from Huntingdon is mentioned, he has just dispatched Wilcox to Alexandria to relieve Forbes. Wilcox tells us, in parenthesis and "though it has nothing to do with the story," that he later married a real Miss Clifton (39). At this point this information is indeed parenthetical – it has not happened yet – but once we learn not only that Mrs. Forbes is the alluring false Miss Clifton but also that she has recently become a widow (it is the first thing she tells him), we know that Wilcox will be safe from further indiscretion. Wilcox's mind, he reassures us in retrospect, was on the job, and so he sorts Mrs. Forbes into the convent.

By 1850 the post office was understood as a closed communications system, a set of channels that linked sender and receiver. The fiction of outsides took work to maintain, and sorting, in particular, linked together two different sets of anxieties. Firstly, there was the fear that letters could not be sorted, the address illegible or not corresponding to the system of "alphabeticalized space," as Kate Thomas has called it, ushered in by the penny post (19). Secondly, and more worrying, were those letters that did not reach their destinations

because they had been stolen, those entrusted to sort able to feel the contents of envelopes as they passed through their hands. There is a striking illustration of this conjunction in an article published in the very first issue of *All the Year Round*'s predecessor, *Household Words*. In "Valentine's Day at the Post Office" Dickens and his sub-editor William Henry Wills offer an account of the General Post Office at St. Martin's-le-Grand. While Dickens and Wills are fascinated by the repetitive work of sorting, they are drawn to the possibilities for theft. To sort, here, is to be tempted, and above the sorting office is a tinted window "whence an unseen eye watches the sorters who are listening to temptation" (9). Wondering if the sorters dream of sorting, Dickens and Wills also wonder whether they have nightmares that indulge the temptation to steal repressed during the day (9).[8] It is not the sorters who are to blame, however: later in the article a senior official blames the public for subjecting its "sorters, carriers, and other humble *employés*" to temptation by sending coins through the mail (10). When Dickens and Wills note again the dimmed glass window at the article's close, it stands, panopticon-like, as an externalized conscience, saving the sorters from themselves (11–12).

Letters that cannot be sorted go to the Dead Letter Office, the "final resting place of the undeliverable," as Kate Thomas has put it (19). It is here that wealth accumulates, Dickens and Wills reporting that £11,000 currently resides there unsorted. Dead letters also feature in "The Travelling Post Office." When Wilcox writes to Huntingdon to tell him that his daughter was the thief, he hears by return that Huntingdon died the day the letter was due to arrive of "some disease of the heart" (41). The implication is that the letter killed him, but the letter might just have been a dead letter, never reaching its destination. For John Durham Peters, the letters in the Dead-Letter Office are dead precisely because they have no chance of interception. These letters no longer move, can no longer conjure senders and receivers; instead, they are bodies that have been interred (the word repository also means tomb).[9] The Dead-Letter Office, then, is a necessary corollary to the emergent role of the postal system in the broader information economy, serving as a material supplement to the disembodied content moved from place to place. As Durham Peters argues, the "need for it to exist at all is an everlasting monument to the fact that communication cannot escape embodiment and there is no such thing as a pure sign on the model of angels" (169). Desire and death: this is not a problem of the rupture of minds, but of bodies. The story might not offer anything about replication as

forward progress, but by presenting Wilcox with an array of Miss Wilcoxes it sets out the erotics of sorting. Wilcox must learn to differentiate while being moved, to maintain faith in a system of outsides that requires him to repress not only his own body but also those of the envelopes that pass through his hands.

Numbers

What is odd about *Mugby Junction* is that the story that makes the difference is the second in the series, not the last. "Barbox Brothers and Co." tells of a trip to a "great ingenious town," Birmingham, where Barbox Brothers stumbles across a lost little girl called Polly. It transpires that she is the daughter of his former lover and, like Phoebe back in Mugby, whose name Polly's resembles, she becomes the means of moving Barbox Brothers. In forgiving his former lover and her husband, Barbox Brothers becomes Barbox Brothers and Co., taking "thousands of partners into the solitary firm" (16), and has one final tale to tell back at Mugby. No longer haunted, no longer "The Gentleman for Nowhere," Barbox Brothers is no longer compelled to haunt. While this exorcism produces a temporal change, however, a before and after, it does not propel Barbox Brothers anywhere in space. Rather than taking a line to somewhere, he takes a house at Mugby, moving on by staying put.

As Ruth Livesey has recently argued, Phoebe, a supposed image of immobility, actually represents a networked modernity. Lying at Mugby, watching the smoke of the trains come and go, she makes lace, a "net-work" that knits together the lines of the junction that she cannot see (216). Yet if Barbox Brothers comes to embrace an identity formed "from the threading vectors of parallel lines, knotted, netted, and worked together," *Mugby Junction* itself offers a distinctive mode of linear movement (216). By closing the frame narrative prematurely with "Barbox Brothers and Co.," the remainder of *Mugby Junction* does not have anything to do with Barbox Brothers and there is no internal logic to dictate the order of the Lines. Instead, these stories stand in sequence, moving the reader on while keeping Barbox Brothers where he is.

This premature ending effects a change of genre. Whereas Barbox Brothers's story sets out as serial fiction, with each part contributing to the overarching plot, as soon as his story has finished we are left instead with the one-after-the-other of the periodical. "Barbox

Brothers and Co." is supposed to mark the moment where Barbox Brothers shifts from being narrated to becoming a narrator: rather than him being a character in someone else's story, the subsequent stories are supposed to be ones he tells. These stories are dead letters, however, no longer speaking to the overarching frame narrative, and so are not spoken by Barbox Brothers or heard by Phoebe and Lamps. And as the remaining lines have nothing to do with Barbox Brothers's story, they also transform the role played by the ghost of Dickens: author no more, he is instead back in the familiar role of conductor, moving the reader along the lines rather than Barbox Brothers. The Lines of *Mugby Junction* are not structured by the linear progress of narrative, nor even the stop–start of serial fiction, but the play of sameness and difference through which periodicals assert a larger ongoing whole with every issue published. Through its textual progress from one story to the next, *Mugby Junction* performs periodical progress. It performs replication.

Periodical publication is haunted by haunting, by the threat of falling from replication into repetition. Every issue of a periodical must offer its readers enough that is new to make it worth reading, but not so much newness that it appears to be a different publication. Like hearts or steam engines, periodicals translate repetitive motion into linear force, but as a print genre they are driven by the tension between the requirement to stay the same while, nonetheless, moving on. Too much sameness, and the periodical risks becoming stuck, like Barbox Brothers, in repetition, but in constantly chasing novelty there is also the danger that it will break free from the structure set out over its back issues and so, like Barbox Brothers and Co., become someone else.[10]

In narrative, it is only at the end that the beginning and the middle can be perceived as a whole; serials like periodicals, however, are always in the midst of unfolding. To replicate, whatever is to be replicated must be finished, have edges, and be a whole, so open-ended genres like periodicals take advantage of the provisional closures at the ends of articles, issues, and volumes to establish forms that can be used again and again. Neither author nor narrator, the periodical editor does not furnish narrative wholes but a precarious middle from which the reader surveys the past (represented by the neat sequence of back issues) and the future, tantalizingly out of reach but reassuringly expected to be much the same. As a print genre predicated on not finishing, periodicals enable repetition while ensuring progression – replication – ordering both past and future by allocating each

a period and numbering it accordingly. Like Barbox Brothers, periodicals move on by staying put: every issue displaces its predecessor, replicating its form while presenting itself as new. Barbox Brothers might reach his happy end, but the stories keep coming nonetheless.

The railway setting of *Mugby Junction* allowed Dickens and his collaborators to explore various aspects of media and mediation in the period. All questions of mediation involve form and content, body and soul, and, in telling tales of the triumph of message over media, it is not surprising that the stories often involve repetitive gothic returns. *Mugby Junction* exploits its gothic themes to offer an examination of the dangers inherent in mechanical repetition, dangers that often result in haunting or being haunted. It acknowledges the tendency of content to efface both machines (and those that tend them) and the matter they make move. It also describes the sheer drudgery of mechanical labour, whether bill-brokering, sorting, or tending engines, yet *Mugby Junction* retains a privileged place for replication as a distinct mode of movement. Characteristic of print, replication provided means of moving forward through remaking, structuring novelty through past forms. Steam engines might be mechanical, but the heart beats and print culture moves.

Notes

1. It is a curious feature of *Mugby Junction* that it does not carry a volume number of *All the Year Round* nor is it paginated as part of the volume. I have cited it accordingly.
2. For a brief account of "The Signal-Man" in another context, see Mussell "'Scarers in Print.'"
3. Chapter 3.
4. Derrida calls this "destinerrance." See "Telepathy" and *The Post Card*. For destinerrance as concept, see Miller, Chapter 3.
5. *Doctor Marigold's Prescriptions* (1865) sold 200,000–250,000 copies; *Mugby Junction* sold its run of 265,000; *No Thoroughfare* sold 300,000. See Slater 546, 554; Drew 11.
6. See Slater 479 for an account of Dickens's difficulties with *The Haunted House* (1859).
7. See Slater, Chapters 23 and 24.
8. Dickens and Wills do not name theft itself; instead it remains sublimated, present only indirectly in the question "does he never dream of *that*?" (9).
9. See Stauffer, paragraphs 1–28.
10. For more on periodicals and repetition see Hughes and Lund, Beetham, and Mussell, "Repetition."

Works Cited

Beetham, Margaret. "Towards a Theory of the Periodical as a Publishing Genre." *Investigating Victorian Journalism*. Ed. Laurel Brake, Aled Jones, and Lionel Madden. London: Macmillan, 1990: 19–32.

Derrida, Jacques. *The Post Card: From Socrates to Freud and Beyond*. Trans. Alan Bass. Chicago: University of Chicago Press, 1987.

——. "Telepathy." *Oxford Literary Review* 10 (1988): 3–41.

Dickens, Charles. *Our Mutual Friend*. London: Chapman and Hall, 1865.

——. "Barbox Brothers." *Mugby Junction* (1866a): 1–10.

——. "Barbox Brothers and Co." *Mugby Junction* (1866b): 10–16.

——. "The Signal-Man." *Mugby Junction* (1866c): 17–25.

——, and William Henry Wills. "Valentine's Day at the Post Office." *Household Words* 1 (1850): 6–12.

Drew, John M. L. "*All the Year Round*." *Dictionary of Nineteenth-Century Journalism*. Ed. Laurel Brake and Marysa Demoor. Ghent and London: Academia Press and the British Library, 2009: 11.

Hughes, Linda, and Michael Lund. *The Victorian Serial*. Charlottesville: University Press of Virginia, 1991.

Livesey, Ruth. *Writing the Stage Coach Nation: Locality on the Move in Nineteenth-Century British Literature*. Oxford: Oxford University Press, 2016.

Matus, Jill. *Shock, Memory and the Unconscious in Victorian Fiction*. Cambridge: Cambridge University Press, 2009.

Miller, J. Hillis. *For Derrida*. New York: Fordham University Press, 2009.

Mussell, James. "'Scarers in Print': Media Literacy and Media Practice from *Our Mutual Friend* to Friend Me On Facebook." *Gramma: Journal of Theory and Criticism* 21 (2013): 163–79.

——. "Repetition: Or, 'In Our Last.'" *Victorian Periodicals Review* 48.3 (2015): 343–58.

Peters, John Durham. *Speaking into the Air: A History of the Idea of Communication*. Chicago: University of Chicago Press, 1999.

Slater, Michael. *Charles Dickens*. New Haven, CT: Yale University Press, 2009.

Stauffer, Andrew M. "Ruins of Paper: Dickens and the Necropolitan Library." *Romanticism and Victorianism on the Net* 47 (2007): n.p.

Stretton, Hesba. "The Travelling Post-Office." *Mugby Junction* (1866): 35–42.

Thomas, Kate. *Postal Pleasures: Sex, Scandal, and Victorian Letters*. Oxford: Oxford University Press, 2012.

The Origins of Replication in Science
Ryan D. Tweney

Michael Faraday (1791–1867) was one of the major scientists of the nineteenth century, with important discoveries in physics and chemistry and, most famously, in the nature of electricity and magnetism, including the first clear account of a field theory of these forces. His first major discovery came in 1821 and won him international fame: he discovered that a current-carrying wire suspended near a magnet would rotate around the magnet (rather than being attracted or repelled), and that a magnet would rotate around a current-carrying wire. The magnetic forces generated by the current in the wire were transverse, not radial; they looped around the wire, not toward or away from the wire.

The late David Gooding explored Faraday's notebook entries for this research in great detail and even attempted his own replications of the results (Gooding 1990). Gooding found that holding a magnetic needle suspended by a thread near to a current-carrying wire (as Faraday did) resulted not in clear circular movement around the wire but rather a chaotic jumping back and forth. In effect, Faraday had to "tame" these movements to show that the magnetic forces produced by the current were in fact orderly. Under the right circumstances, they do produce circular motions of the needle around the wire. Faraday's exploration of these circumstances resulted in a series of constructed set-ups that gradually made the circular motion clearer. He was engaged in "constructive replication": the circumstances were refined to converge on an unambiguous representation.

Figure 14.1 shows a sequence of sketches from Faraday's notebook. Note that as his conception of the orderliness of the phenomena became clear, the sketches became more meaningful, the circular, looping motions being shown in the last row. These led to a sketch of a possible apparatus (Figure 14.2) corresponding to the first set-up which produced circular motions. This was successively refined, eventuating in a large demonstration apparatus (Figure 14.3). Finally (Figure 14.4),

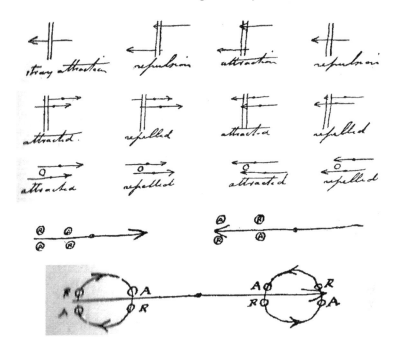

Figure 14.1 Faraday's first notebook sketches of the motion of a magnetized needle near a current-carrying wire (Faraday, September 1821).

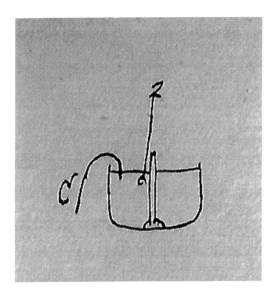

Figure 14.2 Faraday's notebook sketch of a possible apparatus (Faraday, September 1821).

Figure 14.3 Faraday's lecture-demonstration apparatus. The cups are filled with mercury. The left side shows a magnet rotating around a current-carrying wire; the right side shows a current-carrying wire rotating around a magnet (Faraday 1822/1844, Plate IV).

Figure 14.4 Faraday's small demonstration apparatus, sent to correspondents (Faraday 1822/1844, Plate IV).

he developed a miniature version of his laboratory device which he mailed to interested colleagues. By following simple procedures (adding mercury to the tube up to the tip of the needle, connecting a battery at either end to provide current, and holding a magnet against the protruding bottom rod to provide a magnetic field), others could see the effects that he described in publications. His community of correspondents could thus replicate the phenomenon itself.

The replication of scientific findings is today considered an essential part of the methodology of "good science": that is, in order for a scientific finding to be accepted by the scientific community, it must be "replicable" in the sense that other scientists should be able to produce the same effect (or at least be convinced that they could do so). In this sense, public replication is a core value among scientists, differing from its potentially negative sense in the humanities. Thus, a copy of a painting done by someone other than the original painter is potentially a fraud, or, if identified as a copy, of much less value than the original. The public reproduction of a work of art is "merely" a copy, whereas in science public replication is a positive attribute.

The need for replication was apparent in science even before the early nineteenth century, although extended discussion of the need for replication is surprisingly recent, emerging with special force only in the mid-twentieth century. Thus, while the term "replication" is old, it was used in its scientific sense only in the twentieth century (the *Oxford English Dictionary* records the earliest such use from 1914). To avoid anachronism, I will use the term "repetition" when referring to nineteenth-century uses of the concept.

While the history of replication as a formal term in science is surprisingly recent, this is not to say that there was a lack of concern for the "objectivity" of scientific findings, one in which repetition was important. The scientific revolution of the sixteenth and seventeenth centuries included, as an important aspect, a need for public witnessing of science experiments to assure that the findings could be trusted (Shapin and Schaffer). The nature of experimentation in science underwent radical changes from the eighteenth to the nineteenth century. For example, Buchwald, in *The Rise of the Wave Theory of Light*, has characterized these changes in the field of optical experiments. In the eighteenth century, these were primarily qualitative in character; effects were produced in the laboratory and the reports of the experiments described the apparatus and the results in highly "sensuous" terms: that is, in terms of visual appearances, movement, and even (as in the case of chemistry) smells, tastes, touches, and so on. But as

Buchwald showed, the nineteenth century saw the emergence of a different kind of optical experiment, one centered increasingly on quantification and measurement. Similar changes occurred in other areas of science. If we wish to understand the way in which the repetition of scientific results became a core value of scientific judgment during this period, we must locate the changes in the context of broader changes in nineteenth-century science.

In the present chapter, I will first sketch some aspects of nineteenth-century scientific thought, especially concerning repetition, and I will follow this by showing how these themes were reflected in the work of one eminent scientist, Michael Faraday. In the penultimate section, I will describe some recent work on the replication of historical scientific findings, not to confirm their trustworthiness but rather to uncover the underlying practices of the scientists involved. Such "historical replication" has produced important insights for the history of science, the philosophy of science, and the psychology of science, as well as linking this work to efforts by other scholars (in archaeology, art history, and other fields) to recreate the conditions of artifact production in historic contexts. The final section presents an account of the recent scientific concern with replication and its failures, along with some of the implications of its history for present practice.

Science in the Nineteenth Century

The transformation of experimentation in the nineteenth century was part of larger shifts in the way science was construed by its practitioners. Daston and Galison, focusing upon the use of visual imagery in science, have charted the way in which "objectivity" as a core value evolved from an eighteenth-century "truth to nature" conception (which relied upon the statements of "trusted observers"), through the "mechanical objectivity" of the nineteenth century (spurred in part by the development of photography), to a twentieth-century notion of "trained judgment" in which visual images are not of "things seen" but rely instead upon highly transformed – even artificial – diagrams of things not even seeable in principle (as in functional magnetic resonance imaging of the brain or false color images of astronomical objects). In this most recent stage, interpretation of the images relies upon the skilled expertise of the producer, and even of the consumer (who must know how to understand the image). Thus, emerging awareness of repetition can be seen as one phase of a more dramatic change in science, away from the "trusted observer," through a period

of mechanization via instruments and measuring devices, and toward the consensus of experts.

As Buchwald notes, part of the transformation of experimental science involved an increasing use of precise measurement. Often this demanded the development of ever-better instruments and attempts to calibrate them. This was no small task; as Gooday remarked in "Instrumentation and Interpretation," the laboratories of even the most exact sciences were plagued by problems of instability, sometimes from very mundane causes (passing carriages that caused vibrations, inexactness in the construction of the instruments) and sometimes from causes that were not known to the investigators. In effect, experimentation, which was intended to introduce regularity and clarity to the otherwise "messy" appearances of nature, was itself a messy beast. In this context, the evolving practices of science in the nineteenth century were attempts to impose order upon a seemingly chaotic universe, just as Faraday imposed order upon the chaotic needle movements.

The professionalization of science during the long nineteenth century also played a role. In the eighteenth century and well into the nineteenth, the bulk of natural philosophers (as "scientists" were known then) were "gentlemanly amateurs" (Morrell and Thackray). By the end of the nineteenth, most were paid employees of universities, scientific institutions, or industry. This transition brought with it a need for more codification of just what scientists did and how they were trained. Thus, in a seminal text of chemical practice, Lavoisier in 1790 presented descriptions of apparatus and procedures, but only as the final part of a larger general treatise. This was soon followed in the nineteenth century by a large number of "stand-alone" manuals of chemical practice, including one by Faraday (1827).

Scientific communication also changed dramatically in the nineteenth century, in part due to inexpensive printing processes, visual devices such as the magic lantern, and photography. In part also, the early nineteenth century was accompanied by an intense public hunger for knowledge of the new scientific and practical results that proliferated rapidly during the century. The media available for scientific communication – and the nature of what we call scientific education – grew and expanded to wider audiences (Knight).

Finally, the nineteenth century opened with new understandings of *repetitive* phenomena (Cantor 1983). By 1800, there was growing scientific concern with wave motion – periodic and repetitive patterns (sound and water waves, the wave theory of light, and so on). Such patterns were increasingly amenable to mathematical treatment from

the early nineteenth century and culminated in the Maxwellian field theories of electromagnetic radiation toward the end of the century. Wave-like repetition as well as the accumulation of repeated small effects – as in Darwinian natural selection, Lyellian geology, and Maxwellian "billiard ball" kinetic theory – were underpinnings of much scientific thinking.

For example, Thomas Young presented a wave theory of the nature of light, arguing that the full range of optical phenomena could be understood only if light were a periodic vibration (rather than a stream of particles, as had been thought since Newton's time). This was not an entirely new idea (Cantor 1983), but it elevated what had been an untestable "vibratory" theory to a more tractable and testable one. Young himself did not develop the mathematical and quantitative details, but there was an explosion of interest among other scientists. In this context, it is not surprising to see awareness of repetition as a forerunner of the later methodological concept of replication. Waves, after all, are periodic, defined by the repetition of a pattern over and over again. If fundamental principles of nature were repetitive, so too were the evolving practices of scientists.

Repetition in Nineteenth-century Science

In a recent article, Catherine Jackson identifies a "glassware revolution" in early nineteenth-century chemistry. Whereas Lavoisier's eighteenth-century chemical apparatus was expensive and hard to duplicate, that of Justus von Liebig (1803–73), Jöns Jacob Berzelius (1779–1848), and Michael Faraday was based on simple glassware that could be constructed and modified even in quite modest laboratories. By mid-century, specific manuals devoted to glass blowing and related techniques were available and the techniques became widespread, while commercial suppliers of chemical glassware expanded their offerings (for example, Griffin's *Chemical Handicraft* of 1866; see also Lagemann, *The Garland Collection*). This development meant that chemical results obtained by one scientist could easily be repeated and extended in other laboratories.

Being able to conduct experiments on a small scale with inexpensive apparatus insured their spread among a scientific community and even among the public, as witnessed by the emergence of the "lecture–demonstration" aimed at general audiences and texts for children (Taylor, *The Art and Science of Lecture Demonstration*). For example, Jane Marcet's 1806 *Conversations on Chemistry*

described a large number of "at home" experiments. Giving a public demonstration of a phenomenon meant that the demonstrator had to be certain that the phenomenon was repeatable, so the rehearsal of intended demonstrations was important. And, as in Marcet's book, some lecturers encouraged their audiences to try experiments at home and thus attempted to make at least some of the demonstrations as simple and as transparent as possible (Sturgeon).

Attempts to formalize scientific procedures included texts by John Herschel in 1830, William Whewell in1840, and John Stuart Mill in 1843. Mill (1806–73), in particular, formalized the kinds of "experimental inference" that were possible, ranking them in terms of their ability to identify causal relationships. Even so, his attitude toward the repetition of experiments was still anchored in earlier modes of thinking that involved a "trusted observer":

> When a chemist announces the existence and properties of a newly-discovered substance, if we confide in his accuracy, we feel assured that the conclusions he has arrived at will hold universally, though the induction be founded but on a single instance. We do not withhold our assent, waiting for a repetition of the experiment; or if we do, it is from a doubt whether the one experiment was properly made, not whether if properly made it would be conclusive. (228)

Mill was a philosopher, not a scientist. Among scientists themselves, more subtle arguments prevailed. For example, in his great *Experimental Medicine* (1865), the French physiologist Claude Bernard (1813–78) argued that repetition of experimental results was needed, not because some observers could not be trusted but because one could be blinded to important results when operating under the sway of "hypotheses." Thus, in looking for one kind of effect based on a hypothesis, one could fail to see other effects. Further, when two researchers found opposite effects, it was not sufficient to conclude that one must be true and the other false. Instead, it could be that the conditions of one result were different from the conditions under which the other result was obtained. The need was to determine the appropriate conditions, not to reject out of hand one of the findings.

By the end of the nineteenth century, science education at the high school and college level had come to rely on repetition of experiments as a pedagogical device – students were required to obtain a pre-determined result. Earlier "how-to" manuals, like Faraday's *Chemical Manipulation* (1827), were intended for self-study, not the schoolroom. By including an appendix in which a "course of study"

was laid out, Faraday provided a path by which the reader could begin with simpler, more basic, operations and gradually learn to make more complex experiments. Rather than being a "cookbook" for repeating classic results (as in later school-based texts), Faraday's book focused on the development of laboratory skills.

One aspect of the need for repetition appeared early in geology and paleontology. Fossils were the object of scientific interest at least from the seventeenth century, but discoveries in the late eighteenth and early nineteenth centuries, together with a growing awareness of the "deep time" of geological eras (Rudwick), gave an impetus to fossil hunting and to analysis of the specimens that were found. As more and more specimens, many of extreme fragility, came under scrutiny, methods for their safe excavation and transport became important. In 1804, Cuvier was the first to mention preparing a fossil by scraping away the surrounding gypsum matrix, the gypsum actually being what came to be known as "plaster of Paris" (Whybrow). Later, plaster of Paris was used to encase fossils for safe transport from the field to the laboratory.

As museums of natural history began to emerge in Europe and North America, and as public interest grew, fossils themselves began to be exhibited, often involving reconstructions of missing parts (few fossils of an entirely intact organism have ever been found), as well as complete replicas of original fossils. Usually called "casts," these were made by preparing a mold of the original, then filling the mold with a suitable semi-liquid substance which, upon hardening, could be painted in the original "as-found" colors. In advocating for a London museum of natural history, the zoologist Richard Owen (1804–92) made many mentions of the use of casts of fossils for exhibitions (Owen; see also Gowan Dawson's essay in this volume).

The commercialization of such casts began not long after (see Codell and Hughes in the Introduction to this book). The American Henry Augustus Ward (1834–1906), a naturalist and adventurer, traveled to the major collections of fossils in Europe, making molds of significant specimens. On his return to the U.S., he established a business in Rochester, New York, supplying schools and (later) museums with casts of fossils made from these molds. His first general catalog was published in 1866 and contained hundreds of such casts, covering multiple species of both plant and animal fossils (Ward 1866). Ward targeted primarily colleges, advocating casts for educational purposes, and thereby permitting students to see and handle a far larger range of specimens than any local or specialized collection could provide. His business was successful and continues to this day. While his initial focus was upon fossils, he soon

included glass models of infusoria (microscopic creatures) and glass models of soft-tissue invertebrates that permitted viewing of internal organs (Ward's Natural Science Establishment 1878). Such glass models were important well into the twentieth century, as shown, for example, by the magnificent diorama of rotifers at the American Museum of Natural History (Miner). They remain important today.

Models in a more familiar sense (that is, imitations on a small scale of a larger technological artifact) were important in technology throughout the nineteenth century. Thus, the U.S. Patent Law of 1790 permitted the submission of models of inventions, and such models (no larger than 12 in × 12 in × 12 in) were required with all applications starting in 1834 (examples are illustrated in the 1996 Christie's auction catalog, and instructions to inventors are given in the 1865 Munn & Co. manual). The oldest existing patent model, made in 1771 and now in the collection of the American Philosophical Society, depicts a paddle wheel rigged over the side of a ship to power what is now known as a bilge pump (Multhauf 46 and Figure 17). Most of the hundreds of thousands of models given to the Patent Office have been destroyed, but they remain of interest to collectors – and museums! Models also served a productive purpose; rather than simply reproducing another object, they could be part of the process by which new objects were created. In developing their "flying machine," the Wright Brothers used small models and a "wind tunnel" of their own design to test various aspects of airplane design, successively changing the models until desired characteristics were obtained in the wind tunnel (Crouch). After the first successful powered flight in 1903, aviation in general became of great public interest, and manuals for the construction of model aircraft soon appeared (for example, Aston's in 1910). The design of flying models quickly evolved away from the configurations of real aircraft, since the aerodynamics and power requirements of small craft differed from those of their "real" counterparts; here again, models became productive devices, less and less like the originals and themselves unique artifacts.

Quantification and measurement became increasingly important in the nineteenth century, especially in the physical sciences (for examples, see the papers in Krüger et al.). As measurement became more important, the variation due to specific conditions became more important too: differing temperatures and pressures, apparatus movement caused by external noise and vibration, even inconsistency from one observer to another or from time to time within one observer – all these were sources of fluctuation in measurement that necessitated repeated measurement of the same quantity. At first

it was easy to accommodate such differences by simply averaging measurements, but more sophisticated statistical approaches developed across the century. Thus, Kohlrausch (1873), in a widely used manual of physical measurement, presented "least squares" statistical techniques for reducing multiple measurements to a single value, along with an estimate of the precision of the value. Such techniques reflected a "probabilistic revolution" in all the sciences.

Faraday

Michael Faraday's life and work exemplify the preceding claims. Faraday has long been regarded as a paragon of scientific practice, particularly for the power and reach of his laboratory experimentation. Born in humble circumstances and receiving little formal education, Faraday was apprenticed as a bookbinder in his early teens, and thereby gained exposure to books and an intellectual world that he would otherwise have missed. Three of these had a particular impact: an article on electricity in the *Encyclopedia Britannica* ([Tytler], 1797), Jane Marcet's *Conversations on Chemistry* (1806), and a late edition of Isaac Watts's *The Improvement of the Mind* (1809). Marcet's book, in particular, led Faraday to repeat many of the experiments described there, and he later remarked on how satisfying it was to find that her descriptions exactly confirmed the results he could obtain:

> I could trust a fact, – but always cross examined an assertion. So when I questioned Mrs. Marcet's book by such little experiments as I could find means to perform, & found it true to the facts as I could understand them, I felt that I had got hold of an anchor in chemical knowledge, & clung *fast* to it. (Letter to Arthur-Auguste De la Rive, October 2, 1858, in James 2008: 453; emphasis in original)

As was true for Watts, self-education was very much in the air at this time, particularly among young members of the "trade class" in England, and Faraday, like many others, joined self-improvement societies and attended lectures on science (Jenkins). Following Watts's advice, he also kept extensive notebooks and scrapbooks throughout his life.

He abandoned bookbinding in 1813, after being offered a post as assistant to Sir Humphry Davy at the Royal Institution of Great Britain in London. Davy served as Faraday's mentor and the young assistant quickly became a prominent scientist in his own right, achieving status

as a Fellow of the Royal Society (FRS) in 1824 (see James 2010). In subsequent years, he became renowned as perhaps the most visible scientist in nineteenth-century Britain, an "Einstein" of his day.

Faraday's style of doing science was in many respects unique. He knew no mathematics but was possessed of a keen visual ability, later characterized as an "intuitive geometry." While he used no symbolic expressions, his conceptualization of fields of force curving, bending, and moving through space was expressed mathematically only in later years by others (notably James Clerk Maxwell). As an experimenter, he possessed immense skills founded on careful manipulation and a doggedness in pursuing results that surpassed almost everyone else's in science. A brilliant lecturer, he commanded a wide audience for his weekly Friday Evening Discourses. From the mid-1820s he began the Christmas Lectures "for a juvenile audience," a series of five or six lecture–demonstrations, the first ever to be aimed at young people. Several of these were published from notes taken by others, including *The Chemical History of a Candle* (1861), a readable masterpiece that has been in print ever since.

Giving a lecture–demonstration is, of course, a repetition of an established result (just as are laboratory classroom exercises today). Faraday was especially conscious of the need for a demonstration apparatus that could be shown to an audience, in this sense harking back to the old tradition of trusted observers, who now included members of the public at large and even schoolchildren. But something similar could be said even of scientific publication – a journal article asks the reader to trust that the results described could be repeated. Here again, however, Faraday showed special care in how he established that trust.

In the description of Faraday's 1821 research on magnetic rotations at the beginning of this chapter, it is clear that the sequence of sketches, from the first seemingly random movements (Figure 14.1 above) to the demonstration devices (Figures 14.3 and 14.4), can be regarded as replications (in the modern sense), internal replications until they move into a public sphere. Nor was he interested only in repeating his own findings. Quite frequently, when reading a scientific paper (or correspondence), he would immediately attempt to repeat a finding in his own laboratory, often successfully. But there are many references in his correspondence (and sometimes in his publications) to failures to repeat a reported result. At these times he was often eventually able to repeat an effect; at other times he was able to show where the original investigator had gone wrong. And, like Claude Bernard, he often showed that there were particular conditions under which a phenomenon could or could not be observed.

If he relied heavily on the repetition and successive refinement of his laboratory methods, his theoretical ideas also involved repetition in the sense of incorporating waves and vibrations. Thus, in 1831, he spent time investigating what are now called illusions of motion ("peculiar deceptions," in his phrasing), as when moving carriage wheels show ghost-like figures when seen though each other (Faraday 1859b: 291). This was, in effect, research on a cognitive–perceptual problem (Tweney 1992b), in which regularly repeated motions were wrongly interpreted by an observer. This work was followed immediately by several months of experiments on "acoustical figures," the geometric patterns produced when sand or fine powder is sprinkled on a vibrating surface, or the patterns on the surface of a fluid when the container is vibrated (as when running a wet finger around the rim of a partly full wine glass to make it "sing"). Here the problem involved both an observer's perception and cognition (the vibrations being too fast to see singly) *and* the physics of fluids. In this work, Faraday was learning how to tie experiment to theory via the understanding of periodic phenomena. Experiment and theory worked together to "stop time," to make the rapid movements visible to the "mind's eye."

Immediately following this work, Faraday made his most important discovery: that a changing magnetic field would induce an electrical current in a nearby conductor. Space prohibits a full account, but the discovery is the basis of the electric generator and the transformer (just as the 1821 discovery of electrical and magnetic rotations is the basis of the electric motor). This series of researches (Faraday 1839) shares many of the characteristics of his work that I have already discussed, with one notable exception: his theoretical account of the phenomenon – that is, practical applications aside, the discovery linked electricity and magnetism, suggesting that they were two sides of a common *electromagnetic* phenomenon. Further, Faraday's discussion of the results implied the existence of electromagnetic *fields*: that is, non-material entities that fill all space. He construed the fields as composed of *lines of force* curving around magnets and electric charges, fields that were implicated in the very constitution of all matter via chemical affinity. And, more to the point for the current discussion, the fields were closely tied to wavelike, or vibratory, mechanisms.

Over the next twenty-odd years, Faraday conducted thousands of experiments as he sought to tie down and verify these notions, and along the way he discovered many other aspects of electricity and magnetism, while publicly being very diffident about the lines of force. Indeed, the notion of lines of force, even expressed humbly,

attracted little support among his peers, who were largely committed to a "Newtonian" view of forces as "acting at a distance," a notion Faraday (like Newton himself!) could not share. How could forces "act where they were not"? Still, publicly, Faraday remained cautious, trying one way after another to verify experimentally the physical reality of the lines of force; his need for trust in the theoretical claim was as strong as his need for experimental results to be repeatable. These were not futile exercises since a large number of important discoveries were made, many of which had their own theoretical underpinnings; these were readily accepted by others, even as they rejected the overall claims about lines of force. In the end, to confirm the reality of the lines of force, Faraday had to develop *converging* lines of evidence, not merely repeatable ones. Even then, most other scientists did not accept the lines of force as "real." The details of this convergence have been well described by Gooding's "Final Steps" and summarized in Tweney's "Inventing the Field." (See also Cantor et al.)

Wave action was not far from Faraday's mind during the course of this convergence, as shown by his speculation that light itself would prove to be an electromagnetic wave (for example, Faraday 1859c). He was not able to confirm this, although he did succeed in showing that a polarized ray of light could be affected by a strong magnetic field – a strong hint that there was some relation between light and magnetic fields. Later work, especially the brilliant mathematical theory of James Clerk Maxwell and its experimental demonstration by Heinrich Hertz, confirmed that Faraday's speculation was correct. Today, we find no discordance in talking about fields: those that enable our cell phones and televisions or those that extend through interplanetary space, those that emanate from the sun or those that map our brains.

Historical Replication

Faraday can additionally illustrate some recent and potential uses of replication, uses that serve scholarship rather than science as such. In 1856 Faraday carried out an extensive program of research on the "colors of gold" (Faraday 1859a). Because it is so malleable, gold can be hammered into extremely thin sheets, at which point it becomes transparent. But such sheets of "gold leaf" have an interesting optical property. While appearing gold in color under ordinary lighting, if light shines *through* the leaf, the color is green. Faraday had identified this as a puzzle very early in his life; the 1856 research program was

his heroic attempt to understand it. Although his laboratory notes of this program were very extensive, they are puzzling to read, seemingly chaotic, as if he were randomly flitting from one thing to another, without much rhyme or reason. While one conclusion is that he was showing signs of senility (which he definitely displayed later in life), there is another interpretation. In 1998, the almost complete set of specimens that he prepared for this research were found, never having been catalogued, "hiding in plain sight" (like Poe's purloined letter). They were in a mock-up of his laboratory in the basement museum area of the Royal Institution of Great Britain on Albemarle Street in London, sitting in boxes on a shelf. The Royal Institution is still an active scientific research laboratory, and is the oldest laboratory still to be in its original building. (It is unlikely that the 1855 specimens would have survived a move to a new building.) All of the specimens have since been photographed and can be seen online (Tweney 2007). The specimens, mostly ordinary microscope slides with metallic deposits, had been numbered by Faraday, the numbers on each slide corresponding to references in his notes.

Reading the notebook entries with the slides at hand was a revelation! Far from being a chaotic and unorganized series, the numbered slides were, in effect, part of the notebook, material objects that conveyed meaning just as surely as the text itself. Faraday's descriptions in the notebooks made it possible to replicate some of the procedures he used (Tweney 2004; Tweney 2006), and these replicated specimens provided further clues to the way in which he was led to notice key aspects of the phenomena and thereby unlocked the otherwise mysterious way he arrived at two important discoveries (Faraday 1859a): the first metallic colloids and the scattering of light by such colloids, the so-called "Faraday–Tyndall Effect." (These were not seen as consequential until many years later.) While Faraday himself felt he had failed in his main goal, to understand how light and matter interacted, in the end, these *historical replications* opened yet another chapter of the way in which his experimentation was so effective in so many domains. Replication thus can serve scholarship as much as science, and in a fashion similar to that used by archaeologists, art historians, and literary historians, as the other papers in this volume illustrate.

Replication: Now and in the Future

The concept of replication has a lively history in recent writings about methodology in experimental science. For example, following some notable failures of replication of results (some, but not all, due

to fraudulent practices), the Association for Psychological Science (APS) has recently adopted policies allowing for the systematic replication of important findings by independent investigators. While the present chapter concentrates on the nineteenth-century history of replication, I will highlight some of the current concerns.

Ironically, the recent concern with replication in science was triggered by *failures* of replication. There had long been concern with problems in the use of statistical significance testing as a criterion for the reportability of scientific findings (for example, in 1966 by Bakan and in 1987 by Gigerenzer and Murray). Some of the criticism was based on the widespread (but entirely mistaken) notion that a statistically *significant* result meant the result was *replicable* (Tversky and Kahnemann showed this to be a mistaken belief of many psychological scientists). The fallacy arose from the fact that, mathematically, a significant result, if the product of a truly random sampling from an infinite population, would occur by chance alone only a small number of times. But results in the real world are never based on a truly random sample, and populations of interest are never infinite. Thus, in spite of the mathematics, a significant result can be known to be replicable only by actual replication. In this sense, the statistical significance of a result does not give a "crystal ball" look at the future.

Renewed interest in this difficulty was sparked in 2005 by John Ioannidis in a paper entitled "Why Most Published Research Findings are False." Using computer simulations, Ioannidis showed that multiple sources of bias and misinterpretation plagued research conducted in medical settings. Thus, the "randomized control experiment," often regarded as the "gold standard" for evaluating the effectiveness of a new drug or treatment, was usually assessed by statistical significance testing, leading to premature conclusions about the effectiveness of the treatment. The recommendation that results needed *actually* to be replicated has generated much discussion within medical science and the social sciences, and has led to the development of formal approaches to ensure that replications are properly conducted.

The first such formal approach within psychology centered on a contentious finding by Schooler and Engstler-Schooler concerning the memory of eyewitnesses. In the original study, subjects were shown a video of a bank robbery and were then asked to write a verbal description of the robber (experimental condition), or to generate a list of U.S. states and their capitals (control condition). In a subsequent line-up, subjects who had verbally described the robber were significantly *less* likely to identify the actual suspect than control subjects, a phenomenon Schooler and Engstler-Schooler called the "Verbal Overshadowing" effect. Because the study has important practical implications in

the legal domain, and because there had been failures to replicate the study, the editors of the journal *Perspectives on Psychological Science* commissioned dozens of psychology laboratories to conduct replication studies modeled on the original (Simons et al.). Combining the results of all the replications showed that the effect first reported was genuine, but of slightly smaller magnitude.

Controversy about the need for such extended replications continues, however (Nosek et al.), and is part of the continuing discussion of the role of statistical evaluation of the results of experimentation, with some arguing for the replacement of statistical significance testing by Bayesian approaches (which adjust the probability of a hypothesis being true by the available data), or concentration upon confidence intervals and effect sizes (for example, Cumming). One journal, *Basic and Applied Social Psychology*, has even banned the use of significance testing for the articles it publishes (Tramifow)! Most of the discussion has centered on hypothesis testing experiments, however: that is, given a hypothesis (for example, that drug A is better than a placebo drug), one tests the hypothesis by running an experiment. Toward that end, the APS has encouraged the "pre-registration" of such tests, in which the methods and the predicted outcomes are publicly registered prior to conduct of the experiment. This ensures that the data, when gathered, are more likely to be related to the hypothesis rather than "fudged" or the hypothesis changed after the fact (see also Chambers).

The problem with this, however, is that it leaves out *exploratory* experimentation, in which the goal is to develop hypotheses in the first place. Such experimentation cannot be pre-registered, by definition, and yet it can be the most powerful kind for the advancement of science (in "Why Preregistration Makes Me Nervous," Susan Goldin-Meadow expresses this concern crisply and clearly). Faraday's rotating wire experiments of 1821 are of this sort. The experiments were carried out in an attempt to tame a phenomenon; having once achieved this, he refined the experiments until he could comfortably share it with colleagues. While he certainly had expectations about what to look for, he did not have explicit hypotheses; these were developed only after much exploration, as the sequence in Figure 14.1 shows. At first he could perceive only vague attractions and repulsions; only later did he perceive that the true motions were circular (as in the bottom row of his sketches). Only then could he show that the phenomenon was not simply *replicable*, it was *robust*.

In this way, the historical perspective can illuminate the current discussions over replicability. In both psychology and medical research, in fact in any field in which the data are "noisy," being able

to replicate a finding is harder unless the finding is robust. It is worth remembering this (and history is a remembering). There are robust findings in both psychology (Skinner's operant conditioning, say, or the limits of short-term memory) and medicine (penicillin and aspirin, for example). Outside such cases, statistical analysis is important in order to separate "signal" from "noise," and it is in such cases that replication retains its importance.

By tracking the uses and conceptualizations of replication in science, I have tried to show its close connections to other aspects of nineteenth-century science, to the expanding and changing senses of "objectivity," to measurement, to the emergence of probabilistic and statistical science, and to the content of the sciences (as in wave theories and the gradual accumulations in evolutionary theory and geology). I have tried to anchor these sweeping generalities by looking at some specifics of the research of Michael Faraday. Finally, I have tied the earlier concerns to the ongoing controversy over replication and the recent attempts to formalize its use, especially in psychology. Many of these issues will resonate with those in the humanities. Is a writer, correcting and rewording a passage over and over again, doing something all that different from Faraday seeking to impose order on his chaotic needle movements? Is a painting found to be a palimpsest with an earlier version underneath anything different? In the end, are the humanities and the sciences all that different?

Works Cited

Aston, W. G. *Model Flying Machines: Their Design and Construction.* London: Iliffe & Sons Ltd., 1910.

Bakan, David. "The Test of Significance in Psychological Research." *Psychological Bulletin* 66 (1966): 423–37.

Bernard, Claude. *An Introduction to the Study of Experimental Medicine* [1865]. Trans. Henry Copley Greene. London: Macmillan & Co., Ltd., 1927.

Buchwald, Jed Z. *The Rise of the Wave Theory of Light: Optical Theory and Experiment in the Early Nineteenth Century.* Chicago: University of Chicago Press, 1989.

Cantor, Geoffrey N. *Optics After Newton: Theories of Light in Britain and Ireland, 1704–1840.* Manchester: Manchester University Press, 1983.

——, David C. Gooding, and Frank A. J. L. James. *Michael Faraday.* London: Macmillan, 1991.

Chambers, Chris. *The Seven Deadly Sins of Psychology: A Manifesto for Reforming the Culture of Scientific Practice.* Princeton: Princeton University Press, 2017.

Christie's East. *The Art of Invention: American Patent Models 1836–1899 from the Cliff Petersen Collection* [Auction Catalog]. New York: Christie's East, 1996.

Crouch, Tom D. *The Bishop's Boys: A Life of Wilbur and Orville Wright.* New York: W. W. Norton, 1989.

Cumming, Geoff. *Understanding the New Statistics: Effect Sizes, Confidence Intervals, and Meta-Analysis.* London: Routledge, 2012.

Daston, Lorraine, and Peter Galison. *Objectivity.* New York: Zone Books, 2007.

Faraday, Michael. *Chemical Manipulation: Being Instructions to Students in Chemistry, on the Methods of Performing Experiments of Demonstration or of Research, with Accuracy and Success.* London: W. Phillips, 1827.

——. "Experimental Researches in Electricity, First series. On the Induction of Electric Currents" [1832]; rpt. in *Experimental Researches in Electricity.* London: Taylor and Francis, 1839: 1–41.

——. "On Some New Electro-Magnetical Motions, and on the Theory of Magnetism" [1822]; rpt. in *Experimental Researches in Electricity.* London: Taylor and Francis, 1844: 127–51.

——. "Experimental Relations of Gold (and Other Metals) to Light" [1857]; rpt. in *Experimental Researches in Chemistry and Physics.* London: Taylor and Francis, 1859a: 391–443.

——. "On a Peculiar Class of Optical Deceptions" [1831]; rpt. in *Experimental Researches in Chemistry and Physics.* London: Taylor and Francis, 1859b: 291–311.

——. "Thoughts on Ray Vibrations" [1846]; rpt. in *Experimental Researches in Chemistry and Physics.* London: Taylor and Francis, 1859c: 366–72.

——. *The Chemical History of a Candle* [1861]. Sesquicentenary edn. Ed. and intro. Frank A. J. L. James. Oxford: Oxford University Press, 2011.

Gigerenzer, Gerd, and David J. Murray. *Cognition as Intuitive Statistics.* Mahwah, NJ: Erlbaum, 1987.

Goldin-Meadow, Susan. "Why Preregistration Makes Me Nervous." *Association for Psychological Science Monitor* 29.7 (September 2016): 5–6.

Gooday, Grahame J. N. "Instrumentation and Interpretation: Managing and Representing the Working Environments of Victorian Experimental Science." In: *Victorian Science in Context.* Ed. Bernard Lightman. Chicago: University of Chicago Press, 2008: 409–37.

Gooding, David. "Final Steps to the Field Theory: Faraday's Study of Magnetic Phenomena." *Historical Studies in the Physical Sciences* 11 (1981): 231–75.

——. *Experiment and the Making of Meaning.* Dordrecht, The Netherlands: Kluwer Academic, 1990.

Griffin, John Joseph. *Chemical Handicraft: A Classified and Descriptive Catalogue of Chemical Apparatus.* London: John J. Griffin and Sons, 1866.

Herschel, John F. W. *Preliminary Discourse on the Study of Natural Philosophy.* London: Longman, 1830.

Ioannidis, John P. A. "Why Most Published Research Findings are False." *PLoS Medicine* 2.8 (2005): 696–701, <http://www.plosmedicine.org> (last accessed September 29, 2017).

Jackson, Catherine M. "The 'Wonderful Properties of Glass': Liebig's Kaliapparat and the Practice of Chemistry in Glass." *Isis* 106 (2015): 43–69.

James, Frank A. J. L., ed. *The Correspondence of Michael Faraday, Volume 5*. London: Institution of Engineering and Technology, 2008.

——. *Michael Faraday: A Very Short Introduction*. Oxford: Oxford University Press, 2010.

Jenkins, Alice. *Michael Faraday's Mental Exercises: An Artisan Essay Circle in Regency London*. Liverpool: Liverpool University Press, 2008.

Knight, David M. "Scientists and their Publics: Popularization of Science in the Nineteenth Century." In: *The Cambridge History of Science, Vol. 5: The Modern Physical and Mathematical Sciences*. Ed. Mary Jo Nye. Cambridge: Cambridge University Press, 2003: 72–90.

Kohlrausch, Friedrich. *An Introduction to Physical Measurements*. Trans. T. Waller and H. R. Proctor. London: J. & A. Churchill, 1873.

Krüger, Lorenz, Gerd Gigerenzer, and Mary S. Morgan, eds. *The Probabilistic Revolution*. 2 vols. Cambridge, MA: MIT Press, 1987.

Lagemann, Robert T. *The Garland Collection of Classical Physics Apparatus at Vanderbilt University*. Nashville: Folio Publishers, 1983.

Lavoisier, [Antoine Laurent]. *Elements of Chemistry, in a New Systematic Order* [1790]. Trans. Robert Kerr. 5th edn. Edinburgh: W. Creech, 1802.

[Marcet, Jane]. *Conversations on Chemistry, In which the Elements of that Science are Familiarly Explained and Illustrated by Experiments and Plates*. London: Longman, Hurst, Rees, & Orme, 1806.

Mill, John Stuart. *A System of Logic, Ratiocinative and Inductive, Being a Connected View of the Principles of Evidence and the Methods of Scientific Investigation* [1843]. 8th edn. New York: Harper & Brothers, 1882.

Miner, Roy Waldo. *A Drama of the Microscope: The New Rotifer Group*. 2nd edn. New York: American Museum of Natural History, 1928.

Morrell, Jack, and Arnold Thackray. *Gentlemen of Science: Early Years of the British Association for the Advancement of Science*. Oxford: Clarendon Press, 1981.

Multhauf, Robert P. *Catalogue of Instruments and Models in the Possession of the American Philosophical Society*. Philadelphia: American Philosophical Society, 1961.

Munn & Co. *The United States Patent Law: Instructions How to Obtain Letters Patent for New Inventions*. New York: Munn & Co., 1865.

Nosek, Brian A., et al. [Open Science Collaboration]. "Estimating the Reproducibility of Psychological Science." *Science* 349.6251 (2015): aac4716–1 to 4716–8.

Owen, Richard. *On the Extent and Aims of a National Museum of Natural History*. London: Saunders, Otley, & Co., 1862.

Rudwick, Martin. *Earth's Deep History: How It Was Discovered and Why It Matters*. Chicago: University of Chicago Press, 2014.

Schooler, Jonathan W., and Tonya Y. Engstler-Schooler. "Verbal Overshadowing of Visual Memories: Some Things are Better Left Unsaid." *Cognitive Psychology* 22 (1990): 36–71.

Shapin, Steven, and Simon Schaffer. *Leviathan and the Air-Pump: Hobbes, Boyle, and the Experimental Life.* Princeton: Princeton University Press, 1985.

Simons, Daniel J., Alex O. Holcombe, and Barbara A. Spellman. "An Introduction to Registered Replication Reports at *Perspectives on Psychological Science.*" *Perspectives on Psychological Science* 9 (2014): 552–5.

Sturgeon, William. *A Course of Twelve Elementary Lectures on Galvanism.* London: Sherwood, Gilbert, and Piper, 1843.

Taylor, Charles. *The Art and Science of Lecture Demonstration.* Bristol: Institute of Physics Publishing, 1988.

Tramifow, David. "Editorial." *Basic and Applied Social Psychology* 36 (2014): 1–2.

Tversky, Amos, and Daniel Kahnemann. "Belief in the Law of Small Numbers." *Psychological Bulletin* 76 (1971): 105–10.

Tweney, Ryan D. "Inventing the Field: Michael Faraday and the Creative 'Engineering' of Electromagnetic Field Theory." *Inventive Minds: Creativity in Technology.* Ed. Robert J. Weber and David N. Perkins. Oxford: Oxford University Press, 1992a: 31–47.

——. "Stopping Time: Faraday and the Scientific Creation of Perceptual Order." *Physis: Revista Internazionale di Storia Della Scienza* 29 (1992b): 149–64.

——. "Replication and the Experimental Ethnography of Science." *Journal of Cognition and Culture* 4 (2004): 731–58.

——. "Discovering Discovery: How Faraday Found the First Metallic Colloid." *Perspectives on Science* 14 (2006): 97–121.

——. (with the assistance of Neil Berg and Jeff Friedrich). *Faraday's Gold: A Catalog of his 1856 Specimens.* Beatty, NV: Avebury Books, 2007. (CD-ROM and online at <http://aveburybooks.com/faraday/catalog.html> [last accessed September 29, 2017]).

[Tytler, James]. "Electricity." *Encyclopedia Britannica.* 3rd edn. Edinburgh: Andrew Bell and Colin Macfarquhar, 1797.

Ward, Henry A. *Catalogue of Casts of Fossils, from the Principal Museums of Europe and America, with Short Descriptions and Illustrations.* Rochester: Benton & Andrews, Printers, 1866.

Ward's Natural Science Establishment. *Catalogue of Glass Models of Invertebrate Animals.* Rochester: E. R. Andrews, 1878.

Watts, Isaac. *The Improvement of the Mind. Parts First and Second. With a Discourse on Education, and the Remnants of Time Employed in Prose & Verse. A New Edition.* London: Maxwell and Wilson, 1809.

Whewell, William. *The Philosophy of the Inductive Sciences, Founded upon their History.* 2 vols. London: John W. Parker, 1840.

Whybrow, Peter J. "A History of Fossil Collecting and Preparation Techniques." *Curator: The Museum Journal* 28 (1985): 5–26.

Chapter 15

Fathers, Sons, Beetles, and "a *family* of hypotheses": Replication, Variation, and Information in Gregory Bateson's Reading of William Bateson's Rule
David Amigoni

> Sometimes – often in science and always in art – one does not know what the problems were till after they have been solved. (G. Bateson 271)

In 1894 the young Cambridge biologist William Bateson published a book about evolution entitled *Materials for the Study of Variation: Treated with Especial Regard to Discontinuity in the Origin of Species*. Bateson hoped it would be a groundbreaking book; he signaled that in the reference to both "discontinuity" and "the origin of species" in his sub-title, the book announcing its intent to begin to question the received authority of Darwinism. Skeptical of the dominant paradigms for organizing and interrogating evolutionary evidence of variation and selection, Bateson accumulated and published a vast range of facts to challenge Darwin's ascendancy. Among the huge range of sample specimens from museums, private collections, journals, and illustrations, Bateson included some beetle (Coleoptera) specimens manifesting an oddness of character – supernumerary legs – that he sought to explain with reference to a phenomenon that became known as Bateson's Rule. As I will argue, Bateson's Rule presented multiple, and thus over time quite far-reaching, implications for ideas about replication – or "reduplication," as Bateson called it – adding to the stockpile of terms that we have inherited from the Victorian period for assessing the place of ideas about mimicry, imitation, replication, and reproduction in biology and culture.

Gregory Bateson was an ethnographer, biologist, ethologist, theorist of systems, and author of the seminal work *Steps to an Ecology of Mind* (1972); he was also William Bateson's youngest son. Over time – seventy-eight years, to be precise – he came to appreciate the role of his father's rule in understanding patterns of replication and variation in morphogenesis – or the development of shape in an organism – to begin with, and then over a wide range of contexts and systems. He set this out in the essay "A Re-examination of 'Bateson's Rule,'" and other essays that were collected together to make *Steps*. One of the aims of this present volume is to explore the historical roots of both imaginative and anxious responses to replication in scientific and cultural systems. Consequently, this chapter is framed around the complex passages of time and acts of information exchange through which the passing on of ideas across three generations in an intellectual family occurred. My aim in tracing this is to explore replication as a polysemic concept through which the very idea of science and culture *as* systems of information was realized.

Thus, my chapter locates the idea of replication between multiple disciplines and historical contexts: in particular, the chronologies and ranges of expertise that separated three generations. Familial resemblance between questions and hypotheses, as well as between intellectual fathers and their sons, is at the heart of its concerns. The familial resemblances between hypotheses were not always obvious: William Bateson was asking a biological question about the origin of species; Gregory Bateson was asking wider questions about systems and the dynamics of information exchange. He was also looking for patterns in schemes of behavior that were repeated across the generations: how did the same behaviors, separated by time and culture, attain a dominant hold? How might they be resisted and changed? I will show that, in effecting and enabling systems thinking, William Bateson and later Gregory Bateson enrolled historically specific examples of illustration and modeling to articulate versions of replication. These versions, over time, had quite a profound effect in that they moved the emphasis away from a Darwinian paradigm of utility that was organized around principles of mimicry and imitation, and towards a paradigm of replication that emphasized information exchange. Positioned in time and cultural space by a father–son relationship, they worked from a "family of hypotheses"; applied widely, these had the potential to grasp the dynamics of replicated structures underlying phenomena as diverse as mental illness, family relationships, and wider human and political ecologies.

What were the odd, reduplicated, supernumerary characters of beetles (and other creatures) that first commanded the attention of William Bateson? And what was Bateson's Rule?

"Bateson's Rule" [Gregory Bateson stated] asserts in its simplest form that when an asymmetrical lateral appendage (for instance, a right hand) is reduplicated, the resulting reduplicated limb will be bilaterally symmetrical, consisting of two parts each a mirror image of the other and so placed that a plane of symmetry could be imagined between them. (G. Bateson 380)

It is easier to see the symmetrical phenomenon in order to appreciate it – copied in one of the illustrations that Bateson published in *Materials* (Figure 15.1). In the example of the beetle *Carabus scheidleri* we see Bateson's fascination with morphological appendages that were perfect replications of a given feature such as a horn or leg and that were indeed, from the point of view of symmetry or correspondence, a perfect mirror image of the structure. While the

Figure 15.1 *Carabus scheidleri*. From William Bateson, *Materials for the Study of Variation* (1894), p. 483.

structures obeyed symmetry and rules of shape replication in one sense, however, in another the features spectacularly violated them. Because of their location in the body plan of the creature, the leg played no useful role at all: in the illustration, out of the correctly placed right foreleg of the specimen *Carabus scheidleri* extend two other legs, a secondary left leg and a secondary right, a perfect replication or reduplication, as Bateson put it, mirror images of one another – but monstrously out of place.

What was William Bateson looking for in his focus on this perfectly replicated but useless, out-of-place appendage? Gregory Bateson noted his father's responsibility for coining the word "genetics" in 1905 (G. Bateson 380). Indeed, William Bateson remains best known for having rediscovered, along with Hugo de Vries, the experimental work of Gregor Mendel. Bateson was responsible for promoting the importance of the theory in Britain through publications such as *Mendel's Principles of Heredity: A Defence* (1902). This work did indeed shake the Darwinian hold over biology (Bowler 39). It would be wrong to suggest, however, that *Materials*, and Bateson's Rule, were simply anticipations of Mendelian genetics. That was not why Gregory Bateson valued this early aspect of his father's work in arguing that it made a contribution to the complex theory of evolutionary systems.

Evolutionary discourses embed theories of replication in their formation in so far as they interact with theories of heredity: the passing on of likenesses can be popularly expressed in the language of replication. Thus, when the twentieth-century popular naturalist–autobiographer Gerald Durrell recalled witnessing the birth of a seahorse during his Corfu childhood of the 1930s (but written at around the same time as Gregory Bateson was re-evaluating the meaning of Bateson's Rule), Durrell was astonished suddenly to behold "a minute and fragile replica" of the birthing parent swimming before his eyes (Durrell 410). Beyond Durrell's visual impression of biological likeness producing likeness, evolutionary science at a theoretical level continues to draw on thinking about replication, but now the concept continues to play a role in theories of heredity through the modern and still-developing understanding of DNA as a copying device.

The essential point to note about copying and replication as part of a system in the discourse of evolutionary science is that they contribute to a binary: as Gregory Bateson argued when theorizing information systems, the key is to locate the "difference which makes a difference" (G. Bateson 459). In order to work, it is acknowledged, evolution needs difference, variation; consequently, replication needs

variation in order to establish its baselines and to generate the conceptual work that can shape the emergence systems theory. Indeed, my particular focus on replication is part of a wider story about evolutionary understandings of biological and cultural mechanisms of reproduction during the later nineteenth and earlier twentieth centuries. In focusing on replication through William Bateson's work I am thus focusing on a late Victorian paradigm shift in evolutionary accounts of replication, reduplication, and indeed the constellation of nineteenth-century terms that surrounded the Darwinian account, which included imitation and mimicry.

Mimicry came to be seen metaphorically from the later 1860s in the "deceptive," self-protective appearance of some species. Theorized by the naturalists H. W. Bates and Alfred Russel Wallace as a constituent contribution to Darwin's theory of evolution by natural selection, it was a theory premised on utility. As Wallace declared in his classic essay "Mimicry, and other Protective Resemblances Among Animals," published in the *Westminster Review* in 1867, "'Like produces like' is the established rule in nature," but built within that rule was a role for variation that entailed the gradual modification of the terms of likeness under Darwin's law of natural selection (Wallace 14).

The theory of mimicry emphasized the production of "useful or protective resemblances." Natural selection was, for Wallace as its co-elaborator, all-embracing: it affected "every established branch of human knowledge" (Wallace 2) and was capable of explaining "curious facts" and "anomalies" such as strange imitations. Wallace could see such "facts" at work in the morphology of another beetle specimen, *Cyclopeplus batesii* (named after its discoverer, collaborator, and co-theorist of mimicry, Bates).

> The extraordinary little *Cyclopeplus batesii* belongs to the same sub-family of this group as the *Onychocerus scorpio* and *O. concentricus*, which have already been adduced as imitating with such wonderful accuracy the bark of the trees they habitually frequent; but it differs totally in outward appearance from every one of its allies, having taken upon itself the exact shape and colouring of a globular *Corynomalus*, a little stinking beetle with clubbed antennæ. It is curious to see how these clubbed antennæ are imitated by an insect belonging to a group with long slender antennæ. The sub-family *Anisocerinæ*, to which *Cyclopeplus* belongs, is characterized by all its members possessing a little knob or dilatation about the middle of the antennæ. This knob is considerably enlarged in *C. batesii*, and the terminal portion of the antennæ beyond it is so small and slender as to be scarcely visible, and thus an excellent substitute is obtained for the short clubbed antennæ of the *Corynomalus*. (Wallace 27–8)

Wallace's purpose in highlighting the mimic function of structure (the antennae of the beetle) is to find evidence for utility: utility equated to survival against predation through resemblance, "tricking" predators, if you will. Resemblance is shaped by natural selection in response to population pressure; variants promoting a deceptive resemblance advantage acquire an edge in the breeding stakes and are protected, even if they are relatively few in population compared to the abundant numbers of species they mimic. The protection is reinforced by continued sexual selection: females, Wallace argued, are often more strongly marked in the mimicked characteristic or structure.

As Will Abberley's work demonstrates, the mimicry paradigm occupied an important position in Victorian literary culture (Abberley 34–56). Taking Wallace and Bates's work on mimicry as a starting point, I previously explored the question of "like producing like" (2007) through the workings of the concepts of imitation and mimicry in both evolutionary discourse and life writing – in particular, the way in which the biological and the cultural were blended through the narrative of Edmund Gosse's classic memoir of Victorian intergenerational formation and conflict, *Father and Son*. Published in 1907, precisely the point at which the very young Gregory Bateson (b. 1904) was being shaped in relation to his own father–naturalist, Gosse made imitation a central and contested concept in thinking about the replication of likeness *and* the playful production of difference across the generations. As a topic of discourse it was played out through the practice of natural historical illustration in which Philip Henry Gosse's published works were rich, and which Edmund recalled imitating during his childhood (Gosse 123–4). Something resembling James Mark Baldwin's Lamarckian theory of behavioral imitation was implicitly active in Gosse's text as the young Edmund both reproduced and swerved away from his father's illustrations of divine creation through his own acts of (unconsciously pastiche) imitation (Amigoni 177–83). The narrative effect was analogous, I suggest, to Homi Bhabha's influential critical framework for understanding the ambivalence produced by mimicry, deriving as it does from a distinctively Victorian, natural–historical framework (Amigoni 189). This may, in addition, help us to see the often-unheard echoes of ethology and evolutionary discourse in Bhabha's idea of mimicry, as it traveled out of the work of Lacan (something to which Dorothy Moss draws attention in her chapter).

In the new analysis of father and son relationships offered in this chapter, however, I go beyond my reading of Gosse through the mimicry paradigm to look at the Batesons' father and son negotiations as, from different points in time, they reflected on the implications of reduplication. As I shall argue, an interesting combination of natural historical illustration *and* model making in Bateson's work of 1894 constituted a regime of copying that helped, over time, to shape a generative paradigm of replication and variation grounded in informatics, rather than the Darwinian paradigm of utility. It was this that Gregory Bateson glimpsed in his father's work from 1894, from the perspective of his theorizing during the late 1960s.

The Bateson family story stresses variation from orthodoxy, rather than adaptation through mimic blending. Their advancement began in Liverpool trade in the early nineteenth century, which provided material wealth but no easy route to cultural influence. Influence was won at Cambridge through William Bateson's father, William Henry Bateson, a classicist trained at Shrewsbury school who, through scholarly distinction, became Master of St. John's College, Cambridge, in the 1850s (B. Bateson 1–2). Across the generations the Batesons demonstrated a capacity for taking unorthodox views from the cultural margins to the center: William Bateson, the Master of St. John's, achieved it through liberal reformist thought born of Liverpool manufacture and politics, which he used to contest the dominant theological and institutional conservatism of Cambridge University. His son, William Bateson, trained in biology and took himself to the margins through the rejection of Darwinian orthodoxy, before asserting a new approach to evolution through Mendelian genetics that, prior to the Modern Synthesis, could not be easily reconciled to the theory of natural selection. In the first decades of the twentieth century William Bateson championed Gregor Mendel's particulate theories of inheritance following Hugo de Vries's landmark recovery of previously unrecognized, indeed marginal, scientific work (Cock and Forsdyke 198).

His son, Gregory Bateson, was also an unorthodox thinker through his unwillingness to settle into an intellectual career path carved by any one discipline. Originally trained as an anthropologist, he also worked as an ethologist, a family therapist, and an ecologist; he sought connections between, as well as new paths through, disciplines. Bateson developed into a distinctive and innovative theorist following a childhood immersion in a culture of observation focused on natural history that pervaded the family life run by William and

Beatrice Bateson (Lipset 42–9). This included a particular fascination for beetles and insects that had also been a feature of William Bateson's childhood (Lipset 62–3; B. Bateson 3). Gregory had been named after William Bateson's venerated Gregor Mendel (a hoped-for replication signaled by a copied name). A somewhat neglected and underrated son, Gregory grew up under the shadow of his oldest brother's death in the First World War and the post-war suicide of his other brother, Martin. In fact, the family regime was characterized by David Lipset as "didactic." William Bateson's younger brother Edward felt that his older brother had exercised a tyrannical rule over his family: "one of the real Victorian autocrats," he observed to David Lipset (Lipset 45) in a statement that brought the temperament of the fiercely secular William Bateson close to the disposition of Philip Henry Gosse, the Calvinist naturalist who sought decisively to shape young Edmund Gosse.

From a child who collected beetles under the supervision of his brothers, Gregory Bateson developed his deep interest in natural history into a basis for investigating relations between a wide variety of scientific and cultural problems, from animal communication to pathological human psychological behavior to international crises as expressions of human ecology and its communicative systems. The work was linked together as, to use Gregory Bateson's own words in the analysis of his father's work on monstrous reduplications in beetles, a "family of hypotheses," and these intellectually affiliated hypotheses with family resemblances possessed far-reaching explanatory effects.

Fathers, sons, and shared investments in the morphology of beetles indicate that families are themselves systems of replication and variation expressed through communicative relationships. These can be shaped by the patterns that are manifest in particular career paths and opportunities that occur between the generations. In turn, these can be shaped by the structures of ideation – the morphogenesis of idea formation and combination, one might say – that are communicated between the generations. All are implicated in familial relations of governance and power. There are, then, wider ramifications that arise from the stories we pass on about natural history and science as contested components of our culture. Emilie Taylor-Brown's chapter in this volume demonstrates this in its reflections on the place of replication in stories of "priority" in scientific discovery.[1]

Precisely how did those wider implications emerge from William Bateson's approach to reduplicated appendages in beetles in *Materials for the Study of Variation*? How did his approach enlist concepts such

as copying, modeling, and replication in making those implications available for wider use? In rejecting Darwinian orthodoxy, Bateson was interested in evidence of discontinuity and much less interested in evidence of utility of the kind that was so important to the mimicry paradigm and its place in Darwin's theory of natural selection. Yet Bateson's early work, prior to his rediscovery of Mendel, could have had no conception of genes as the locus for replication – a process that was not grasped until Crick and Watson discovered the copying machine of DNA in 1953. The challenge for Bateson in *Materials for the Study of Variation* was to begin to understand the relationship between stable forms of replication and sudden, perhaps species-changing, morphological variation between generations of organisms through descent: in other words, under conditions separated by time, phenotypical specificity, and without the intervention of an obvious artificer.

Bateson used a very particular image of human copying to state the problem, an analogy of wax melting and modeling:

> If a man were asked to make a wax model of the skeleton of one animal from a wax model of the skeleton of another, he would perhaps set about it by making small additions to and subtractions from its several parts: but the natural process differs in one essential from this. For in Nature the body of one individual has never *been* the body of its parent, and is not formed by a plastic operation from it; but the new being is made again new from the beginning, just as if the wax model had gone back into its melting pot before the new model has begun. (W. Bateson 33)

Thus, while a human copier would fashion a new wax model from a previous copy, nature performs no such act. Instead, each new copy is made seemingly anew, the wax model having been thrown back into a melting pot before the emergence of the new model. Bateson thinks through a striking metaphor that may owe something to Plato's analogy between a block of wax and memory in the *Theaetetus*; whatever the source, it draws attention to the place of copying and modeling in his argument.

We can explore how this worked through, firstly, the conventional representations that enable Bateson's analysis of *Carabus scheidleri* (Figure 15.1). These lead to the presentation, secondly, of an innovative, alternative device that abstractly modeled *parts* of the beetle, in particular the extra legs (that is, in Figure 15.1, the pair which are growing out of the normal leg extending out to the right). These parts are transposed into a mechanical contrivance that mapped and

tabulated the possible combinations of binaries produced by the variable spatial arrangements between normal and aberrant parts (Figure 15.2: as the handle and cogs turn, the aberrant legs, and the normal legs, turn to adopt the pre-determined, but variable, relations of symmetry to one another). The original malformed *Carabus*

480 MERISTIC VARIATION. [PART I.

set to "Ventral" the two supernumeraries will turn their dorsal surfaces to each other, and so on. The model SL thus rotates twice on its own axis for each

FIG. 153. A mechanical device for shewing the relations that extra legs in Secondary Symmetry bear to each other and to the normal leg from which they arise. The model *R* represents a normal right leg. *SL* and *SR* represent respectively the extra right and extra left legs of the supernumerary pair. *A* and *P*, the anterior and posterior spurs of the tibia. In each leg the *morphologically anterior* surface is shaded, the posterior being white. *R* is seen from the ventral aspect and *SL* and *SR* are in Position VP.

revolution round R, but the surfaces of the model SR always remain parallel to those of the model R. In every possible position therefore each model is the image of its neighbour in a mirror tangential to the circle of revolution. In the figure the models have the position they should have if arising postero-ventrally. Here the plantar surface of SL is at right angles to the plantar surfaces of the other two legs.

Since at each radius the relative position of the legs differs, it is possible to define these positions by naming the radius. This will be done as shewn in Fig. 154. In this diagram imaginary sections of the legs are shewn in the various positions they would assume at various radii. The central thick outline shews a section of the normal leg, a longer outline distinguishing the anterior surface from the posterior. The radii are drawn to various points *D, A, V, P,* representing the dorsal, anterior, ventral and posterior positions respectively. Intermediate positions may be marked by combinations, *DA, VVP,* &c., using the system employed in boxing the Compass.

On several of the radii ideal sections of the extra legs are shewn in thin lines, the shaded one being the nearer and the plain one the remoter. *M¹* and *M²* shew the planes of the imaginary mirrors.

The manner in which the pair of extra limbs are compounded with each other in their proximal parts, and with the normal limb at their

Figure 15.2 William Bateson's mechanical device for showing the relations that extra legs in symmetry bear to each other and the normal legs from which they arise. From William Bateson, *Materials for the Study of Variation* (1894), p. 480.

scheidleri, on which the model was based, was of course just one among a massive catalogue of variations consulted in collections of aberrant specimens that Bateson arranged to see, describe, and record through illustration for the purposes of his book. Bateson's *Materials* was copiously illustrated by two illustrators named in the Preface (P. Parker and Edwin Wilson: W. Bateson xi). Beyond this prefatory acknowledgment, however, this mode of illustrative copy was not further recognized as being conspicuously *authored* as an artifact, even though important traditions of engravings of Coleoptera and other orders had developed, notably in Germany by the natural history copperplate engraver, Jakob Sturm, who was active between the 1790s and the 1840s. In 1791–2 Sturm published a set of 100 hand-colored copperplate engravings of insects called *Insekten-Cabinet nach der Natur gezeichnet und gestochen* ("Insect cabinet, drawn and engraved from nature"). While this tradition of copying shaped the representation of *Carabus scheidleri* with its perfectly articulated legs, as well as its replicated, yet excess and misplaced legs, Bateson's text "looked through" the illustration, as it were, in order that the reader should gaze upon the unmediated original. The illustration is announced as "the property of Dr Kraatz."[2] In other words, conventions of natural historical copying through practices of illustration were abundantly present, initially recognized, but finally elided from Bateson's text by a proprietorial acknowledgment.

In one sense this was the consequence of a culture of proprietorial collecting as a basis for intellectual property (Strasser 303–40; Browne 959–67). The elision is perhaps also due to Bateson's desire for a very different kind of model to grasp the distinctive nature of what he sought to explain through the monstrous additional legs of *Carabus scheidleri.* Above all, Bateson sought the patterned system behind the reduplication – a variation that was often, in effect, the replication of regularly observable structures, no matter how odd they seemed to be on first examination. Hence, in his analysis of beetle monstrosities he distinguishes between those morphological features that were regular, despite their seeming irregularity, and those which might produce real, species-transforming sports.[3] Bateson grasped this by means of an alternative system of demonstration, a practically different kind of copying device in the form of a mechanical model.

As Julie Codell and Linda Hughes indicate in their Introduction to this volume, developments in nineteenth-century biology prompted new practices of model making (they cite the example of Alcide d'Orbigny and August E. Reuss and their model "plaster army"

of microfossils). Following this kind of lead, William Bateson himself entered what we might describe as the field of modeling in the form of that bizarre little machine that he built to enact the principle behind Bateson's Rule. As we have seen, it became a part of *Materials* in the form of an illustration; tellingly, it was reproduced by Gregory Bateson in turn in his much later essay about his father's work and legacy (G. Bateson 388).

Bateson's Rule was demonstrated in this way, mapping the relations between supernumerary legs and normal legs that will prevail anywhere on a beetle's body plan. Turn the lever beneath the heavy wooden plate and this will, in turn, rotate the normal mounted leg (R) on its cogged plate; the interconnected, cog-mounted supernumerary legs (SR, SL) will fall into the pre-ordained relationship, symmetrical mirror images of one another; the machine would always enact some variant of Bateson's Rule. Except that, as he settled down to the business of describing the actual specimens, Bateson could always see exceptions, features that exceeded the machine's precise delivery of binary regularities and patterns of symmetry: "*it would not be true to assert that these rules are followed with mathematical precision,*" he warned (W. Bateson 482; Bateson's italics). It was difficult to see, Gregory Bateson observed, quite "what he was after" (G. Bateson 379).

The plurality of possibilities is an important point: we should not in any sense see William Bateson's early work of 1894 as just the precursor of an inevitably to-be-realized theory of genetic replication. Instead, it is significant that William Bateson designed his mechanical demonstration of Bateson's Rule to fall somewhere between a contrivance based on cogs and wheels – like the analogue workings of a watch, a resonant object in biology since Paley and Darwin – and a computational device that would model, through the very solid replications of identical, three-dimensional legs, combinations of positions, or the binaries that we have come to associate with digitized information. Gregory Bateson knew what he, the son, was after. He would ultimately explain Bateson's Rule in terms of informatics: message pathways, blocked communications, absence of information orienteering.

Gregory Bateson, of course, reproduced this image of Bateson's little machine in his essay on Bateson's Rule. In another linked context of argument he also alluded to the workings of a 1960s computer in his essay "From Versailles to Cybernetics," a contribution to *Steps to an Ecology of Mind*. In that essay he contemplated,

through the Treaty of Versailles, the question of dramatic historical change and the collective trauma it could deliver. In thinking about the actors capable of generating that damage he alluded to the business of modern international states in designing thinking machines programmed to play game theories to determine international policy. Bateson imagined the workings of "the computer . . . [which] cranks and heaves and gives an answer." The cranking and heaving of cogs and levers is redolent of William Bateson's machine for replicating the workings-out of his rule, but we should also note Gregory Bateson's idea of the computer *that provides an answer*. As Codell and Hughes note in their Introduction, the etymology of "replication" is grounded in the Latin verb *replicare*, to reply or respond (G. Bateson 484). The practice of replication is inseparable from dialogue and communication.

When Gregory Bateson replied to his father's work of 1894 from the perspective of the late 1960s he did so from a position of multi-disciplinary and indeed multi-institutional ties and affiliations (the Oceanic Institute, University of Hawaii, University of California at Santa Cruz), announcing that his motto was to "divide in order that you may not be conquered" (Lipset 274–5). Opportunities for resistance to power, politics, and control pervaded Gregory Bateson's innovative intellectual work in ways that had not occurred to his rather more autocratic father. That said, genetics was the field into which he intervened when he re-appraised his father's work, precisely in order to extend its range of applicability: "Re-examination of 'Bateson's Rule'" appeared in the *Journal of Genetics* in September 1971; he republished it in *Steps to an Ecology of Mind* (1972). The key original illustrations from *Materials*, reproduced again in this present chapter, occupied an important position in Gregory Bateson's reply.

Gregory Bateson's multi-disciplinary career in anthropology, biology, ethology, and therapy was evident in the construction of *Steps*. The essay was positioned following the sections of the book that dealt with his theory of schizophrenia and pathological relationships (III), and biology and evolution. It is a challenging yet strategically placed essay: it mediates between interpersonal dynamics, in which structures of relations and power can be replicated and varied, and evolutionary biology, where morphologies might be replicated or varied. Building on the insight that Bateson's Rule was a rule designed to be broken, Gregory Bateson swerved away from the idea of a rule as a single hypothesis, a patriarchal injunction. He looked instead to what

he took his father to be working through: in identifying "a *family* of hypotheses rather than a single one," Gregory Bateson identified a group of conceptual tools to explain the *systems* of replication and variation that he observed in his father's monstrous beetle specimens but also beyond these phenomena, in quite different but systematically *related* fields (G. Bateson 384). Here, Bateson wove together his identities as a researcher of ethology and animal communication (in particular dolphins), and as a contributor to the understanding of schizophrenia, through his theory of the so-called "double bind," through which psychic being becomes fatally entangled in contradictory communications and blocked or absent messages.

It is also important to remember that this *family* of conceptual tools was shaped by familial networks as well as intellectual bonds that created family-like senses of belonging and moral obligation. Gregory Bateson, along with the anthropologist Margaret Mead (Bateson's first wife) and the mathematician Norbert Weiner, were leading figures in the intellectual formation that shaped the new discipline of cybernetics, or the understanding of systems comprising information, control, and feedback loops (for the history, see, for instance, the project on the *Cybernetics Thought Collective*, Illinois). Cybernetics was a transformative contribution to knowledge in Bateson's new analytic of familial relations, so to speak: "the biggest bite out of the fruit of the Tree of Knowledge that mankind has taken in the last 2000 [sic] years" (G. Bateson 484). Information flowing through and between patterns of symmetry (ways of understanding *producing*, and *receiving* contexts) became, for Gregory Bateson, a new way of re-examining his father's work in a language of "messages" that he felt his father groped towards but could not articulate.

Building on his father's interest in redundancy, rather than utility, Gregory Bateson came to explain Bateson's Rule, manifest in the beetles' monstrous reduplications, in terms of a system of information transmission that *lacked* crucial orientating information (basically, where genetic information needs to go) in its receiving contexts (or the "places" where that information can properly realize its developmental plan). We are accustomed, now, to thinking of genetic copying and replication in the informatics paradigms of messaging and information that reside in the molecular domain of particulate chemicals and proteins. But for Bateson the messages were also immanent in the construction and patterns of relationships organized among families, where a division of labor replicated over time and between generations may create or confirm a pathological identity. This was

a vital, field-traversing move that was important to Bateson's value as an interdisciplinary thinker and which was shaped by his own orientation to trends in biological theory. It is important to note that Gregory Bateson remained a committed but sophisticated Lamarckian: in *Steps* he cited the work of his geneticist friend and collaborator C. H. Waddington, whose groundbreaking work has gone on to shape the new field of epigenetics and human ecology that has developed a radically complex and expanded notion of context in the understanding of heredity and biological systems (G. Bateson 256–8; Goldberg et al. 635–8).

Finally, the *family* institution as a system of intergenerational replication and variation (through resistance) helped to shape the family of hypotheses that would explain the passing on of networks that sustain and reproduce power relations. In his work on schizophrenia, and in particular his influential theory of the double bind, Gregory Bateson came to see the condition as being fuelled by distorted or contradictory messages, or blocked patterns of communication which could induce psychotic breakdowns. While this theory was embraced by the social constructionist anti-psychiatry movement of R. D. Laing, from the perspective of Gregory Bateson's high Victorian inheritance the double bind radically extended a continuum that was grounded in late eighteenth-century life science, nineteenth-century evolutionary biology, and the cybernetic systems through which the underlying workings of both became manifest. Moreover, through this continuum a Victorian and post-Victorian family itself was implicated in a quest of (self-)discovery. Thus, in his essay "Double Bind 1969," placed in the section of *Steps* dealing with "Form and Pathology in Relationships," Gregory Bateson signaled through a footnote the relationship between the cultural and the biological; referring to Goethe's botanical analogy – that plants have a syntax and a grammar – Bateson stated that it must be "formally correct because morphogenesis, like behaviour, is surely a matter of messages in contexts." To support this contention, he cites as a context his own essay on Bateson's Rule that occupies an important position in *Steps* (G. Bateson 276).

"Double Bind 1969" contributed powerfully to Gregory Bateson's discovery of a linked process of replication. The double bind was, precisely, a way of seeing and understanding – while therapeutically breaking – the intergenerational replication of pathological family relationships, some of which might end in schizophrenia, an illness that was produced, in Gregory Bateson's view, by a division

of familial communicative labor that structurally inscribed identities, positions, and either impossible expectations or contradictory messages. In one sense, biographically, Gregory Bateson had much personal experience and insight from which to work. The phrase "Bateson's Rule" had a double meaning: not only was it a way of biologically explaining monstrous morphogenesis and the possibility of species change but also it explained the monstrous exercise of power and authority within a particular kind of intellectual family. While Gregory Bateson genuinely revered and honored the intellectual memory of his father, there is little doubt that William Bateson's will to governance exercised a control over his family through which driven scientific achievement and the withdrawal of approval following the failure to meet the expected standard contributed to the suicide in 1922 of Martin Bateson, Gregory Bateson's older brother. Martin Bateson aspired to be a poet, playwright, and actor rather than have the career in the sciences for which his family "inheritance" had prepared him and for which he was being trained (Lipset, Chapter VII).

This aspect of the Bateson family story illuminates patterns of replication around family advancement, behaviors, roles, and expectations that were repeated over a long duration, from the early nineteenth century to the early twentieth. Social elevation through training in the classics and biology was an important means of advancement for two generations of male Batesons in their roles as fathers and sons. But there were also more damaging replicated patterns: the young William Bateson, beetle collector, bored schoolboy, and would-be geneticist, suffered badly beneath the collective disappointment and disapproval of a self-making regime comprising William Henry Bateson and disciplinarian grandfathers and headmasters. Gregory, the youngest son of William Bateson the geneticist and himself a beetle collector, had also, in the early years of the twentieth century, been inscribed into the role of under-achieving son. Gregory both recognized and sought to break the replicated pattern through his theory of the double bind while providing the tools to analyze pathological family relationships and their communicative contexts. Those tools continue to be used and reflected upon in some therapeutic settings today (Gibney 48–55).

To conclude, this is all the more remarkable given that the double-bind theory had started its expanding conceptual life in the 1890s as an attempt to account for the monstrous reduplication

of beetles' legs. Indeed, Gregory Bateson came to see information systems, through essays such as "A Re-examination of 'Bateson's Rule,'" as only partially recognized but vital drivers of his father's biology, a view confirmed by present-day biologists who continue to reassess (and rehabilitate) William Bateson's long-term significance to biology as a branch of the wider science of bioinformatics (Cock and Forsdyke 506, 668). In that sense, complex historicity, the Victorian intellectual family, and the intergenerational transmission of ideas and information have delivered one of the more unexpected, but important, outcomes of biological thought about replication developed during the 1890s.

A still wider science of informatics can include the workings of imaginative textual expression by acknowledging the interactive and reflective properties of this model in the further expansion of biological and cultural systems. If over time Bateson's Rule could hold a double meaning as well as generating new openings for theoretical development, modes of expression such as fiction and autobiography can be seen to work in the same way. In that sense, literary texts are not merely repositories for illustrations of singular biological paradigms; instead, they are active, generative textual systems that grow new meanings in light of more complex and even competing models of biological and cultural systems.

A concluding return to Gosse's *Father and Son* can illuminate this. Earlier in my chapter I reprised my argument that Edmund Gosse's autobiography enacts the paradigm of biological mimicry in the account of Edmund's developing likeness to, and difference from, his naturalist father, a likeness and difference represented in narrating the son's imitation of the father's natural history illustrations. As narrative, Gosse's text can represent other patterns of communication and messaging between father and son in which non-human agents can intervene to disrupt the making of a double bind. Gosse's study of two temperaments narrates an attempt, which ultimately fails, to replicate in the son the precise identity and Calvinist faith of Philip Henry Gosse. The symmetry and repeated patterning that organize the mission are stressed as the father guides his son "hand in hand" through a "jungle of symbols," inscribing the son in the tenets of his faith by seeking to make the son almost a symmetrical mirror image of the father's selfhood (Gosse 79–80). This mission of communication and didactic instruction continues into the father's fervent acts of prayer to God by Edmund's bedside. Edmund, however, recalls above all the source of a sudden interruption and breakage of this pattern

of communication: "Suddenly a rather large insect, dark and flat . . . appeared at the bottom of the counterpane and slowly advanced." Though "nothing worse than a beetle," the creature bypasses unseen the bowed, praying head of Philip Henry Gosse to be seen only too clearly by young Edmund as "all a twinkle of horns and joints." The detail of the remembered image is telling – the articulations of horns and leg-joints convey the sense of sumptuously engraved, natural historical illustration. In addition, of course, the beetle possesses "more legs than a self-respecting insect ought to need" (Gosse 113). Edmund's scream of fear breaks the pattern of communication, beginning to unravel the ensnarement that ties Edmund into a double bind. As a therapist might put it, Edmund is enabled to exit the field of interaction to break, if only temporarily, the replicated pattern. Notably, it is a many-legged beetle that assists him in breaking this fearful symmetry with his father.

Notes

1. A particularly acute example of this was the dispute between Charles Darwin and the writer Samuel Butler, around the question of the priority in "discovering" the theory of evolution. Samuel Butler argued, in *Evolution, Old and New* (1879), that priority should not be assigned to Darwin: that Darwin had borrowed, without acknowledging, the work of Buffon, Lamarck, and his own grandfather (Erasmus). For an account of the dispute see Amigoni 146–7. Both William and Gregory Bateson became entangled in this long-running dispute: see Cock and Forsdyke 521–58.
2. Ernst Gustav Kraatz, the leading German entomologist of the later nineteenth century, specializing in Coleoptera, was one of the numerous naturalists to lend Bateson valuable items from their personal collections of specimens for the purpose of compiling and writing *Materials*. Kraatz had also written about Sturm's lavishly illustrated *Insect Cabinet* work for a leading German entomological journal in 1875 (Kraatz 157–60). A copy of the original *Insecten-Cabinet* (extremely rare) can be consulted at the library of the Academy of Natural Sciences, Philadelphia, U.S., <http://www.sil.si.edu/DigitalCollections/nhrarebooks/sturm/sturm-introduction.htm> (last accessed September 29, 2017). Readers who wish to see digitized versions of Sturm's original illustrations (printed, then hand-painted) may consult the Smithsonian's online digital collections for the comparable *Verzeichniss meiner Insecten-Sammlung* (List of my insect collection), <http://www.sil.si.edu/imageGalaxy/ImageGalaxy_MoreImages.cfm?book_id=sturm> (last accessed September 29, 2017).

3. "Sport" is a regularly used term in biology and breeding circles to refer to a morphogenetic aberration. The question, for Bateson, is what role this aberration plays in species formation.

Works Cited

Abberley, Will. "Animal Cunning: Deceptive Nature and Truthful Science in Charles Kingsley's Natural Theology." *Victorian Studies* 58 (2016): 34–56.

Amigoni, David. *Colonies, Cults and Evolution: Literature, Science and Culture in Nineteenth-Century Writing.* Cambridge: Cambridge University Press, 2007.

Bateson, Beatrice. *William Bateson, Naturalist: His Essays and Addresses Together with a Short Account of his Life.* Cambridge: Cambridge University Press, 2009.

Bateson, Gregory. *Steps to an Ecology of Mind* [1972]. Chicago: University of Chicago Press, 2000.

Bateson, William. *Materials for the Study of Variation: Treated with Especial Regard to Discontinuity in the Origin of Species.* London: Macmillan, 1894.

Bowler, Peter. *The Eclipse of Darwinism: Anti-Darwinian Evolution Theories in the Decades Around 1900.* Baltimore: Johns Hopkins University Press, 1983.

Browne, Janet. "Natural History Collecting and the Biogeographical Tradition." *História Ciências, Saúde Manguinhos* 8 [supplement] (2001): 959–67.

Butler, Samuel. *Evolution, Old and New: or, the Theories of Buffon, Dr. Erasmus Darwin, and Lamarck, as compared with that of Charles Darwin.* [1879]. 3rd edn. London: Jonathan Cape, 1921.

Cock, Alan G., and Donald R. Forsdyke. *Treasure Your Exceptions: The Science and Life of William Bateson.* New York: Springer, 2008.

Cybernetics Thought Collective Project. University of Illinois, Urbana-Champaign, <https://archives.library.illinois.edu/thought-collective/cybernetics-thought-collective/> (last accessed September 29, 2017).

Durrell, Gerald. *Birds, Beasts and Relatives in* The Corfu Trilogy. London: Penguin, 2006.

Gibney, Paul. "The Double-bind Theory: Still Crazy-making After All These Years." *Psychotherapy in Australia* 12.3 (2006): 48–55.

Goldberg, Aaron D., C. David Allis, and Emily Bernstein. "Epigenetics: A Landscape Takes Shape." *Cell* 128.4 (2007): 635–8.

Gosse, Edmund. *Father and Son: A Study of Two Temperaments* [1907]. Ed. A. O. J. Cockshut. Keele: Ryburn Press, 1994.

Kraatz, G. "Jacob Sturm's Insecten-Cabinet." *Deutsche entomologische Zeitschrift* 19 (1875): 157–60.

Lipset, David. *Gregory Bateson: The Legacy of a Scientist*. Boston: Beacon Books, 1982.

Strasser, Bruno J. "Collecting Nature: Practices, Styles, Narratives." *Osiris* 27.1 (2012): 303–40.

Wallace, Alfred Russel. "Mimicry, and Other Protective Resemblances Among Animals." *Westminster Review* 88 (July 1867): 1–43.

Afterword: The Implications of Nineteenth-Century Replication Culture

Julie Codell and Linda K. Hughes

We now live in a world dominated by replication. Our notions of simulacra, virtual reality, genetic engineering, and digital culture, and our anticipations of technological singularity, when computers transform and then surpass human intelligence through nanosecond replication and inaugurate the post-human, may seem a world away from the nineteenth century. Yet our current world has emerged from a complex cultural legacy that the preceding essays outline. In this brief afterword we reflect on nineteenth-century replication as the pre-history of our own era.

As Jay David Bolter and Richard Grusin point out in *Remediation*, the very terms we use in our computer-networked professional lives replicate old media terms. We call the electronic data that we share via computer transfer a "file," and we store our files in "folders," which are usually represented in word-processing software or online "boxes" by icons based on paper or hanging folders that were once filed in cabinets (Bolter and Grusin). Some of us read scholarly publications in born-digital journals, but across the sciences, social sciences, and humanities many academic journals today – even the venerable *Science*, founded in 1880 – are issued in both old-media paper formats and new-media digital forms. Speaking of the digitized journals and related databases we access routinely, contributor James Mussell has emphasized that a digital "copy" is in fact not a "copy" but a replica edition that changes the original print edition, generating alternative metadata and networks in the process. Yet editorial interventions and the roles of anonymous workers in producing digital journals bear important

analogues to journal publication in the nineteenth century (Mussell; see also Fyfe).

Other links between the nineteenth century and our digital era include what is now considered the first computer program, which was published by Ada Lovelace in 1843 after she and Charles Babbage discussed Babbage's plan for an analytical engine. Appropriately, this exciting narrative has recently been adapted by Sydney Padua in her graphic novel entitled *The Thrilling Adventures of Lovelace and Babbage* (2015). Padua's work even includes replicated nineteenth-century documents in her chapter appendices. Lovelace and Babbage's ideas were anticipated in the seventeenth century by René Descartes and in the eighteenth century by clergyman and philosopher William Paley, who speculated on machines replicating themselves and displacing human beings. Samuel Butler, in his novel *Erewhon* (1872), informed by Darwin's theory of evolution, proposed a self-replication machine. Replication by machine or humans had earlier been imagined in Mary Shelley's 1818 *Frankenstein*; in the image of the Golem, Jewish folklore's animated being created from inanimate matter; and in philosophical arguments since the eighteenth century (whether by Gottfried Leibniz or Descartes) over whether humans were replicable machines.

Such speculations were both technological and gothic, anticipating modern echoes in science fiction and artificial intelligence research from the *Battlestar Galactica* television series to Cynthia Breazeal's Jibo family robot. Take the Buzz Rickson black MA-1 jacket, for example, the fictional replica of a Second World War bomber jacket invented by William Gibson in *Pattern Recognition* that was then made real and is now for sale online.[1] Like the MA-1 jacket and the replicas of art works and models of events (medieval jousts, imperial durbars) for sale on many websites, replicas allow time-traveling to the past, collapsing temporal and spatial distances, and also allow invented memories of imagined things that never materially existed except in replication. Replicas have their own production, reception, and network systems, often marked by temporal distance, as in paleontology, or new markets for recent art works or revised literary texts. Nineteenth-century industrial processes produced a modern mass culture that has in turn created contemporary systems for replicating extinct species (the de-extinction movement), frameworks of knowledge (for example, Wikipedia), and objects (for example, home fabrication and the interconnectivity and automation implied by the Internet of Things).

Replication has many new meanings today, of course. In gaming,

> replication is the mechanism by which the computers in a network game are kept in sync. If you are writing code that will be used in a network game and causes effects that might be seen by more than one player, then you need to be aware of replication.[2]

In cultural matters the interest in replication has been partly motivated by postmodernism, which, in reaction against modernism's "purity," fetish of originality, and often troubled relationships to traditions of the past, formed an aesthetic based on replicating Old Master paintings with new content (for example, the work of Cindy Sherman), and favoring copying, repetition, skepticism, relativism, distrust of grand narratives, irony, and the rejection of absolute truths or universals.

The study of replication raises provocative issues, such as the nature of post-humanism and digital culture. We now have greater control over the planet than ever, and our historical period has been dubbed the Anthropocene. We have power to change soil or climate radically, or to eradicate species. We now rely heavily on algorithms and computational systems whose power and complexity threaten to leave us behind. We have become so dependent on our copies – virtual, ephemeral, licensed but not owned – that some fear a loss of the very texture of experiences that once defined originality and human consciousness.[3] Indeed, Elon Musk declared artificial intelligence an "existential threat" to humanity at a conference of U.S. governors in July 2017.[4]

Replication, as we observe in our Introduction, is the mechanism of Darwin's theory of evolution in all species. Not until the twentieth century did biologists identify the structure of the DNA molecule and better understand its replication in each parent of human offspring, but now gene replication is also being transformed by new scientific and technological developments. In August 2017 news outlets reported that a laboratory in Oregon had successfully edited DNA in a human embryo to rid it of a harmful and otherwise inheritable gene mutation.[5] Now the door has been opened for designer babies that could, like artificial intelligence, eradicate human evolution as we have understood it thus far.

Intriguingly, some economists have adopted the theory of biological and genetic evolution as a paradigm for theories of the diffusion of new manufacturing technologies: "change occurs through deviations

from displayed characteristics in much the same way as mutations occurring as copying errors in the act of passing on genetic information from one generation to another" (Berg 8). In Maxine Berg's view, such genetic copying "has an analogue in the copying of ideas and inspirations in knowledge" that she likens to what Richard Dawkins terms the meme.[6] The evolutionary meme stored in the brain determines behavior; the cultural meme has no pre-determined goal but is culturally transmitted through replication involving "variation, innovation, and selection" (Berg 8).

If potential developments of replication today pose threats to some of our most cherished assumptions about lived experience and human importance, the history of nineteenth-century replication also suggests that replicas can expand human creativity, political and ethical awareness, and shared access to increased knowledge. Museum sites offer broader availability to art and historically significant works than ever before through digital replicas. Virtual doctors working remotely via digitized medical records and livestreaming carry the potential to bring medical resources to world populations. Reading of print, like vinyl records, is making a comeback in this historical moment, but replicated online catalogues and reviews are vital for helping consumers and enthusiasts access high and popular culture, while digitized genealogical records and individualized DNA analysis are assisting a pastime favored by older adults reconstructing family trees. Digitally replicated books and professional journals, whether open-access or commercially distributed, are likely to remain crucial to researchers and scholars for decades to come. We close by encouraging other scholars across disciplines to engage the legacy of the nineteenth-century industry of replications and acknowledge the histories of our current replicating practices.

Notes

1. We thank our Arizona State University colleague Ed Finn, founding director of the Center for Science and the Imagination, for suggesting these examples.
2. The quotation comes from the "Unreal Wiki" site at <https://wiki.beyondunreal.com/Legacy:Replication> (last accessed July 29, 2017).
3. These debates are not novel, of course, but the terms of argument have changed, since we can now envision self-replicating robots that might consume all matter in their drive to reproduce. Drexler's notion of tiny machines constrained only by their architects' imagination is slowly coming true in engineering laboratories, while replicating machines

flourish elsewhere, from computer viruses to "rep-rap" 3D printers that can build copies of themselves (see Drexler, *Engines of Creation*). Most successful perhaps may be the Internet's viral memes.

4. Musk's address was reported on "Morning Edition" of National Public Radio on July 18, 2017; see <http://www.npr.org/2017/07/18/537844706/elon-musk-artificial-intelligence-poses-existential-risk> (last accessed July 29, 2017).

5. See, for example, Healy in the *Los Angeles Times* of August 2, 2017.

6. The meme, a cultural unit, like the biological gene, which can replicate itself through dissemination of ideas, was explored by Richard Dawkins (*The Selfish Gene*, 1976) and Douglas Hofstadter (*Metamagical Themas*, 1985), generating a term, memetics, in which language was examined as a virus. K. Eric Drexler in *Engines of Creation*, 1986, coined the term "gray goo" to describe a similar imagined molecular nanotechnology.

Works Cited

Berg, Maxine. "From Imitation to Invention." *The Economic History Review* 55.1 (2002): 1–30.

Bolter, Jay David, and Richard Grusin. *Remediation: Understanding New Media*. Cambridge, MA: MIT Press, 1999.

Dawkins, Richard. *The Selfish Gene*. Oxford: Oxford University Press, 1976.

Drexler, K. Eric. *Engines of Creation*. Garden City, NY: Anchor Press, 1986.

Fyfe, Paul. "An Archaeology of Victorian Newspapers." *Victorian Periodicals Review* 49.4 (Winter 2016): 546–77.

Healy, Melissa. "In a First, Scientists Rid Human Embryos of a Potentially Fatal Gene Mutation by Editing their DNA." *Los Angeles Times* August 2 (2017), online edition, <http://www.latimes.com/science/sciencenow/> (last accessed August 22, 2017).

Hofstadter, Douglas. *Metamagical Themas*. New York: Basic Books, 1985.

Mussell, James. *The Nineteenth-Century Press in the Digital Age* (Palgrave Studies in the History of the Media). London: Palgrave Macmillan, 2012.

Padua, Sydney. *The Thrilling Adventures of Lovelace and Babbage*. New York: Pantheon, 2015.

Notes on Contributors

Julie Codell is Professor of Art History at Arizona State University and affiliate faculty in English, Gender Studies, Film, and Asian Studies. She wrote *The Victorian Artist* (2003; paperback rev. edn 2012); edited *Transculturation in British Art* (2012), *Power and Resistance: The Delhi Coronation Durbars* (2012), *The Political Economy of Art* (2008), *Genre, Gender, Race, and World Cinema* (2007), and *Imperial Co-Histories* (2003); and co-edited with Joan DelPlato, *Orientalism, Eroticism and Modern Visuality in Global Cultures* (2016), with L. Brake, *Encounters in the Victorian Press* (2004), and with D. S. Macleod, *Orientalism Transposed* (1998). She has received fellowships from Yale's British Art Center, the National Endowment for the Humanities, the Getty Foundation, the Kress Foundation, the Huntington Library, the Ransom Center, and the American Institute for Indian Studies. Her current projects are a study of Victorian artists' replicas and the art market, and the rhetoric of Victorian painting.

Linda K. Hughes, Addie Levy Professor of Literature at Texas Christian University, specializes in Victorian literature and culture with special interests in historical media studies (illustrated poetry, periodicals, serial fiction); gender and women's studies; and transnationality. She is author of *The Cambridge Introduction to Victorian Poetry* (2010) and *Graham R.: Rosamund Marriott Watson, Woman of Letters* (2005, awarded the Colby Prize); co-author of *Victorian Publishing and Mrs. Gaskell's Work* (1999) and *The Victorian Serial* (1991); and editor or co-editor of several volumes, including *A Feminist Reader: Feminist Thought from Sappho to Satrapi* (4 vols, 2013), *Teaching Transatlanticism: Resources for Teaching Anglo-American Print Culture* (2015), and *The Cambridge Companion to Victorian Women's Poetry* (scheduled for publication in 2018). She also served as Associate Editor of the Wiley–Blackwell *Encyclopedia of Victorian Literature* (4 vols, 2015). Currently, she is completing a book project on ten progressive Victorian women writers and their cultural interchange and networks in Germany.

Will Abberley is Senior Lecturer in Victorian Literature in the School of English, University of Sussex. He wrote *English Fiction and the Evolution of Language, 1850–1914* (2015). His current research explores concepts of biological mimicry and deception in the long nineteenth century, and their representations in literature. Besides academic publications, he has turned aspects of his research into numerous broadcasts for BBC Radio. His research for the essay in this collection was made possible by an Early Career Fellowship funded by the Leverhulme Trust.

David Amigoni is Professor of Victorian Literature at Keele University, where he is also Pro Vice-Chancellor for Research. He has published extensively on Victorian life writing and Victorian literature and science, notably *Victorian Biography* (1993) and *Colonies, Cults and Evolution* (2007). He is working on a project about biological and cultural theories of inheritance between c. 1880 and 1960, and the intellectual families (Darwins, Batesons, Huxleys) who were influential in their development. He was editor of the *Journal of Victorian Culture* (2005–8) and editor in chief of *Literature Compass* between 2014 and 2016.

Dan Bivona is Associate Professor of English Literature at Arizona State University in Tempe. He is the author of three books: *Desire and Contradiction* (1990), *British Imperial Literature, 1870 to 1940* (1998), and (with Roger B. Henkle) *The Imagination of Class: Masculinity and the Victorian Urban Poor* (2006). He co-edited with Marlene Tromp an anthology entitled *Culture and Money in the Nineteenth Century: Abstracting Economics* (2016). His current project is tentatively entitled "The Natural and Social History of Pluck."

Suzanne Daly is Associate Professor of English at the University of Massachusetts Amherst, where she teaches courses on the Victorian novel, literary theory, and the literature of the British Empire. She is the author of *The Empire Inside: Indian Commodities in Victorian Domestic Novels* (2011), and articles on Charlotte Brontë, Dickens, Gaskell, and Trollope. She is currently writing a book about Imperial philanthropy in the nineteenth century.

Gowan Dawson is Professor of Victorian Literature and Culture in the Victorian Studies Centre at the University of Leicester, and Honorary Research Fellow of the Natural History Museum, London. He is the author of *Show Me the Bone: Reconstructing Prehistoric Monsters in Nineteenth-Century Britain and America*

(2016) and *Darwin, Literature and Victorian Respectability* (2007), and co-author of *Science in the Nineteenth-Century Periodical: Reading the Magazine of Nature* (2004). With Bernard Lightman, he is general editor of *Victorian Science and Literature*, 8 vols (2011–12), and editor of *Victorian Scientific Naturalism: Community, Identity, Continuity* (2014).

Sally Foster is Lecturer in Heritage and Conservation at the University of Stirling. Her research is interdisciplinary, cutting across cultural heritage management, archaeology, history, art history, and museology, with a particular interest being the nineteenth-century replication of early medieval material culture. In addition to recent articles on replication in the *Journal of the History of Collections, Journal of Victorian Culture*, and *European Journal of Archaeology*, the third edition of her bestseller, *Picts, Gaels and Scots*, appeared in 2014.

Kathryn Ledbetter is Professor of English at Texas State University. She is author of *Victorian Needlework* (2012); *British Victorian Women's Periodicals: Civilization, Beauty, and Poetry* (2009); *Tennyson and Victorian Periodicals: Commodities in Context* (2007, awarded the Colby Prize); *"Colour'd Shadows": Contexts in Publishing, Printing, and Reading Nineteenth-Century British Women Writers* (with Terence Hoagwood, 2005); and *The Keepsake (1829)*, a facsimile edition, with introduction and notes (with Terence Hoagwood, 1999). She has published articles in various newspapers, magazines, and scholarly journals, including *Studies in the Literary Imagination; Victorian Poetry; Victorian Periodicals Review; Papers of the Bibliographical Society of America; Journal of Modern Literature;* and *Victorian Newsletter*.

Elizabeth Carolyn Miller is Professor of English at the University of California, Davis. She is the author of *Slow Print: Literary Radicalism and Late Victorian Print Culture* (2013), which was named North American Victorian Studies Association Best Book of the Year and received Honorable Mention for the Modern Studies Association Book Prize, as well as *Framed: The New Woman Criminal in British Culture at the Fin de Siècle* (2008). Her articles have appeared in *Modernism / modernity, Feminist Studies, Victorian Literature and Culture, Victorian Studies,* and elsewhere. Her current research focuses on capitalism and ecology in nineteenth-century Britain. At present she is working on a book project titled "Extraction Ecologies and the Literature of the Long Exhaustion, 1830–1930."

Dorothy Moss is Curator of Painting and Sculpture, and Curator of Performance Art at the Smithsonian National Portrait Gallery. She also directs the triennial Outwin Boochever Portrait Competition. Her current projects include curating the Portrait Gallery's first performance art series as well as exhibitions on Sylvia Plath and portrayals of workers in the U.S. from the eighteenth century to the present. From 2008 to 2013, Moss taught an American Studies seminar for the Smith College / Smithsonian semester program on new technology in American art museums and the impact of new media on the exploration of identity in contemporary portraiture. She has contributed to numerous exhibition catalogues and to publications such as the *Burlington Magazine, American Art, click!: photography changes everything*, and *Gastronomica*.

James Mussell is Associate Professor of Victorian Literature and Director of the Centre for the Comparative History of Print (Centre CHoP) at the University of Leeds. He is the author of *Science, Time and Space in the Late Nineteenth-Century Periodical Press* (2007) and *The Nineteenth-Century Press in the Digital Age* (2012). He is one of the editors of the *Nineteenth-Century Serials Edition* (*NCSE*, 2008) and *W. T. Stead: Newspaper Revolutionary* (2012).

Emilie Taylor-Brown is a postdoctoral research fellow on the *Diseases of Modern Life* project at St. Anne's College, Oxford. She has published on the parasite as a gothic literary archetype in *Monsters and Monstrosity from the Fin de Siècle to the Millennium* (2015); on parasitologists' literary imaginations in the *Journal of Literature and Science* (2014); and on the reign of the super-virus in *Unnatural Reproductions and Monstrosity: The Birth of the Monster in Literature, Film, and Media* (2014). In 2013 she co-authored an essay in the parasitology journal *Parasites and Vectors* (2013), drawing on research carried out during her Bachelor of Science degree in Biology. Her current work, which is informed by microbiome studies, investigates changing interdisciplinary understandings of gastrointestinal health throughout the nineteenth century.

Ryan D. Tweney is Emeritus Professor of Psychology, Bowling Green State University. His research interests have centered on understanding and explaining the nature of scientific thinking and have included laboratory work on scientific problem solving and on confirmation bias, cognitive–historical analyses (especially of Michael Faraday and James Clerk Maxwell), and the replication of historically important scientific experiments. His current research centers

on the metaphoric underpinnings of mathematical representations in physical science, with a focus upon Maxwell's mathematical reinterpretation of Faraday's field theory, and on the application of similar ideas to the development of better science education. His publications include Tweney, Doherty, and Mynatt, *On Scientific Thinking* (1981), and Tweney and Gooding, *Faraday's 1822 "Chemical Notes, Hints, Suggestions, and Objects of Pursuit"* (1991), as well as many papers and book chapters.

Index

Note: Page numbers in *italics* indicate illustrations. Page numbers followed by an n refer to end-of-chapter notes.